MODERN ART
PRACTICES AND DEBATES

Realism, Rationalism, Surrealism

MODERN ART
PRACTICES AND DEBATES

Realism, Rationalism, Surrealism
Art between the Wars

Briony Fer David Batchelor Paul Wood

YALE UNIVERSITY PRESS, NEW HAVEN & LONDON
IN ASSOCIATION WITH THE OPEN UNIVERSITY

First published 1993 by Yale University Press in association with The Open University
Reprinted with corrections 1994

4 6 8 10 9 7 5 3

Library of Congress Cataloging-in-Publication Data
Fer, Briony.
Realism, Rationalism, Surrealism: Art between the Wars/
Briony Fer, David Batchelor, Paul Wood.
p. cm. – (Modern art – practices and debates)
includes bibliographical references and index
ISBN 0–300–05518–8 (cloth)
0–300–05519–6 (paper)
1. Realism in art 2. Constructivism (Art)
3. Surrealism 4. Art, Modern – 20th century
I. Batchelor, David II. Wood, Paul III. Title IV. Series
N6494, R4F47 1993 709'.04'1–dc20 92-50987

Edited, designed and typeset by The Open University
Printed in Hong Kong by Kwong Fat Offset Printing Co. Ltd

CONTENTS

PREFACE

This is the third in a series of four books about art and its interpretation from the mid-nineteenth century to the end of the twentieth. Each of the books is self-sufficient and accessible to the general reader. As a series, they form the main texts of an Open University course, *Modern Art: Practices and Debates*. They represent a range of approaches and methods characteristic of contemporary art-historical debate. The present book as a whole addresses debates in, and about, the avant-garde in the years between the two world wars.

In the first chapter David Batchelor considers responses by artists, primarily in France, to the First World War. He relates the emergence of a 'School of Paris', and the competing avant-gardes of Purism, Dada and early Surrealism, to the wider social conditions existing in the wake of both devastation and victory. However, he is also concerned to indicate ways in which art can achieve independence from its determining conditions.

Briony Fer contributes two chapters. In the first she looks at the emergence of a concept of construction art. Her focus is the post-revolutionary Soviet Union, though she also considers work in France and Weimar Germany. Her aim is to examine why construction proved so powerful a metaphor for artists at this time, which leads her to consider ideas of utility and decoration in art and design. In her second chapter Briony Fer turns to consider aspects of Surrealism. Here her emphasis is on questions of sexual difference. She looks at Surrealism's use of the legacy of Freud, and studies a wide range of textual and photographic sources rather than paintings alone. In particular, she reviews Surrealist magazines and the contribution of Georges Bataille.

In the final chapter Paul Wood addresses the widespread debate over the question of Realism in art. For many, Realism represented an alternative to what was seen as the isolation or even élitism of the avant-garde, a viewpoint that gained support from the adoption of Socialist Realism as the official art form of the Soviet Union. However, other voices insisted that the avant-garde had a role to play in the development of a modern realism adequate to the conditions of the twentieth century.

Open University texts undergo several stages of drafting and review. The authors would like to thank those who commented on the drafts, notably Lynn Baldwin and Professor Thomas Crow. Paul Wood was the academic co-ordinator; John Pettit was the editor. Picture research was carried out by Tony Coulson; Alison Clarke keyed in the text. Richard Hoyle was the graphic designer, Roberta Glave the course administrator.

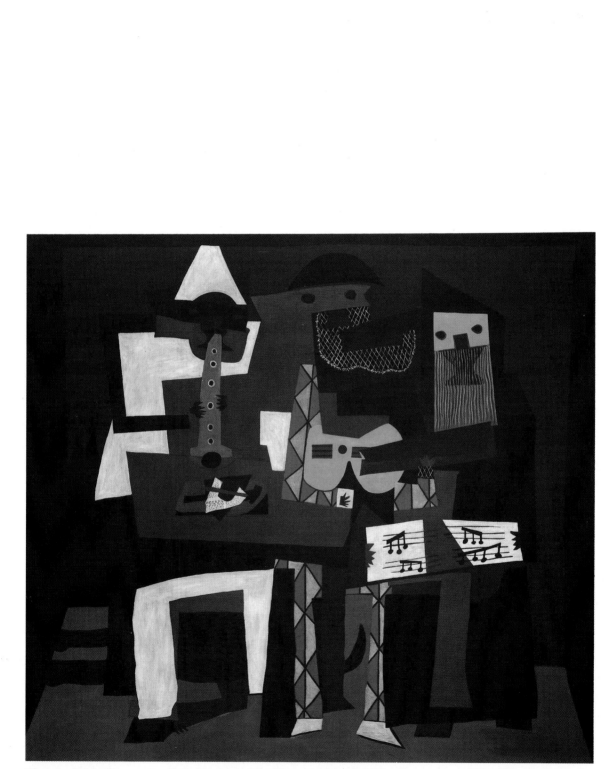

Plate 1 Pablo Picasso, *Les Trois Musiciens* (*The Three Musicians*), 1921, oil on canvas, 201 x 223 cm. Collection, The Museum of Modern Art, New York; Mrs Simon Guggenheim Fund. © DACS, London, 1993.

CHAPTER 1
'THIS LIBERTY AND THIS ORDER': ART IN FRANCE AFTER THE FIRST WORLD WAR

by David Batchelor

Introduction

Early in 1926 Alexandre Cabanel's *The Birth of Venus* of 1863 was consigned to the basement of the Musée du Luxembourg, together with 180 other nineteenth- and early twentieth-century Academic paintings considered 'too space-consuming for their pictorial value' (quoted in C. Green, *Cubism and its Enemies*, p.131). Their place in the main galleries of the museum, alongside what remained of the Academic collection belonging to the French state, was to be filled with works by Monet, Renoir, Van Gogh, Degas, Matisse, Bonnard and other artists associated with the Modern Movement. In this way works associated with unofficial and anti-Academic interests, from Impressionism to Fauvism, became visibly absorbed into the pantheon of officially sanctioned art in France.

By admitting non-Academic art into the Luxembourg, the trustees of official art were probably doing little more than symbolically and belatedly recognizing that Academic training and values had become largely irrelevant in the contemporary world, and in the world of contemporary art. They had become irrelevant both culturally and economically, in the culmination of a process that began in the mid- to late nineteenth century. Put briefly, the annual official exhibitions, or Salons, had been displaced from the cultural and economic centre of art by a number of forces, including the development of a substantial network of independent dealers and collectors in Paris. We know (from M. Gee, *Dealers, Critics and Collectors of Modern Painting*) that this market became the main arena within which non-Academic art was displayed, bought and sold. Before and after the First World War this market expanded massively, to the point where there was little need for an artist to submit work to one of the annual Salons if he or she could secure regular, one-person exhibitions in a reputable commercial gallery. By the 1920s, depending on the status of the gallery, such exhibitions had become more likely than the official Salons to generate both income for the artists and critical attention.

But it does not follow that, because there was no significant Academic mainstream (in relation to which independent artists could position themselves in critical opposition), modern art developed freely and without contest and division. On the contrary: if anything the divisions became sharper between the two world wars. The difference is that they were enacted *within* the range of work that is loosely grouped under the umbrella of modern or independent art. The history of this period is, to some extent, a history of interest-groups vying over the status and significance of the recent, and not so recent, history of art; over the meaning of modern art; and over the nature of modern life.

It is important to stress that inquiring into the character and content of such divisions is not merely a matter of sociological detail. It is rather more basic to the questions of meaning in art. For example, in the same way as the character and quality of Édouard

Manet's *Olympia* of 1863 had been established, in part, by its self-conscious differentiation from models of Academic competence embodied in work such as Cabanel's *The Birth of Venus*, so we might expect work from the inter-war period to have been engaged in similar processes of playing itself off against more established or competing paradigms of taste and artistic competence. It is in no small part through such a process of association and dissociation that works of art acquire meaning, or that meanings are attached to works of art. The implication here is that a significant aspect of the meaning, or expressive character, of works of art is established by their being placed within a framework of alternatives.

An example might clarify this. The expressive character of a wavy line, such as Figure A, is in itself indeterminate. It seems fairly meaningless to ask, 'does this express order or chaos?' But if it is placed near an irregular zigzag such as Figure B, the same question becomes answerable. We would probably reply that Figure A is 'more like order' than Figure B. If, however, in place of Figure B we introduced a smoother line, Figure C, and asked the same question, we would probably see Figure C as more expressive of order. That is to say, a different context of alternatives will probably alter what we perceive the expressive character to be. So, if Figure A is the conventional way of representing chaos, Figure B will look like overstatement; whereas in the context where Figure B is the norm, Figure A will appear as understatement.

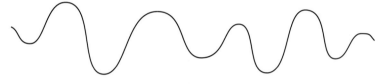

Figure A

Figure B

Figure C

Works of art are, on the whole, more complex things than wavy lines or zigzags. But it will be part of the aim of this chapter to show how such exercises are relevant to the investigation of meaning in art in general, and how they are useful to the study of this period in particular.

Consider the following small selection of paintings produced or exhibited in Paris within a year or two of 1921: *The Three Musicians* by Picasso (Plate 1); *The Odalisque with Red Culottes* by Matisse (Plate 2); *Composition with Red, Yellow and Blue* by Mondrian (Plate 3); *The Nantes Road* by Vlaminck (Plate 4); *Still-life with Pile of Plates* by Jeanneret (Plate 18); *The Two Punchinellos* by Severini (Plate 5); and *The Child Carburettor* by Picabia (Plate 6).

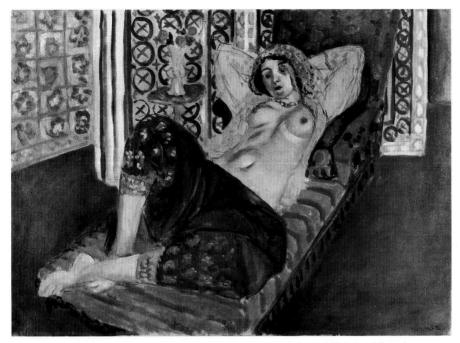

Plate 2 Henri Matisse, *L'Odalisque à la culotte rouge* (*The Odalisque with Red Culottes*), 1921, oil on canvas, 65 x 90 cm. Musée National d'Art Moderne, Centre Georges Pompidou, Paris. © Succession Matisse, Paris and DACS, London, 1993.

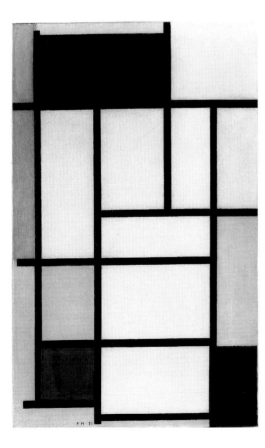

Plate 3 Piet Mondrian, *Compositie met rood, geel en blauw* (*Composition with Red, Yellow and Blue*), 1921, oil on canvas, 80 x 50 cm. Haags Gemeentemuseum, The Hague. © DACS, London, 1993.

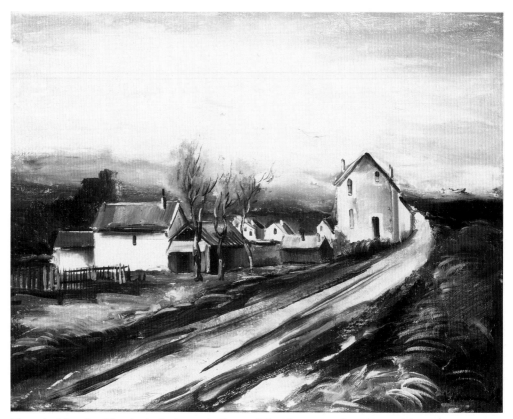

Plate 4 Maurice Vlaminck, *La Route de Nantes* (*The Nantes Road*), 1922–23, oil on canvas, 55 x 65 cm. Present whereabouts unknown. Photographic Archives of The National Gallery of Art, Washington DC, from a negative by Taylor and Dull for Parke-Bernet Galleries Inc. © ADAGP, Paris and DACS, London, 1993.

All of these artists exhibited more or less regularly in commercial galleries and public exhibitions immediately after the First World War. Their work was bought and sold through dealers at auctions, and was discussed and criticized in newspapers and the art press. That is to say, they all worked within the same broad cultural and economic space, even if they did not enjoy equal critical and commercial success within it. Clearly, though, as we can see from the examples, this space sustained a considerable diversity of work.

Not all the commentators of the period categorized and differentiated this range of material in the same way. Rather, the structure of differentiation was itself a matter of argument and dispute. Even within a group of pro-Cubist commentators there were evident differences of emphasis. Fernand Léger, for example, at the time of the Salon des Indépendants of 1921, recognized 'three groups … the sub-Impressionists, the Cubists and the Sunday painters'. The minor Cubist painter André Lhote detected four categories instead of Léger's three: '1 academicism; 2 impressionism; 3 constructive naturalism; 4 cubism'. The critic Maurice Raynal, on the other hand, conceived of only two distinct tendencies, 'Realism and Idealism'; for him the division boiled down to a question of whether the painting was based on a naturalistic rendering of observed forms (Realism), or whether the artist 'lifts [his art] above nature' to produce an autonomous composition 'born of the artist's imagination' (quoted in Green, *Cubism and its Enemies*, pp.124–5). This latter category – Idealism – he associated with the work of the Cubist painters. Nevertheless a common thread runs through these commentators' classifications: each assumes a fundamental distinction between a pre-Cubist and a post-Cubist picture-space, although each may also have viewed that distinction from a somewhat different perspective.

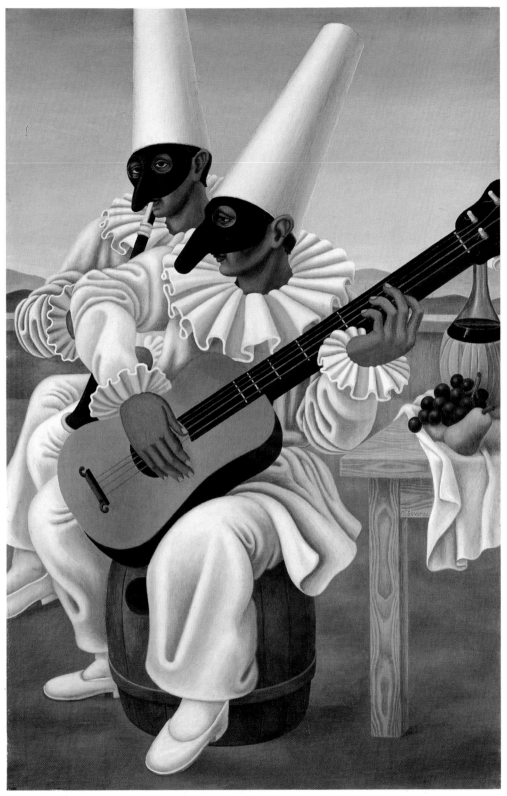

Plate 5 Gino Severini, *Les Deux Polichinelles* (*The Two Punchinellos*), 1922, oil on canvas, 92 x 61 cm. Haags Gemeentemuseum, The Hague. © ADAGP, Paris and DACS, London, 1993.

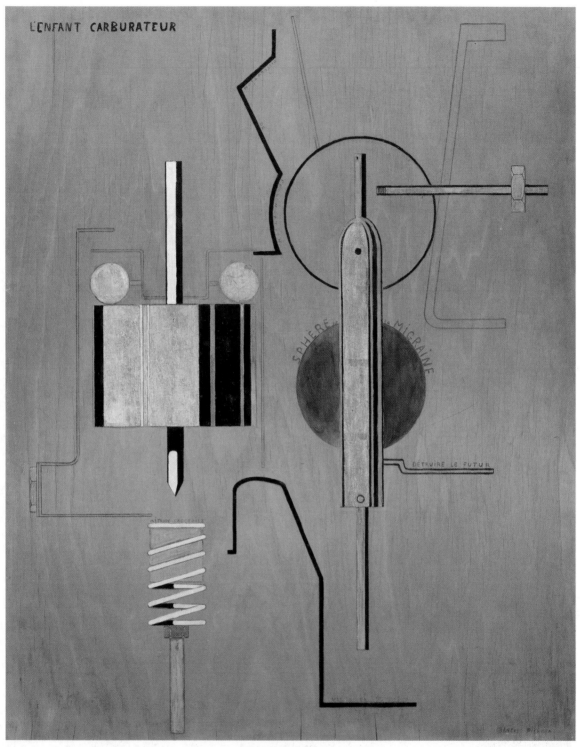

Plate 6 Francis Picabia, *L'Enfant carburateur* (*The Child Carburettor*), 1919, oil, gilt, pencil and metallic paint on plywood, 126 x 101 cm. Collection of Solomon R. Guggenheim Museum, New York. © ADAGP/SPADEM, Paris and DACS, London, 1993.

Naturalism, Classicism, the School of Paris

The kinds of differentiation we have just looked at, between pre- and post-Cubist picture-space, seem straightforward enough. They were also made topical immediately after the war – especially, perhaps, for these Cubist-oriented writers – when a wide variety of naturalistic painting re-emerged in Paris. The return to more conservative styles of painting by the erstwhile Fauves Matisse, Vlaminck and Derain (see Derain's *The Laden Table*, Plate 7) was regarded by these writers as a retreat from the achievements of pre-war Cubism. Furthermore, a group of artists whose work had not acquired prominence before the war – among them de Segonzac, Utrillo, Kisling and Laurencin (see de Segonzac's *Still-life with Eggs*, Plate 19, and Utrillo's *Bernot's*, Plate 8) – began by the early twenties to attract considerable critical and commercial attention.

The label 'School of Paris' is often applied to this loose grouping of painters working in an informal, naturalistic style around this time. In fact the term was conceived only in the late twenties and applied retrospectively – and then in differing ways by various authors. Nevertheless, by the middle of the decade this type of work was enjoying immense commercial success, while Cubist-oriented work was fetching very low prices in comparison. Some examples will illustrate this point. In 1924 Juan Gris's *Washstand* (1912) made only 330 francs at a sale. Pablo Picasso's *Ma Jolie* (1911) fetched 6,500 francs later that year, whereas de Segonzac's *Drinkers* (1910) went for over 100,000 francs in 1925. By 1926, when the market for Cubist-oriented work had generally improved, a more abstract painting by Mondrian could still fetch only 700 francs. (Green gives more details of prices in Chapter 8 of his *Cubism and its Enemies*.)

The overwhelming commercial success of artists such as de Segonzac, Vlaminck and Derain was accompanied by an equal amount of critical acclaim. One of their most prominent and respected advocates was the critic Louis Vauxcelles. For him, the work of these artists embodied a cluster of related virtues – in particular, a love of and respect for nature, and an intuitive and sensuous approach based on feeling, honesty, directness and innocence. Clearly de Segonzac's *c.*1923 *Still-life with Eggs* (Plate 19) is based on observation; in addition, its rustic motif, earth colours, dark tonal range, heavy surface and handling were evocative of a group of rural and Realist still-lives from Courbet to Van Gogh. Together these elements could be taken to point in the general direction suggested by Vauxcelles. But this hardly seems sufficient reason for Vauxcelles and others to

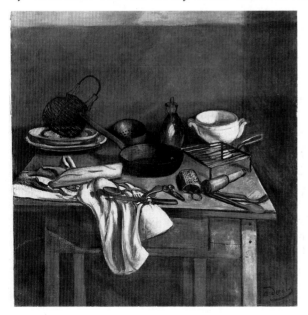

Plate 7 André Derain, *La Table de cuisine* (*The Laden Table*), 1921–22, oil on canvas, 59 x 58 cm. Musée de l'Orangerie, Collection Jean Walther and Paul Guillaume, Paris. Photo: Réunion des Musées Nationaux Documentation Photographique. © ADAGP, Paris and DACS, London, 1993.

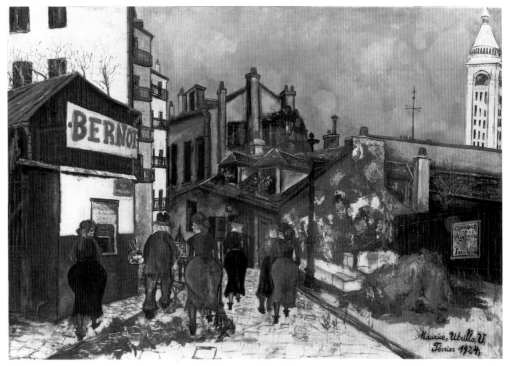

Plate 8 Maurice Utrillo, *La Maison Bernot* (*Bernot's*), 1924, oil on canvas, 99 x 146 cm. Musée de l'Orangerie, Collection Jean Walther and Paul Guillaume, Paris. Photo: Réunion des Musées Nationaux Documentation Photographique. © ADAGP/SPADEM, Paris and DACS, London, 1993.

make the claims that they did. Rather, the authors gave weight to their claims, not so much by analysing individual works as by carefully positioning them within a network of strategic oppositions. In particular, the value of these naturalistic works was established by setting them in direct contrast with the 'excesses' and 'failings' of Cubism. For Vauxcelles, Cubism had always encapsulated the antithesis of everything of value in art: it was excessively intellectual, cold, calculated, artificial and lacking spontaneity or feeling. Most of all it seemed to reject nature:

> But nothing valid is created without nature. One only creates with her. And without her, Cubist, you will end up only with spectres, with abstract phantasms, with bizarre arabesques … that is to say with nothingness.
>
> (Vauxcelles, quoted in Green, *Cubism and its Enemies*, p.168)

In the 1920s Vauxcelles was still warning against the 'perils of seductive intellectualism, of unbridled logic and algebra!' Thus in the face of such disasters, naturalistic paintings such as de Segonzac's or Vlaminck's could be regarded as vehicles for warmth, intuition, realism and so forth – everything denied in Cubism. Many of the contemporary commentaries on these artists put less stress on the naturalism of the work than on the naturalness of the artists' temperaments and their highly personal approach to their work. De Segonzac 'enclosed himself in his naturalism', thereby 'keeping away from all [Cubist] influence', according to the critic Roger Allard. And the artist himself put it:

> As for me, I aim to express to the best of my ability, with all my love, that which I love: a French landscape, a beautiful woman with a noble body. One will see later if it is art … I believe a great deal in solitary work; the state of grace is revealed in contact with nature. A French peasant said to me one day: 'It's odd how the world becomes stupid when it has too much teaching.'
>
> (de Segonzac, quoted in Green, *Cubism and its Enemies*, p.174)

We will look later at some of the Cubist-oriented work of this period. Before doing so, it is important to note that there were significant differences within the range of naturalistic painting being produced in Paris at the time. For example, while there was enough in Matisse's *Odalisque* (Plate 2) to appeal to pro-naturalist commentators, it is in almost every respect a very different type of painting from de Segonzac's or Vlaminck's. Its exotic subject-matter, bright colour, lightness of touch and attention to the decorative, point in a very different direction from the provincial rusticity of de Segonzac. Matisse was far from alone in using a loosely naturalistic technique to portray distant and apparently unrealistic scenes. Picasso, Derain, Severini, Gris and others all adopted a naturalistic technique within a conventional perspective framework in the depiction of single- or multiple-figure compositions. The majority of these depicted, not a rural present but images of a Classical past. This range of painting also dealt more in generalized themes of human existence than in the specifics of time, place and character.

We will discuss shortly some of the explanations that have been offered for the emergence of overtly Classical themes and naturalistic techniques in non-Academic circles. For the moment it is worth noting some of the characteristics of work of this kind. The theme of maternity became one of the most common in the representation of women, together with the associated image of the female figure, often in simple Hellenic costume, carrying freshly harvested produce or freshly drawn spring-water. In each of these cases woman is represented primarily as an image of fertility – the bearer of new life and sustenance, be it animal, vegetable or mineral. (Matisse's paintings are a notable exception.) In Picasso's

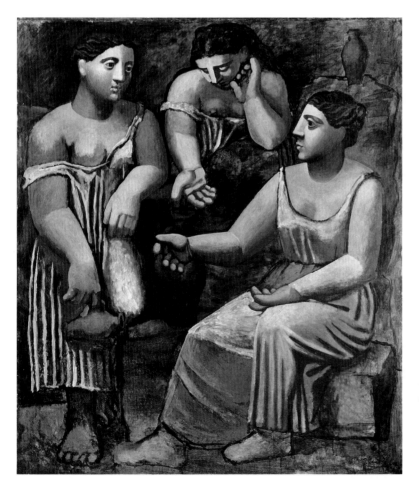

Plate 9 Pablo Picasso, *Trois Femmes à la source* (*Three Women at the Spring*), 1921, oil on canvas, 204 x 174 cm. Collection, The Museum of Modern Art, New York; gift of Mr and Mrs Allan D. Emil. © DACS, London, 1993.

Plate 10 Gino Severini, *Maternità* (*Maternity*), 1916, oil on canvas, 92 x 65 cm. Collection Jeanne Severini. Photo: Giraudon. © ADAGP, Paris and DACS, London, 1993.

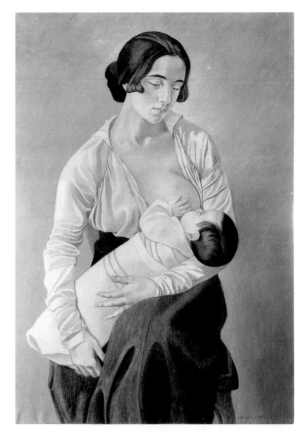

paintings she is usually a monumental figure in a Classical cotton shift (see Picasso's *Three Women at the Spring*, Plate 9, and untitled drawing, *c.*1922, Plate 61). Severini's rather earlier representation of motherhood, *Maternity* (Plate 10), is dressed in more modern costume, but its rather bland naturalism evokes more of an abstract, universal theme than a particular instance of child-rearing. Braque's large *The Basket-carrier* (Plate 11) is considerably less naturalistic, but even more Classical and monumental in its orientation.

The preferred theme through which the male figure was represented was at least as generalized and historicized as in the treatment of woman. Picasso, Gris, Derain, Severini, Metzinger and others all depicted male figures in the costumes of the Italian *commedia dell'arte* (see Picasso's *Seated Harlequin*, Plate 12, and Severini's *The Two Punchinellos*, Plate 5). All these works are laden with self-conscious reference to historical themes and art-historical sources. Picasso's *Seated Harlequin* was even painted in tempera, a traditional medium of Italian painting which went into decline with the development of oil paint. It is as if the overriding aim were to evacuate the picture of any specific reference to the modern world and to invoke instead that side of art connected with tradition and continuity. Painterly naturalism in these works seems entirely devoid of contemporary realism. It appears to have been used for ends that were quite distinct from the naturalism of Vlaminck, de Segonzac and their circle. Local detail, rustic simplicity and their association with direct and uncomplicated aims on the part of the artist are replaced by art-historical reference, quotation of Classical sources, allegory, self-conscious artifice and the associations of erudition and sophistication. At the risk of over-simplification, it could be said that while for one group of artists naturalism is used to invoke the values of nature, for another it is mobilized in a reflection on culture.

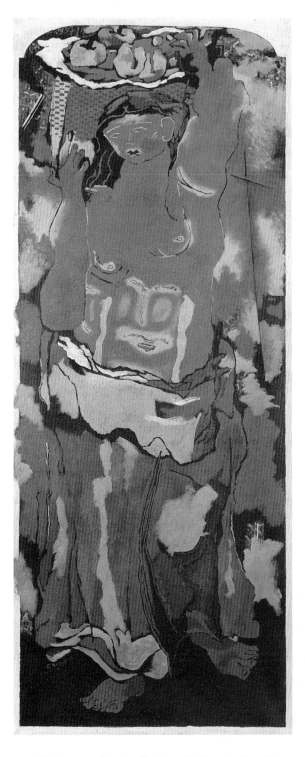

Plate 11 Georges Braque,
Le Canéphore (*The Basket-carrier*),
1922, oil on canvas, 180 x 73 cm.
Musée National d'Art Moderne,
Centre Georges Pompidou, Paris.
© ADAGP, Paris and
DACS, London, 1993.

The issue of naturalistic painting during this period is further complicated by the fact that some of the most apparently ardent Classicist painters also continued to work in overtly Cubist styles. Picasso's large painting of *The Three Musicians* (Plate 1), for example, treats the same *commedia dell'arte* subject in an explicitly Cubist manner, as had his earlier

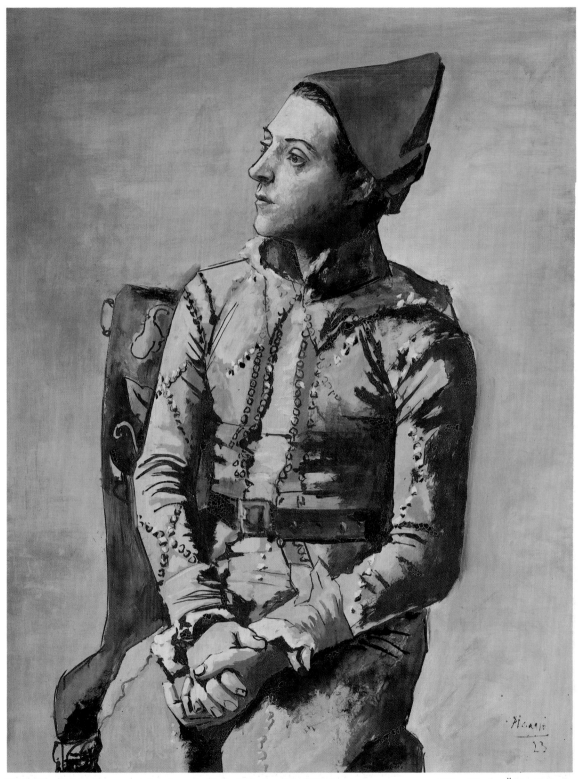

Plate 12 Pablo Picasso, *Arlequin assis* (*Seated Harlequin*), 1923, tempera on canvas, 130 x 98 cm. Öffentliche Kunstsammlung, Kunstmuseum Basel, G1967.9. Photo: Colorphoto Hinz. © DACS, London, 1993.

Harlequin of 1915 (Plate 13). In each painting all modelling and perspective are eliminated as the schematic figures are set in a shallow space of apparently overlapping or intersecting planes of flat colour. A similar use of shallow space and blocks of flat colour is evident in Braque's *The Basket-carrier* (Plate 11), although the result is a far less abstracted picture than Picasso's. Gris also sought to combine his Cubist technique with explicitly historical themes, but in his case by producing Cubistic updates of some historical paintings. His *The Woman with a Mandolin* of 1916 (Plate 14) is a reworking of Corot's *c.*1865 *Dreamer with a Mandolin* (Plate 15), where the main compositional elements have been schematized, arranged as flattened coloured shapes and combined with a certain amount of residual graphic detail.

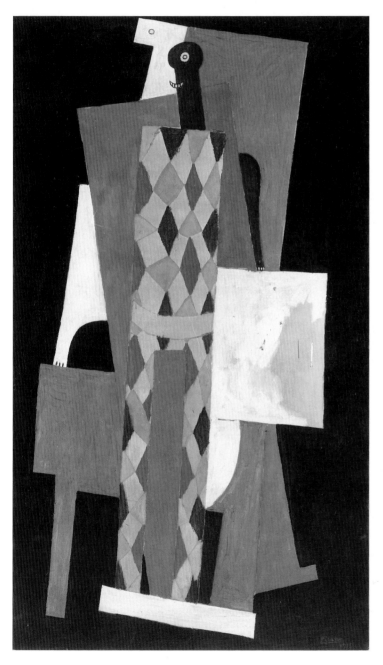

Plate 13 Pablo Picasso, *Arlequin* (*Harlequin*), 1915, oil on canvas, 184 x 105 cm. Collection, The Museum of Modern Art, New York; acquired through the Lillie P. Bliss Bequest. © DACS, London, 1993.

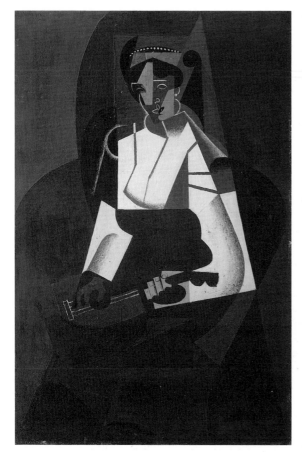

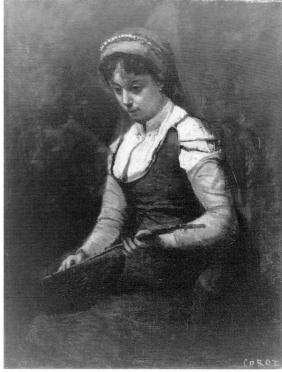

Plate 15 Jean-Baptiste Camille Corot, *Rêveuse à la mandoline* (*Dreamer with a Mandolin*), 1860–65, oil on canvas, 51 x 37 cm. The Saint Louis Art Museum, Missouri, 31:1988.

Plate 14 Juan Gris, *La Femme à la mandoline (d'après Corot)* (*The Woman with a Mandolin (after Corot)*), 1916, oil on canvas, 92 x 60 cm. Öffentliche Kunstsammlung, Kunstmuseum Basel.

Thus even within the range of naturalistic painting produced during and after the war, there are signs of diversity and in some cases direct incompatibility of aims and interests. But the question remains: how can we account for this apparent withdrawal from the radicalism of pre-war non-Academic art in favour of more conventional forms of representation? In recent years several art historians have argued that the reasons for these shifts lie outside the immediate realm of art and within wider cultural developments precipitated by the effects of the 1914–18 War. It *is* hard to imagine that events of such global significance as the First World War and the October Revolution in Russia did not affect the outlook of artists – as they did of other people. But it may be another matter to indicate exactly how a response to these events was embodied in particular works of art. There were of course some quite practical ways in which the First World War affected the development of modern art. For example, the Parisian art economy was effectively shattered during the war: some artists, including Braque and Léger, were mobilized; some died; others emigrated; a few stayed in Paris as foreign non-combatants. Exhibitions, including the annual Salons, were cancelled; trade dried up; and the key independent dealer from the pre-war period – the German, Daniel-Henry Kahnweiler – had his entire stock of work sequestered and was prevented from conducting business. So, as we might expect, the period after the war was characterized by confusion and a lack of cohesion as

artists, dealers, critics and others sought to regroup, recover lost momentum, pick up old threads and re-establish their position in relation to the currents of pre-war art.

In itself this doesn't say much about specific types of painting; it only sketches an approximate set of social relations within which pictures were made and circulated. The art historian Kenneth Silver has argued that the spectres of war and revolution exerted a much more direct and visible influence on the development of art in this period (K. Silver, *Esprit de Corps*). He has pointed out the similarity between the rhetoric of right-wing political commentators in France and the rhetoric of many artists, critics and cultural theorists. In particular he has noted how the clusters of terms and ideas that sustained the idea of the 'call to order' and 'reconstruction' in post-war France were echoed in the writing and statements of artists, and incorporated in the styles and themes of their art. The imagery of the 'call to order' was itself established by setting up oppositions between the claimed virtues of the post-war period and the alleged decadence of the period before the war, with the war itself cast in the role of precipitating the changes. First, pre-war France was represented as having lapsed into moral and spiritual decay: the country and its people were frivolous, weak, disorganized and capricious. Then, through the agency of the war, it had been purged of these afflictions to emerge true to its real self: disciplined, strong, organized and clear-minded. In the cultural rhetoric of reconstruction, this latter cluster of terms was brought together under a single unifying heading – Classicism. The Classical tradition, it was argued, was the true tradition of French culture, but one from which the nation had been lured by various foreign influences, most of which were taken to be German in origin. Thus the rhetoric of Classicism was, in one respect at least, the vehicle for a thinly veiled ideology of nationalism. So far so clear. But the similarities that Silver noted between the political and the aesthetic rhetoric of the period have become converted by some authors into less flexible kinds of relation. It has been assumed, and in some cases explicitly argued, that the more traditional, more 'conservative' forms and techniques of painting are the direct effects of a more authoritarian, more 'conservative' political culture (see, for example, B. Buchloh, 'Figures of authority, ciphers of regression'). This assumption is itself usually based on a prior one, namely the commonplace idea that forms of artistic 'radicalism' (a term usually standing for technical innovation) are themselves ciphers of political 'radicalism'. Is it then reasonable to assert that the entire range of Classically oriented work from this period is just so much evidence of artists' having internalized reactionary political ideas? Are these therefore reactionary paintings? Is it the case that the widespread move towards more 'conservative', naturalistic painting is a direct analogue of the more 'conservative' political climate in post-war France? Questions of this sort seem important, and they have been asked a lot in recent years. They seek to address a basic issue about the relation of art to the wider ideological and political forces at work in a culture. They ask about the relationship of politics to aesthetics.

These are important questions to ask, but it is also important to hesitate before answering them, and to look at the terms in which they are put. We should note that they often deal in broad generalizations, treat a wide range of individual works as if they were all the same and, above all, make judgements in advance of viewing the evidence of the work. While the issue of the relations between art and politics lies close to the heart of this chapter, I also want to resist reducing these questions to a formula, to a kind of litmus test by which art may be assumed, because of some *general* characteristics, to display a certain political colour. I am not convinced that issues in art can be decided in such ways. It is unwarranted to assume, simply because a group of paintings treats the same basic subject in the same general style, that they are in any *significant* ways similar as works of art. What we may be able to say, for example, about a *commedia dell'arte* scene by Severini will not necessarily be applicable to a painting on the same theme by Picasso. Rather, it is necessary to look at details of particular works and argue the issue case by case.

Groups, magazines, programmes

So far we have considered only works produced by individuals working in approximately the same cultural and economic conditions in post-war Paris. To treat all work in this manner would be to ignore an important feature of much artistic production of the period – that many artists organized themselves into identifiable groups and issued a range of textual, pictorial and organizational work in the name of that group.

Indeed, part of the history of modern art is a history of artists organizing themselves into groups. When artists and other members of the cultural intelligentsia began to perceive their interests as distinct from, or in opposition to, those of the Academy or of official art, they were forced to look for some independent framework within which to pursue those interests. Such a framework would have to provide space in which to work – actual space to publicize and exhibit work, but also, and just as important, intellectual space in which to develop and to defend the interests of the group. The Impressionist group is the obvious early example of this tendency, although Courbet's independent Realism exhibition at the 1855 Paris Exposition Universelle was arguably the first such event. Self-conscious displays of independence, in one form or another, are a feature of most of the main moments of late nineteenth- and early twentieth-century art. A list of such moments would include the Pont Aven group formed in Brittany around Gauguin during the late 1880s, the Fauve room at the 1905 Salon d'Automne, the Die Brücke exhibition at the Seifert factory in Dresden during 1906, the Blaue Reiter exhibitions of 1911–12 in Munich, the Cubist room at the 1911 Salon des Indépendants, and the Futurist activities in Milan from around 1910. Furthermore, as organization of this sort became a prerequisite of avant-garde art, so it tended to become more a focus of attention in itself. Essays and manifestos declaring the aims of the groups and proclaiming the allegiance of various figures increasingly became a feature of such work to the point where, in the case of the Futurists, it became one of the main sites of production for the group.

It's significant that many of these groups attracted not only artists, but a broad range of individuals involved in one or other aspect of cultural production. Poets, writers, critics, musicians and architects have all, at one time or another, become integral parts of such allegiances. The period between the wars is characterized not only by the proliferation of artists' groups of this kind, but also by the high profile that such groups acquired. Considerable attention was given to developing the theoretical side of the groups' work, and to developing strategies of self-promotion. Typically a group would take a number of initiatives. It would give itself a name (and, as we shall see, this often carried considerable significance); publish a manifesto of aims and interests; produce a magazine; organize meetings, conferences, exhibitions or events; and, in some cases, do whatever was possible to sabotage the work of others. The groups aimed to do far more than merely promote a novel style or technique. The three groups we will consider in the next three sections (on Purism, Dada and Surrealism), and many others besides, saw their work as actively engaged in tackling the problems of a dramatically changing world.

It is at this point that similarities begin to give way to differences, and that differences begin to breed complications. While all these groups regarded themselves as significantly involved in substantial processes of change, there was little consensus over what kinds of change were being experienced or should be encouraged, and equally little agreement over what part artists could, or should, play in bringing them about. Some regarded themselves as prophets of change, others as analysts, or agitators, others as observers. It was through their magazines and manifestos that these claims and projections were presented, debated, responded to, and developed. There's a case for saying that the importance of these magazines and their attendant forms of activity was often equal to, and at times greater than, much of the art produced under the aegis of the group. At least it is likely that if we look at the art independently of the wider range of activities, we risk developing a very restricted sense of what that art might have meant.

There might be many reasons for a particular group of artists, poets, writers and so on to organize themselves in such a way. And different individuals might be attracted to the group for different motives. Certainly the aim was usually to take a public stance outside and in opposition to the conventional intellectual and institutional forms of legitimation. Attachment to a group may also have provided little-known artists with a way of making themselves visible to curators, critics, etc. where otherwise they might have remained in obscurity. By the 1920s it seems that the formation of radical independent groups could serve both these purposes: as much as they represented a stance outside the established norms and forms of legitimation, they could also represent a stepping stone in the pursuit of a more orthodox artistic career.

Purism and L'Esprit Nouveau

In Paris, during March 1920, Charles-Édouard Jeanneret and Amédée Ozenfant, the artists who together founded the Purist group, published their manifesto, 'Purism', in the group's journal *L'Esprit Nouveau* ('the new spirit'). It declared:

> Logic, born of human constants and without which nothing is human, is an instrument of control and, for he who is inventive, a guide towards discovery; it corrects and controls the sometimes capricious march of intuition and permits one to go ahead with certainty ...

> One of the highest delights of the human mind is to perceive the order of nature and to measure its own participation in the scheme of things; the work of art seems to us to be a labour of putting into order, a masterpiece of human order ...

> Now a law is nothing other than the verification of an order. In summary, a work of art should induce the sensation of mathematical order, and the means of inducing this mathematical order should be sought among universal means.
> (C.-E. Jeanneret and A. Ozenfant, 'Purism', pp.59, 61)

L'Esprit Nouveau was published 28 times between 1920 and 1925, contained an average of over 100 pages per issue, was produced on good quality paper and included colour reproductions. It was made up of lengthy, scholarly-looking essays on a wide range of subjects, interspersed with photographic reproductions and advertisements. Its cover design and internal layout remained unchanged throughout the five years of its publication. Each cover listed the contents of that issue, and the general headings 'experimental aesthetics, painting, sculpture, architecture, literature, music, engineering aesthetics, theatre, music-hall, cinema, circus, sports, fashion, books, furniture and aesthetics of modern life'. Overall the magazine's size, layout and consistency of appearance graphically reinforced the implication given in the clipped tone of the manifesto: Purism was a serious, thoughtful and ambitious project (Plate 16).

In spite of the considerable quantity of material produced by contributors, the magazine remained largely the vehicle of its two editors. Jeanneret, the painter and writer, is better known as Le Corbusier, which was the pseudonym he adopted in the early 1920s for his work as journalist and architect. Ozenfant, also a painter and writer, had earlier edited a small magazine during 1915 and 1916, entitled *L'Élan*. Their first collaboration was to produce an exhibition, and an accompanying booklet entitled *Après le Cubisme* that was published in November 1918, a few days after the signing of the armistice. It was a collaboration that ended, effectively, with the demise of *L'Esprit Nouveau* in 1925.

In the same year in which their manifesto, 'Purism', was published in *L'Esprit Nouveau*, Ozenfant and Jeanneret produced a series of still-life paintings (for example, Plates 17 and 18). Clearly they saw their painting and writing as mutually supporting components of the same project. The opening section of their text gives considerable

Plate 16 Cover of *L'Esprit Nouveau*, no.1, 1920. Da Capo Press Reprint, 1968, New York.

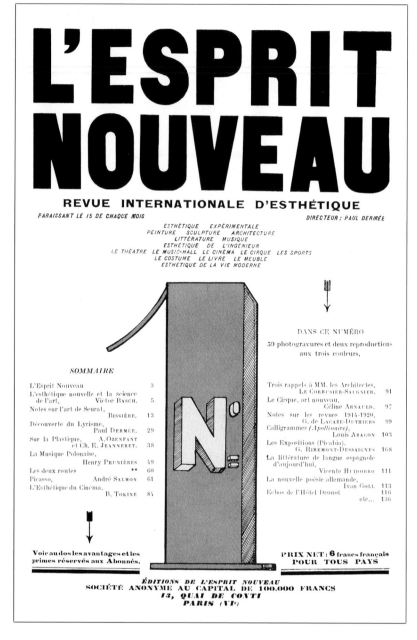

emphasis to such terms as 'logic', 'order' (mentioned seven times) and 'control'. Elsewhere in the text they describe their painting as 'an association of purified, related, and architectured elements' (p.67). Purism, they acknowledge, 'offers an art which is perhaps severe, but one that addresses itself to the elevated faculties of mind' (p.66). The emphasis throughout is on rationality, clarity of conception and precision of execution. And, as with other painting of the period, these qualities were emphasized not in the work alone but through a careful placing of it against other tendencies in French art. Having stated that their work set out to 'control and correct' the 'capricious' tendencies of intuition, they went on to place the Purist art of 'conception' against 'those arts whose only ambition is to please the senses' (p.66). They were obviously referring to the range of naturalistic painting that Vauxcelles and others, using a similar range of terms to the Purists but giving exactly the opposite value, were seeking to promote.

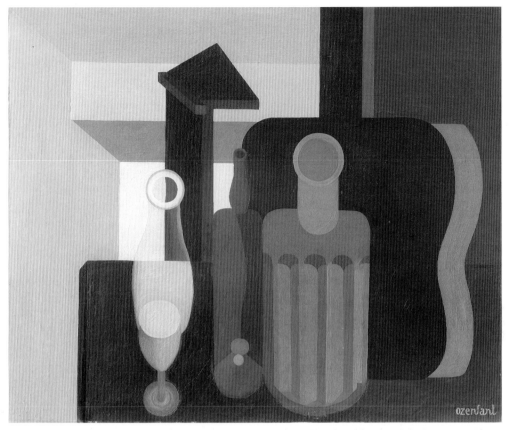

Plate 17 Amédée Ozenfant, *Flacon, guitare, verre et bouteille à la table verte* (*Flask, Guitar, Glass and Bottle with a Green Table*), 1920, oil on canvas, 81 x 101 cm. Kunstmuseum Basel, La Roche Bequest. © DACS, London, 1993.

Thus it would be appropriate to compare Jeanneret's 1920 *Still-life with Pile of Plates* (Plate 18) with de Segonzac's *Still-life with Eggs* (Plate 19) of *c*.1923. While the Jeanneret is significantly larger than de Segonzac's work (at 81 x 100 cm to 59 x 38 cm), they clearly share a range of basic features. Each depicts a group of familiar, everyday utensils, arranged on a surface, probably a table top. The objects in each work fill the central area of the pictorial rectangle while the upper area gives way to an indefinite deeper space. And there is some similarity in the range of earth colours used by both artists. The clearest differences between the works are in the handling – there is a much higher degree of finish in Jeanneret's – and the type of spatial projection used. While neither artist uses a definite perspective structure (only Jeanneret indicates any specific deep space, in the top left-hand corner of the picture), the objects in de Segonzac's painting are shown lying oblique to the picture plane. The objects in Jeanneret's work, by contrast, are 'flattened' against the picture plane, their vertical and horizontal surfaces being shown simultaneously in the same plane. In addition, there is a much more formal character to Jeanneret's work: verticals and horizontals dominate the entire composition; the line representing the edge of the table runs almost exactly through the centre of the painting, and all the objects conform to this structure; specific detail is eliminated as flat surfaces are painted in flat, even colour and modelling is schematized.

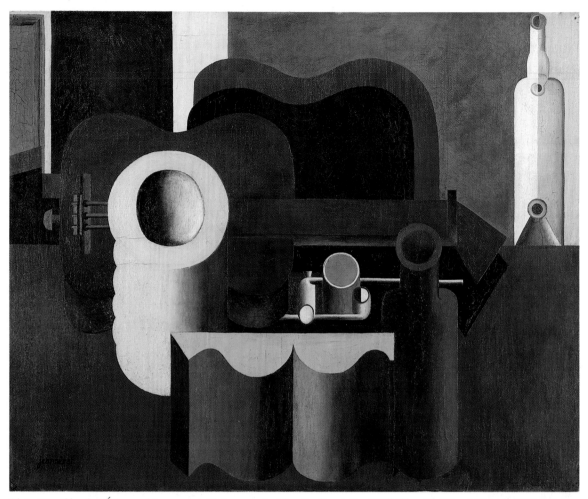

Plate 18 Charles-Édouard Jeanneret, *Nature morte à la pile d'assiettes* (*Still-life with Pile of Plates*), 1920, oil on canvas, 81 x 100 cm. Öffentliche Kunstsammlung, Kunstmuseum Basel. Photo: Colorphoto Hinz. © DACS, London, 1993.

Such differences of detail were regarded at the time as highly significant. Each was seen to invoke a different set of art-historical reference points and a different set of assumptions about how a picture is made and what intellectual and cultural resources it is made from. This served to place them within distinct intellectual and artistic trajectories, most obviously as regards the recent past. Raynal's division of art into 'Realist' and 'Idealist' tendencies is an example of how such works were seen as embodiments of utterly separate and antithetical positions. The Purists developed a similar line of argument.

In a variety of ways Jeanneret's still-life makes overt reference to Cubist painting of the pre-war period. This is secured more by *how* the objects are represented than by *what* objects are included in the picture. However, in important ways this work differs from the pre-war Cubist models. Although the objects are schematized and flattened out, each object remains self-contained and unambiguously depicted: objects are clearly differentiated from each other as well as from the space they inhabit. Schematization is never taken as far as the quasi-diagrammatic codification of parts that it reached in Braque's or Picasso's work. Nor is there any of the deliberate ambiguity or paradox often found in early Cubist paintings and collages.

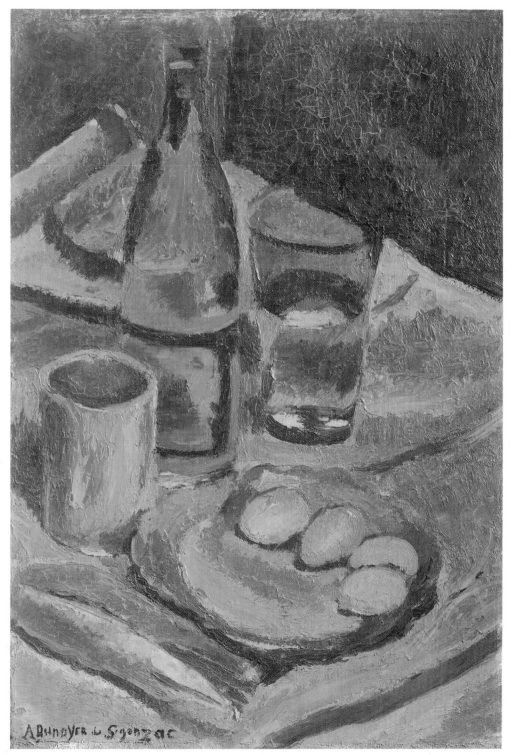

Plate 19 André Dunoyer de Segonzac, *Nature morte aux œufs* (*Still-life with Eggs*), *c.*1923,
oil on canvas, 59 x 38 cm. Courtauld Institute Galleries, London. © DACS, London, 1993.

By such means Jeanneret's painting does what any work must do if it aims to be a candidate for the modern in art. It embodies a series of pointers that serves simultaneously to associate it with and dissociate it from a range of precursors and alternatives. First, it distinguishes itself from current naturalistic painting by invoking the legacy of Cubism. Second, it distinguishes itself from pre-war Cubism in order to be seen as somehow having progressed from that point. It is this second aspect of the work that now needs to be examined.

It is easy enough to say that these are tidied-up Cubist still-lives, and that they therefore correspond to the sense of order extolled in the Purist manifesto. But for Jeanneret and Ozenfant there was much more at stake in these works. In *L'Esprit Nouveau* no.17 (June 1922) they included an illustration (Plate 20) in which reproductions of their still-life paintings were overlaid with a network of ruled lines and measured angles. The obvious implication was that these were works structured according to some form of mathematical calculation. In an issue published a little over a year earlier (*L'Esprit Nouveau* no.5, February 1921), within a long essay by Jeanneret entitled 'Regulating lines', a similar illustration was included (Plate 21) that depicted two examples of Classical architecture, each overlaid with a similar series of lines. These parallel illustrations give graphic form to a claim made throughout Jeanneret's and Ozenfant's writing of the time: the 'order' they extolled was the same as the order underpinning Classical architecture. The claim made

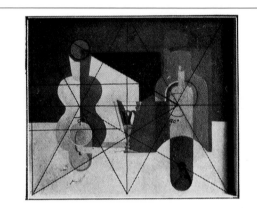

JEANNERET

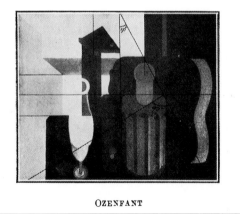

OZENFANT

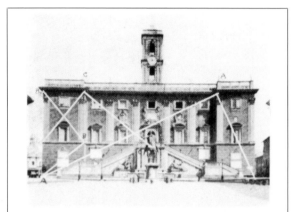

EXTRAIT DES COMMENTAIRES MÊMES DE BLONDEL SUR SA PORTE SAINT-DENIS (Voir en tête de l'article).

La masse principale est fixée, l'ouverture de la baie est esquissée. Un tracé régulateur impératif sur le module de 3, divise l'ensemble de la porte, divise les parties de l'œuvre en hauteur et en largeur, règle tout sur l'unité du même nombre.

LE PETIT TRIANON

Lieu de l'angle droit

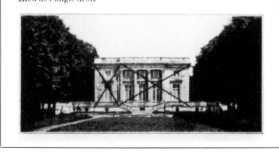

Plate 20 Paintings by Charles-Édouard Jeanneret and Amédée Ozenfant, *L'Esprit Nouveau*, no.17, p.1993, 1922. Da Capo Press Reprint, 1968, New York. © DACS, London, 1993.

Plate 21 *L'Esprit Nouveau*, no.5, p.571, 1921. Da Capo Press Reprint, 1968, New York.

for their paintings, therefore, was not merely that these were smartened up forms of Cubism, but rather that they represented a modern development of the Classical tradition of ancient Greece. Much of their seventeen-page manifesto, 'Purism', and many of the articles on art and architecture that dominated *L'Esprit Nouveau*, elaborated this claim. Numerous essays expounded their conception of the artistic tradition from which Purism had emerged, and discussed key figures of that tradition. Included in this lineage were Raphael, Poussin, Chardin, Ingres, Corot, Cézanne, Seurat and Rousseau. The argument that linked these figures – and also included more general categories such as Greek art and 'Negro' sculpture – was that all this work drew on a deeper level of reality than was represented in the 'superficial sensations' of Impressionism and naturalism. Thus, in an illustration from *L'Esprit Nouveau* no.1 (Plate 22) made up of six photographs of a range of ancient and recent art, Monnet (sic) and Rodin are listed as 'bad', while Gris and Seurat are grouped with 'Negro' and Greek art as 'good'.

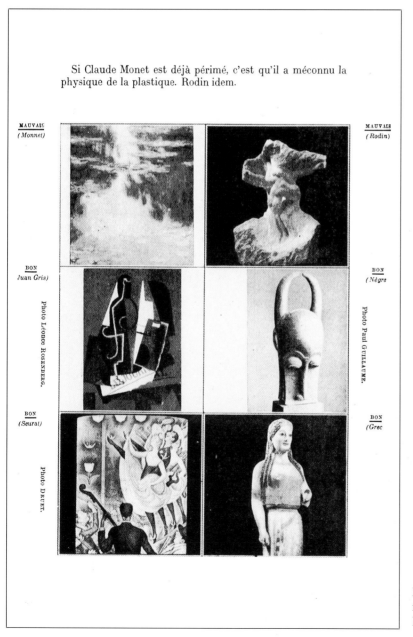

Plate 22 *L'Esprit Nouveau*, no.1, p.45, 1920. Da Capo Press Reprint, 1968, New York.

Plate 23 *L'Esprit Nouveau*, no.1, pp.43 and 44, 1920. Da Capo Press Reprint, 1968, New York.

The basic thesis that enabled these categorical oppositions to be developed was derived from the Platonic belief in a realm of 'ideal forms' independent of the actual physical world. It was held that these forms constituted a universal and unvarying structuring principle at the heart of all cultural manifestations. For Jeanneret and Ozenfant these were termed 'primary elements', and consisted of the basic geometric forms of the circle, the triangle and the square, and their three-dimensional equivalents, the sphere, the pyramid and the cube. In all cultures, they continued, these universal structuring elements were always and necessarily mediated through 'secondary sensations', a term they used to indicate both types of literal ornamentation and embellishment, and the kinds of allusion and association through which we habitually see such forms. Thus the 'primary element' of the cube or the sphere, they argued, would only exist through the grafting on of 'secondary' resonances: we would experience these forms, for example, in the shape of a brick or a ball. Again, these claims were expressed diagrammatically through a series of illustrations in *L'Esprit Nouveau* (Plate 23).

These general claims were given a historical character by Jeanneret and Ozenfant when they argued that, largely as a result of the requirements of industrial production, actual objects were 'evolving' and becoming more 'purified' as surplus or inessential ornamentation was pared away. For the Purists this process was the principal defining characteristic of culture: 'Civilizations advance,' stated Jeanneret in *L'Esprit Nouveau* no.10 (July 1921). 'Culture is the flowering of the effort to select. Selection means rejection,

Plate 24 *L'Esprit Nouveau*, no.10, pp.1140–41, 1921. Da Capo Press Reprint, 1968, New York.

pruning, cleansing; the clear and naked emergence of the Essential.' This argument that, alongside organic evolution through the Darwinian concept of natural selection, there exists an equivalent system of 'mechanical selection', is illustrated in a double-page spread of *L'Esprit Nouveau* entitled 'Evolution of the forms of the automobile 1900–1921'. In another page of photographic comparisons, Jeanneret and Ozenfant likened the development of the car to the development of Classical architecture (Plate 24). On the left-hand page, Paestum is pictured above a 1907 Humbert car, and each is compared with a later more 'purified' example – the Parthenon, and a 1921 Delage Grand-Sport – on the opposite page. The assertion that the modern form of the Classical is to be found in the products of advanced industrial production was applied by Jeanneret and Ozenfant not only to what were then exotic commodities such as cars and aeroplanes, but also to the most basic everyday objects – bottles, glasses, pipes and plates. Thus they asserted another level of significance for their paintings of everyday objects and utensils: these more or less simple and unexceptional products were ascribed a kind of higher *moral* order by virtue of their standardized, functional 'purity'.

There is a further and more specific historical angle to the Purists' theory of the links between the Classical, the mechanical and the modern. It is the argument that one of the principal, and beneficial, effects of the First World War was to enable the emergence of the 'new spirit' of Classical order. It is concisely stated by Jeanneret in one of a series of essays originally published in *L'Esprit Nouveau*, and later reprinted as the book *Vers une*

Architecture (1923, published in English as *Towards a New Architecture* in 1927). In a section devoted to a discussion of the evolution of the aeroplane, he noted:

> the War was an insatiable client, never satisfied, always demanding better. The orders were to succeed at all costs and death followed a mistake remorselessly. We may then affirm that the airplane mobilized invention, intelligence and daring: *imagination* and *cold reason*. It is the same spirit that built the Parthenon.
>
> (Le Corbusier, *Towards a New Architecture*, p.101)

The 'new spirit' that gave their magazine its name, and that was constantly evoked and celebrated in their essays, was therefore Classical in character, and revivified by the experience of the war:

> There is a new spirit abroad: it is a spirit of construction and synthesis, moved by a clear conception of things. Whatever one may think of it, this spirit animates the greater part of human activity today.
>
> (*L'Esprit Nouveau*, no.1, 1920, p.3)

Thus proclaimed Jeanneret and Ozenfant in the opening essay of *L'Esprit Nouveau* no.1 and, as the second sentence makes clear, they interpreted the term in wide social terms, not as something restricted to the realms of art.

As Silver has demonstrated, the terminology and rhetoric of 'order', the 'Classical' and the 'new spirit', which were consistently exploited by the Purists, were not their own invention (Silver, 'Purism: straightening up after the Great War'). Rather, as we noted earlier, these terms were used very widely in French political, philosophical and cultural circles during and after the war. In this way, it has been argued that the Purists' 'order' was not derived, as they claimed, from the universal ideals of Classical antiquity, but was rather the product of a rhetoric determined by a particular range of contemporary social and political interests.

But this nationalist and occasionally racist thread in Purist aesthetics needs to be placed alongside another, no less significant feature – the Purists' regular citing of the universal (the transhistorical and transcultural), which does not square easily with the nationalistic rhetoric. By 1921 Jeanneret had developed close contact with other groups of artists outside France who professed a similar idealist and essentialist theory of art and culture. In particular, relations were established with the De Stijl group based in Holland (1917–33), and the Bauhaus school in Weimar Germany (1919–32). According to the anti-German rhetoric of the 'call to order' in France, association with the latter group could have counted almost as fraternizing with the enemy. Thus there was, in Purism, at least as much emphasis on its international or transnational character as on its sense of Frenchness.

There was some interchange of ideas and of personnel between these groups during the early 1920s. The first issue of *L'Esprit Nouveau* included a translation of the second De Stijl manifesto written by Theo Van Doesburg, the group's organizer and editor of the magazine *De Stijl*, which could have served Jeanneret and Ozenfant as a model for their publication. Van Doesburg spent periods at the Bauhaus between 1921 and 1923 when it was under the directorship of Walter Gropius, and Jeanneret had met Gropius in Paris. Van Doesburg's main theoretical work, *Principles of Neo-Plastic Art*, was published as a Bauhaus book in 1925. Works by De Stijl artists were exhibited in Paris at the gallery most closely associated with the Purists, and paintings by Mondrian were reproduced in *L'Esprit Nouveau* – although Jeanneret remained sceptical of such extreme forms of abstraction. Illustrations in *De Stijl* magazine and *Principles of Neo-Plastic Art* reduce natural form to its supposed geometric essence in a series of pseudo-mathematical diagrammatic stages (for example, Plate 25), while teaching material devised by Klee and by Kandinsky at the Bauhaus often used simple geometric forms as the basic vocabulary of Bauhaus design. In the writing of Gropius and Van Doesburg, the main tenets of Platonic essentialism are clearly discernible. For Gropius, 'The basic building elements –

Plate 25 Theo Van Doesburg,
De Stijl, vol.1, no.9, p.99, 1918.
Reprinted by permission of
Atheneum, Bakker, Polak and
Van Gennep Reprint, 1968.

throughout time and in all countries – consist of the geometric trilogy ensuring validity in all human creativity' (W. Gropius, 'Statement', quoted in *Bauhaus*, Royal Academy of Arts, p.21). Van Doesburg talked in more general terms about the need to use 'elementary' and 'objective, universal formative means' in the production of 'progressive art' in the post-war era (T. Van Doesburg, 'Report of the De Stijl group', pp.56–9).

For Jeanneret, Gropius and Van Doesburg there was considerably more at stake in their work than the production of a newer style of modern painting or design. All three practised as architects, and for each of them architecture came to occupy a central place, both in their conceptions of the modern world and in their understanding of how contemporary art and design could contribute to that world. For Gropius, in a fragmented and specialized world, architecture would, if rooted in 'objective knowledge of optical facts', become a total work of art, the new *Gesamtkunstwerk* that would 'rise one day towards heaven from the hands of a million workers like the crystal symbol of a new faith' (W. Gropius, 'Manifesto', quoted in *Bauhaus*, Royal Academy of Arts, p.13). For Jeanneret, architecture was a 'pure creation of the spirit' and, as each implies by the tone of his writing, the new building would not simply provide the physical material for a reconstructed Europe, but would serve moreover as the basis of a moral and spiritual reconstruction. It is important that, in the writing of these three architects and theorists, it

is either assumed or categorically stated that the higher truths of Platonic Reality and its consequences would be quite inaccessible to the majority of people. But people would, none the less, *respond* to the changes instituted as a result of the new architecture and design.

Several of these themes are captured in the Messianic tone of Gropius' early 'Address to the Bauhaus students':

> ... a universally great, enduring, spiritual-religious idea will rise again, which finally must find its crystalline expression in a great *Gesamtkunstwerk*. And this great total work of art, this cathedral of the future, will then shine with its abundance of light into the smallest objects of everyday life ... We will not live to see the day, but we are, and this I firmly believe, the precursors and first instruments of such a new, universal idea.
>
> (Gropius, quoted in H. Wingler, *The Bauhaus*, p.36)

In their vision of things, the artist, designer or architect would occupy an immensely important and privileged position in the post-war world, both prophetic (able to perceive things outside the scope of ordinary humans) and instrumental (able to direct the course of human activity through a kind of environmental engineering).

Dada

In Zurich during 1918 the Romanian artist Tristan Tzara wrote an eight-page essay, 'Dada Manifesto 1918'. Published in the third number of *Dada*, a small magazine that he also edited, the final section of the essay read:

> **Dadaist disgust**
>
> Every product of disgust capable of becoming a negation of the family is Dada; a protest with its whole being engaged in destructive action: Dada; knowledge of all the means rejected up until now by the shamefaced sex of comfortable compromise and good manners: Dada; abolition of all logic, which is the dance of those impotent to create: Dada ... abolition of memory: Dada; abolition of archaeology: Dada; abolition of prophets: Dada; abolition of the future: Dada; absolute and unquestionable faith in every god that is the immediate product of spontaneity: Dada ... Freedom: Dada Dada Dada, a roaring of tense colours, and interlacing of opposites and of all contradictions, grotesques, inconsistencies: LIFE.
>
> (T. Tzara, 'Dada Manifesto 1918', p.20)

The label 'Dada' refers not so much to a single group of artists working with one set of shared aims or interests, as to a diverse range of activities and forms of literary and artistic production that took place in several European cities between 1916 and 1922/3. Furthermore, there is no single factor unifying the activities that took place under the aegis of Dada, or the twenty or so separate titles of pamphlets and magazines that professed a Dada orientation.

Dada activities in these cities took place relatively independently, if not in ignorance, of each other. The four main sites were: Zurich, between 1916 and 1919, where Tzara was involved with other expatriates and refugees from war-torn Europe; Berlin, between 1917 and 1920; Cologne, during 1919 and 1920; and Paris, from 1920 until 1922. In addition, Francis Picabia had been involved in Dada productions in Barcelona, Zurich and New York (where he had collaborated with Marcel Duchamp and Man Ray and published his journal *391*), before coming to Paris in late 1919. He was soon followed by Tzara who brought *Dada* magazine with him, and then by the artists Max Ernst and Jean Arp (from Cologne and Zurich respectively). Lastly, Kurt Schwitters produced Dada work in Hanover between 1923 and 1932.

Almost every feature of the Dada magazines contrasts with *L'Esprit Nouveau*. Whereas the latter kept the same format, layout, size and style for all 28 issues of its five-year run, Dada magazines were for the most part thin, cheaply and quickly produced, and short-lived (some lasting for only a single issue). But in the same way as *L'Esprit Nouveau* was designed to embody and express the mood and self-image of the Purist group, so the Dada magazines were designed to reflect the interests and pretensions of their groups. Likewise, Tzara's manifesto was intended to attract the attention both of like-minded individuals and of those they sought to antagonize. The manifesto – a celebration of negation, contradiction, spontaneity and 'destructive action' in a text full of allusion, metaphor and deliberate grammatical disarray – stands in dramatic contrast to the measured tone of the Purist's quasi-logical pronouncements. And it goes without saying, too, that it was not aimed at eliciting approving nods from such as Vauxcelles and de Segonzac.

Zurich and Paris

While Tzara's text isn't representative of all Dada production, it does epitomize the version of Dada that was brought to and developed in Paris. However, the kinds of commentary produced through Dada publications do reveal some shared points of departure. Chief among these was an overt and often militant rhetoric of hostility towards the established social order, a hostility vindicated, they would have argued, by the carnage of world war. In direct contrast to the sanitized representations of the Purists, for whom the war represented what they termed the 'Great Test' of the French spirit, the Dadaists regarded the war as irrefutable proof of the irredeemable corruption of bourgeois society. There was nothing to be salvaged. For Tzara, 'Honour, Country, Morality, Family, Art, Religion, Liberty, Fraternity once answered to human needs. Now nothing [remains] but the skeleton of convention' (Tzara, quoted in W. Rubin, *Dada and Surrealist Art*, p.10). For Marcel Janco, one of Tzara's collaborators in Zurich, 'We had lost confidence in our "culture"' (Janco, 'Dada at two speeds', p.36). But if the Dadaists agreed that the existing social order had failed or was corrupt, they did not necessarily agree on what the consequences might be for artistic activity – what their aims should be, and what strategies might best be adopted to achieve those aims. 'We have enough Cubist and Futurist academies: laboratories of formal ideas', Tzara asserted in his 1918 manifesto, and went on to proclaim that 'there is a great negative work of destruction to be accomplished. We must sweep and clean' (Tzara, 'Dada Manifesto 1918', pp.15, 19). It was particularly the Zurich and Paris Dada groups who asserted that the edifices of bourgeois culture needed to be razed. For Janco, 'Everything had to be demolished' ('Dada at two speeds', p.36). According to Jean Arp, who figured in both groups, 'Dada aimed to destroy the reasonable deceptions of man...'; and he continued: 'The bourgeois regarded the Dadaist as a dissolute monster, a revolutionary villain ... The Dadaist thought up tricks to rob the bourgeois of his sleep' (Arp, 'Dadaland', p.28).

If the members of the Zurich Dada group aimed at negation/destruction in the social and cultural sphere, they gave it symbolic form in their graphic and literary work through techniques of structural and semantic breakdown. For example, one of their main techniques was systematically to exploit random pictorial and literary effects. Randomness served as a means of crowding out established pictorial and literary conventions, of disrupting the procedures by which pictures and poems were traditionally made meaningful or beautiful. Its most usual form was a collage-based arrangement of materials, materials that were often taken from sources not conventionally associated with the fine arts. In Tzara's 'To make a dadaist Poem', for example, he offered the instructions:

> Take a newspaper.
> Take some scissors.
> Choose from this paper an article of the length you want to make your poem.
> Cut out the article.

Next carefully cut out each of the words that makes up this article and put them all in
a bag.
Shake gently.
Next take out each cutting one after the other.
Copy conscientiously in the order in which they left the bag.
The poem will resemble you.

(Tzara, *Seven Dada Manifestos and Lampisteries*, p.39)

To which he added the ironic, 'And there you are – an infinitely original author of
charming sensibility, even though unappreciated by the vulgar herd'.

It is in Arp's work that consistent use is made of a type of pictorial randomness. His
Rectangles arranged according to the Laws of Chance (Plate 26) of 1916–17 is presented by the
title as an approximate visual equivalent of Tzara's instructions for the production of a
poem. It is one of a series of collages and reliefs produced over a number of years that
were given the same general title, and it is easy to imagine how he might have devised a
set of procedures and rules whereby certain unplanned and contingent elements could
play a role in determining the outcome of the work. In keeping with these techniques, for
the third issue of the magazine *Dada* a scattered layout was introduced, along with over-
printing and multiple typefaces, as a means of embodying, instead of just describing,
logical and semantic breakdown (Plate 27).

If techniques containing degrees of randomness were introduced into a range of Dada
work, this was never reducible to 'pure' chance. Elements of chance were mobilized *within*
various production processes in order to generate certain *significant* effects. For many of
those involved in Dada, the generation of semantic and structural breakdown was seen as
either potentially revelatory in itself, or as a preliminary stage in the generation of sub-

Plate 26 Jean Arp, *Rectangles
arrangés selon les lois du hasard*
(*Rectangles arranged according to the
Laws of Chance*), 1916–17, torn and
pasted paper, 49 x 25 cm. Collection,
The Museum of Modern Art, New
York; gift of Philip Johnson. © ADAGP,
Paris and DACS, London, 1993.

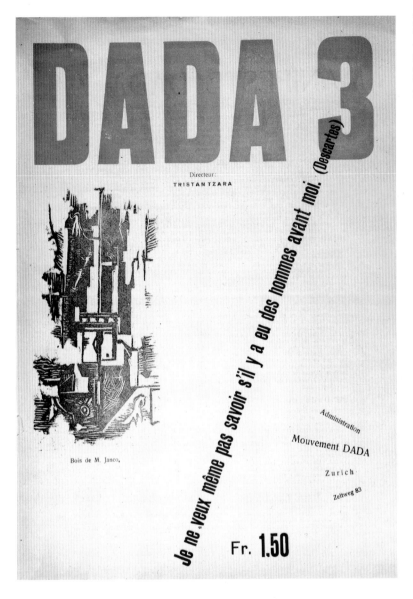

Plate 27 Cover of *Dada*, no.3, 1918, with a woodcut by Marcel Janco. Bibliothèque Littéraire Jacques Doucet, Paris. Photo: Charmet. © ADAGP, Paris and DACS, London, 1993.

sequent forms or meanings. Thus Janco, having noted that 'we had lost confidence in our "culture"', and asserted the need to 'demolish' everything, went on to proclaim, 'We would begin again after the *tabula rasa*' (Janco, 'Dada at two speeds', p.36). And for Tzara, the aim of the 'negative work of destruction' was 'to *sweep and clean*', and then 'affirm the cleanliness of the individual after the state of madness...' (Tzara, 'Dada Manifesto 1918'). Arp, too, immediately qualified his claim that Dada aimed 'to destroy the reasonable deceptions of man' by indicating that in doing this people would 'recover the natural and unreasonable order' (Arp, 'Dadaland', p.28). For Arp, Dada was 'against art [but] for nature. Dada is direct like nature'. So 'chance' was anything but merely arbitrary or meaningless. Rather,

> since the disposition of planes, and the properties and colours of these planes seemed to depend purely on chance, I declared that these works, like nature, were ordered to the 'laws of chance', chance being for me a limited part of an unfathomable *raison d'être*, an order inaccessible in its totality.
>
> (Arp, quoted in Ades, *Dada–Constructivism*, p.37)

The picture of Dada that emerges is not one of pure negativity and generalized destruction. Randomness, chance, the unplanned and the contingent functioned as significant elements within a theorized critique of a particular culture. That said, it was also the case that Tzara and others in Zurich and Paris offered a less than precise characterization of the cultural order they aimed to 'demolish'. For Arp it was the culture of 'reasonableness'; for Tzara it was those forces that suppress individual 'spontaneity' in the name of order, logic and unity. 'How can one put order into the chaos that constitutes that infinite and shapeless variation: man?', asked Tzara in the 1918 manifesto. And he continued,

> I detest greasy objectivity, and harmony, the science that finds everything in order …

> Logic is always false. It draws the threads of notions, words, in their formal exterior, towards illusory ends and centres. Its chains kill, it is an enormous centipede stifling independence.
> (Tzara, 'Dada Manifesto 1918', p.11)

Many of these themes of unpredictability, breakdown and apparent incoherence are shown in the work of Francis Picabia who, in 1919, brought his magazine *391* to Paris, via New York, Barcelona and Zurich (Plate 28). As well as engaging in many Dada polemics, producing texts and poetry, Picabia made some of the most striking Dada-related pictures. Many of these involved the copying or piecing together of fragments of technical illustrations to produce absurd, machine-like forms that also carried anthropomorphic or sexual connotations (Plates 6 and 29). Picabia had worked on the fringes of the Cubist group in Paris before the war. In 1915, having left France for the safety of the USA, he became involved in New York avant-garde circles, principally through his involvement in

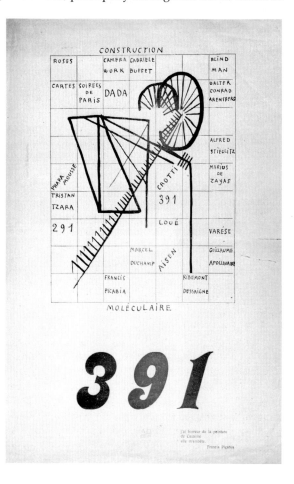

Plate 28 Cover of *391*, no.8, 1919, with a design by Francis Picabia. Bibliothèque Littéraire Jacques Doucet, Paris. Photo: Charmet. © ADAGP, Paris and DACS, London, 1993.

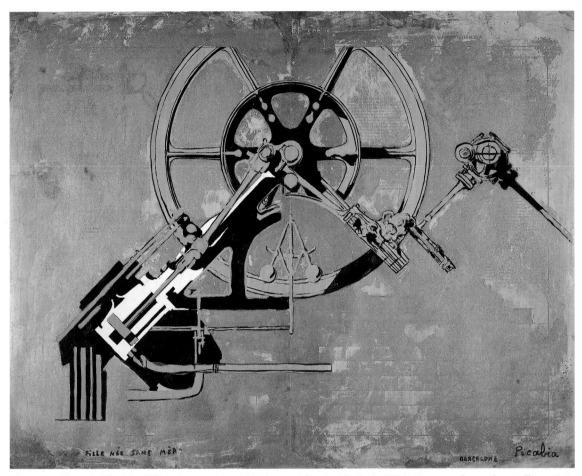

Plate 29 Francis Picabia, *Fille née sans mère* (*Girl born without a Mother*), 1916–18, gouache and metallic paint on paper, 50 x 65 cm. Scottish National Gallery of Modern Art, Edinburgh. © ADAGP/SPADEM, Paris and DACS, London, 1993.

the magazine *291*, published by the photographer Alfred Steiglitz. Marcel Duchamp was also resident in the city at the time, and it is highly likely that it was through his influence that Picabia embarked on his 'mechanomorphic' pictures during 1915–16.

Duchamp was already famous for having renounced his Cubist-oriented painting in favour of the 'ready-made'. This was the term he coined for the everyday mass-produced objects he displayed in art galleries in place of paintings or sculpture. His first 'ready-made', *Bicycle Wheel* (1913), consisted of the front wheel and fork of a bicycle secured upside down to the seat of a stool (Plate 30). This was followed by *Bottle Rack* and other pieces that were distinguished by being completely un-worked by the artist. In one sense, these may be described as extensions of the principle of Cubist collage to the point where the fragment of the external world is actually substituted for the picture rather than subsumed within it. It could also be argued that this presentation of a literal object *as* literal object takes it beyond the realm of representation and therefore beyond the realm of art. But there is an important way in which Duchamp has worked on the object (however minimally) by presenting it in an unconventional context. Through the act of placing the thing in an art gallery it becomes displaced, unfamiliar, anomalous. In such acts of calculated displacement, Duchamp sought to draw attention, not to the intrinsic beauty of bicycle wheels and bottle racks but to the conventions, habits and prejudices underlying our expectations of art and of the circumstances under which we normally view it.

Plate 30 Marcel Duchamp, *Roue de bicyclette* (*Bicycle Wheel*), 1951 (third version after the lost original of 1913), metal wheel, 64 cm diameter, mounted on a painted wooden stool, 60 cm high, overall height 128 cm. The Sidney and Harriet Janis Collection; gift to The Museum of Modern Art, New York. © ADAGP, Paris and DACS, London, 1993.

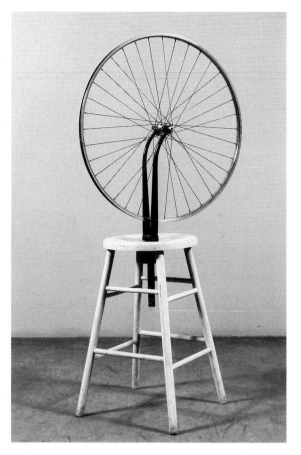

Although Duchamp himself had little to do with the constituted Dada groups in Europe, his 'ready-mades', and works such as his *LHOOQ* (see Plate 31), were seen to embody the iconoclastic spirit of Dada, to challenge the conventional concepts of artistic skill and aesthetic value. He was also to become a mentor of sorts for the Surrealist group. But it was in his *The Bride Stripped Bare by her Bachelors, Even* (Plate 32), known as *The Large Glass*, started in 1915 and abandoned in 1923, that the most ambitious picture on the theme of the machine-human was undertaken. An intricate fabrication in glass and metal, using various impersonal quasi-diagrammatic forms of depiction and random effects (like trapping dust between surfaces), the work is also intentionally an intricate and obscure representation. In a series of notes that accompanied the work, Duchamp nominally identified various sections as codified figures. The upper and lower divisions of *The Large Glass* were reserved for 'the bride' and her 'bachelors' respectively; the 'nine malic moulds' represented uniformed male figures (gendarme, priest, etc.); the diagrammatic chocolate grinder in the lower centre of the picture represented masturbation ('the bachelor grinds his own chocolate'); the bride herself was 'basically a motor' fuelled by 'love gasoline' and a 'desire magneto'; and so on. Thus Duchamp offered an ironic interpretation of the work, bringing together the human and the mechanical around the theme of desire and sexuality. In its Absurdist flavour it is similar to the contemporary writings of Alfred Jarry and Raymond Roussel, both of whom parodied the 'advances' of modern science and depicted human relationships as impoverished, mechanical and sterile.

Picabia's 'mechanomorphic' works continue this theme through concise and elegant conjunctions of pictures and titles. In a series of 'portraits' executed during 1915, and some

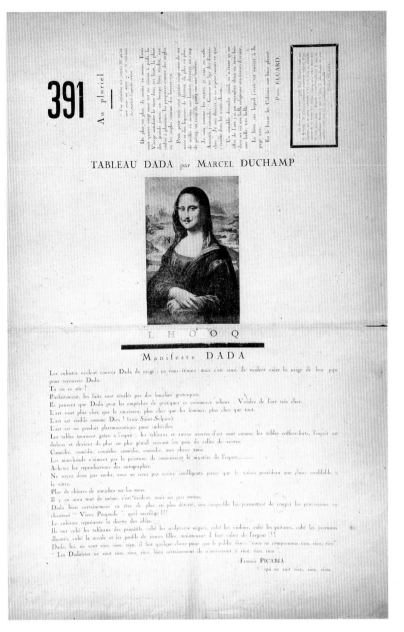

Plate 31 Francis Picabia, cover of *391*, no.12, 1920, with a version of Marcel Duchamp's *LHOOQ*. Bibliothèque Littéraire Jacques Doucet, Paris. Photo: Charmet. © ADAGP/SPADEM, Paris and DACS, London, 1993.

cover designs for *391*, Picabia reproduced simple diagrams of mechanical forms (reminiscent of the 'ready-mades'), to which he added small printed captions. A spark plug, for example, becomes *Portrait of a Young American Girl in a State of Nudity* (Plate 33), and a ship's propeller is titled *Ass* (see Plate 34). In other works Picabia reproduced fragments of cut-away diagrams of car parts, and sometimes collaged together linear drawings of machine parts (see Plate 35). By isolating fragments – or by coupling discrete elements – Picabia was able to produce clean and functional-looking but ultimately absurd machine forms, often containing strong sexual allusions. In 1915 he was quoted as saying:

> The machine has become more than a mere adjunct of life. It is really a part of human life – perhaps its very soul. In seeking forms through which to interpret ideas or by which to expose human characteristics I have come at length upon the form which appears most

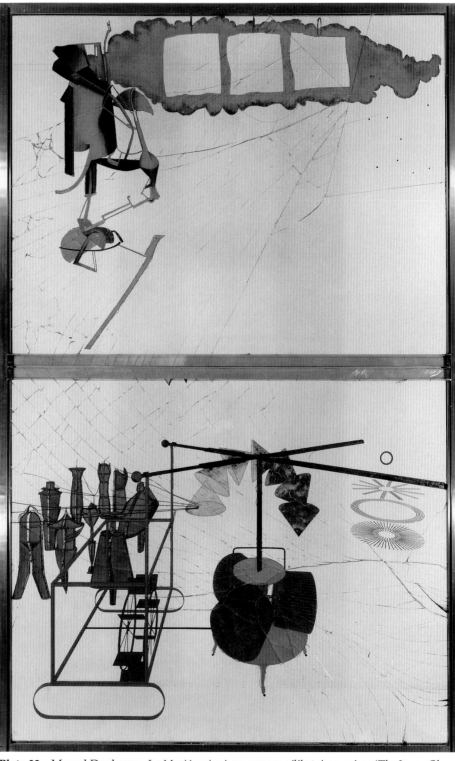

Plate 32 Marcel Duchamp, *La Mariée mise à nu par ses célibataires, même* (*The Large Glass, or The Bride Stripped Bare by her Bachelors, Even*), 1915–23, oil and lead wire on glass, 277 x 173 cm. Philadelphia Museum of Art; bequest of Katherine S. Dreier 52.98.1. © ADAGP, Paris and DACS, London, 1993.

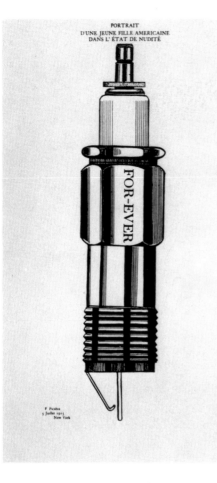

Plate 33 Francis Picabia, *Portrait d'une jeune fille américaine dans l'état de nudité* (*Portrait of a Young American Girl in a State of Nudity (Spark Plug)*), 1915, ink on paper, dimensions unknown. Private collection.
© ADAGP/SPADEM, Paris and DACS, London, 1993.

brilliantly plastic and fraught with symbolism. I have enlisted the machinery of the modern world, and introduced it into my studio …

Of course, I have only begun to work out this newest stage of evolution. I don't know what possibilities may be in store. I mean simply to work on and on until I attain the pinnacle of mechanical symbolism.

(Picabia, quoted in W. Camfield, *Francis Picabia*, p.77)

In just about every respect, Picabia's use of machine imagery contrasts strikingly with the Purists' use of it. While the Purists saw machinery as the embodiment of clarity, utility, efficiency – the product of the highest forms of human achievement – Picabia tended to regard it with a more sceptical view of human capacities and achievements. His 'mechanomorphic' absurdities could also be read as parodies of the Futurists' infatuation with machinery as an emblem of modernity; they converge with Tzara's hostility towards rationality, logic and organization; they could be regarded as reflections on the barbaric uses to which machines were being put in the war. Their implied human and sexual character could be taken as punning references to production and reproduction in humans and in machines, about power, drives and performance. They could be seen to point to some notion of sublimated desire in industrial production, or to something mechanical and regulated in human relationships.

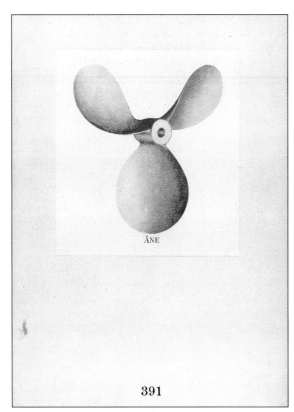

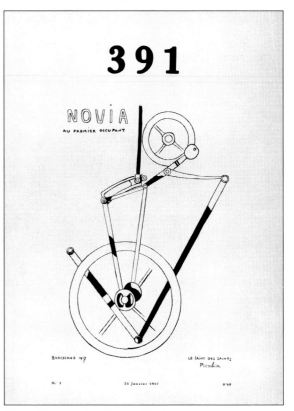

Plate 34 Francis Picabia, *Âne* (*Ass*), 1917, pastel or crayon on paper, 19 x 17 cm, used by Picabia as the cover of *391*, no.5. Photograph by courtesy of the Getty Center for the History of Art and the Humanities, Santa Monica. © ADAGP/SPADEM, Paris and DACS, London, 1993.

Plate 35 Francis Picabia, *Novia au premier occupant* (*Sweetheart of the First Occupant*), 1917, ink and metallized gouache, 37 x 26 cm, used by Picabia as the cover of *391*, no.1. Photograph by courtesy of the Getty Center for the History of Art and the Humanities, Santa Monica. © ADAGP/SPADEM, Paris and DACS, London, 1993.

Berlin and Cologne

It is one of the distinguishing features of Dada groups in Berlin, and to a lesser extent Cologne, that their targets were more precise and political than was the case in Zurich or in Paris. There are several possible reasons, and the palpable differences between the cities of Zurich and Berlin at the end of the First World War are clearly significant here. While the former had remained neutral and relatively prosperous, Berlin had experienced defeat, the revolution of 1918–19, the Spartacist uprising and its brutal suppression, the defeat of the Workers' Councils, and the establishment of the highly vulnerable Weimar Republic. Richard Hülsenbeck, who started with the Zurich group and moved to Berlin in 1917, noted the difference between the two cities: 'While in Zurich people lived as in a health resort, chasing after the ladies and longing for nightfall that would bring pleasure barges, magic lanterns, and music by Verdi, in Berlin you never knew where your next meal was coming from' (Hülsenbeck, 'Dada forward', p.46). But the political character of Berlin Dada was far from uniform: Richard Shepherd has distinguished between those who exploited the *rhetoric* of revolutionary politics as a Dada strategy, and those who sought to use Dada as a political weapon (R. Shepherd, *Dada*). Within the first group he included Hülsenbeck with Raoul Hausmann, Johannes Baader, and others. Their commitment to ideas of spontaneity, absurdity and individual psychic freedom places them fairly close to

the aspirations of the Zurich group. A distinguishing feature of the second Berlin group, the prominent figures in which were John Heartfield and George Grosz, was the replacement of this largely psychological account of emancipation with an overtly political one. Thus, while these two factions would have agreed that the prevailing social order and its attendant political, social and cultural institutions represented real obstacles to the project of emancipation, they would not necessarily have agreed on how to attain this emancipation. That is evident in the different types of manifesto and graphic work produced by the different factions of Berlin Dada.

For Hülsenbeck, somewhat like Arp, the aim of Dada was to produce something more direct and immediate, something unfettered by the trappings of 'civilized' thought and convention. As he wrote in his 'First Dada speech in Germany' in 1918:

> The word Dada symbolizes the most primitive relation to the reality of the environment; with Dadaism, a new reality comes into its own. Life appears a simultaneous muddle of noises, colours and spiritual rhythms, which is taken unmodified into Dadaist art, with all the sensational screams and fevers of its reckless everyday psyche and with all its brutal reality.
>
> (Hülsenbeck, quoted in H. Richter, *Dada*, p.106)

In contrast to this, the work of Grosz and Heartfield, who had both joined the German Communist Party (KPD) at its inception, was in general overtly political. 'Dada struggles on the side of the revolutionary proletariat' ran a large banner in their Gross Dada-Messe exhibition of 1920 (quoted in Shepherd, *Dada*, p.51).

Plate 36 Raoul Hausmann, cover of *Der Dada*, no.1, 1919. Deutsches Literaturarchiv, Schiller-Nationalmuseum, Marbach. © DACS, London, 1993.

Plate 37 George Grosz, cover
of *Der Blutige Ernst*, no.4, 1919.
Deutsches Literaturarchiv,
Schiller-Nationalmuseum,
Marbach. © DACS, London, 1993.

The techniques of collage and montage were also used extensively in German Dada,
but again to rather different ends by its various factions. In the work of Hausmann, who
edited *Der Dada*, there is often a high level of fragmentation, overlap and apparently
arbitrary scattering of items taken from the pages of newspapers and magazines (Plate 36).
Its effect is something more or less equivalent to the 'simultaneous muddle of noises' that
Hülsenbeck had proposed in his 1918 manifesto. When Grosz made use of collage,
however, particularly in the Dada magazine *Der Blutige Ernst* ('deadly earnest'), the
technique served principally as a means to topicalize some politically satirical cartoons.
For example, in the fourth issue (November 1919), collaged advertisements for bars, hotels
and entertainments provided the backdrop to a line-drawing showing a reclining, wing-
collared German bourgeois in the company of a half-naked woman, presumably a prosti-
tute. Below this the ironic caption reads, 'Work and don't despair' (Plate 37).

Collage and montage became the favoured techniques of a variety of Dada produc-
tions. In Hanover, Kurt Schwitters embarked on a series of collages made from scraps of
waste paper, cigarette packets, bus tickets and so forth, which became the basis of his
work until his death in the 1950s (Plate 38). In Cologne, starting in 1919, Max Ernst pro-
duced several series of collage-based pictures. For some of these he made absurd machine-

Plate 38 Kurt Schwitters, *Bild mit 2 kleinen Hunden (Bild mit Arumgewächsen) (Picture with Two Small Dogs (Picture with Spatial Growths))*, 1920 and 1939, mixed media on board, 97 x 69 cm. Tate Gallery, London. © DACS, London, 1993.

like forms by combining several images from printers' line-blocks, and filling these out with ink drawing and writing (Plate 39). The pictures echo in their imagery the drawings and paintings made by Picabia between 1915 and 1919. A series of small photo-collages made by Ernst in 1920 produces similar effects through the combination of fragments of mechanical objects with bits of human anatomy (Plate 40). It is in the work of Otto Dix, who took part in the First International Dada Fair in Berlin, that the image of mechanized human, or humanized machine, is given a specific point of reference (Plate 41). While Dix's figures are grotesquely caricatured, it is clear that he was deriving his imagery from the wounded and mutilated soldiers who began visibly to populate the streets of German cities during and after the war.

This theme of the machine/human reflects, in the differing ways in which it was taken up by the artists, some of the diversity of interests within Dada. Picabia's and Ernst's works are more suggestive of psychological readings than Dix's which, through the specificity of their references, make themselves more available to a particular contemporary political interpretation.

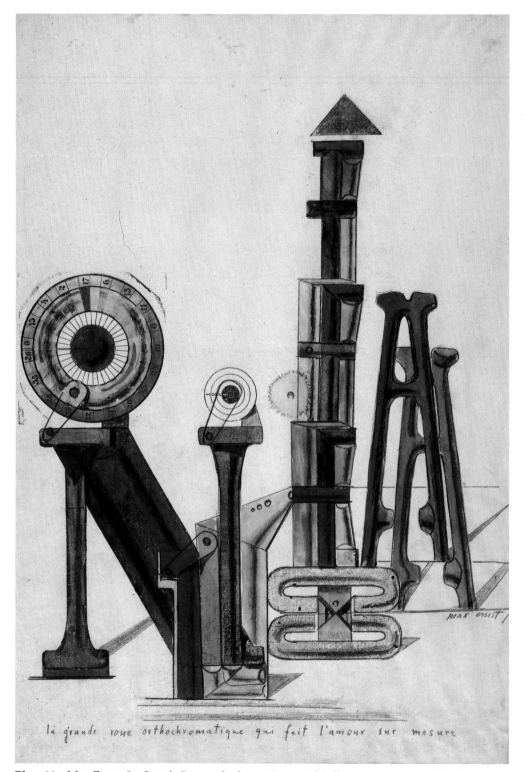

la grande roue orthochromatique qui fait l'amour sur mesure

Plate 39 Max Ernst, *La Grande Roue orthochromatique qui fait l'amour sur mesure* (*The Great Orthochromatic Wheel that Makes Love to Measure*), 1919, pencil rubbing of printers' blocks, and rough proof with pen and ink, watercolour and gouache on paper, 36 x 23 cm. Musée National d'Art Moderne, Centre Georges Pompidou, Paris. Donation de L. et M. Leiris.
© ADAGP/SPADEM, Paris and DACS, London, 1993.

Plate 40 Max Ernst, *Die Anatomie als Braut* (*Anatomy as Bride*), 1921, collage, 11 x 8 cm. Private collection. © ADAGP/SPADEM, Paris and DACS, London, 1993.

There is clearly a problem in trying to represent succinctly the ideas and activities that took place under the aegis of Dada. It isn't just that the one general label was used to stand for a range of geographically, intellectually, politically and artistically diverse work. It is also that, for many of those who produced the work, one of its characteristics was that it systematically avoided clarity, consistency and logical analysis. In the same way as many Dada pictures are clearly ironic and others are, so to speak, only ironically clear, some are intentionally confusing but are not necessarily the product of confused intentions. Similarly, much Dada writing is of the same uncertain character. What may sound like a clear statement of intent may only be intended to lay a false trail.

There is the further confusion that we are interpreting these works and utterances from a distance, so it is often difficult to distinguish a statement meant to convey a literal truth from one that is largely rhetorical. (This is obviously a difficulty for any historical interpretation, not just in the analysis of Dada.) There was, for example, a lot of antipathy expressed against earlier art. Hostility to Cubism and Futurism was meted out in much Zurich and Parisian Dada, and German Dada was often couched in highly anti-Expressionist terms. But while it is clear that the Dadaists sought to distance themselves from what these movements may have *become* towards the end of the second decade of the century, their work was in many ways dependent upon those earlier styles and techniques. Without Cubism, for example, there would have been no precedent for collage; Futurist irrationalism, vitalism and simultaneity pervade much of their writing and 'cabarets'; their appeals to 'directness', to 'nature', and to some form of pre-cultural organic community, or *Gemeinschaft*, as well as their woodblock-printing techniques, are clearly derived from Expressionism. This apparent contradiction may be explained if we think of the Dadaists as engaged – in similar ways to the Cubist and naturalist groups that

Plate 41 Otto Dix, *Kartenspielende Kriegskrüppel* (*Crippled War Veterans Playing Cards*), 1920, oil and montage on canvas, 110 x 87 cm. Private collection. © Otto Dix Stiftung, Vaduz.

we've already discussed – in producing a kind of rhetorical self-portrait. Thus their physiognomy was defined in part through a kind of negative shading, a darkening of the surrounding areas, in order to make their profile stand out in more striking relief.

As for the political rhetoric of Dada, it clearly carried more significance for some than for others. Certainly the Dadaists sought to bring art into a different and more critical relationship with the wider culture than it was seen to have had until then. For many, the implication of this was an engagement with questions of social change and political

action. For several participants in the Zurich and Berlin groups, the requirements of political activity began to take precedence over their Dada activities, and they withdrew from the arena of avant-garde art altogether. For others there is little evidence that their militancy ever became political. A few, most notably John Heartfield, attempted to sustain a relationship between the interests of advanced art and progressive politics.

From Littérature *to* La Révolution Surréaliste

It is tempting to think of the relationship between Dada and Surrealism as one of straight-forward succession. Certainly there were relations between the two groups, but for the main part those writers who allied themselves with Surrealism in 1924 had been working together independently of Dada, and for some time before Dada emerged as a force in Paris. In keeping with other would-be avant-garde groups of the period, these young men – among them the poets André Breton, Louis Aragon, and Philippe Soupault – organized around, and made themselves publicly visible through, a small, independently produced magazine. Before this, and immediately after the armistice, they had all begun to contribute to a couple of small literary reviews in Paris, *Sic* and *Nord-Sud*. Their own review, *Littérature*, was published in twenty issues between March 1919 and August 1921 (Plate 42). After a seven-month break, *Littérature: nouvelle série* was published thirteen times until

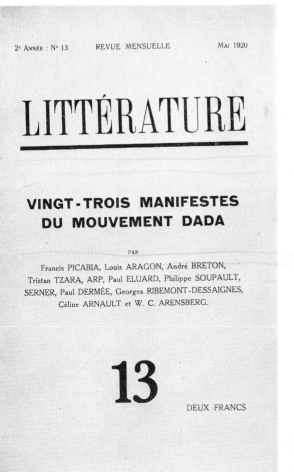

Plate 42 Cover of *Littérature*, no.13, 1920. Bibliothèque Littéraire Jacques Doucet, Paris. Photo: Charmet.

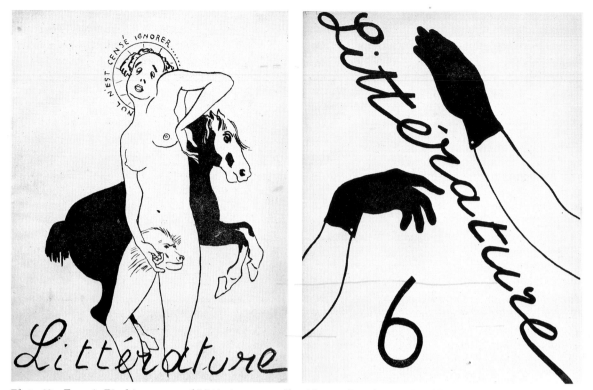

Plate 43 Francis Picabia, covers of *Littérature: nouvelle série*, nos 5 and 6, 1922. Bibliothèque Littéraire Jacques Doucet, Paris. Photo: Charmet. © ADAGP/SPADEM, Paris and DACS, London, 1993.

June 1924. As with most magazines of its kind, monthly publication was intended but never consistently achieved. *Littérature* was a small-format magazine containing between 24 and 32 pages of poems, short reviews and occasional prose essays by its editors – Aragon, Breton and Soupault – and by older and more widely recognized figures from the pre-war literary and artistic circles, including Guillaume Apollinaire, Pierre Reverdy and Max Jacob, all of whom had also published material in *Sic* and *Nord-Sud*. There was some discussion of contemporary art, but only one picture appeared in the whole of the first series of the magazine. The new series of *Littérature* differed most obviously in featuring (from no.4) striking cover designs by Picabia (Plate 43). In later issues, more extended essays and polemics by its editors began to appear more regularly between poems and reviews.

Littérature had little in common with the Dada magazines published in Paris (*Dada, 391*, and Tzara's two-issue *Cannibale* of early 1920). *Littérature* was much more conservative in its layout, typography and range of texts. While there were some contributions from Tzara to the first series and by Picabia to the new series, and although one issue of the magazine was given over entirely to 'Vingt-trois manifestes du mouvement Dada' (Plate 42), *Littérature* may be represented, retrospectively at least, largely as a site wherein the future Surrealists developed a range of theoretical resources and techniques for literary production and the critique of literary convention. Both 'Les champs magnétiques' (1919) and 'L'entrée des médiums' (1922), commonly regarded as the two most important proto-Surrealist texts, appeared in extracts in *Littérature*.

La Révolution Surréaliste (Plate 44) was a considerably more ambitious affair than either series of *Littérature* had been. It was larger in format, page quantity and production run; it was printed on higher-grade paper, with more and better-quality reproductions. It was, however, published much less regularly – only twelve issues were produced between

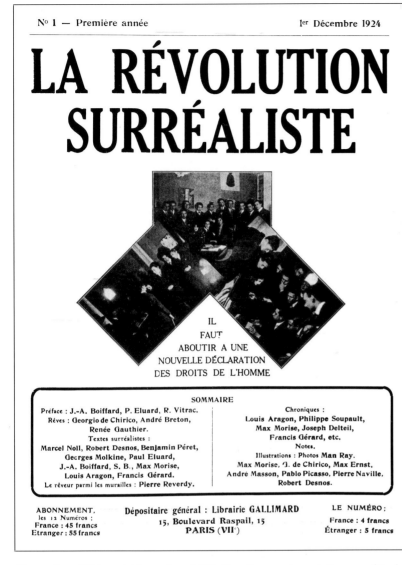

N° 1 — Première année 1ᵉʳ Décembre 1924

LA RÉVOLUTION SURRÉALISTE

IL
FAUT
ABOUTIR A UNE
NOUVELLE DÉCLARATION
DES DROITS DE L'HOMME

SOMMAIRE

Préface : J.-A. Boiffard, P. Eluard, R. Vitrac.
Rêves : Georgio de Chirico, André Breton,
Renée Gauthier.
Textes surréalistes :
Marcel Noll, Robert Desnos, Benjamin Péret,
Georges Molkine, Paul Eluard,
J.-A. Boiffard, S. B., Max Morise,
Louis Aragon, Francis Gérard.
Le rêveur parmi les murailles : Pierre Reverdy.

Chroniques :
Louis Aragon, Philippe Soupault,
Max Morise, Joseph Delteil,
Francis Gérard, etc.
Notes.
Illustrations : Photos Man Ray.
Max Morise, G. de Chirico, Max Ernst,
André Masson, Pablo Picasso, Pierre Naville,
Robert Desnos.

ABONNEMENT.
les 12 Numéros :
France : 45 francs
Etranger : 55 francs

Dépositaire général : Librairie GALLIMARD
15, Boulevard Raspail, 15
PARIS (VII°)

LE NUMÉRO :
France : 4 francs
Étranger : 5 francs

Plate 44 Cover of *La Révolution Surréaliste*, no.1, 1924. Arno reprint edition reproduced by permission of Ayer Company.

December 1924 and December 1929. For the most part it was edited by Breton, who also wrote the lengthy 'Manifesto of Surrealism' in October 1924 announcing the group's existence. Breton's text is long, rambling and florid; the following paragraph, introducing some of the central themes, is typical of his style:

> We are still living under the reign of logic: this, of course, is what I have been driving at. But in this day and age logical methods are applicable only to solving problems of second-ary interest. The absolute rationalism that is still in vogue allows us to consider only facts relating directly to our experience. Logical ends, on the contrary, escape us. It is pointless to add that experience itself has found itself increasingly circumscribed. It paces back and forth in a cage from which it is more and more difficult to make it emerge. It too leans for support on what is most immediately expedient, and it is protected by the sentinels of common sense. Under the pretence of civilization and progress, we have managed to banish from the mind everything that may rightly or wrongly be termed superstition or fancy; forbidden is any kind of search after the truth which is not in conformance with accepted practices. It was, apparently, by pure chance that a part of our mental world which we pretended not to be concerned with any longer – and, in my opinion by far the most important part – has been brought back to light. For this we must give our thanks to

Sigmund Freud. On the basis of these discoveries a current of opinion is finally forming by means of which the human explorer will be able to carry his investigations much further, authorized as he will henceforth be not to confine himself solely to the most summary realities. The imagination is perhaps on the point of reclaiming its rights. If the depths of our mind contain strange forces capable of augmenting those on the surface, or of waging a victorious battle against them, there is every reason to seize them – first to seize them, then, if need be, to submit them to the control of our reason. The analysts themselves have everything to gain by it. But it is worth noting that no means has been designated a priori for carrying out this undertaking, that until further notice it can be construed the province of poets as well as scholars, and that its success is not dependent upon the more or less capricious paths that will be followed.

(Breton, 'Manifesto of Surrealism', pp.9–10)

The manifesto is over 40 pages long. It is a wide-ranging text, and includes lengthy anecdotes about friends, fictional narratives, lists and examples of Surrealist poetry. Its form and tone contrast with those of the Dada manifestos, which were generally short, internally contradictory and aggressive in tone. Breton maintains an air of erudition and scholarship; he enlists aspects of philosophy, psychology and literary history in making his argument; and he invokes a sense of disdain for social and cultural convention, rather than antagonism towards it.

The manifesto has often been read as a generalized critique of rationality, or of bourgeois rationality, in an appeal to what Breton terms the 'marvellous' – a celebration of the irrational, of the fantastical, and of dreams. But even a cursory reading of the above passage clearly indicates that Breton had something more specific in mind when he indicted, not 'rationality' but 'the absolute rationalism that is still in vogue'. As I've already indicated, the terms of the 'call to order' in post-war France were emphatic in their invocation of the discipline, clear-mindedness and rationality of the French spirit. It seems much more likely that it was this range of ideas, exemplified in Jeanneret's talk of 'cold reason', that provided the broad context for Breton's criticisms. The Surrealists were, after all, living and working at the same time and in the same city as the Purists and other Classically- and Platonically-oriented artists and writers.

Two main themes run through the passage from the manifesto quoted above, themes that were to form the principal theoretical resources of the Surrealists' critique of contemporary culture. First, Breton projects a series of images of the human imagination as a caged animal pacing back and forth behind the bars of contemporary rationalism. These images are derived from the philosophical and cultural tradition of Romanticism, where the imagination was characteristically represented as limitless in its potential, but blunted in actuality by the constraining and repressive forces of civilization and rationality. To this Romantic conception of the imagination, Breton introduces a psychoanalytic representation of the mind as divided between the conscious part, and the hidden, unconscious repository of instinct, experience and desire. The theories and therapeutic techniques developed by Freud, Breton goes on to argue, may be exploited to enable the imagination to 'reclaim its rights'.

There is another thread of ideas that became increasingly prominent in Surrealist theory during the mid- to late 1920s, one that added a social and political dimension to the mainly psychological emphasis of the first manifesto. It is condensed into the word 'revolution', which made up half of the title of the Surrealist magazine, and was developed in many of the short proclamations, essays and pamphlets that formed a significant part of Surrealist production. For example, the Surrealists' 'Declaration of 27 January 1925', signed by 26 members of the group, stated:

(1) We have nothing to do with literature; but we are quite capable, when necessary, of making use of it like anyone else.

(2) *Surrealism* is not a new means of expression, or an easier one, nor even a metaphysic of poetry. It is a means of total liberation of the mind *and of all that resembles it.*

(3) We are determined to make a Revolution.

(4) We have joined the word *surrealism* to the word *revolution* solely to show the disinterested, detached and even entirely desperate character of this revolution.
(quoted in M. Nadeau, *The History of Surrealism*, pp.262–3)

The conjoining of the intellectual threads of Romanticism, psychoanalysis and 'revolution' into a systematic body of theory was, above all, an extremely ambitious aim. Its progress was not smooth. For many Surrealists the more or less vague allegiance to 'revolt' originally had more to do with looking back to the revolutions of the eighteenth and nineteenth centuries. By the fourth issue of *La Révolution Surréaliste* (July 1925, the first to be edited by Breton), there is evidence that a post-1917 concept of revolution was beginning to take its place. In 1927 Breton, Aragon and others joined the Communist Party of France (PCF). As their understanding of the nature of social revolution developed, so the question of the compatibility of these beliefs with those of Romanticism and psychoanalysis became the subject of protracted debate within the group. The internal history of Surrealism is, in part, the history of that debate.

One of the main sites of that debate during the 1920s was the twelve issues of *La Révolution Surréaliste* and the occasional pamphlets and manifestos put out by members of the group. Like *Littérature*, the Surrealist magazine had none of the typographic inventiveness of Dada productions, but it differed from *Littérature* in most other respects. *La Révolution Surréaliste* reflected the ambitions of Breton and his colleagues in the mid-1920s, and probably also the recognition that if they were going to acquire much visibility in the increasingly competitive avant-garde circles in Paris at that time, they would have to square up to the likes of the sophisticated and ambitious *L'Esprit Nouveau*, and not just a few irregularly produced Dada magazines. The 'conservative' appearance of *La Révolution Surréaliste* was in fact derived from the cover of the scientific magazine *La Nature*, the positivist leanings of which would have made it an appropriate target for Surrealist parody. The layout of the magazine was equally dry – a typical page would consist of two columns of small, closely set type sometimes alleviated by a small drawing or photograph. In the earlier numbers of *La Révolution Surréaliste* there is a range of texts, from lengthy discussions of dreams and psychoanalytic issues to short, inflammatory attacks on institutions of the French state. There are few textual references to poetry or art, i.e. to those things for which Surrealism is now chiefly remembered. When an illustration was included, it usually bore no relation to the text around it. It was only with the fourth issue of the magazine that any systematic discussion of art is included (Breton's 'Surrealism and painting'), and there is an increase in the amount of poetry printed.

It was a basic assumption for Breton, as it had been for many others, that naturalistic painting had long been untenable. In 1922 he had commented on the need to 'liberate painting from the convention of representation', dismissing 'a return to naturalism [as] absolutely null and void'. In his 'Manifesto of Surrealism', three pages were devoted to a derisive commentary on the 'realistic attitude' and to naturalistic methods in novel writing. Elsewhere in the text, Breton attacked the convention of attending to mere 'summary realities' in art and literature. And in 'Surrealism and painting' he set up 'the very narrow concept of imitation', the 'treacherous nature of tangible entities', and the 'facile connotations of everyday experience' that took their model from the 'external world', against the insistence that the 'plastic work of art will refer to a *purely interior model* or will cease to exist'.

Thus far, Breton's view of art is comparable to the Purist belief in the priority of the 'conceptual' over the 'perceptual' in artistic representation. The point of divergence comes in their understanding of where the 'Real' resided, given that it didn't coincide with surface appearances. For the Purists, as we have seen, reality was to be found in the 'elevated' heights of the Platonic Ideal; for the Surrealists, only probing the 'depths' of the unconscious could reveal the determining impulses of life.

As I've noted, the principal techniques of Surrealist poetic and artistic production derived, during the 1920s at least, from Freudian and Romantic ideas. From Freud the Surrealists took the concept of 'automatism'. The technique of 'automatic writing' enabled psychoanalysts to elicit from a patient some clues to the workings of his or her unconscious. It helped with diagnosis and treatment of mental disorder. For the Freudian the unconscious exists as a repository of memories, experiences and instincts *repressed* by the conscious mind for the conduct of ordinary social life. (The Surrealists' use of psychoanalysis will be discussed in greater detail in Chapter 3.)

For the Surrealists the theory of the unconscious and the technique of 'automatism' could function, not as a means of helping individuals to adjust to established social norms but as a means first of systematically bypassing those norms, and then of furnishing a body of material that could be used to demonstrate their limited and repressive character. Thus in the 1924 manifesto Breton offered a dictionary-type definition of Surrealism:

> SURREALISM, n. Psychic automatism in its pure state, by which one proposes to express – verbally, by means of the written word, or in any other manner – the actual functioning of thought. Dictated by thought, in the absence of any control exercised by reason, exempt from any aesthetic or moral concern.
> (Breton, 'Manifesto of Surrealism', p.26)

The results of the first experiments in 'automatic' writing were published as 'Les champs magnétiques', extracts from which were reproduced in *Littérature* no.7 (September 1919). In this collaborative work, Breton and Soupault attempted systematically to reproduce the unselfconscious and apparently unconnected flow of thoughts and images that psychoanalysts often try to elicit from their subjects, and that for Breton were witnessed during those periods of lapsing from consciousness into sleep. For Breton 'Les champs magnétiques' was 'indisputably the first Surrealist (and in no sense Dada) work, since it was the first systematic use of automatic writing' (Breton, 'Les champs magnétiques', p.11).

The earliest examples of an 'automatic' technique being applied to the production of graphic work were executed by André Masson (Plate 156). Some of these pen-and-ink drawings appear to have started as more or less randomly produced scribbles, out of which the beginnings of images were suggested. At least, the bundle of scattered, fragmented and apparently unrelated forms would have been interpreted – assuming they were not planned by the artist – as evidence of unconscious mental activity, and as potentially revelatory in their contents. In his own, possibly self-mythologizing account of the time, Masson claimed to have devised various ways of frustrating or outflanking the control of the conscious mind through strategies of sleep deprivation, semi-starvation and drug-taking.

Max Ernst

It was in the graphic work and painting produced by Max Ernst between 1924 and 1927 that the most systematic and consistent use was made of 'automatic' techniques of production. The first result was a series of small pencil drawings produced under the title of 'Natural History' during 1924–25 (Plate 45). Ernst called this technique *frottage* ('rubbing'), which involved rubbing a pencil or crayon over a sheet of paper placed on the textured surface of rough-grained wood, foliage, textile, string and so forth. It was the more or less random results of this process that, Ernst claimed, acted to 'provoke' the resulting imagery. By 1926/7 Ernst had extended this process to the production of paintings, using *grattage* ('scraping') (Plate 46). In his autobiography, *Beyond Painting*, Ernst narrated his 'discovery' of the process of frottage:

> I began to experiment indifferently and to question … all sorts of materials to be found in my visual field: leaves and their veins, the ragged edges of a bit of linen, the brush strokes of a 'modern' painting, the unwound thread of a spool, etc. There my eyes discovered

Plate 45 Max Ernst, *Histoire Naturelle: Le Start du châtaignier* (*Natural History: The Chestnut Tree's Take-off*), 1925, frottage, pencil and gouache on paper, 26 x 43 cm. Private collection. © ADAGP/SPADEM, Paris and DACS, London, 1993.

> human heads, animals, a battle that ended with a kiss ... rocks, the sea and the rain, earth-
> quakes, the sphinx in her stable, the little tables around the earth ...
> (M. Ernst, *Beyond Painting*, p.7)

And he added, echoing Breton's statement from the 'Manifesto of Surrealism':

> The procedure of frottage, resting thus upon nothing more than the intensification of the
> irritability of the mind's faculties by appropriate technical means, excluding all conscious
> mental guidance (of reason, taste, morals), reducing to the extreme the active part of that
> one whom we have called, up to now, the 'author' of the work, this procedure is revealed
> by the following to be the real equivalent of that which is already known by the term
> *automatic writing.*
> (Ernst, *Beyond Painting*, p.8)

The defining quality of an 'automatic' drawing is the *process* whereby some image is made to emerge from (or is 'provoked' by) a series of non-iconic marks through a form of reading-in. But in developing the image, Ernst usually took care to avoid taking it to the point where its 'random' origins were obscured. In a painting such as *The Horde* (Plate 46), the origins of the painting remain visible in the finished work: Ernst first covered the canvas with one or more layers of brown paint, placed it over an uneven surface made with an unravelled spool of string, and then scraped over this with a crayon. The lines produced as the orange crayon passed over the string form the basic contours of the imagery. Schematic highlights and modelling are then added to further establish the forms of the struggling creatures. Lastly, areas are masked out with opaque blue paint to make the figures stand out as silhouettes against a low horizon. But while the large figure occupying much of the right-hand side of the canvas is resolved enough to have arms, hair and eyes, forms to the left remain little more than tangled shapes. Thus, in the same way as the various figure-forms seem to have been frozen in movement, the painting itself appears to have been halted in the process of its transition from formlessness to definition.

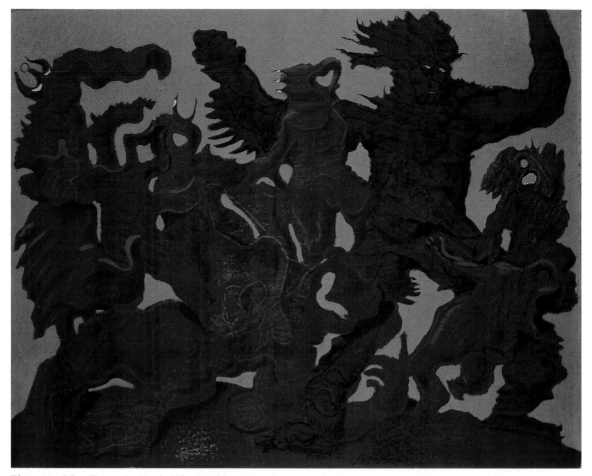

Plate 46 Max Ernst, *La Horde* (*The Horde*), 1927, oil on canvas, 46 x 55 cm. Collection, Stedelijk Museum, Amsterdam. © ADAGP/SPADEM, Paris and DACS, London, 1993.

While paying attention to the random and unplanned elements of a work such as *The Horde*, we shouldn't overlook those aspects that can't be accounted for in terms of an 'automatic' process. The basic compositional structure of the painting, for example, is not a one-off effect produced by the tangle of string under the canvas. Rather, the schematic landscape space – foreground figures, horizon and blue backdrop – is a feature of nearly *all* of Ernst's collages and paintings from the early twenties through to the forties. This schema or template precedes the production of individual pictures, and was probably necessary to provide some basic means of ordering the web of lines and colours. Furthermore, certain themes were regularly re-used by Ernst. The image of a dark, semi-petrified forest formed the central motif in a number of his grattage paintings from 1927 (Plate 173). These were produced in the same way as *The Horde*, the image being built through a combination of scraping over a rough surface and masking out. It is inviting to read such works as allegories of the unconscious – as highly self-conscious, symbolic representations of the human mind as conceived in Surrealist terms. The Surrealists often represented the mind as a labyrinth – dark, intricate, unchartable, forbidding and intriguing.

In works such as these, which are fairly typical of Ernst's paintings of the mid- to late 1920s, the relationship of randomness to planning is far from straightforward. There are randomly produced aspects of the work, areas in which a shape or line or form is not prescribed in advance, but these are executed within certain pre-given limitations of format,

composition and imagery, within certain tolerances. In such paintings, randomness is not synonymous with arbitrariness: it is always contained within the strictures of a planned production process.

A variety of techniques for producing 'automatic' texts and pictures was developed by the Surrealists during the mid-1920s. Under the title of *Le Cadavre exquis* (*The Exquisite Corpse*), a number of collectively produced 'automatic' drawings and texts were reproduced in *La Révolution Surréaliste* (for example, Plate 47). These were made according to the rules of the children's game 'Head, body and tails', or 'Consequences', where the first player would write a section of a sentence or draw a section of a figure, fold over the paper and pass it on to the next player. The resulting image or text, in being made by several players, would have been produced outside the conscious control of any single participant. All forms of automatic production shared this intent to evade what Breton had termed 'any control exercised by reason'. But this does not mean the works were produced in a purely random manner. Rather, as we have seen, the Surrealist artists and writers went to considerable lengths to devise strategies to *systematically* outflank 'any aesthetic or moral concern'. In the main this meant, as Ernst noted, an initial stage – in which a set of lines or shapes was randomly generated – followed by a stage where the artist would 'draw out' any imagery *suggested by* the randomly produced material.

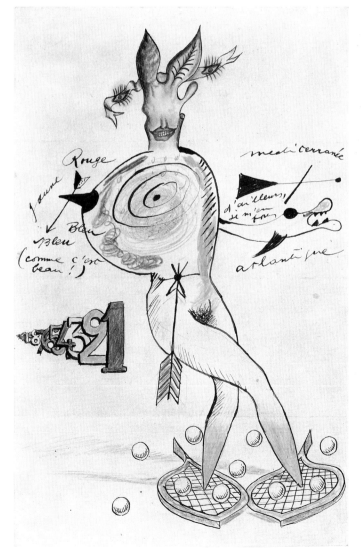

Plate 47 Man Ray, Yves Tanguy, Joan Miró and Max Morise, *Le Cadavre exquis* (*The Exquisite Corpse*), 1926–27, ink, pencil, colour crayon on paper, 37 x 23 cm. Collection, The Museum of Modern Art, New York; purchase fund. © ADAGP, Paris and DACS, London, 1993.

Joan Miró

A number of paintings by Joan Miró between 1925 and 1927 are highly suggestive of such an 'automatic', unplanned and apparently 'spontaneous' production of semi-abstract forms and lines. In both *The Siesta* (Plate 48) and *Painting* (Plate 153), a single-colour ground contains a dominant flat, white shape and a series of smaller forms and lines. The effect is of a series of fragile forms floating in an atmosphere of some kind: it is hard to suggest any more definite subject-matter. But in the case of *The Siesta*, two preliminary drawings (Plates 49 and 50) show that the process behind Miró's work is almost the exact reverse of Ernst's or Masson's. The first sketch shows a fairly conventional scene, at least in art-historical terms – a rural or Arcadian idyll, with mountains, sea, sun, a foreground with playing or reclining figures, wine, food, music, flowers, animals. The scene's mood of innocent playfulness is emphasized in the 'naïve' graphic style Miró adopts. (Miró, of course, was no naïve. He trained as a professional painter in Barcelona before moving to Paris with the aim of involving himself with the Modern Movement.) The second sketch is a highly edited, highly schematized version of the first. The figure, house and clock have been condensed into one shape, the ring of dancers (a quotation of Matisse's *La Danse*) has been reduced to a dotted circle, the mountains have become an independent shape separate from the horizon, the sun and cloud have been combined into a haze of radiating lines. The painting of *The Siesta* is a fairly precise transcription of the second sketch, without any major alterations. Thus, while there are some generic similarities between Miró's and Ernst's paintings – amorphous, organic forms silhouetted against an indefinite deep space – they are none the less quite distinct *types* of painting. Whereas *The Horde* was made by a process in which the imagery was built up from a random series of blobs and

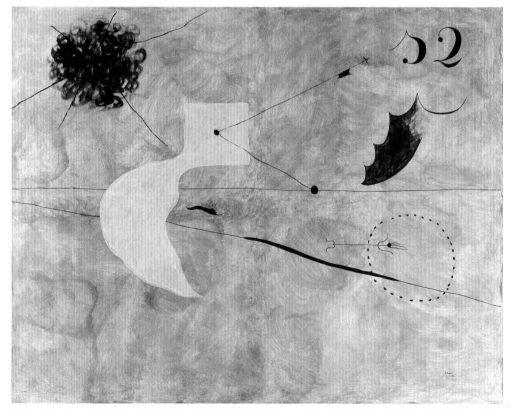

Plate 48 Joan Miró, *La Sieste* (*The Siesta*), 1925, oil on canvas, 89 x 146 cm. Musée National d'Art Moderne, Centre Georges Pompidou, Paris. © ADAGP, Paris and DACS, London, 1993.

Plate 49 Joan Miró, preliminary drawing for *The Siesta*, from 1925 Notebook, charcoal and pencil, 17 x 19 cm. Fundació Joan Miró, Barcelona. Photo: F. Catala-Roca. © ADAGP, Paris and DACS, London, 1993.

Plate 50 Joan Miró, preliminary drawing for *The Siesta*, from 1924–26 Notebooks, charcoal and pencil, 15 x 22 cm. Fundació Joan Miró, Barcelona. Photo: F. Catala-Roca. © ADAGP, Paris and DACS, London, 1993.

lines, the starting-point of Miró's painting is a particular range of imagery that he then reduces to an arrangement of flat shapes and contours. This process of working from a series of preliminary studies and sketches, which is derived from traditional academic training, and Miró's tendency to take his subjects from the traditional genres while updating them in various ways, is discussed further in the final section of this chapter.

Surrealist collage

Another technique that the Surrealists used extensively was collage, although it came to prominence only during the late twenties. This technique was again invested with psycho-analytic significance by Breton, Ernst and its other exponents, although the basic 'formula' of collage they ascribed to the Romantics, and to Isidore Ducasse (the 'Comte de Lautréamont') in particular. Breton often cited Lautréamont's phrase, 'As beautiful as an umbrella and a sewing machine lying together on a dissecting table', as exemplifying the 'marvellous', and such unsolicited pairing of unrelated items became the stock-in-trade of Surrealist collage (Plates 51 and 52). Writing in *Beyond Painting* under the heading 'What is the mechanism of collage?', Ernst evoked Lautréamont:

> A ready-made reality, whose naïve destination has the air of having been fixed once and for all (a canoe), finding itself in the presence of another and hardly less absurd reality (a vacuum cleaner), in a place where both of them must feel displaced (a forest), will, by this very fact, escape to its naïve destination and to its identity; it will pass from its false absolute, through a series of relative values, into a new absolute value, true and poetic: canoe and vacuum cleaner will make love.
>
> (Ernst, *Beyond Painting*, p.13)

Collage, for Ernst, achieves two things: first, it has a disruptive character as objects are displaced from their ordinary range of expectation and association. Second, through this act of displacement, it becomes possible to transcend this realm of convention (what Ernst calls its 'false absolute') and arrive at another, 'new absolute' understanding. In this way, collage is seen to perform a function similar to that of 'automatic' writing, drawing and

painting: it is intended to provide the technical means whereby its maker or viewer would become able to break out of the 'cage' of mere 'expediency' and to see things in a more 'true and poetic' light.

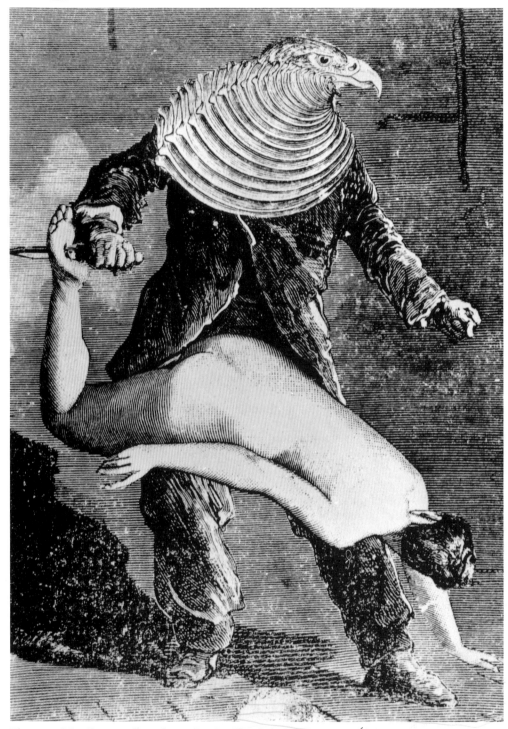

Plate 51 Max Ernst, collage from *Une Semaine de bonté ou Les Sept Éléments capitaux* (*One Week of Kindness or the Seven Capital Elements*), 1930, Paris, J. Bucher. Photo: Jacqueline Hyde. © ADAGP/SPADEM, Paris and DACS, London, 1993.

Plate 52 Max Ernst, *L'Inconscience du paysage devient complète* (*The Unconsciousness of the Landscape Becomes Complete*), *The Hundred Headless Woman*, 1929, Paris, Éditions du Carrefour. Photo: Jacqueline Hyde. © ADAGP/SPADEM, Paris and DACS, London, 1993.

Ernst had produced collages of various sorts when working with the Dada group in Cologne; between 1921 and 1923, during which time he moved from Cologne to Paris, Ernst made a series of works which, although oil paintings, exploited the collage effect of conjoining disparate elements in a single space (Plate 54). The exaggerated perspective and schematic modelling of these works provide a consistent stage-like arena for the various figures and forms to occupy in a frozen tableau. They are highly reminiscent of paintings by the Italian artist Giorgio de Chirico whose work the Surrealists admired (Plate 53). While by 1924–25 Ernst had dropped this type of illusionistic painting in favour of the less highly resolved and more elusive imagery of frottage-based work, he continued to produce a number of collages made up from late nineteenth-century line-block illustrations. Other painters such as René Magritte and Salvador Dali developed their own styles of illusionistic painting that continued to exploit the *effects*, if not the *technique*, of collage.

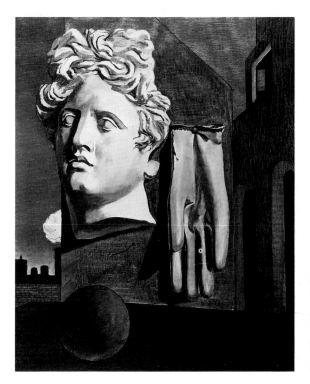

Plate 53 Giorgio de Chirico, *Les Délices du poète* (*The Song of Love*), 1914, oil on canvas, 73 x 60 cm. Collection, The Museum of Modern Art, New York; bequest of Nelson A. Rockefeller, 1979. Photo: Charles Uht. © DACS, London, 1993.

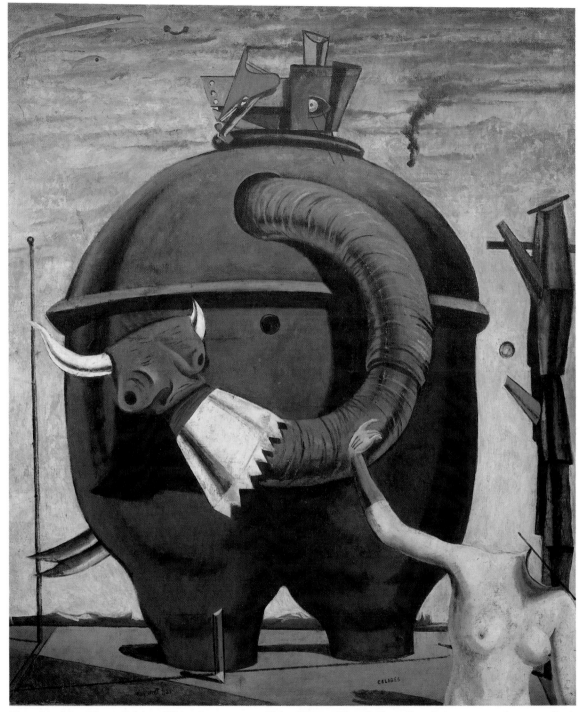

Plate 54 Max Ernst, *Celebes*, 1921, oil on canvas, 126 x 108 cm. Tate Gallery, London. © ADAGP/SPADEM, Paris and DACS, London, 1993.

With the exception of these last works, it is a feature of much Surrealist art that its techniques left little room for conventional ideas of skill, composition, inspiration and so on. For many Surrealists, including the young English poet and writer David Gascoyne (who, in 1935, published the first full-length account of Surrealism for an English audience), this critique of artistic convention was one of its most significant features. 'The most scandalous thing about Surrealist art from the point of view of the reactionary critics', he wrote,

> is its tendency to do away with the old hierarchies of technical skill, 'fine drawing', etc. Surrealism represents the point at which poetry and painting merge into one another; and if poetry should be made by all, not one, then everyone should be able to make pictures also … All that is needed to produce a Surrealist picture is an unshackled imagination (and the Surrealists have often claimed that every human being is endowed with imagination, be he aware of it or not), and a few materials: paper or cardboard, pencil, scissors, paste, and an illustrated magazine, a catalogue or a newspaper. The marvellous is within everyone's reach.
>
> (D. Gascoyne, *A Short Survey of Surrealism*, p.106)

Common ground

Up to this point much of the discussion has been structured around the observation that modern art in Paris after the First World War was highly divided. The substantial conceptual and technical divisions between the naturalist and Cubist-based work were further complicated by a series of animated subdivisions within each of these broad camps. Earlier I stressed the basic division between those who oriented around the Purist group and *L'Esprit Nouveau*, and those who identified with the interests of the emergent Surrealist group and Dada. While it is clear there were many antagonisms, disputes and disaffections within any one of these groups, these do not appear to have troubled the more basic division between those who supported the 'call to order' and those who aimed to negate or otherwise oppose it. It seems we could represent this historical moment as two parallel but separate developments in post-war French art. But this would be to overlook a key point: that these groups in Paris derived many of their ideas and developed their projections from the *same* intellectual and artistic material. This material was the legacy of Cubism and, in particular, the work of Apollinaire and Picasso. From the period immediately after the armistice until the mid-1920s, the magazines reveal a high level of consensus about the value of this work. This is not to say, of course, that all the commentators saw the *same* value in Apollinaire's writing and Picasso's paintings. Rather, this material became an axis around which competing representations were developed and fought out.

Apollinaire

In 1917 the small magazine *Nord-Sud* was launched by Pierre Reverdy. Its opening statement read:

> What could be less astonishing than that we judge the moment has come to group ourselves around Guillaume Apollinaire. More than anyone today he has broken new ground, opened new horizons. He has the right to all our fervour and admiration.
>
> (P. Reverdy, *Nord-Sud*, no.1, p.2)

In 1918 an issue of *De Stijl* was dedicated to Apollinaire's memory (Plate 55); *L'Esprit Nouveau* no.26 (1924) was made up entirely of fifteen essays under the subtitle 'Special issue dedicated to Guillaume Apollinaire'; and almost every other magazine of the time

Plate 55 Title-page (dedicated to Guillaume Apollinaire) of *De Stijl*, no.2, 1918. Atheneum, Bakker, Polak and Van Gennep Reprint, 1968.

made regular and respectful reference to the poet through discussions, interviews and dedications, or by the inclusion of examples of his poetry or prose. But there were also more symbolic ways in which these younger artists and writers marked their identification with his *œuvre*. A significant example is the use that was made in the immediate post-war period of the term 'l'esprit nouveau'. In cultural circles the phrase was closely identified with Apollinaire's writing. He had first used it in print during 1917 in the programme notes for Jean Cocteau's ballet *Parade,* which he entitled 'Parade et l'esprit nouveau'. Of the several other occasions on which he used the phrase, the most important was in a lecture entitled 'L'esprit nouveau et les poètes', delivered shortly before his death in November 1918 and published posthumously. In keeping with the political rhetoric of the time, Apollinaire's characterization of the phrase was both Classicist and nationalist. Asserting that 'l'esprit nouveau' was 'a lyrical expression of the French nation, just as the classic is a sublime expression *par excellence* of the same nation', he went on to applaud this new 'sense of duty which conquers the emotions and limits them', to celebrate 'scientific terminology' and 'the artisans who improve the machine', and to claim that a 'return to first principles' was motivated by a deeply felt 'horror of chaos' (G. Apollinaire, 'L'esprit nouveau et les poètes', p.230).

It is easy to see how the ideas and values intoned by Apollinaire were picked up and developed by ambitious younger artists such as Jeanneret and Ozenfant. In titling their journal *L'Esprit Nouveau,* they not only publicly indicated their allegiance to the influential poet, critic and intellectual force behind Cubism, they also effectively upstaged any other competing claim to that legacy. But it was not only those who identified with the 'call to order' who sought to lay claim to the legacy of Apollinaire. No less than the Purists,

Breton worked hard to add weight to his conception of the future of art by attaching it to a persuasive interpretation of its past. He did this by finding material from the art and writing of the pre-war and war-time periods that could be used in support of his particular programme, in much the same way as had the Purists, and from largely the same sources. In early 1919, almost a year before *L'Esprit Nouveau* began publication, he had invited Tzara to contribute to *Littérature,* stressing its commitment to 'the new spirit for which we are fighting' (quoted in Ades, *Dada and Surrealism Reviewed*, p.162). And during 1921–22 Breton set about organizing two public events clearly intended as strategic interventions in the arguments over the meaning of 'l'esprit nouveau'. But the proposed International Conference for the Determination of the Direction and the Defence of the Modern Spirit (to which prominent figures from the Purist and Dada groups were invited), and the mock trial of the influential right-wing literary figure Maurice Barrès, ended in well documented fiascos. Whatever the real aims behind these initiatives, their effect was to open up and dramatize some basic differences of interest between the various groups.

However, it is not the case that Breton and the *Littérature* group simply gave up their claims to the legacy of Apollinaire and 'l'esprit nouveau'. In the new series of the magazine there are occasional references to the term. In pieces of high parody, Picabia targeted Jeanneret and Ozenfant (the 'hairdressers of Cubism'), Rosenberg, ('who carries Cubism as Jesus carried the cross'), Raynal, Cocteau and others (Picabia, 'Picabia dit dans *Littérature*', p.18). More importantly, though, at around this time the term 'surrealism' began to acquire a place in Breton's vocabulary. It has a particular significance within the contest over 'l'esprit nouveau'. Not only was the neologism coined by Apollinaire and used publicly in the same year as 'l'esprit nouveau', but the two terms were closely identified with each other in his writing. In the programme notes for *Parade*, Apollinaire described the ballet as 'a sort of Sur-realisme in which I see the point of departure for a series of manifestations of that New Spirit…' And his own play *Les Mamelles de Tirésias*, first performed a month after *Parade*, was subtitled by Apollinaire, 'A surrealist drama in two acts and a prologue: chorus, music and costumes in accordance with the new spirit' (Apollinaire, programme for *Les Mamelles de Tirésias*, p.4).

For Apollinaire, both terms were identified with the human capacity for abstract thought and the ability to create forms independent of any precedent in nature. Accordingly, the first surreal act was the invention of the wheel – something 'unnatural' and unprecedented. For Apollinaire, 'l'esprit nouveau' and the 'surreal' were characterized by geometry, technology *and* a sense of the unusual and unforeseeable. And just as the Purists were able to point to areas of Apollinaire's writing to back up their own conceptions of post-war art and culture, so the *Littérature* group was able to draw on sections of 'L'esprit nouveau et les poètes' in support of its own increasingly divergent interests. For example, as well as extolling the 'sense of duty which conquers the emotions and limits them', Apollinaire's text also contains passages that strongly prefigure Breton's expansive concept of the imagination and sense of the 'capricious paths' of poetic inquiry. For Apollinaire 'the least fact is a postulate for the poet, a point of departure for a vast unknown where bonfires of complex implications blaze'. And he went on to celebrate the 'encyclopaedic liberty' which was the legacy of 'Romanticism', the 'freedom of unimaginable opulence', and the responsibility of poets to 'guide you, alive and awake into the nocturnal closed world of dreams' ('L'esprit nouveau et les poètes', pp.234–5).

It is only possible to guess at the extent to which Apollinaire furnished Breton with ideas about the poetic significance of the dream and Romantic concepts of the imagination. But when, in October 1924, Breton publicly adopted the term 'surrealism' – in the title of a theoretically ambitious and de luxe quality magazine – he was clearly aiming to do exactly what Jeanneret and Ozenfant had managed earlier. He was indicating that his projections were both attached to and extensions of the legacy of pre-war avant-garde ideas and art.

Thus both the Purist and Surrealist groups devised tactics for, and devoted time and space to, representing the significant work of the pre-war period in terms that appear to legitimize their own conceptions of post-war art. Both groups recognized the significance of Apollinaire's writing in this process; the other figure whose work became a primary focus of attention for contending groups after the war was Picasso. But in a variety of ways Picasso represented more of a problem than Apollinaire: he was still alive and, moreover, still producing an apparently unruly variety of pictures, pictures that seemed (more obviously than was the case with Apollinaire's writing) immediately to threaten any one set of theoretical projections built around them.

Picasso

At the time of the armistice Picasso had not shown any new work in Paris for nine years. In 1918, given the enforced absence of Kahnweiler, the bulk of the remaining Cubists – including Braque, Léger and Gris – signed contracts with Léonce Rosenberg, self-styled promoter of a Cubism suited to a reconstructed France. Picasso signed instead with Léonce's brother, Paul, through whom were arranged the majority of the artist's nine one-man exhibitions in Paris between 1919 and 1928. In addition to these, work by Picasso was included in numerous group exhibitions over the same period. These are of interest because through them an association of some sort was implied between Picasso's work and just about every other group making a claim to represent the authentic direction of post-war art. In some exhibitions his work was hung alongside that of other pre-war heavyweights – Matisse and Derain, for example. On occasions it was included in exhibitions of the younger generation of painters set to be packaged as the 'School of Paris'. In other shows, examples of his paintings were presented with work by artists associated with *L'Esprit Nouveau*; the fifth and final exhibition in a series entitled Maîtres du Cubisme, at Rosenberg's Galerie de l'Effort Moderne, was devoted to Picasso. And in 1925 several Picassos were displayed in the first Exposition de la Peinture Surréaliste at the Galerie Pierre.

Picasso's status as leader of pre-war Cubism was not contested by either the Purists or the Surrealists. But one might expect these commentators to have been more circumspect about the range of highly naturalistic, so-called Ingresque drawings and paintings that he began producing from 1915 (*Portrait of Olga in an Armchair*, Plate 56; *Portrait of Igor Stravinsky*, Plate 57). In fact they were not. It is a notable feature of most of the commentaries published immediately after the war that his work as a whole – or rather his creative persona – was placed above and beyond the standards of their normal criticism. André Salmon, writing in the first issue of *L'Esprit Nouveau*, set the tone for much of what was to follow, in his short survey of Picasso's artistic development:

> Picasso does not tie himself down … When the Cubist era began, Picasso was in an admirable position, his free genius flowering as never before … Picasso is alone between earth and heaven, followed by those to whom he showed the way, and preceded by the man he used to be. Picasso remains alone after bestowing new truths upon us … crowned with grace.
> (Salmon, 'Picasso')

Breton, in 'Surrealism and painting', wrote in one of his passages on Picasso:

> For all these reasons, we claim him unhesitatingly as one of us, even though it is impossible and would, in any case, be impertinent to apply to his methods the rigorous system that we propose to institute in other directions … I shall always oppose the absurdly restrictive sense that any label would impose on this man from whom we confidently expect great things … Picasso himself is absolved by his genius from all primary moral obligations.
> (Breton, 'Surrealism and painting', *La Révolution Surréaliste*, no.4, p.30 and no.6, p.31)

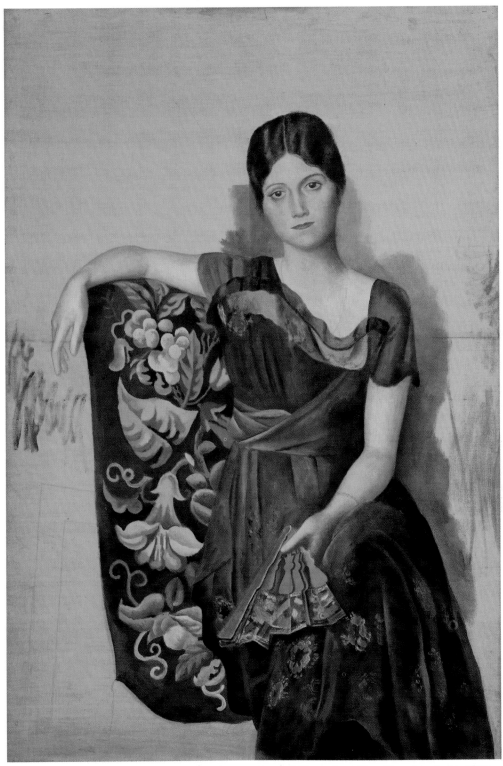

Plate 56 Pablo Picasso, *Portrait d'Olga dans un fauteuil* (*Portrait of Olga in an Armchair*), 1917, oil on canvas, 130 x 89 cm. Musée Picasso, Paris. Photo: Réunion des Musées Nationaux Documentation Photographique. © DACS, London, 1993.

Plate 57 Pablo Picasso, *Portrait d'Igor Stravinsky* (*Portrait of Igor Stravinsky*), 1920, pencil on grey paper, 62 x 49 cm. Musée Picasso, Paris. Photo: Réunion des Musées Nationaux Documentation Photographique. © DACS, London, 1993.

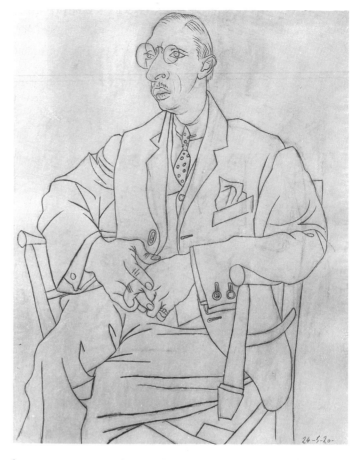

Thus Picasso was represented not as someone who produced an uneven body of work – some parts of which merited attention and some of which might better be passed over in silence – but as someone whose entire output formed a unity transcending ordinary terms of reference. There might be additional ways of explaining this treatment of Picasso as a kind of Nietzschean 'Superman'. First, it might have been that the stakes were too high, that no aspiring leader of post-war art was going to risk possible isolation through being seen to criticize work by an artist of such prestige and respect. Alternatively, it might have been that these authors had noticed something about Picasso's work, even in its most naturalistic vein, that somehow distinguished it from the more run-of-the-mill naturalism. Probably there was an element of both those things.

It is certainly the case that the overt naturalism in a drawing or painting by Picasso from this period is always somehow *qualified*, either within the picture or by a closely related work. Exactly how this qualification is achieved varies from work to work, and it is worth looking more closely at a few examples. We have already noted how Picasso often took a similar theme and represented it in differing styles. Between 1915 and 1923 the harlequin figure was the subject of several paintings, from the most naturalistic (for example, *Seated Harlequin*, Plate 12) to the most flattened and planar (for example, *Harlequin*, Plate 13, or *The Three Musicians*, Plate 1). This tendency to alternate between two or more distinct styles carries certain implications. It suggests, first of all, that each style is an example of *a* means of representing, but that neither can assume a *privileged* relationship with the world it depicts. If nothing else, this emphasizes the issue of the material character of representation. It is hard to suppress the sense, when faced with such work, that we are looking, not so much at the object in a picture but at a way of picturing an object. Furthermore it follows from this that different modes of representation will call to

attention different aspects of what is represented. Ozenfant, writing in *L'Esprit Nouveau* no.13 (1921) under the pseudonym Vauvrecy, characterized this aspect of Picasso's work in terms of someone writing in different languages:

> Can ... people not understand that Cubism and figurative painting are two different languages, and that a painter is free to choose either of them as he may judge it better suited to what he has to say?

> ... Some things, for instance, are better expressed in algebraic than in geometrical terms, as the latter may conform more neatly to this or that mode of thought ... Do we deny the value of algebra when we practise geometry?
>
> (*L'Esprit Nouveau*, no.13, 1921, pp.1492–3)

Picasso's graphic work of the period appears to complicate this issue further by emphasizing the different modes of representation *within* the broad category of naturalism. In many of these drawings, Picasso effectively rehearses the traditional division between linear and tonal depiction. Drawings such as his *Portrait of Igor Stravinsky* (Plate 57) and *Portrait of Guillaume Apollinaire* (Plate 58) are exclusively and emphatically linear, whereas

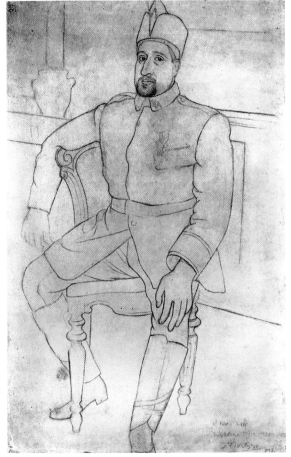

Plate 58 Pablo Picasso, *Portrait de Guillaume Apollinaire* (*Portrait of Guillaume Apollinaire*), 1916, pencil on paper, 48 x 31 cm. Private collection. Photograph by courtesy of Sotheby's, London. © DACS, London, 1993.

Plate 59 Pablo Picasso, *Portrait d'Ambroise Vollard* (*Portrait of Ambroise Vollard*), 1915, pencil on paper, 46 x 32 cm. Metropolitan Museum of Art, New York; the Elisha Whittelsey Collection, Elisha Whittelsey Fund, 1947. © DACS, London, 1993.

his *Portrait of Ambroise Vollard* (Plate 59) uses both techniques, but in distinct areas of the same work. It is a curious feature of all these works that while a highly illusionistic technique is used, its effect is more to declare than to deny the artifice of representation. During the early 1920s Picasso executed a number of works that further emphasize the differences within naturalistic drawing by depicting the same theme in different graphic modes. Around 1922 Picasso produced a number of works on the theme of maternity. In one (Plate 60) the figures of mother and child are executed in a highly abbreviated linear style, with a soft pencil or crayon. Patches of watercolour indicate the colour of clothes, curtains, etc., but in such a way that they remain separate and distinct from the drawn lines. In the next sketchbook (Plate 61) the two figures are depicted in an overtly tonal manner, built up in several layers of cross-hatching with a hard pencil. In addition, while the latter drawing is overtly classicizing in its execution, composition and costume, the former is more suggestive of a contemporary bourgeois family scene.

With drawings such as these, the question of the status of the subject arises. During the post-war period the theme of maternity had been conscripted into the rhetoric of the 'call to order', as we noted earlier. In this context, the argument would go, there could no longer be an 'innocent' representation of the subject, free from this baggage of associations. Are these works then reducible to illustrations of this propaganda? I think not, but not only because Picasso had recently become a father himself and would, therefore, have

Plate 60 Pablo Picasso, untitled drawing, 1922, pencil, watercolour and pastel drawing on paper, 16 x 12 cm, from Sketchbook no.76, p.37. Private collection. Photograph: Bill Jacobson Studio by courtesy of The Pace Gallery, New York. © DACS, London, ARS, New York, 1993.

Plate 61 Pablo Picasso, untitled drawing, *c*.1922, pencil drawing on paper, 42 x 31 cm, from Sketchbook no.77, p.28. Private collection. Photograph: Bill Jacobson Studio by courtesy of The Pace Gallery, New York. © DACS, London, ARS, New York, 1993.

witnessed such scenes. Rather, it is a matter of technique, and the types of observation embodied in Picasso's techniques – observation of the motif, and observation of the processes of representation. The effect is that the works look as if they are a result of *scrutinizing* the subject rather than simply illustrating it.

Picasso's naturalistic painting also often displays different techniques, and this division often takes place within the same work. *The Painter and his Model* (1914; Plate 62), probably the earliest surviving example of Picasso's post-Cubist naturalistic painting, is a small work painted on a linen drying-up cloth. It looks unfinished. A small section of the

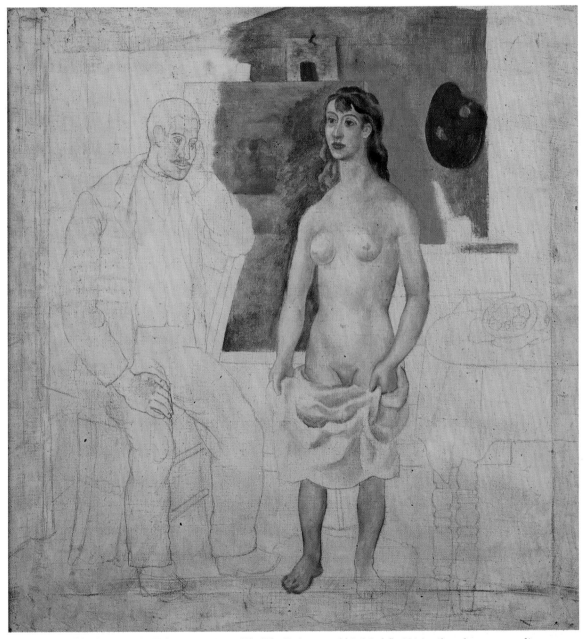

Plate 62 Pablo Picasso, *Le Peintre et son modèle* (*The Painter and his Model*), 1914, oil and crayon on linen, 58 x 56 cm. Musée Picasso, Paris. Photo: Réunion des Musées Nationaux Documentation Photographique. © DACS, London, 1993.

work is painted in naturalistic colour and tone while the remaining areas exist only in pencil outline. It may well be that Picasso had intended to paint the entire area but, for some reason, didn't complete the work. It may also be that Picasso noticed something in this unfinished painting that gave it a quality that might otherwise have been lost – for in other slightly later paintings he appears deliberately to exploit this quality as a device. For example, *Portrait of Olga in an Armchair* (Plate 56) is quite emphatically 'unfinished'. The figure and drapery are only tied into the surrounding bare canvas by some areas of rough shading, some loose undescriptive brushwork, and some light pencil drawing. The effect, again, is both to heighten and to defeat the illusionism of the meticulous paintwork in the centre of the picture. Again, the viewer is faced with a picture of picturing as much as with a portrait of a young woman. And in the case of *The Painter and his Model*, the viewer is faced with a picture of an artist frozen in the process of making a painting, and with a picture frozen in the process of being painted. There is an important sense, I think, in which these paintings owe more to the conventions of collage than to those of naturalistic painting. It is as if the illusionistic parts of the work are 'pasted' on to the canvas surface. They become bits of material layered onto other pictorially distinct bits of material.

In other works of the period these devices are made less obvious, but they none the less shape the overall character of the work. The *Seated Harlequin* and *Seated Woman in a Chemise* (Plates 12 and 63), both from 1923, are striking examples of illusionistic painting.

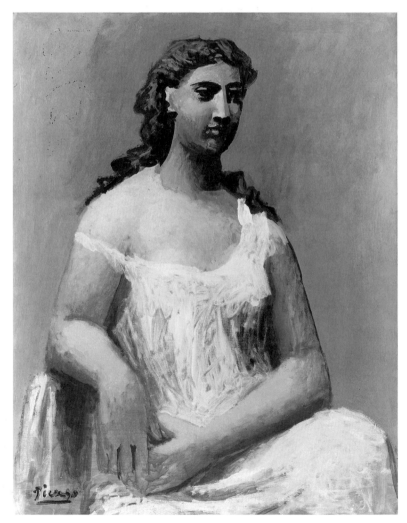

Plate 63 Pablo Picasso, *Femme en chemise assise* (*Seated Woman in a Chemise*), 1923, oil on canvas, 92 x 73 cm. Tate Gallery, London. © DACS, London, 1993.

In each a single figure stands out from an indeterminate background. The *Seated Woman in a Chemise* appears monumental and sculptural in her white cotton shift, but at the same time there are areas in the painting – around her right hand for example – where the definition gives way to thinned paint and very loose brushwork. The cotton shift is also indicated in such an abbreviated way that the process of representation is, again, given at least equal emphasis with the thing represented. Likewise the *Seated Harlequin* (Plate 12) is both convincingly three-dimensional in places and obviously two-dimensional in others. In this painting the sense of solid form is also dissolved in the lower part of the figure and, moreover, the central section of the figure is visibly made up of three quite distinct and independent elements – thinly painted outlines, schematic modelling and patches of colour. Again, it is as if these elements are collaged together or layered over one another; they coexist on the same surface rather than form a fully integrated unity. The effect is of something provisional, open and light. In a painting of a comparable theme, Severini's *The Two Punchinellos* (Plate 5), these qualities are entirely absent.

Other paintings by Picasso declare their artifice in other ways. The figures in many of his 'Classical' scenes are massively distorted, sometimes subtly, occasionally grotesquely. The body of his *Large Bather* (Plate 64), for example, is hugely inflated. Nevertheless, though monumental, the figure is not grotesque – because of the precise delicacy of her

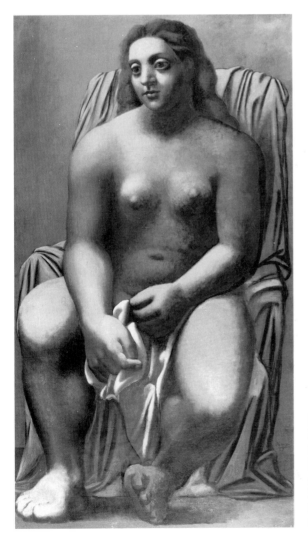

Plate 64 Pablo Picasso, *Grande Baigneuse* (*Large Bather*), 1921, oil on canvas, 180 x 98 cm. Musée de l'Orangerie, Collection Jean Walther and Paul Guillaume, Paris. Photo: Réunion des Musées Nationaux Documentation Photographique. © DACS, London, 1993.

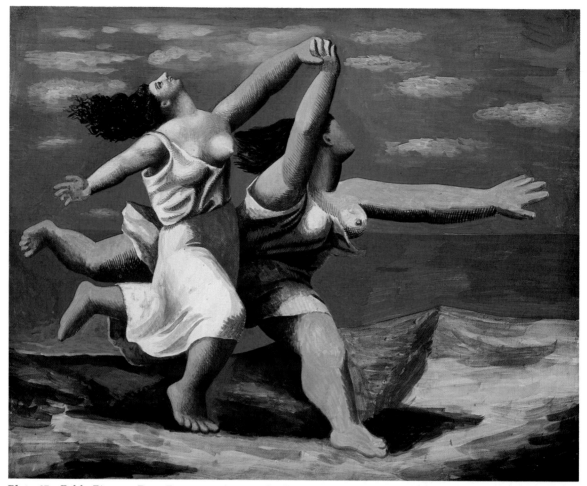

Plate 65 Pablo Picasso, *Deux Femmes courant sur la plage (La Course)* (*Two Women Running on the Beach (The Race)*), 1922, gouache on plywood, 33 x 41 cm. Musée Picasso, Paris. Photo: Réunion des Musées Nationaux Documentation Photographique. © DACS, London, 1993.

posture and her distracted expression. Likewise the figure in the centre of the small gouache *Two Women Running on the Beach (The Race)* (Plate 65) is stretched into a cruciform shape extending almost to the four edges of the panel. The left arm and leg of this figure are about twice the size of the arms and legs of the foreground figure, but paradoxically this does more to enhance the compositional balance of the painting than disrupt it. It is hard to place these figures, or the more obviously grotesque couple in *The Two Bathers* (Plate 66), within the rhetoric of post-war Classical idealism. The figures are schematized, distorted and idiosyncratic: the formal balance of the painting is achieved only at the expense of the figures' Classical proportions. While these works use some of the language of Classicism, that language is emptied of its assumed moral content. However, these are not exactly parodic or ironic works. They rehearse a certain 'language' of representation, but they do not rubbish it. Their ambivalence means that they remain hard to place. In this sense these paintings share with Apollinaire's later writing the capacity simultaneously to evoke contradictory qualities within a single work.

In 1925 Picasso produced an ambitious painting that both draws on many of the interests and devices outlined above, and marks a departure from his 'Classicism' of the previous few years. *The Three Dancers* (Plate 67) is a large painting (215 x 142 cm) and a

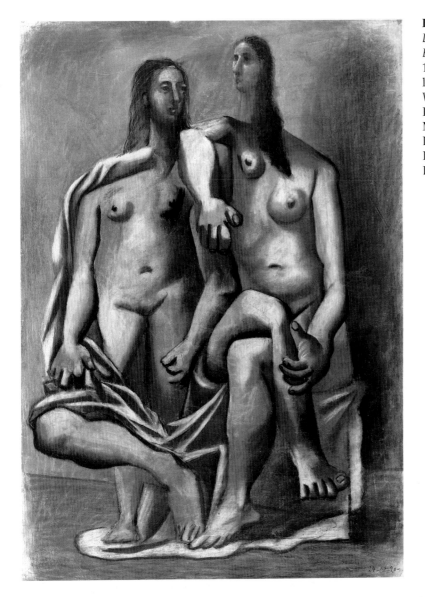

Plate 66 Pablo Picasso, *Les Deux Baigneuses* (*The Two Bathers*), 1920, oil on canvas, 194 x 163 cm. Musée de l'Orangerie, Collection Jean Walther and Paul Guillaume, Paris. Photo: Réunion des Musées Nationaux Documentation Photographique. © DACS, London, 1993.

complex composition. While invoking the rhetoric of Classicism in its theme – the naked or semi-naked dancers suggest the Graces – the painting also invokes in its structure the planar Cubism of, for example, *The Three Musicians* (Plate 1). There is no modelling in this work, space being suggested only by interlocking planes of flat colour bounded by black contours. The figures are neither sensuous nor monumental, as was the case in some of the earlier nudes, nor are they comic and playful in the way suggested by the *commedia dell'arte* disguises of *The Three Musicians*. The effect is rather of something awkward and discontinuous, which immediately sets the work against the conventional expectations that accompany the genre. For example, two drawings of the same subject (Plates 68 and 69), one heavily modelled and static, the other entirely linear and flowing, are both quite extreme in their way, but they nevertheless stay within the conventional expressive range of the genre.

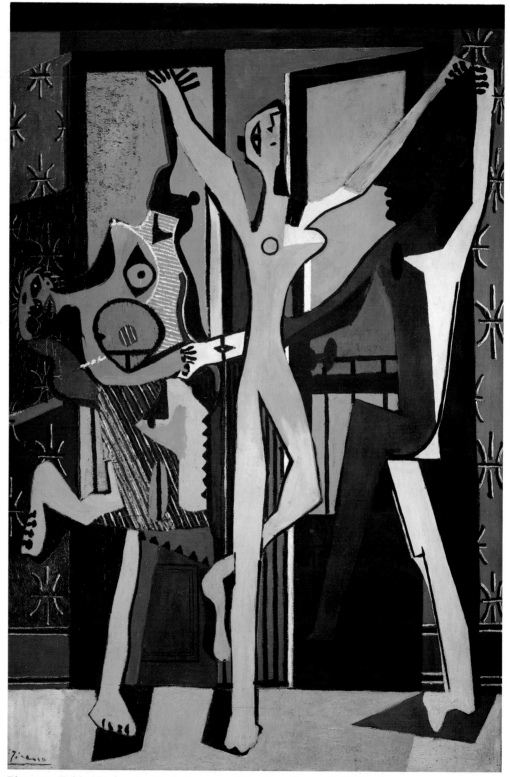

Plate 67 Pablo Picasso, *Les Trois Danseuses* (*The Three Dancers*), 1925, oil on canvas, 215 x 142 cm. Tate Gallery, London. © DACS, London, 1993.

Plate 69 Pablo Picasso, *Les Deux Danseuses* (*The Two Dancers*), 1919, pencil on paper, 31 x 24 cm. Collection of Mr and Mrs Tony Ganz. © DACS, London, 1993.

Plate 68 Pablo Picasso, *Les Trois Danseuses* (*The Three Dancers*), 1919, pencil on paper (three sheets pasted together), 37 x 33 cm. Musée Picasso, Paris.
Photo: Réunion des Musées Nationaux Documentation Photographique. © DACS, London, 1993.

In the painting, the three life-size figures are depicted in front of French windows that look out over a balcony into the distance. As so often in Picasso's work, the figures occupy most of the height and width of the picture and are contained tightly within the pictorial rectangle. However, each figure is depicted in a significantly different manner. The central dancer seems the most straightforward – a distorted, pink, 'cut out' figure with a circle for a breast and some schematic highlights on the left shoulder. The main oddity is the depiction of the face, the prim expression of which is upset by an incongruous vertical eye. This oddity can be accounted for if it is read instead as a manic grinning mouth on a sideways tilted head, in which case the overall expressive character of the figure is thrown into doubt.

This deliberate ambiguity produces a kind of domino effect throughout the entire picture. Just about every other element of the painting is similarly set up to produce two or more conflicting or discontinuous readings. For example, the white lines on the upper part of the figure on the left of the painting suggest in a highly schematic form the Classical cotton shift: the white line across her right shoulder is an echo of both the 1923 *Seated Woman in a Chemise* (Plate 63) and the 1905 *Girl in a Chemise*, each of which is shown with a strap falling from the same shoulder. At the same time, the diagonal coloured lines on the lower part of the body have been interpreted (on the basis of X-ray evidence) as being derived from a 1920s Charleston dress. The bisected blue oval on the dress may be read as a view of the balcony rail and sky in the background – or alternatively as a schematic rendering of the woman's vagina. Similarly, the circular blue area with the red circle may be seen as depicting the space between her arched back and arm or, possibly, as another

breast. And the figure's head is either a grimacing, compressed, full face, or its forehead may be seen as a benign crescent-moon profile. The figure on the right of the picture is made up of two sets of contrasting angular shapes (without a consistent linear contour), which has led some commentators to interpret it as male. It has been given both a large silhouetted head enclosed by the two raised arms (in which case the gaps between the schematic fingers may be read as equally schematic tufts of hair), and a much smaller profile within this head. The area around the figures is equally unstable. For example, the edge of the open door is highlighted in different places so that it becomes impossible to say whether it opens inwards or outwards; and the repeated pattern that borders each side of the painting is presumably derived from wallpaper, but also offers a visual echo of the three-figure grouping.

The setting up of visual ambiguities, paradoxes and discontinuities of this sort had been a feature of Picasso's output for many years. One effect of these devices is to make the viewer more conscious of his or her *active* part in the process of producing the representation. In *The Three Dancers*, the multiple uncertainties and discontinuities conscript the viewer into this work. In this largely 'frozen' composition, the dance itself is played out, perhaps, not in the implied movements of the figures, but in the movements of styles between the figures, and in the way the viewer is made to move between a series of unstable signs.

It is perhaps for these sorts of reason that the work so attracted Breton. It was reproduced in *La Révolution Surréaliste* no.4 of 15 July 1925 – the first time that the work had been seen outside Picasso's studio. The same issue of the magazine contained the first part of Breton's essay 'Surrealism and painting', which was illustrated exclusively with examples of Picasso's non-naturalistic work. For Breton, Picasso had assumed the 'immense responsibility' of

> so heightening his awareness of the treacherous nature of tangible entities that he dared break openly with them and, more particularly, with the facile connotations of their everyday appearance.
>
> (Breton, 'Surrealism and painting', *La Révolution Surréaliste*, no.4, p.28)

Later in the text Breton described what he saw as the main contribution the artist could make towards the advancement of the Surrealist revolution:

> The Revolution is the only cause on behalf of which I deem it worth while to summon the best men that I know. Painters share responsibility, with all others to whose formidable lot it has fallen, to make full use of their particular means of expression *to prevent the domination by the symbol of the thing signified.*
>
> (Breton, 'Surrealism and painting', *La Révolution Surréaliste*, no.6, p.30)

And in relation to Picasso's overtly naturalistic works:

> Nothing seems to me more entertaining or more appropriate than that, in order to dis-illusion the insufferable acolytes or to draw a sigh of relief from the beast of reaction, he should occasionally make a show of worshipping the idols he has burnt.
>
> (Breton, 'Surrealism and painting', *La Révolution Surréaliste*, no.4, p.29)

The first point here is that Breton describes the job of the artist in overtly political terms, although the kind of intervention he proposes for the painter takes place within the sphere of representation. By destabilizing the *conventional* relation between symbol and object, the artist partakes in the radical 'revision of real values' and furthers the 'grim struggle between the actual and the possible'. For Breton, this had been at the heart of Picasso's work for at least a decade and a half. And it continued to be, in spite of attempts to conscript his work into the service of reaction.

Contested space

At the beginning of the previous section, 'Common ground', I suggested that the relationship between the Purists and the emerging Surrealist groups *might* be described as one of parallel but separate development. The discussion that followed showed how that was not the case; rather I indicated how and to what extent these groups derived aspects of their terminology, ideas and programmes from common artistic and cultural sources. Within each of the two terms – 'l'esprit nouveau' and 'surréalisme' – were condensed large bundles of overt and insinuated associations, evasions, allegiances and oppositions. If the common cultural ancestry was, via the figures of Apollinaire and Picasso, the legacy of Cubism, then the marked differences between the two main groupings become both more striking and more in need of explanation. Should we be surprised that such disparate programmes could have evolved out of the same ancestry? Or should we expect such common ancestry to be a *precondition* for such opposed developments, in the sense that it provided the necessary cultural space over which such differences could be fought out?

Before looking more closely at these issues, it is important to note that the lines of demarcation that were being drawn up between groups were far less clear for some than they were for others. Certain artists – perhaps those who considered themselves first and foremost *modern* painters rather than, say, *Surrealist* painters or *Purist* painters – seemed somewhat more relaxed about what aspects of other art they might exploit, while recognizing that identification with one or another group remained a practical necessity. Further, there were those who became practised either at changing their allegiances from time to time, or at maintaining a presence in both camps simultaneously. For example, a kind of parallel or dual existence was maintained by Theo Van Doesburg who, while editing *De Stijl*, also produced a range of Dada-influenced work under the pseudonym of I.K. Bonsett. And Paul Dermée, one-time director of *L'Esprit Nouveau*, also produced his own Dada magazine, *Z*. In addition, there were numerous instances of writers associated with *Dada* or *Littérature* making occasional contributions to, for example, *L'Esprit Nouveau*, and vice versa.

Joan Miró

But the most interesting case is that of Miró. Clearly there are several aspects of his work that are properly associated with Surrealist interests – his highly idiosyncratic editing and veiling of subject-matter, the overtly playful and childlike mood of the pictures, the codified sexual themes and imagery, and so on. But at the same time, as we have noted, some technical characteristics of his work are largely unrelated to the preferred Surrealist technique of 'automatism'. Rather, he retained relatively conventional or conservative means of painting, even if he used them towards fairly unconventional ends. In certain respects his techniques – of abstracting from a naturalistic source through a series of studies – are reminiscent of the more formal schemes produced by, for example, Jeanneret or Gris. Furthermore, many of the subjects of his paintings from the mid-1920s – when he exhibited under the aegis of Surrealism – are drawn directly from the preferred themes of the Neo-Classicist painters. Most obvious among these are his *The Harlequins' Carnival* (Plate 70) and *Maternity* (Plate 72). A preliminary drawing for the former painting (Plate 71), which includes a grid for scaling up the work onto a larger canvas, shows how his playful composition conforms to a tightly planned pictorial structure. In the finished painting the central figure is placed in the exact centre of the rectangle; the figure on the left is exactly half-way between the centre and the left-hand edge of the painting; the left edge of the window balances this out by following the same line on the right-hand side of the picture; the floor line is a fraction below the centre of the work; the diagonal line formed by the left-hand harlequin's pipe and hat is on the diagonal between the top left and bottom right of the canvas; and so on.

Plate 70 Joan Miró, *Le Carnaval des arlequins* (*The Harlequins' Carnival*), 1924–25, oil on canvas, 66 x 93 cm. Albright Knox Art Gallery, Buffalo; Room of Contemporary Art Fund, 1940. © ADAGP, Paris and DACS, London, 1993.

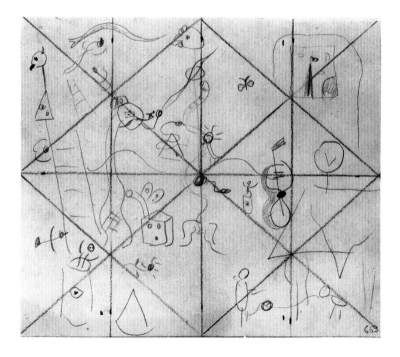

Plate 71 Joan Miró, sketch for *The Harlequins' Carnival*, 1924, charcoal and pencil on paper, 17 x 19 cm, from 1924–26 Notebooks. Fundació Joan Miró, Barcelona. Photo: F. Catala-Roca. © ADAGP, Paris and DACS, London, 1993.

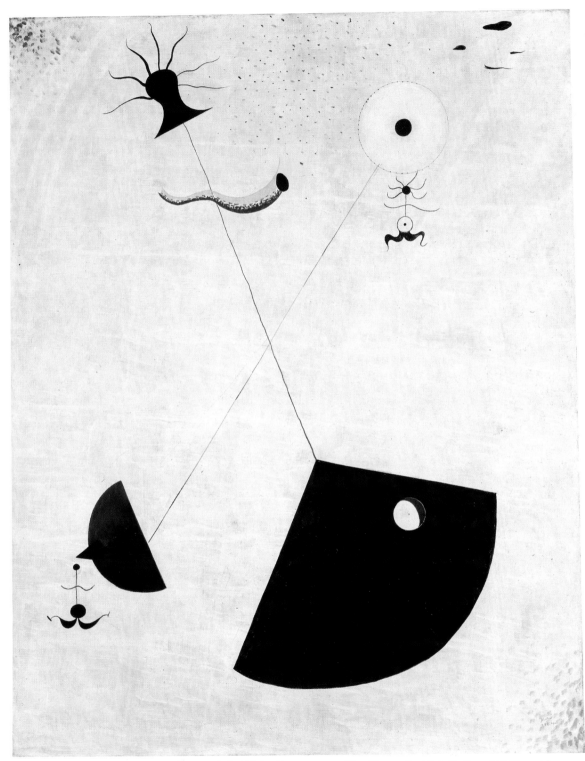

Plate 72 Joan Miró, *Maternité* (*Maternity*), 1924, oil on canvas, 91 x 74 cm. Scottish National Gallery of Modern Art. © ADAGP, Paris and DACS, London, 1993.

But in contrast to this Jeanneret-like pictorial structure, there is nothing remotely 'Classical' in what Miró does to the forms in his picture. Rather, his 'infantile' distortions are emphatically subjective as compared with the crypto-Platonic 'objective' reductions produced under the aegis of Purism or De Stijl. The exaggeration of features such as the central harlequin's right arm and hand probably owes more to Picasso's manipulation of a figure's size and scale. So, too, does his reduction of volumes either to flattened shapes or single lines, the inclusion in several paintings of lettering or parts of words, and the codification of certain motifs into ambiguous signs. What seems most Surrealist in Miró's paintings of this period is his development of a private vocabulary of signs, rooted in autobiography and redolent of sexual themes and private obsessions. For example, the sun motif in the window of *The Harlequins' Carnival* is often used also to represent a woman's vagina and pubic hair, and the ladder was identified by Miró as a symbol of escape and freedom.

In this and other works from the period, Miró's painting has something of the quality of Apollinaire's writing. In each a tension is maintained between a sense of 'order' and of 'disorder', between structure and improvisation. This tension seems tilted in Miró's work more in the direction of improvisation, but it would be a mistake to overlook the planning and formal structure that underpin the appearance of the paintings. And we should note that his works of the mid-1920s were being made at exactly the time when the two aspects of modernity were coming to be seen by others, not as complexly linked but as directly *opposed*.

Maternity, like *The Harlequins' Carnival*, takes as its point of departure a favourite 'call

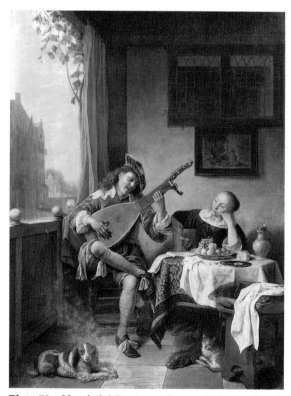

Plate 73 Hendrik Maertensz Sorgh, *De Luitspeler* (*The Lute Player*), 1661, oil on panel, 52 x 39 cm. Rijksmuseum, Amsterdam.

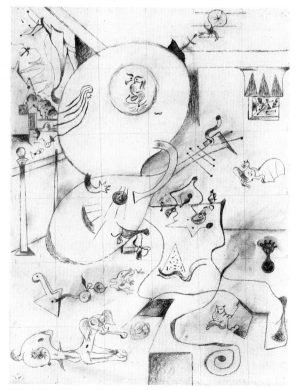

Plate 74 Joan Miró, sketch for *Dutch Interior 1*, 1928, charcoal and graphite pencil on paper, 63 x 47 cm. Collection, The Museum of Modern Art, New York; gift of the artist. © ADAGP, Paris and DACS, London, 1993.

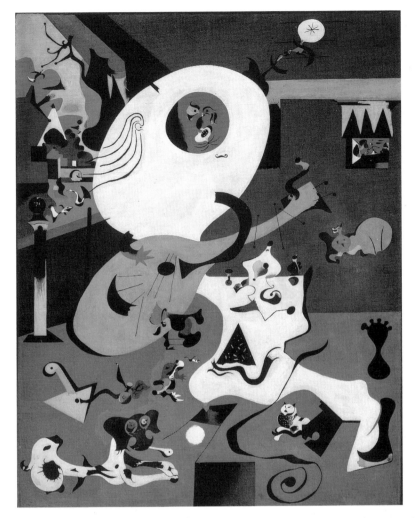

Plate 75 Joan Miró, *Intérieur hollandais* (*Dutch Interior 1*), 1928, oil on canvas, 92 x 73 cm. Collection, The Museum of Modern Art, New York; Mrs Simon Guggenheim Fund. © ADAGP, Paris and DACS, London, 1993.

to order' theme, but subjects it to particularly whimsical reductions of form and distortions of scale. The *Dutch Interior* paintings, which Miró executed in 1928 after a trip to The Netherlands, also take as their starting-point a group of naturalistic representations – specific seventeenth-century genre paintings by Sorgh, Jan Steen and Vermeer (for example, Plate 73). These are also 'modernized' by Miró through the flattening of form, elimination of detail and the intensification of colour – all in a highly personalized, semi-collage way. Again, the final paintings are slightly modified versions of earlier drawings (Plates 74 and 75). They are interesting in the context of this chapter because they also relate to the practice among Purist-oriented painters of updating examples of old-master paintings. Miró's version of Sorgh's *The Lute Player* might, for example, be compared with Gris's reworking of Corot's *Dreamer with a Mandolin* (Plate 15).

'This liberty and this order'

Miró seems to have been something of an exception among the younger generation of artists who came to prominence after the war. For, as we've seen in this chapter, different groups generally took *separate* aspects of Apollinaire's essays and commentaries to inform or legitimate their conceptions of the proper direction of contemporary art. There was a division within Apollinaire's text between the 'classics' – with their predicates of order, duty, good sense, and so on – and images of uncharted spaces and 'complex bonfires' in

the 'vast unknown' of the imagination, which he saw as inherited from the 'Romantics'. While Apollinaire attempts to unify this Classical/Romantic opposition within his one text – 'This liberty and this order which combine in the new spirit' ('L'esprit nouveau et les poètes', p.230) – he hardly resolved their contradictory characters into a working synthesis. Rather, it is the Classical that predominates, while modified to some extent by the Romantic:

> There is no more 'Wagnerism' in us, and the young authors have cast from them all the enchanting relics of the colossal romanticism of Germany and Wagner, as well as the rustic finery of the sort we all inherited from Jean Jacques Rousseau.
> (Apollinaire, 'L'esprit nouveau et les poètes', p.229)

What remained of the Romantic inheritance was 'a curiosity that pushes [the new spirit] to explore all the realms capable of furnishing literary material'.

As we saw earlier, a number of texts were written during and after the war in an attempt to define the proper character of French culture. The main thing that distinguishes Apollinaire's essay is that he retains at least *some* attachment to the ideas of Romanticism. Even as he does, a further division is established between the two traditions: while the Classical and its predicates are held to be embodied in the French 'spirit', so the Romantic and its predicates are classed by Apollinaire as German in origin. Silver has shown how many politicians, philosophers, writers and artists of the war and post-war period represented the conflict between Classicism and Romanticism as the cultural analogue of the military conflict between France and Germany. In a direct echo of Apollinaire, Paul Dermée wrote, also in 1918:

> The crazy stallion of our passions is firmly bridled. The reins are pulled up close ... the mastery of the self is the moral and aesthetic ideal of the classic epochs ...
> Rousseau, the adoration of nature, unbridled lyricism, the insurrection of slaves, the rights of people, the *vivre sa vie*, Bernstein, finally Bergson and his metaphysics of the *élan vital* are but one and the same attitude before the world: Romanticism.
> (quoted in Silver, *Esprit de Corps*, pp.104, 209)

For Fernand Léger the aim of French art was the flourishing of a 'society without frenzy, calm, ordered, knowing how to live naturally within the Beautiful without exclamation or Romanticism' (quoted in Silver, *Esprit de Corps*, p.371). Auguste Rodin, writing a short time before his death in 1917, emphasized the need to 'abandon all the chimeras coming from a sick mind and return to the true ancient tradition ... We don't need the German influence, but rather the most beautiful of classic traditions' (Silver, p.106). Maurice Denis, the writer and artist, listed 'revolutionary prejudices, the excesses of individualism, the taste for paradox, the fetishism of the unexpected or the original' as the 'blemishes of our art' and 'also the blemishes of French society' (Silver, p.233). In all these statements, the image of the good and the French is given definition largely through being set in stark contrast with that which it is *not*. It is a familiar rhetorical strategy that reached its most concise formulation in the essays of the right-wing philosopher and man of letters, Henri Massis. In his 'Defence of the West', published as late as 1926, he wrote:

> Under the cover of a Romanticism that proclaims the ruin of material culture, repudiates the worship of organization, and exalts the inward contemplation of the orient, it is her intellectual revenge on the classic west ... that Germany is seeking to prepare.
> (H. Massis, 'Defence of the West', p.235)

The text was written as a reply to Oswald Spengler's *Decline of the West*, 1917, which, according to Massis,

> flattered the German in his taste for the confused, the unfinished, the thing that is not, the novelty that has no name, the chaos from which anything may emerge, where the imagination may dream without end, where nothing possessed form or limit.
> (H. Massis, 'Defence of the West', p.235)

It is worth examining more closely the structure of this rhetorical opposition of 'Classical' and 'Romantic' values. We have already seen how a range of 'positive' predicates lines up under the general label 'Classical', providing rhetorical underpinning of much post-war French art, whether technically conservative or radical. If we also take the bundle of 'negative' terms grouped under the label 'Romantic' and lay them out as a series of oppositions, the right-hand column begins to look remarkably like a list of the predicates of Surrealism:

Classical	Romantic
France	Germany
Occident	Orient
order	chaos
reconstruction	revolution
civilization	barbarism
collective	individual
culture	nature
reason	emotion
discipline	caprice
synthesis	analysis
clarity	confusion

We have noted how Breton sought to conjoin Romanticism and 'revolution' in early Surrealist tracts; and while it would be too easy to say that, in repudiating the 'dream', Massis had psychoanalysis in mind, it is none the less revealing to see how Freud was represented in France during the war. In the preface to *La Psychoanalyse des nervoses et des psychoses* (1914), the first full-length account of psychoanalysis to be published in France, its authors warned:

> Freud's doctrine, which derives from Germanic philosophy and not, as has sometimes been said, from the French genius of Charcot, will find that moderation, the inspiration behind the Latin genius, is a very useful adversary.
>
> (Régis and Hesnard, quoted in D. Macey, 'Fragment of an analysis: Lacan in context', p.3)

Thus, if these kinds of example are taken as typical, there is an important sense in which the Surrealists were *not* the first either to introduce or to conjoin in a discourse on French culture the previously distinct themes of Romanticism, 'revolution' and psychoanalysis. During the war these terms had already been incorporated in such a discourse – in which they were seen as a malign influence on French culture and tradition. If my claim is correct, this may help to explain why the term 'revolution' was regularly and insistently flaunted by Surrealists in their early publications, when they appeared to have little political or theoretical understanding with which to back it up. It may also help to make sense of the Surrealists' theatrical and public championing of Germany and things Germanic, since to identify with Germany was – rhetorically or otherwise – to stand outside and in opposition to the political, moral and aesthetic mainstays of French culture. An attachment to 'Orientalism' was also a strong feature of early Surrealist rhetoric, and for essentially the same reasons. Several texts by Breton, Aragon, Artaud and others make appeals to Asia ('the citadel of every hope'), to Buddhism and to the Dalai Lama ('send us your illumination'). In some passages the Orient becomes their revolutionary salvation:

> Western world, you are condemned to death. We are Europe's defeatists ... Let the Orient, your terror, answer our voice at last! We shall awaken everywhere the seeds of confusion and discomfort. We are the mind's agitators ... Rise, thousand-armed India, great legendary Brahma. It is your turn Egypt ... Rise, O world!
>
> (quoted in Nadeau, *The History of Surrealism*, p.121)

Plate 76 *Le Monde au temps des Surréalistes* (*The World in the Time of the Surrealists*), *Variétés: revue mensuelle illustrée de l'esprit contemporain*, Brussels, Éditions Variétés, 1929, pp.26–27, offset, printed in black, page size 24 x 17 cm. Collection, The Museum of Modern Art Library, New York.

It ought to be noted that this apocalyptic vision of revolutionary salvation from the East did not go uncontested within Surrealism, and in fact generated the first 'crisis' of the group, a dispute during 1925–26 between Breton and Pierre Naville over the conceptualization of revolution. Against Breton's 'abusive use of the Orient myth', Naville concluded with a direct, historical-materialist argument:

> Wages are a material necessity by which three-quarters of the world's population are bound, independent of the moral conceptions of the so-called Orientals or Occidentals. Under the rod of capital, both are exploited …
> (quoted in Nadeau, *The History of Surrealism*, p.141)

As late as 1929, aspects of the rhetoric of Orientalism and Germanism are still visible in the output of Surrealism. In *The World in the Time of the Surrealists* (Plate 76), for example, Western Europe is made up of only three countries, Ireland, Germany and Austria-Hungary, and two cities, Paris (situated in Germany) and Constantinople. The rest of Europe is designated 'Russia', with China and Tibet given prominent status. As elsewhere, this polemical pro-Orientalism gets mixed with a more politically-based anti-colonialism, the latter being shown in the map through the reorganization of the sizes of various countries: Ireland overwhelms a dot to its right that represents the British mainland, and the continent of North America is made up exclusively of Alaska, Labrador and Mexico.

Given this rhetorical division of the political, intellectual, moral and aesthetic world, it is possible to look at the artistic output of Surrealism from a slightly modified perspective. As we've seen, the schematic and simplified still-lives of Jeanneret and Ozenfant, and the equally schematic Cubism and naturalism of Gris and Severini, were offered as embodiments of Classical, French clarity and synthesis. It is likely, therefore, that a picture or

a piece of writing in which degrees of randomness were exploited and emphasized (and through which unclear, ambiguous and paradoxical images were generated) would have read not simply as 'irrational' in some general sense but, in its departure from the preferred cultural values and artistic techniques, as anti-'call to order' – and thus as anti-nationalistic, or even anti-French. For example, the passage above in which Massis described the 'German ... taste for the confused, the unfinished, the thing that is not, the novelty that has no name, the chaos from which anything may emerge, where the imagination may dream without end...' might also serve as a strikingly precise description of an 'automatic drawing' by Masson, or a painting such as *The Horde* by Ernst (Plate 46). And, as we noted earlier, it is these technical aspects of Surrealist production, at least as much as its often overt sexual themes, that were seen to embody and convey its 'revolutionary' aims. So it seems that something as simple as a wavy line could, under very particular circumstances, carry in it the threat of revolution.

References

ADES, D., *Dada–Constructivism*, exhibition catalogue, London, Annely Juda Fine Art, 1984.

ADES, D., *Dada and Surrealism Reviewed*, exhibition catalogue, London, Arts Council of Great Britain, 1978.

APOLLINAIRE, G., 'L'esprit nouveau et les poètes', 1918, in R. Shattuck (ed.), *Selected Writings of Guillaume Apollinaire*, New York, New Directions, 1971 (an edited version is reprinted in Harrison and Wood, *Art in Theory, 1900–1990*, section III.a.2).

APOLLINAIRE, G., programme for *Les Mamelles de Tirésias*, reprinted in *Sic: édition complète*, p.4, Paris, Éditions Jean-Michel Place, 1980 (facsimile reprint).

ARP, J., 'Dadaland', in L.R. Lippard (ed.), *Dadas on Art*, New Jersey, Prentice-Hall, 1971.

Bauhaus, exhibition catalogue, London, Royal Academy of Arts, 1968.

BRETON, A., 'Surrealism and painting', *La Révolution Surréaliste*, no.4, pp.26–30, 1925, and no.6, pp.30–32, 1926 (an edited version of another translation is reprinted in Harrison and Wood, *Art in Theory, 1900–1990*, section IV.c.4).

BRETON, A., 'Les champs magnétiques', 1919, translated by D. Gascoyne, London, Atlas Press, 1985.

BRETON, A., 'Manifesto of Surrealism' in *Manifestos of Surrealism*, translated by R. Seaver and H.R. Lane, Michigan, Ann Arbor Press, 1972 (an edited version of The First Surrealist Manifesto is reprinted in Harrison and Wood, *Art in Theory, 1900–1990*, section IV.c.2).

BUCHLOH, B., 'Figures of authority, ciphers of regression' in B. Buchloh, S. Guilbaut and D. Solkin (eds), *Modernism and Modernity*, Vancouver Conference Papers, Nova Scotia College of Art and Design, 1981 (an edited version is reprinted in F. Frascina and J. Harris (eds), *Art in Modern Culture: An Anthology of Critical Texts*, London, Phaidon, 1992).

CAMFIELD, W., *Francis Picabia: His Art, Life and Times*, New Jersey, Princeton University Press, 1979.

Dada: Zurich–Paris, 1916–22, Paris, Éditions Jean-Michel Place, 1981 (facsimile reprint).

ERNST, M., *La Femme 100 têtes*, 1929, translated and republished as *The Hundred Headless Woman*, New York, George Braziller, 1981.

ERNST, M., *Beyond Painting*, translated by D. Tanning, New York, Wittenborn and Schultz, 1948 (first published as 'Au-delà de la peinture', *Cahiers d'Art*, vol.XI, nos 6–7, 1936).

Max Ernst: A Retrospective, exhibition catalogue, W. Spies (ed.), London, Tate Gallery, 1991.

L'Esprit Nouveau, 1920–25, vols 1–28, New York, Da Capo Press, 1968 (facsimile reprint).

GASCOYNE, D., *A Short Survey of Surrealism*, London, Macdonald, 1935.

GEE, M., *Dealers, Critics and Collectors of Modern Painting: Aspects of the Parisian Art Market Between 1910 and 1930*, Ph.D. thesis, University of London, 1977.

GREEN, C., *Cubism and its Enemies*, New Haven and London, Yale University Press, 1987.

HARRISON, C. and WOOD, P. (eds), *Art in Theory, 1900–1990*, Oxford, Blackwell, 1992.

HASLAM, M., *The Real World of the Surrealists*, New York, Galley Press, 1978.

HÜLSENBECK, R., 'Dada forward' in L.R. Lippard (ed.), *Dadas on Art*, New Jersey, Prentice-Hall, 1971 (an edited version is reprinted in Harrison and Wood, *Art in Theory, 1900–1990*, section III.b.6).

JANCO, M., 'Dada at two speeds' in L.R. Lippard (ed.), *Dadas on Art*, New Jersey, Prentice-Hall, 1971.

JEANNERET, C.-E. and OZENFANT, A., 'Purism', 1920, in R. Herbert (ed.), *Modern Artists on Art*, New Jersey, Prentice-Hall, 1964 (an edited version is reprinted in Harrison and Wood, *Art in Theory, 1900–1990*, section III.a.7).

LE CORBUSIER, *Towards a New Architecture*, London, Architectural Press, 1927 (published in 1923 as *Vers une Architecture*).

Littérature, Paris, Éditions Jean-Michel Place, 1978 (facsimile reprint).

Littérature: nouvelle série, Paris, Éditions Jean-Michel Place, 1978 (facsimile reprint).

MACEY, D., 'Fragment of an analysis: Lacan in context', *Radical Philosophy*, vol.35, autumn 1983.

MASSIS, H., 'Defence of the West', *New Criterion*, vol.4, no.2, 1926, pp.224–43.

MIRÓ, J., *Catalan Notebooks*, London/Geneva, Academy Editions/Skira, 1977.

NADEAU, M., *The History of Surrealism*, London, Jonathan Cape, 1968.

Nord-Sud, Paris, Éditions Jean-Michel Place, 1980 (facsimile reprint).

On Classic Ground: Picasso, Léger, de Chirico and the New Classicism, 1910–1930, exhibition catalogue, London, Tate Gallery, 1990.

PICABIA, F., 'Picabia dit dans *Littérature*', *Littérature: nouvelle série*, no.4, p.18.

La Révolution Surréaliste: collection complète, Paris, Éditions Jean-Michel Place, 1975 (facsimile reprint).

RICHTER, H., *Dada: Art and Anti-art*, London, Thames and Hudson, 1965.

ROSEMONT, F., *André Breton and the First Principles of Surrealism*, London, Pluto Press, 1978.

ROSEMONT, F. (ed.), *André Breton: What is Surrealism? Selected Writings*, London, Pluto Press, 1978.

RUBIN, W., *Dada and Surrealist Art*, London, Thames and Hudson, 1969.

SALMON, A., 'Picasso' in M. McCully (ed.), *A Picasso Anthology: Documents, Criticism, Reminiscences*, London, Arts Council of Great Britain, 1981.

SHEPHERD, R. (ed.), *Dada: Studies in a Movement*, Chalfont St Giles, Alpha Academic, 1979.

SILVER, K.E., 'Purism: straightening up after the Great War', *Artforum*, vol.XV, no.7, 1977, pp.56–63.

SILVER, K.E., *Esprit de Corps: The Art of the Parisian Avant-Garde and the First World War, 1914–1925*, London, Thames and Hudson, 1989.

Le Surréalisme au service de la Révolution: édition complète, Paris, Éditions Jean-Michel Place, 1976 (facsimile reprint).

TZARA, T., 'Dada Manifesto 1918' in L.R. Lippard (ed.), *Dadas on Art*, New Jersey, Prentice-Hall, 1971 (an edited version is reprinted in Harrison and Wood, *Art in Theory, 1900–1990*, section III.b.3).

TZARA, T., *Seven Dada Manifestos and Lampisteries*, translated by B. Wright, London, John Calder, 1977.

VAN DOESBURG, T., 'Report of the De Stijl group', *De Stijl*, vol.5, no.4, 1921.

VAN DOESBURG, T., *Principles of Neo-Plastic Art*, 1925, translated by J. Seligman, London, Lund Humphries, 1969 (an edited version is reprinted in Harrison and Wood, *Art in Theory, 1900–1990*, section III.c.4).

VAN DOESBURG, T. (ed.), *De Stijl*, vols 1–5, 1917–19 (the first De Stijl manifesto is reprinted in Harrison and Wood, *Art in Theory, 1900–1990*, section III.c.3).

WINGLER, H.M., *The Bauhaus: Weimar, Dessau, Berlin, Chicago*, translated by W. Jabs and B. Gilbert, Cambridge Massachusetts, and London, MIT Press, 1969.

CHAPTER 2
THE LANGUAGE OF CONSTRUCTION

by Briony Fer

Introduction

In 1924 two metal constructions were illustrated side by side in *L'Esprit Nouveau*, the Purist magazine that we discussed in Chapter 1. One was by the Russian Constructivist Konstantin Medunetsky (Plate 77), the other by László Moholy-Nagy (Plate 78), a Hungarian artist then working at the Weimar Bauhaus. No title or context was given for either of the works, but the juxtaposition suggested that they had something in common.

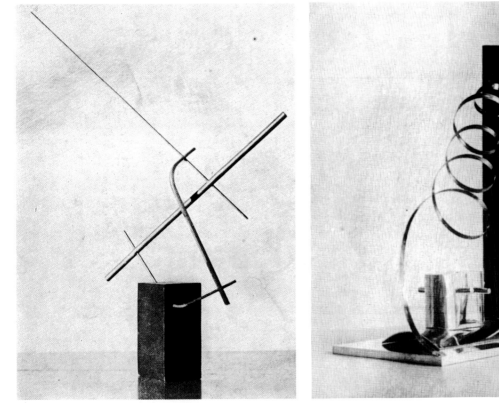

Plate 77 Konstantin Medunetsky, construction illustrated (untitled) in *L'Esprit Nouveau*, no.21, 1924. Da Capo Press Reprint, 1968, New York.

Plate 78 László Moholy-Nagy, construction illustrated (untitled) in *L'Esprit Nouveau*, no.21, 1924. Da Capo Press Reprint, 1968, New York.

That common ground is my starting-point. For here we have two works produced in quite different circumstances but that were thought to share something significant in their appearance – in the way in which they were put together, in the materials they were made of and in their geometric form. The connection between them was not simply that they were two pieces of sculpture, but two objects of *construction*. And that idea – of the modern art work *as* construction – is one of the issues I'll be discussing. For 'construction' was a loaded term, and it pervaded the language of art in the inter-war period. It implied a particular view of modernity, not only in terms of what was considered 'modern' in art, but of how modern art related to a rationalized, modern culture.

Medunetsky's work is now lost, but it may have been made of more than one metal, and even painted in parts, like his *Spatial Construction* (Plate 80) of about the same date. Moholy-Nagy also used metal, attaching a spiral to a vertical plane (Plate 79 shows this more clearly). Although both artists arranged and shaped the metal elements, they made no attempt to mask the fact that these were modern industrial materials: Medunetsky used metal rods, which he either left straight or bent at an angle; Moholy-Nagy used nickel-plated iron. These were materials that did not conventionally belong to the realm of art, but that did conventionally belong to the realm of industrial production. What each artist made with these materials was an abstract construction concerned with basic formal elements, the line or the spiral, in space. This begs the question, to which I shall return, of what marked these works out as constructions, and why certain types of material were considered appropriate to 'construction', while others were not.

L'Esprit Nouveau ('the new spirit') claimed these works as the products of *un esprit de construction* ('a spirit of construction'), where art was harnessed to the larger processes of modernization – industry, science and technology. Whatever their differences, they shared certain features in that they, like the other art works and industrial products illustrated in the magazine, expressed the 'constructive' as the ideal form of the modern; their formal similarities were more significant and of greater value than the differences in the material and ideological conditions in which they were made. What mattered in this ideal form of the modern were order, clarity, discipline, control and the Classical, which won out over the negative terms of the decorative and the ornamental, the fugitive and the incidental. David Batchelor discussed in Chapter 1 how the Purist aesthetic was bound to the rhetoric of the post-war 'call to order' and the French tradition. Yet the language of construction was by no means circumscribed by this rhetoric, or by Paris. And my aim in this chapter is to consider why the language of construction was so compelling to a much wider range of artists, working in radically differing social and political contexts.

For example, although Russia, Germany and the Austro-Hungarian Empire had all experienced revolutions at the end of the First World War, the results of these upheavals differed considerably. Following the successful Bolshevik Revolution of 1917, Lenin drew Russia out of the war, having won victory on the platform of 'peace, land and bread'. The German revolution that followed almost a year later in November 1918 was defeated, but it brought down the Kaiser and put in place, not Communism – as many on the German Left, as well as in Moscow, had hoped – but an unstable social democracy. In both countries, the overthrow of authoritarian rulers was accompanied by acute problems of recovery from the war; and in Russia, the dismantling of the Tsarist autocracy and the transformation to Communism entailed massive social and political upheaval.

For many artists on the Left in the 1920s, including Moholy-Nagy, the single most significant reference point was no longer the Parisian avant-garde but the revolutionary connotations of construction, with revolutionary Russia as the new symbol of advanced culture. Yet what Moholy-Nagy understood by construction was in practice at odds with what it meant to Medunetsky and the Russian Constructivists themselves. Despite the ground shared and the similarity of appearance, Moholy-Nagy's *Nickel Construction* was still produced as an *art* object, whereas Medunetsky's, ostensibly at least, was not.

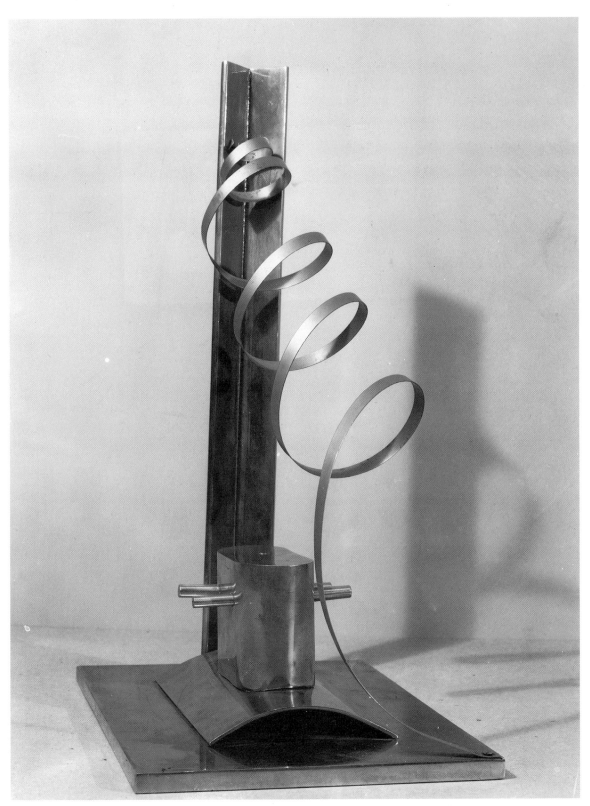

Plate 79 László Moholy-Nagy, *Nickel Construction*, 1921, nickel-plated iron, welded, 36 x 18 x 24 cm. Collection, The Museum of Modern Art, New York; gift of Mrs Sibyl Moholy-Nagy.

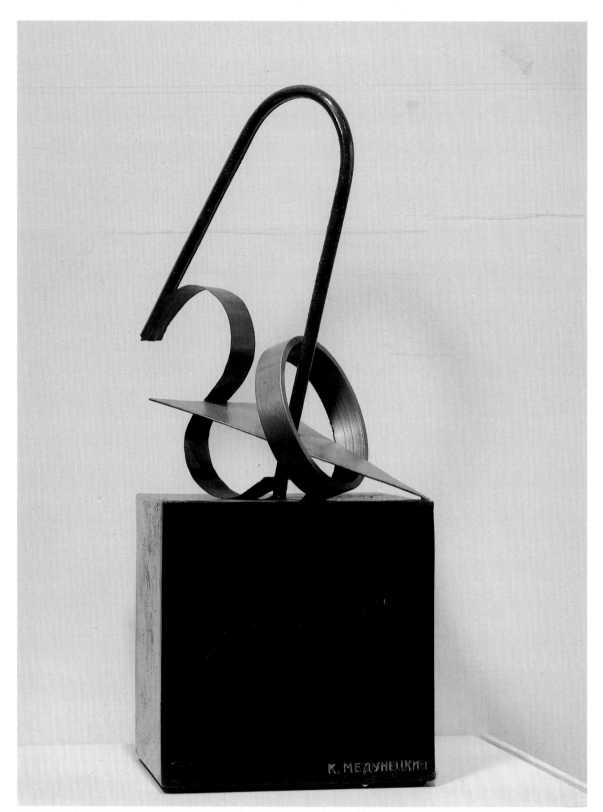

Plate 80 Konstantin Medunetsky, *Spatial Construction*, 1920, tin, brass, iron and aluminium, 45 cm high. Yale University Art Gallery, New Haven; gift of Collection Société Anonyme.

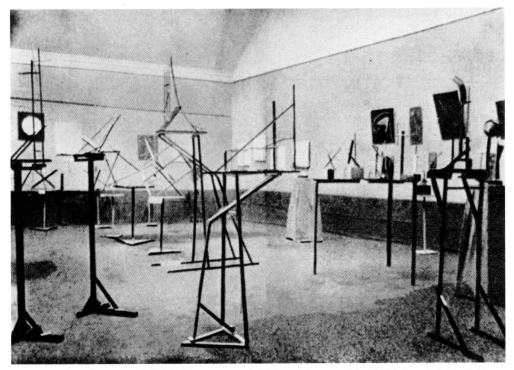

Plate 81 Installation of the third OBMOKhU exhibition, Moscow, May 1921. 'Veshch' no.1/2, 1922, British Library Cup.4085.g.25. Reproduced by permission of the British Library Board.

Medunetsky's constructions had been exhibited in Moscow in 1921 at an exhibition of so-called 'laboratory work'. This was the third exhibition of the OBMOKhU group, the Society of Young Artists (see Plate 81). The photograph appears to show an installation of an exhibition of art works; yet the rationale behind the group show was that these pieces were 'experiments' in the scientific sense. They were not shown simply as art objects, but as work in progress that did not fit into the category of 'art'; they may have been exhibited *like* art works, but they were not to be read *as* art works. Aiming to show 'practical ways of working and using new materials' (Vladimir Stenberg, quoted in C. Lodder, *Russian Constructivism*, p.96), the OBMOKhU group used industrial materials to make 'constructions' rather than 'art objects' (by which they meant easel painting and figurative sculpture).

In this context, Medunetsky's work in three dimensions was an experiment on the basic material and spatial elements of construction. The premise behind it and the other works in the exhibition was that a rational, calculable system of construction could be investigated scientifically, and that the principles established could then be applied in utilitarian work, in what we would now call design. This investigation was considered specialized work, whereby artists could become involved in the processes of production under the transformed conditions of the new society. After the Revolution of 1917, art had increasingly come to be questioned as a viable category; easel art was seen by many avant-garde artists and theorists as the product of individualist, bourgeois societies, and inappropriate to a society organized on collective, proletarian bases. In March 1921, the First Working Group of Constructivists had produced a programme outlining their strategy, in which they identified their aim 'of achieving the communistic expression of material structures' ('The Programme of the First Working Group of Constructivists', 1921, quoted in Lodder, *Russian Constructivism*, p.94). The basic structural tenets established in 'laboratory work' would be applied to produce useful goods; and this work in

'intellectual and material production' would play a vital part in the construction of communist culture.

Moholy-Nagy, as I've said, took a somewhat different approach. He did not seek to abandon 'art' altogether in the way that some of the Russians did, but instead advocated a new unity between art and technology. He saw himself as part of a far wider 'constructive' movement, in terms that were loosely compatible with the way in which his work was represented in *L'Esprit Nouveau*. In *The Book of New Artists* that he wrote with Lajos Kassák in 1922, he juxtaposed one of his own works with a construction by the Russian Constructivist Aleksandr Rodchenko and a photograph of the OBMOKhU exhibition (Plate 82). Though his work was identified with the Russian Constructivists, Moholy-Nagy worked with different resources – with a Constructivist vocabulary but also with elements of a Dadaist mistrust of the authentic aesthetic object. Although still within the realm of art, *Nickel Construction* seems fairly close to the edge of how far art could go in the direction of technology without losing its identity completely. This aspect is accentuated if we look at Moholy-Nagy's work in the context of Theo Van Doesburg's Dada magazine *Mécano*, where it had been entitled *Nickel-Plastik* (*Nickel Sculpture*) (Plate 83). Here it is the incongruous figure of the spiral that assumes priority, rather than the 'constructive'

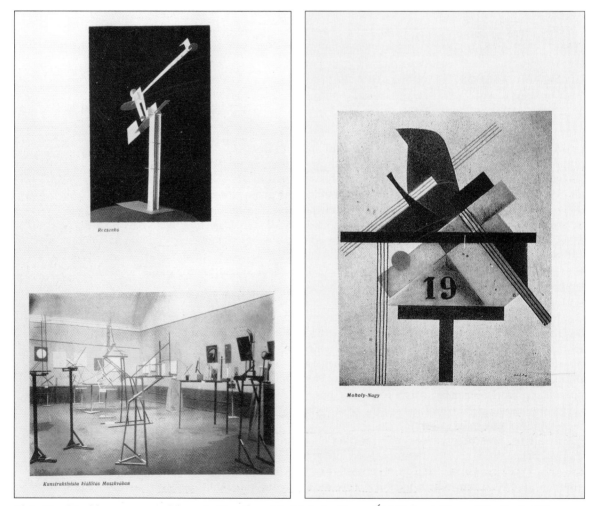

Plate 82 Double-page spread from L. Kassák and L. Moholy-Nagy, *Új Müvészek könyve* (*The Book of New Artists*), 1922, showing (left) work by Aleksandr Rodchenko and the third OBMOKhU exhibition, and (right) a work by László Moholy-Nagy. National Art Library, Victoria and Albert Museum, London.

Plate 83 László Moholy-Nagy, *Nickel-Plastik,* and Serge Charchoune, *Cigarette Dada,* in an unfolded spread of four pages from *Mécano,* no.Blau, 1922. Bibliothèque Nationale, Paris.

relationship of art and technology that would be emphasized in *L'Esprit Nouveau.* In this number of *Mécano* of 1922, Raoul Hausmann's poem of jumbled sounds and letters tumbles down the spiral of Serge Charchoune's drawing, *Cigarette Dada,* formally echoing the spiral of Moholy-Nagy's construction.

Plate 84 A bank vault, *L'Esprit Nouveau*, no.21, 1924. Da Capo Press Reprint, 1968, New York.

Plate 85 Dental equipment, *L'Esprit Nouveau*, no.21, 1924. Da Capo Press Reprint, 1968, New York.

In *L'Esprit Nouveau*, on the other hand, Medunetsky's and Moholy-Nagy's constructions appeared as part of a series of illustrations that included a safe door of a bank vault (Plate 84) and Purist paintings by Charles-Édouard Jeanneret (Le Corbusier) and Amédée Ozenfant. Although the links were only implicit, these images followed on from Ozenfant and Jeanneret's article 'Formation de l'optique moderne' ('Formation of a modern optics'), where analogies were drawn between Roneo filing cabinets, dental equipment (Plate 85) and modern works of art. The selection of images may appear highly idiosyncratic, but it corresponded to a view of modernity exemplified in a wide range of artefacts. Analogies operated on a number of levels – between formally similar types of object, and more broadly between modern utilitarian objects and modern works of art. Where contrast was intended, it was spelled out clearly. For example, the geometric typewritten form, which corresponds to 'our natural functions', was contrasted with the (disparaged) handwritten 'tortures de l'informe' ('the tortures of formlessness') (Plate 86). Fear of the 'informe' or 'formless' was the constant underside of the preoccupation with construction. The comparison was made on the assumption that human beings function rationally, like a

La machine à écrire elle-même affranchit notre œil des tortures de l'informe ; la géométrie de la typographie se conforme mieux à nos fonctions naturelles.

Plate 86 Examples of handwritten and typewritten script in A. Ozenfant and C.-E. Jeanneret, 'Formation de l'optique moderne', *L'Esprit Nouveau*, no.21, 1924. Da Capo Press Reprint, 1968, New York.

machine; the typewriter is a kind of prosthetic object that improves on the human hand as an instrument for writing; the 'informe' is tortuous and needs to be suppressed, because it does not correspond to use.

It has been suggested that only the aesthetic dimension, the formal trappings, of Russian Constructivism were assimilated in the West, and not its utilitarian base – in short, that Constructivism was understood wrongly. The way in which Medunetsky's work was almost casually placed next to Moholy-Nagy's in *L'Esprit Nouveau* appears to confirm this, by suggestion at least. The juxtaposition seems to confer the status of an *art* object equally on both works, and to show them as examples of a 'constructive' tendency that extended across national boundaries. Certainly the intention was to identify a common purpose, and to this end Le Corbusier in particular made many contacts with artists and commentators outside France and gave their work exposure in *L'Esprit Nouveau*. The magazine was to be a showcase of new work from home and abroad, and not simply a consolidation of a French tradition. Notably, it published articles on the changes in revolutionary Russia at a time when, in France in particular, such information was hard to come by. Simply to say that Russian Constructivism was understood 'wrongly' does not really help us to explain the powerful affinity that was perceived between the works as 'constructions'. Nor, I think, should we assume too hastily that the Constructivist rejection of 'art' *per se* was straightforward, when it may be that the status of objects as 'laboratory work' was at least ambiguous. And while *L'Esprit Nouveau* did not reject art in favour of utilitarian work, it celebrated – and made central to its aesthetic – utilitarian, everyday artefacts. It is also doubtful that the Constructivist works produced in the West, such as Moholy-Nagy's, were 'simply' art objects, if that is to imply that their status is entirely secure. Moholy-Nagy may have produced his work in different circumstances, but it may also have fitted uneasily with established ideas as to what an art object should be and how it related to other utilitarian objects.

Some real or imagined relationship between 'art' and 'utility' seems to be at stake in all these examples, despite the diverse ways in which the relationship was proposed. More generally, construction can be seen as a redefinition of the art object in these symbolic terms, but in ways that varied according to context. The question we shall consider here is why the language of construction seemed so powerful, and could translate into different cultures – although, as with all translations, its meaning was transformed in the process. Why was geometric form considered not only appropriate but such a potent expression of the modern? These questions hinge on the relations between 'high' and 'mass' culture, utility and decoration, the art object and the manufactured object, geometric form and 'formlessness', pure form and the capacity of forms and materials to trigger associations. I begin by looking at Russian Constructivism and the various meanings of 'construction' current in the years that followed the Bolshevik Revolution of 1917, when the language of construction was identified with revolutionary change. I go on to consider 'construction' in the broader European context as the site of a mythology of the modern, in which ideas of technological change and social liberation were interwoven with a belief in the power of geometric form, and in which a geometric, abstract art was part of a Utopian project.

Russian Constructivism

Art as construction

The specific character of the Russian context can be at least partly gauged by the ambiguous status of the objects shown at the third OBMOKhU exhibition. Another photograph of the installation (Plate 87) shows a little more clearly how the objects were exhibited. There were works hung on the walls, free-standing constructions, and constructions suspended on wires from the ceiling. One of the free-standing constructions was Georgii Stenberg's *Construction for a Spatial Structure No.11* (Plate 88) made of iron, glass and wood; the metal elements were assembled with bolts and welded: it was a construction made in modern industrial materials using industrial processes of assembly. Like the works by Medunetsky we have already looked at, it was not conceived of as a piece of sculpture; yet neither was it an industrial product. It had been exhibited a few months before at a show called The Constructivists in January 1921, also in Moscow. This seems to have been the first appearance of the term 'constructivist', and the artists involved, Medunetsky and the two Stenberg brothers, declared 'art and its priests outlawed' (quoted in A. Nakov, *2 Stenberg 2*, p.66). Constructivists did not see themselves as artists in the conventional sense, and the objects they produced were not to be construed as art. In March they signed The Programme of the First Working Group of Constructivists, joining with the Constructivist group focused around Rodchenko and Varvara Stepanova.

Although Rodchenko had not previously been part of the OBMOKhU group, he participated in their third exhibition, where he showed a series of hanging constructions including *Oval Hanging Construction No.12* (Plate 89). Rodchenko had begun this series well before the decisive commitment to utilitarian work was declared in the programme,

Plate 87 Installation of the third OBMOKhU exhibition, Moscow, May 1921. 'Veshch' no.1/2, 1922, British Library Cup.4085.g.25. Reproduced by permission of the British Library Board.

Plate 88 Georgii Stenberg, *Construction for a Spatial Structure No.11*, 1920, iron, glass and wood. Dimensions and present whereabouts unknown. Photograph by courtesy of Dr Christina Lodder.

but it was included in the exhibition as 'laboratory work'. That is, after it had been made it came to be thought of as 'research'. These shifts are never cut and dried, but it is significant that Rodchenko *produced* this construction as an art work, and *exhibited* it as a piece of research. The practice of art came to be characterized by, and even *became*, a continual process of re-definition. This re-definition of even recently produced work according to shifting categories of art, research and production shows the insecure and transitional character of these works and of the world in which they were made. They were open to reinterpretation even by those who had made them: something that may have been made as an art object could cease to be seen as one. (And they were open to further reinterpretation: later on, under a different set of pressures, Rodchenko looked back critically and saw all these 'experiments' as, once again, art.)

These shifts indicated how ambivalent the work was – an ambivalence that can apply, I think, to the exhibition as a whole, in which, as we've seen, works were shown *like* art objects but not strictly speaking *as* art objects. It was not a matter of artists simply changing their minds, but of genuine contradictions in the transition of one form of practice to another. In the circumstances, contradictions were inevitable and even necessary. Constructivists refused the category 'art', yet used an art exhibition as a forum; they rejected art as a viable practice, yet set themselves up as artistic specialists, working in the laboratory. Any set of refusals and negations only makes sense through what is refused and negated. Although 'laboratory work' was not produced as art, it still worked with and against the available conventions, just as Medunetsky used a fairly conventional plinth for his construction (Plate 77), but pierced it with the metal rod, invading the secure, separate status of the base of a sculpture. This ambivalence demonstrates the problematic status of the work at this period (both as art and as 'not art').

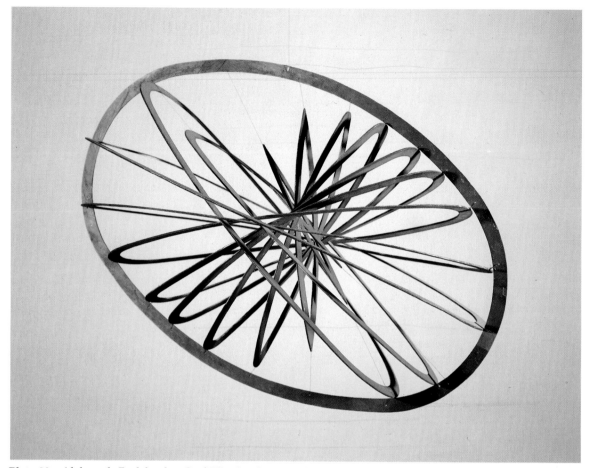

Plate 89 Aleksandr Rodchenko, *Oval Hanging Construction No.12*, *c.*1920, plywood, open construction partially painted with aluminium paint, and wire, 61 x 84 x 47 cm. OBMOKhU 3 Collection, The Museum of Modern Art, New York; acquisition made possible through the efforts of George and Zinaida Costakis, and through the Nate B. and Frances Spingold, Matthew H. and Erna Futter and Enid A. Haupt Funds.

The constructions exhibited at the OBMOKhU show related back to work done before the Revolution – for instance, to Vladimir Tatlin's use of industrial materials such as zinc and lead in his reliefs and counter-reliefs (Plate 90). But the conditions underpinning exhibitions had changed, with the loss of a private market for art after 1917. Artists who had previously sold to private collectors now relied on other means of economic support, working in arts administration in the new ministry of culture, NARKOMPROS, and in the new art schools set up in the reorganization after the Revolution. Avant-garde artists moved from the margins of Bohemia to play central roles in the reorganization of culture. Their previous work on abstract form and materials was taken as the basis for a new kind of practice that would be relevant to a new society. After the Revolution, artists also became involved in all sorts of agitational and propaganda work – for example, designing posters, street decorations for revolutionary festivals, and street kiosks. This work was produced during the period of civil war that followed the Revolution and lasted until 1921 when the White Russian Forces were finally quashed. 'Laboratory work' was harnessed to production from 1921, when Constructivists directed their work on the material and formal elements of construction into utilitarian projects. This shift was not simply the inevitable outcome of the crisis of art and the insecure status of painting. For, however much the move to produce useful goods appears a logical conclusion to the problem of

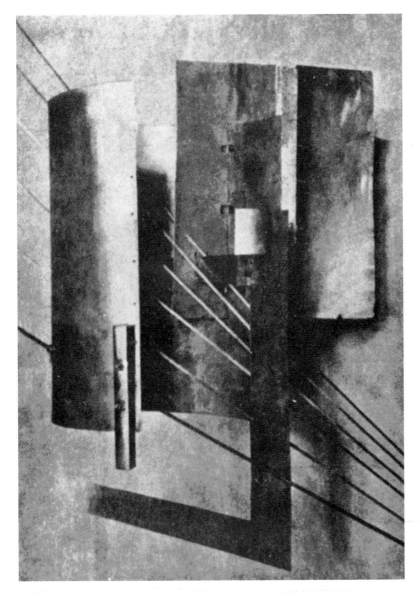

Plate 90 Vladimir Tatlin, relief from Tramway V exhibition catalogue, organized by Ivan Puni/Jean Pougny, March 1915, in Petrograd. Reproduced from J. Pougny, *Catalogue de l'œuvre*, H. Berninger (ed.), Tübingen, Editions Ernst Wasmuth, 1972.

the artist's role after the Revolution, it was only after 1921, when there was some recovery in industrial output to feel part of, that an involvement with production became feasible. It coincided with what many saw as the betrayal of the aims of the revolution: with the New Economic Policy of 1921, Lenin introduced some private enterprise into the devastated economy, producing a renewed demand for consumer goods.

The interval characterized as 'laboratory work', though fairly short-lived, draws attention to some of the problematic and shifting aspects of art as construction that I want to pursue, and to 'construction' as a multi-faceted term. So far, I have looked at 'construction' in three-dimensional works. 'To construct' means to put together, to build, to assemble; and work in three dimensions might seem most obviously to use a process of construction. As we've seen, in Stenberg's *Construction for a Spatial Structure No.11* (Plate 88), iron components are literally bolted and welded together using industrial processes. Yet these techniques were displaced from their normal usage and assimilated into the idea of artistic construction. The work was listed in the Constructivists' catalogue as *Konstruktsiya prostranstvenovo sooruzheniya 4*. Stenberg used the term *konstruktsiya*, a

technical term derived from building; *prostranstvenovo* means 'spatial'; *sooruzheniya*, translated as 'apparatus', was a technical term for a system or structure. The term 'artistic construction' (*khudozhestvennoe konstruirovanie*) was also used to apply the technical aspects of construction to art. 'Construction' was applicable to two-dimensional surfaces, to paintings, or to reliefs such as Tatlin's. Both terms, *konstruktsiya* and *konstruirovanie*, originated in architecture and the building industry, but had come to describe the art object. Discussing the way in which construction could be understood in painting, the critic Nikolai Tarabukin wrote:

> The painter could only adopt the general structure of the concept from technology, and not by any means all its elements. The concept of construction in painting is composed of entirely different elements from the same concept in technology. By the general concept of construction … we mean the whole complex of elements which are united into one whole by a certain kind of principle and which, in its unity, represents a system. Applying this general definition to painting, we should consider the elements of the painterly construction to be the material and real elements of the canvas …
> (N. Tarabukin, 'From the easel to the machine', p.140)

Tarabukin traced this use of 'painterly construction' back to Cézanne, but the art-critical use of the term in Russia seems to have derived largely from its currency in French Cubist theory, with which the Russian avant-garde was familiar.

Tatlin had called his works 'reliefs' and 'counter-reliefs', and 'selections of materials' – although they were no less 'constructed' than later Constructivist works. The sympathetic critic Sergei Isakov, writing in 1915 ('On Tatlin's counter-reliefs', p.335), stressed the 'principle of constructiveness' so manifest in Tatlin's counter-reliefs (for example, Plate 90). And for the Russian Formalist critic Viktor Shklovsky, the single most important quality of an art object, as a constructed object, was its *faktura*, its surface texture, the evidence of its having been made: as he put it, again in an article on Tatlin, '*Faktura* is the main distinguishing feature of that specific world of specially constructed objects the totality of which we are used to call art' (Shklovsky, 'On *faktura* and counter-reliefs', p.341). As a literary critic, Shklovsky could talk about poetry in the same terms, and we shall return a little later to the question of how a verbal text could be classified as a particular kind of 'constructed object'. *Faktura, or the material aspect of the surface*, was seen as the peculiar property of the art work, while the external world 'is perceived as a series of hints, a series of algebraic signs, as a collection of objects possessing volume, but not a material aspect, a *faktura*' (Shklovsky, p.341). The work, for Shklovsky, referred to the world (by hints and signs), but its distinctive character was as an artistic construction.

Although the term 'construction' had appeared in art criticism in the pre-revolutionary period, it took on additional meanings after 1917. It came to be associated with the idea of the artist as constructor, which had connotations of the engineer and of useful work. Mikhail Kaufman's photograph of Rodchenko, with his hanging constructions folded on the wall behind, represents him in this guise – as a constructor, wearing a constructor's suit designed by himself and made by Stepanova (Plate 91). In 1918 in the journal *Art of the Commune*, the critic Osip Brik wrote that the artist was 'now only a constructor and technician, only a supervisor and a foreman…'.[1] The important point here is that art was seen, not as 'creation' but as a particular kind of work, which was analogous to other kinds of work in industry and production. The term 'construction' was powerful because of its multiple associations, as we shall see – with language, with industry and with the construction of socialism. 'Foremanism', to pick out one of Brik's other analogies, hardly had the same ring.

[1] quoted by C. Lodder (*Russian Constructivism*, p.77), who identifies this as almost certainly the first use in print of the term 'constructor' in connection with art. In my treatment of the Russian material in this chapter, I am indebted to her wide-ranging, detailed and impressive research.

Plate 91 Mikhail Kaufman,
photograph of Aleksandr
Rodchenko with folded
constructions, 1921.
Costakis Collection.

Construction versus composition

One way in which 'construction' came to be defined was in opposition to 'composition',
and in the spring of 1921 INKhUK held a series of debates to look at this distinction. INKhUK
was the acronym for the Institute of Artistic Culture, set up in 1920 as a centre for
theoretical research. In practice, it provided a fairly informal forum where artists, critics,
theorists and other interested parties could meet to discuss pressing issues and argue out
priorities. Drawings were produced for discussion, such as the two pairs by Medunetsky
and Vladimir Stenberg (Plates 92–95). As Christina Lodder has discussed (*Russian Con-
structivism*, p.83), conflicts emerged between those who thought that construction must be
related to utilitarian work and ultimately industrial production, and those who thought of
it as an artistic category. The examples shown here are by two artists committed to
utilitarian work, who believed that certain principles and methods could be established in
'laboratory work'. For them, the aesthetic was irrevocably linked with the idea of com-
position, and was therefore retrogressive. Medunetsky's *Composition* (Plate 92) is framed
by ruler-drawn lines; within that frame, geometric elements such as the circle are suppos-
edly *composed* rather than constructed on the surface. His *Construction* (Plate 93), on the

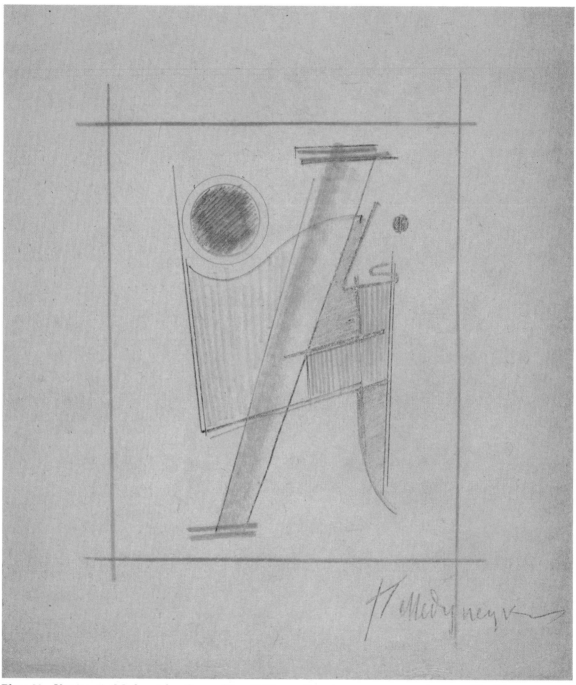

Plate 92 Konstantin Medunetsky, *Composition*, 1920, pencil and orange crayon on paper, 27 x 24 cm; on reverse, INKhUK stamp no.26. Costakis Collection.

other hand, is a drawing of a three-dimensional object, a construction in space. Stenberg's drawings (Plates 94 and 95) show the same distinction between two and three dimensions. Both received some criticism for their constructions, which were thought to be drawings *of* technical constructions, a consequence of their view that construction was most effective in three dimensions.

Plate 93 Konstantin Medunetsky, *Construction*, 1920, brown ink on paper, 27 x 19 cm; on reverse, INKhUK stamp no.27. Costakis Collection.

Plate 94 Vladimir Stenberg, *Composition*, 1920, coloured pencil on paper, 21 x 14 cm; on reverse, INKhUK stamp no.5. Costakis Collection.

Plate 95 Vladimir Stenberg, *Construction*, 1920, ink on paper, 25 x 19 cm; on reverse, INKhUK stamp no.6. Costakis Collection.

In an INKhUK paper setting out the position of the Constructivists, the real crux of the distinction between composition and construction was not just a matter of whether a work was made in two or in three dimensions, but of a far broader contrast of approach:

> *Construction is the effective organization of material elements.*
>
> The indications of construction:
> i. the best use of materials
> ii. the absence of any superfluous elements.
>
> The scheme of a construction is the combination of lines, and the planes and forms which they define; it is a system of forces. Composition is an arrangement according to a defined and conventional signification.

(quoted in C. Lodder, *Russian Constructivism*, p.84)

Here the virtues of construction are set against the negative terms of composition: construction uses materials economically whereas composition uses superfluous and merely decorative forms; construction is a 'system' that is, by implication, *not* subject to the 'defined and conventional signification' characteristic of composition. We could interpret this to mean that construction is not subject to any kind of signification or meaning, but that is not exactly what is said; the text refers specifically to *conventional* signification, such as might be found in figurative painting. Other modes of signification, other ways of meaning, may be at work, but they are neither clearly defined nor fixed. So, despite the contrast set up, we should not necessarily see 'system' and 'signification' as mutually exclusive.

After all, it is hard to argue that these constructions are inherently any more systematic than other possible configurations: they are constructions only by association. They drew on a currency of contemporary references – to three-dimensional constructions, to the methods of technical drawing, and to the work of the scientist or engineer. We could say, therefore, that for a work to signify as a construction depended on the 'hints' and 'algebraic signs' (to which Shklovsky had referred) being set in train in the first place. Shklovsky's emphasis had been on the art work's *resistance* to these references and signs, a resistance that ensured art's specially 'constructed' character: *only* hints, *only* signs, they did not betray the full effectiveness of a work *as art*. Yet the point of our discussion here is to try to retrieve some of that suggestiveness in terms of then current beliefs about the world, to see those hints and signs as playing a positive rather than negative role in the production of meaning, while we retain a sense of the effectiveness of artistic construction.

'Construction' seems to have been such a powerful frame of reference because it interlocked with other areas of social experience. For example, in political discourse the 'building' of socialism was a recurrent term. The Constructivist programme of 1921 referred to the part to be played in the 'building up' of communist culture, echoing the constant use made by Lenin of the metaphor of 'communist construction'. Lenin believed that communism had to exploit for its own ends the science, technology and culture left behind by capitalism: 'We must build socialism out of this culture, we have no other material – we have bourgeois specialists and nothing else. We have no other bricks with which to build' (V.I. Lenin, 'The achievements and difficulties of the Soviet government', p.70). This metaphor was current at this period. For instance, Plate 96 shows the 'building

Plate 96 Anon., *The Building of Socialism*, 1919, black and white lithograph, 71 x 104 cm. Uppsala University Library BS207.

of socialism' (*zdanie sotsializma*) as a classical building; it depicts the various stages of economic development, from the Middle Ages to the Revolution, as layers built one upon the other, moving through Marx and Engels to Lenin. However, despite the similarities of language, the Constructivists were not concerned with providing a *picture* of the building of socialism in this way, or indeed with building upon the cultural traditions indicated by Lenin. For instance, when Tatlin in the *Monument to the Third International* (Plate 97) symbolized the development of Socialism, he used the forms of an abstract construction, envisaged on a huge scale where, according to Nikolai Punin, 'the spiral represents the movement of liberated humanity' (Punin, 'The monument to the Third International', p.346). The monument was built only in model form, but it was designed to be made in modern technological materials using advanced engineering techniques – the supporting structure in iron, the suspended 'rooms' in glass. As a symbolic structure it combined an avant-garde vocabulary of artistic form with technology and utility. (See Chapter 4 for further discussion of Tatlin's monument.)

Plate 97 Vladimir Tatlin, drawing for *Monument to the Third International*, 1920. Photograph by courtesy of Moderna Museet, Stockholm.

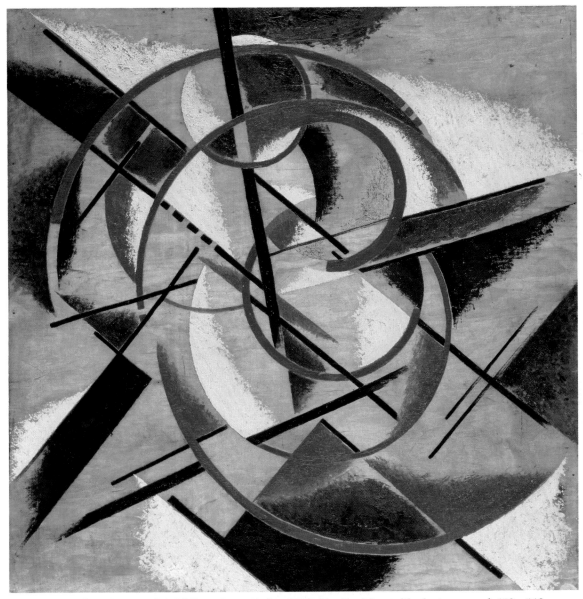

Plate 98 Lyubov Popova, *Spatial Force Construction*, 1920–21, oil with marble dust on wood, 113 x 113 cm. Costakis Collection.

The drawn line

In order to say something more about the force of the idea of 'construction', I shall focus on just one of its elements – the drawn line. We should not be surprised, perhaps, that drawing was such a central concern, given its associations with the elementary composition of painting in the fine-art tradition *and* with the kind of technical drawing used in industry.[2]

Lyubov Popova's *Spatial Force Construction* (Plate 98) is an example of how certain techniques were used to signify the working of a rational system of construction. The

[2] M. Nesbit has done some extremely interesting work on the line and the geometric in France, discussed in her series of Durning-Lawrence lectures, *The Language of Industry*, given at University College London in 1991. See also her article on drawing, industry and mass production, 'Ready-made originals'.

Plate 99 'Curves' from *The Encyclopaedia Slovar* (generally known as *The Brockhaus Efron*), vol.67, opposite p.740, 1907. British Library 2108d. Reproduced by permission of the British Library Board.

broken, ruler-drawn line of the diagram refers to diagrammatic drawing of the kind found in Plate 99. Like the materials and technical methods that were borrowed from the realm of industry in the three-dimensional constructions we looked at earlier, the diagrammatic line is derived from the realm of science and technical drawing. In one of the studies for this work (Plate 100) this diagrammatic layout is more obvious, but still the final work has elements of that notation. The works do not represent the world by 'conventional signification', if that is taken to be the model used in figurative art, but they contain allusions to the world in which they were produced through a currency of associations of materials and methods.

One of the most important features of artistic construction was that it was treated as a system that could be broken down into component parts. Its elements could be analysed, dissected and put back together again. The basic building bricks of construction were broadly formal in character and included *faktura* (surface texture), line, colour, plane,

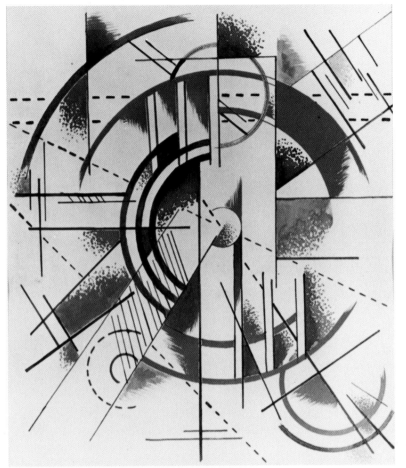

Plate 100 Lyubov Popova, *Spatial Force Construction*, 1920–21, watercolour on paper, 46 x 40 cm. Tretyakov Gallery, Moscow, TR74. Gift of George Costakis.

space and material. Each element in the system could be worked on and analysed separately from the others. So Rodchenko, for example, could concentrate in one series of works on the line – the line as far as was possible exclusive of all other concerns, minimizing evidence of surface texture or colour. His *Non-Objective Painting* (Plate 101) of 1919 was made up of lines on an unobtrusive brown surface – lines of different lengths, in different combinations. In a notebook drawing of the same year, this work is shown as one of several possibilities, each using lines in different permutations (Plate 102). Works such as Plate 101 were produced *as* paintings, to reiterate a point I have already made, but were later redefined as research – as the idea of painting became increasingly hard to defend. In 1921, Rodchenko identified the line as a basic element in the system of construction: it was 'the carcass, the skeleton, the relationship between different planes; it could also show movement, collision, conjunction, break and continuation' ('The line', p.293). The line could be isolated (Plate 103) and then deployed in various combinations. As an element in the system of construction, it was treated as 'raw material', a basic component; but it was also seen as a 'device', as a form*ing* element that could implement a variety of effects, for example where the line demarcated areas of pictorial space or suggested recession. In *Linear Construction* (Plate 104), the line as a perspectival device for showing recession in space is at the same time hinted at and denied by concentrating attention on the line as an element in the construction of the surface. Like the carcass or the skeleton, where only a structure is left, the line is one of the basic elements of construction to remain when all the superficial elements of composition have been removed.

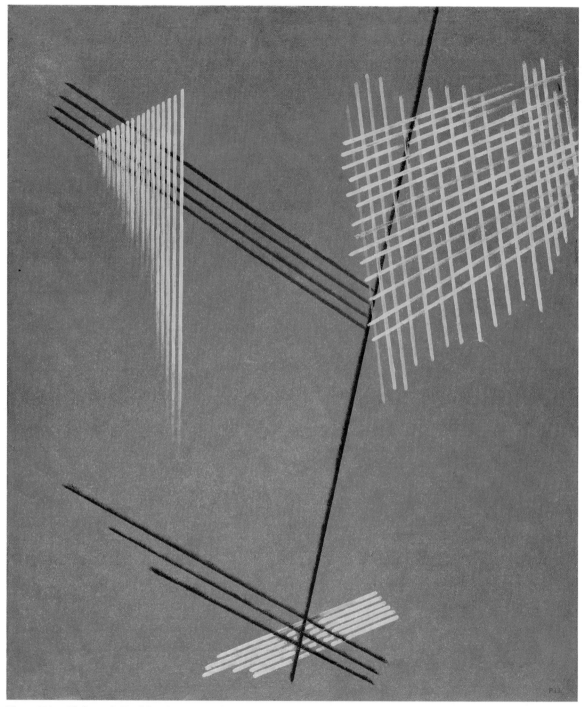

Plate 101 Aleksandr Rodchenko, *Non-Objective Painting*, 1919, oil on canvas, 85 x 71 cm. Collection, The Museum of Modern Art, New York; gift of the artist, through Jay Leyda.

Plate 102 Aleksandr Rodchenko, a page from a notebook, 1919. Rodchenko Family Archive, reproduced from G. Karginov, *Rodchenko*, 1979, Budapest, Corvina Kiado.

Plate 103 Aleksandr Rodchenko, sketch for the cover of the booklet *The Line*, 1921. Rodchenko Family Archive, Moscow.

Plate 104 Aleksandr Rodchenko, *Linear Construction*, 1919, oil on panel, 47 x 36 cm. Private collection. Photograph by courtesy of Musée d'Art et d'Histoire, Geneva.

Plate 105 Vasily Kandinsky, *Abstraction*, 1918, indian ink on paper, 24 x 16 cm. Tretyakov Gallery, Moscow, TR5. Costakis Collection.

The line in both these works by Rodchenko has, of course, been drawn. And it has been drawn in a certain way, to take on a particular character. It has not been drawn free-hand as in Vasily Kandinsky's *Abstraction* (Plate 105), where cross-hatching, dots, curves and angles display purposefully the hasty marks of the artist's hand. The effect of these marks was interpreted by Kandinsky, and by his opponents, as both psychological and expressive. Kandinsky had returned to Russia from Germany in 1915 and was involved in the INKhUK debates in 1920–21, until he was ousted by the Constructivists – subsequently moving back to Germany, and to the Bauhaus. Kandinsky's commitment to the expression of emotion was taken by the Constructivists to be retrogressive. For Rodchenko,

> the inaccurate, trembling line traced by the hand cannot compare with the straight and precise line drawn with the set square, reproducing the design exactly. Handcrafted work will have to try to be more industrial. Drawing as it was conceived in the past loses its value and is transformed into diagram or geometrical projection.
> (Rodchenko, 'The line', p.294)

The old role of the line in composition is transformed in the language of construction. The laxity of a 'trembling line' drawn by the artist's hand is considered less precise and there-fore of less value than a line drawn using a set-square, as if the hand plays no part. Indus-trial techniques could serve as correctives to the arbitrary character of the hand-made. The brush, for Rodchenko, had formerly had a use in conveying the illusion of an object; but its value was now exhausted, a sign only of servitude to an anachronistic model of illusionistic art. The Constructivists' attempt to 'depersonalize' practice, to take it out of the realm of individual artistic expression, made it necessary to mediate the hand of the

Plate 106 Varvara Stepanova,
Painter at an Easel, 1920,
tempera on paper, 40 x 35 cm.
Photograph by courtesy of
Aleksandr Lavrentiev and the
Rodchenko Family Archive,
Moscow.

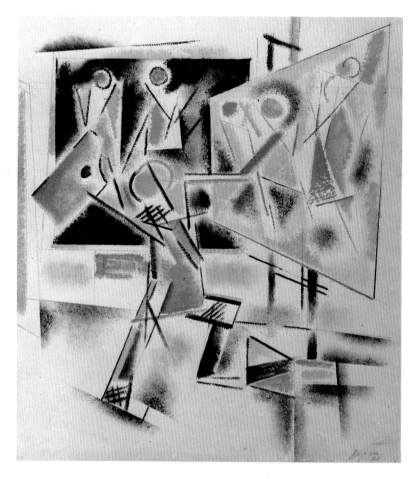

artist as much as possible. Thus, '*Faktura* in painting (impasto, glaze, etc.) has been superseded by mechanical tools (roller, press, etc.) which make possible a scientific analysis of form and material' (Rodchenko, p.294). The way in which the lines were drawn was itself suggestive: straight, ruler-drawn lines signified in part the tools that had been used to draw them, tools that were associated with draughtsmanship and technical drawing. Stepanova talked of 'mechanized factures', where the spray-gun or the roller mediated the hand of the artist (Plate 106). The point here is that the spray-gun no more mediated – in any literal sense – the artist's hand than, say, the more conventional brush, but the use of 'mechanized' techniques signified difference from the conventional techniques of painting. Art becomes here, not a matter of *depicting* new symbols but of renegotiating itself as a symbolic practice, in a continual state of redefinition through the means that it uses.

In 1923, in an article published in LEF (the journal of the Left Front of the Arts), Brik wrote about Rodchenko's move into production:

> Rodchenko was an abstract artist. He has become a Constructivist and a production artist. Not just in name, but in practice.
> (O. Brik, 'Into production', p.130)

He compared Rodchenko with other artists who had merely adopted the fashionable jargon of Constructivism:

> Instead of 'composition', they say 'construction', instead of 'to write' they say 'to shape', instead of 'to create' – 'to construct'. But they are all doing the same old thing …
> (Brik, p.130)

'The same old thing' was painting pictures, or applying ornament in applied art (whether it be flowers or Suprematist circles), or working on abstract aesthetic problems in a vacuum. 'Not just in name,' Brik stressed, 'but in practice'. As Brik says, this re-naming was not merely a matter of preferring one term over another, but part of a fundamental change in how art was perceived – and a redescription that involved a change in the terms of reference. Rodchenko's ruler-drawn lines were meaningful if they were seen as components in a system of construction: the lines were represented *as* part of that system; to talk about works such as these as 'non-representational' obscures this fundamental point.

Underlying Brik's comments was the idea that changes in the forms of linguistic description are bound to changes in the practice of art. There is a relationship between them, and yet one is neither superfluous to, nor simply synonymous with, the other. Next, I want to consider further how art, as an autonomous system of signs, was understood to be both analogous with, as well as distinct from, the formal character of language.

The language of construction and the construction of language

Art and language

When I compared Rodchenko's and Kandinsky's line drawings, I noted their differing character – one ruler-drawn, one traced unevenly by hand – and the connotations that each held in a given context. It is worth bearing in mind, however, that the claim for the expressive value of a painting made up of abstract forms – over and above a 'pattern' and the merely 'decorative' or 'utilitarian' value attributed to design – had been fought for by Kandinsky and others in the early 1910s.[3] Now, in changed circumstances, the ruler- or compass-drawn line symbolically reinstated a utilitarian basis for art: precisely because of its utilitarian connotations, the line could trace an intersection between art and industry. It was still vital that work in construction be distinct from the ornamental patterns of applied or decorative art, but it was also set squarely against the spiritual significance with which earlier abstract artists had sought to imbue artistic form – which came to be linked by the Constructivists with retrogressive notions of individuality, psychology and subjectivity. The line, for Rodchenko, could serve as the sign of a 'red farewell' to all that,[4] and could usher in the new conditions of collective work. The gesture was made technically (just a line, or a series of lines on a surface of board) but the gesture was politically inflected – a symbolic point of intersection, too, with Bolshevism.

These were important ideological differences, yet we should not lose sight here of the common ground over which they were fought. Both Kandinsky and the Constructivists declared a commitment to the idea that art was part of a revolutionary programme. They described artistic form in similar terms – for instance, in their mutual insistence on a basic formal vocabulary of line, surface, plane, space, colour, texture. They shared the belief that art was a kind of language, made up of formal components, and not dependent on resemblance to objects in the world. Yet their respective approaches depended on different models of the kind of language that art might be. It is one thing to agree on a structure, another to agree on the value and significance of its component parts. The question I want to pursue here is how it was the Constructivist model that won out.

In 1920 the INKhUK programme was initially set up on the basis of a plan devised by Kandinsky, who at that time was centrally involved in its activities. The effects of the formal properties of art were to be examined as 'a bridge to the explanation of their

[3] See C. Harrison's discussion of the emergence of abstract art, in Chapter 3 of Harrison *et al.*, *Primitivism, Cubism, Abstraction*.

[4] See Harrison *et al.*, Chapter 3.

influence on man's psychology' (Lodder, *Russian Constructivism*, p.79). On Kandinsky's psychological model, certain colours were thought to invoke particular moods and emotional states. Kandinsky sent out questionnaires asking members of INKhUK to say which colours affected them most powerfully, to comment on the different effect of lines, both geometric and freely drawn, in order to establish, on a scientific basis, the laws underlying intuitive perception (Lodder, p.80). The programme was reminiscent of the aesthetic principles Kandinsky had outlined as early as 1910 when he had claimed that the 'two elements – *paint and line – constitute the essential, eternal, invariable language of painting*' ('Content and form', p.22). 'Essential', 'eternal', 'invariable': these are terms hard to reconcile with the Constructivist concerns with material and formal principles that I have outlined. Yet Kandinsky's view had grown out of, and still had much in common with, the Russian Symbolist tradition that continued to be influential even after the Revolution. In the context of that tradition, it was by no means novel to talk about the language of art, and to mean by it the formal properties of the medium. The analogy with language had come to the fore in Symbolism because of just this capacity to accord priority to the medium of art rather than to illusionistic description. However, whereas in Symbolism the medium operated to express a higher reality, many avant-garde artists before the Revolution (such as Tatlin and Rodchenko) had insisted that the medium was an end in itself, referring to the form or the material 'as such'. If art was like language, it was analogous to a different model of language from that used by Kandinsky.

The artist Nadezhda Udaltsova had lamented in 1915, for example: 'But when, for goodness' sake, will they start to talk about the form of modern art, about the painter's genuine language?' (Udaltsova, 'How critics and the public relate to contemporary Russian Art', p.308). Frustrated by the hostility of the critics, Udaltsova demanded that modern art be discussed in the terms it required, in terms, that is, of its *form*. Her own work and view of art had been influenced by the period she had spent, together with Popova, studying in Paris, and by her acquaintance with French Cubism. For Udaltsova, to talk of the 'language' of art did not mean, as it had for Kandinsky, the essential or universal character of art. She used the term, I think, both more loosely than Kandinsky, to refer to the formal concerns of modern painting (the form painting took, and not what it depicted), and more precisely, to refer to a specific artistic language that derived from French Cubism – we could even say learnt from Cubism by the Russian avant-garde. Although the French Cubists had never completely abandoned the represented object, they rendered it so illegible, by breaking down the representational process into fragments, planes and graphic marks, that Cubism was regarded as the point of departure for modern pictorial concerns. Even when Rodchenko comes to write 'The line' in 1921, it is to Cubism that he turns to explain current developments, for it was Cubism that had demonstrated that 'the new form – the surface – demanded new organizing principles' (p.293). The line had surfaced in a new form in Cubist painting, as a graphic mark rather than as a contour to delineate solid bodies or three-dimensional forms; sometimes it corresponded to the shape of a glass or a bottle, but more often did not. Cubism had shown that the 'painter's genuine language', to refer back to Udaltsova's phrase, was formal in character and grounded in the rules and conventions (for Rodchenko, 'organizing principles') that govern representation, that are artificial rather than 'natural' or 'essential'.

When Shklovsky wrote about Tatlin's reliefs (Plate 90) in 1921, he began by pointing to the prevalent but, as he saw it, untenable Symbolist view of the language of art:

> There is a well-known approach to artistic form, i.e. to art itself, an interpreter translating certain ideas of the artist from the language of his soul into a language comprehensible to the beholder. For the proponents of this view, words in literature and oils in painting are a grievous necessity.
>
> (Shklovsky, 'On *faktura* and counter-reliefs', p.34)

By contrast, Tatlin had had to leave painting altogether in order to demonstrate the concerns of the 'constructed object' of art. When Shklovsky went on to discuss Tatlin's *Monument to the Third International* (Plate 97) in an associated article, he elaborated:

> The word in poetry is not just a word: it produces dozens and thousands of associations. A literary work is permeated with them as Petersburg's air is permeated with snow in a blizzard.
>
> A painter or a counter-relief artist does not have the freedom to confine the movement on a canvas or between the supports of an iron spiral within this blizzard of associations. These works of art have their own semantics.
>
> (Shklovsky, 'The monument to the Third International', p.343)

By saying that works of art have their own semantics, Shklovsky suggests they have a structure like verbal language; yet they have their *own* semantics, their own way of meaning through pictorial rules and conventions, which is distinct from verbal language. The metaphor Shklovsky uses of the blizzard – which evokes a screen of interconnecting, fluctuating forms and meanings – locates the interest (and the meaning) of art in the formal and material character of the 'constructed object', not the 'language of the soul'.

The formal method

Analogies with language serve two main purposes – the first to draw out a structural similarity between the systems of 'art' and of 'language', the second to specify how art differs from language. Even a fairly neutral term used often today in the language of art history, such as 'formal vocabulary', tends in both these directions. When we refer to a 'formal vocabulary', we do not mean that the forms used in a painting are literally like words in a vocabulary, but something looser, that there is a differentiated set or repertoire of forms in use. True, this may be so common a phrase that it no longer carries the weight of the analogy with language – but I suggest that the fact that we may not even think of it as a metaphor shows how far thinking about art is bound up with thinking about language.

When Lyubov Popova wrote a short programme to accompany the work she exhibited in Moscow in 1919, she presented her ideas differently from her fellow artists by setting them out schematically:

(+) Painting	(–) Not painting but the depiction of reality
I. *Architectonics*	
(a) Painterly space (cubism)	I. *Aconstructiveness*
(b) Line	(a) Illusionism
(c) Color (suprematism)	(b) Literariness
(d) Energetics (futurism)	(c) Emotions
(e) Texture	(d) Recognition
II. The necessity for transformation by means of the omission of parts of form (began in cubism)	

(Popova, 'Statement from the catalogue of the Tenth State Exhibition: Non-Objective Creation and Suprematism', p.146)

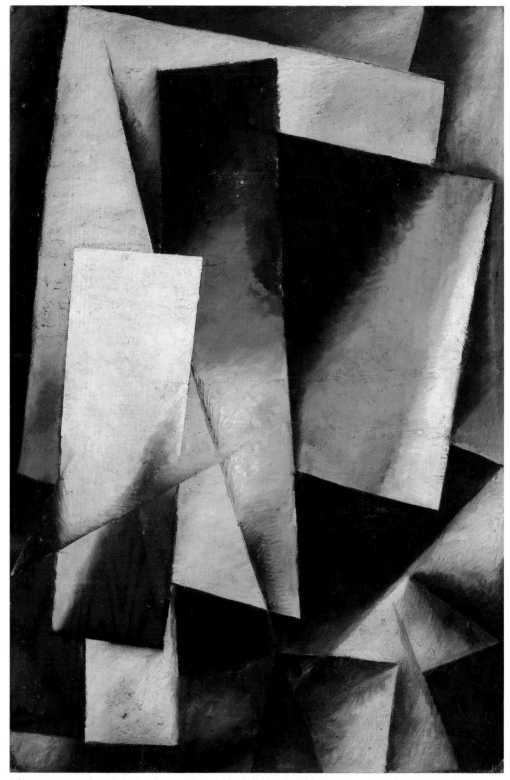

Plate 107 Lyubov Popova, *Painterly Architectonic, c.*1918, oil on canvas, 105 x 70 cm. Private collection. Photograph by courtesy of Waddington Galleries.

This was Popova's way of mapping out not only her own concerns (see, for instance, Plate 107) but the priorities of contemporary art. Notice how she lists under 'architectonics' (structural principles) a series of terms that could be applied in an analysis of a particular painting but that also distinguishes different trends in the production of painting in general. (She adds the genesis of formal characteristics in particular movements – painterly space in Cubism, for example.) The drift of what she has to say is similar to the other artists' programmes. It could have been a draft for one of them, and yet it was published in this form, which is almost diagrammatic in its layout, each column headed with a plus or a minus sign, emulating a mathematical formulation. It also demonstrates, rhetorically, how far the new painting was defined in terms of what it was *not*, in a series of negative terms that were suppressed – illusionism, literariness, emotions, recognition.

All these 'aconstructive' elements were associated with the depiction of reality. To Popova, 'literariness' in painting was an 'extraneous' element, an interloper that intruded on the true realm of art. More precisely, all these negative terms relate to a narrative tradition in Russian painting dating back to the nineteenth century. The Realist artist Ilya Repin, for example, had produced large-scale narrative paintings on radical social themes. An example may illustrate my point. *They Did Not Expect Him* (Plate 108) was painted illusionistically; it told a story, focusing on an emotionally charged moment when the political exile returns to his family; it depended for its force on the recognition of the heroic but emaciated figure of the revolutionary. Indeed, it was so important to Repin that people should identify the painting's narrative, emotional and political content that he repainted the exile's face several times to convey the right amount of suffering, but not to the extent that the Right could interpret the revolutionary as a crazed political criminal (E. Valkenier, *Russian Realist Art in the State and Society*). Like Popova, Shklovsky saw this as a tradition where art had undergone a 'dissolution in alien elements'; Repin, he claimed, was an artist, but only in so far as he produced particular types of objects,

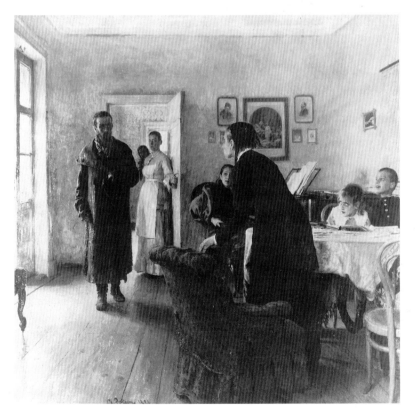

Plate 108 Ilya Repin, *They Did Not Expect Him*, 1884–88, oil on canvas, 161 x 168 cm. Tretyakov Gallery, Moscow. Photograph by courtesy of the Society for Co-operation in Russian and Soviet Studies, London.

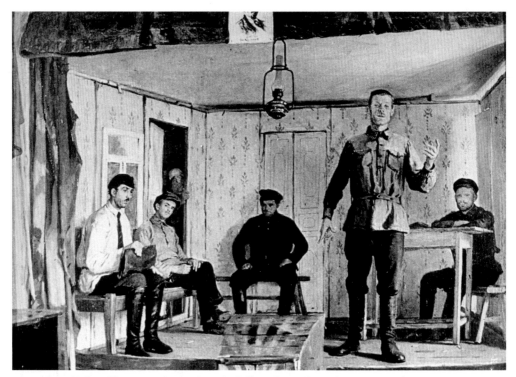

Plate 109 Yefim Cheptsov, *A Meeting of a Village Party Committee*, 1924, oil on canvas,
59 x 77 cm. Tretyakov Gallery, Moscow. Photograph by courtesy of the Society for
Co-operation in Russian and Soviet Studies, London.

canvases covered with oils ('On *faktura* and counter-reliefs', p.341). Despite the antipathy
of the avant-garde, the Realist tradition continued into the twenties, when it was revived
as a form of painting appropriate to the needs of a socialist society. For those factions
hostile to Constructivism and 'leftist' art, the type of realism found in a work such as
Yefim Cheptsov's *A Meeting of a Village Party Committee* (Plate 109) had the power to
'reflect' the everyday life of the proletariat and the peasantry; it could celebrate the heroes
of socialism.[5] But new heroes and new symbols were inserted in painting that otherwise
adhered to a nineteenth-century mode of representation. The contrast could hardly be
starker – between on the one hand a painting of a party worker talking from the stage of
what might be a village hall, which *depicts* a 'speech', which invokes spectators of the
painting as its 'audience', and on the other the idea of art as an autonomous system with a
language-like character (compare Plates 109 and 110).

 I think the concerns that Popova sketched out, and certainly as they were elaborated
elsewhere in Constructivism, can loosely be called a formal method. I say loosely because,
strictly speaking, the 'formal method' at this period refers to the work of the Russian For-
malists, who were primarily literary critics and linguists. Russian Formalism was a school
of literary criticism based around two groups – the Moscow Linguistic Circle, founded in
1915, and OPOYAZ, the Society for the Study of Poetic Language set up in St Petersburg in
1916. Shklovsky was a member of OPOYAZ, as was Osip Brik. Roman Jakobson, who left
the Soviet Union in 1921 and later became an important figure in the development of
Structuralism, was a prominent linguist and a member of the Moscow group. The Formal-
ists had close ties with the Constructivists, through figures such as Brik in particular, and
had been involved with the avant-garde before the Revolution.

[5] This form of realism is discussed at length in Chapter 4.

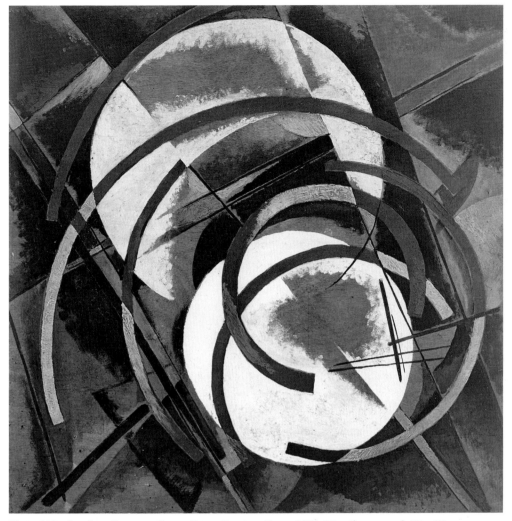

Plate 110 Lyubov Popova, *Space–Force Construction, c.*1920–21, oil on panel, 78 x 78 cm. Private collection, courtesy Annely Juda Fine Art.

The Constructivists' interest in a rational system of construction, one that could be analysed and broken down into parts, had a great deal in common with Formalist ideas about the nature of language – about what language was, how it worked and how it could be analysed. 'Construction' was one of the key concepts in the Russian Formalist view of language, in its central concern with the way in which language was structured. As I have already indicated, the term 'construction' had various meanings and connotations. One of these figurative senses was the grammatical construction of language. The Formalist use of the term extended beyond this conventional sense to refer more generally to the way in which language was put together. Their main concern was with the special qualities of poetry and prose writing. Jakobson defined the key property of literature as 'literariness', by which he did not mean its story-telling, its narrative content (as Popova had in the pictorial context), but rather the specifically literary qualities of texts, that made literature and poetry unlike any other medium. In his essay of 1917, 'Art as technique', Shklovsky rejected the idea that the image was the distinctive feature of poetry. The idea that poetic language entailed 'thinking in images' – visual images – was the conventional view of literature that Formalists sought to undermine. They drew attention to the fabric, the material character, of the text – its basic 'literariness'. The use of imagery was only one of

many devices that made up the fabric of the text and, for the Formalists, should not receive privileged treatment.

If the language of construction was related to Formalist ideas of the construction of language, the relationship was two-way. Jakobson later claimed that it was Cubism which had prompted the reconsideration of the way in which signifying systems operated (Jakobson, 'Phonological studies: retrospect', p.632). And some of the key terms, including 'construction', were either originally derived from or took their particular force from the language of art. Perhaps the most vivid example of this is *faktura*, which in early Formalism in particular is a term applied by the literary critics to the artificial *texture* of poetic language. They regarded language, not as a vehicle for narrative, for ideas, or for images, but as having a 'surface' with a 'density'. This surface is not 'seen through', or transparent, but – to recall Shklovsky's phrase – is a screen like a blizzard. *Faktura* or texture, as in Popova's schema, is set against 'recognition'. Especially in Shklovsky's formulation, the whole point of art as a constructed object was that it did *not* allow easy recognition, and therein lay the pleasure of aesthetic experience. 'The purpose of art', he wrote, 'is to impart the sensation of things as they are perceived and not as they are known. The technique of art is to make objects unfamiliar' ('Art as technique', p.12). Shklovsky's emphasis was on displacement, on the 'making strange' (*ostranenie*) or 'defamiliarizing' of normal perceptions. The function of art was the *deflection* of familiar perceptions, not their reflection.

I am not suggesting here that the Constructivists applied a Formalist model of language to art, but rather that a reconsideration of what language was like was necessary to their redefinition of art as construction. Along with the references to science, industry and technology, there is, at the heart of the idea of construction, a sense of undoing, of dismantling. Construction refers to the assemblage or building up of parts, but it also, as a process, entails the idea of its own deconstruction. It was this sense of self-reflexiveness that Constructivism shared with Formalism.

Useful work

As Formalism developed in the debates of the twenties, it was increasingly pressed to address questions of the position of art in culture; it had to defend its position in the face of Marxist claims for the social basis and production of art. Of what use was the study of the text or painting as an autonomous object, independent of social or economic determinants, in such circumstances? It was in this context that Brik outlined the OPOYAZ contribution to the proletarian construction of culture in the journal LEF in 1923:

(1) A scientific system instead of a chaotic accumulation of facts and personal opinions.

(2) A social evaluation of creative people instead of an idolatrous interpretation of the 'language of the gods'.

(3) A knowledge of the laws of production instead of a 'mystical' penetration into the creation.

(Brik, 'The so-called "formal method"')

The Formalist view of literature was as a series of texts ('there are no poets and writers,' Brik wrote, 'there are just poetry and writing'). Its value did not lie in the individual writer – everything a poet writes 'is totally worthless as an expression of his "I"' (Brik, p.274). This corresponded with the Constructivists' attitude to the role of the individual artist, to mysticism, to science and to production. The joint claims for a *scientific* system, for *social* evaluation, and for production, represented a united 'Left Front' against the contemporary trend towards realism and reflection theories.

Some critics argued that while systems and structures might be worked out independently of social considerations, they could – once established – be put to social use.

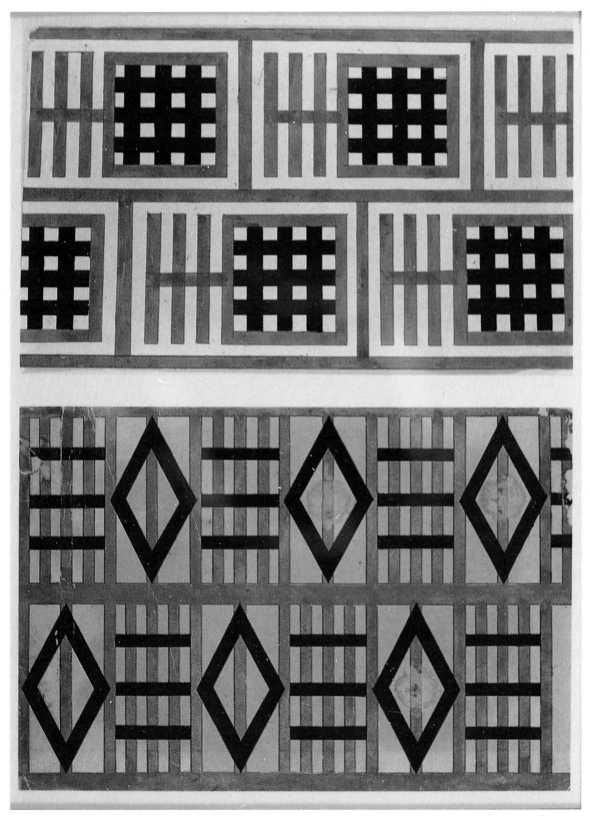

Plate 111 Lyubov Popova, *Textile Designs*, 1923–24, gouache on cardboard, 21 x 36 cm; india ink and gouache on paper, 21 x 31 cm. Museum of Decorative and Applied Art, Moscow. Reproduced by permission of Philippe Sers Éditeur, from D.V. Sarabianov and N.L. Adaskina, *Liubov Popova*, 1989.

The critic Boris Arvatov wrote in support of Constructivist work: 'The point is that we can build socially purposeful forms … only by proceeding from the material itself and the methods of its processing' ('The proletariat and leftist art', p.228). The appearance of an object would be determined by its use but also by the materials of which it was made. The Constructivist programme of March 1921 had called this process the 'communistic expression of material structures'. Because it rejected 'the language of the gods' and idealist views of art, Constructivists saw their own work, in contrast, as 'materialist' and consistent with historical materialism in the Marxist sense. When Aleksei Gan wrote in 1922 of 'materialism in the field of artistic labour' ('Constructivism', p.35), he was claiming that the Constructivist project was compatible with Marxism, but incompatible with prevailing Vulgar Marxist interpretations of art as the reflection of society.

As the debate between Formalists and Marxists developed in the twenties, the earlier opposition – between the Formalist approach to art as entirely separate from society and social life, and the Vulgar Marxist view that art simply reflected social life – became less clear-cut. Some Formalists took on board some of the Marxist criticism to create various kinds of 'socio-formalism'. Shklovsky, once the most extreme exponent of art's separation from life, allied himself after 1925 to 'factography', or the 'literature of fact'. This was a form of reportage expounded by, among others, Brik and Mayakovsky, which corresponded with Rodchenko's work in photography. Here the ideas of material, device and construction were put at the service of 'social command', the watchword of the LEF group. The shift of emphasis to reportage in literature followed the same logic as the move from art to production, where the social usefulness of an object was understood to define its form. Thus the device was no longer seen in terms of artistic effect; it was now disengaged from what Arvatov called the 'fetishism of aesthetic devices, aesthetic materials and aesthetic tools' (Arvatov, quoted in V. Erlich, *Russian Formalism*, p.112) and deployed to utilitarian ends.

In an article of 1924, Brik defined the basic idea of production art to be when 'the outer appearance of an object is determined by the object's economic purpose and not by abstract, aesthetic considerations' (Brik, 'From pictures to textile prints', p.249). The commitment to social usefulness had, by now, rendered even the category of 'laboratory work' untenable, at least as it had been understood in 1921. Both Stepanova and Popova produced designs for fabrics in the early twenties and, from 1923 or 1924, worked for the First State Textile Print Factory in Moscow (see Plate 111). Brik saw this involvement in industry as the way ahead for Constructivism. He also advocated photography, following Rodchenko's adoption of that medium in 1924. In an article entitled 'Photography versus painting' of 1926, Brik attacked easel painting – especially the kind that tried to emulate photography. His particular target was the so-called heroic realism of the AKhRR group (Association of Artists of Revolutionary Russia), of which Cheptsov was a member, which had gained power and influence by the mid-1920s supported by the patronage of the party, the unions and the Red Army (for a detailed discussion of AKhRR, see Chapter 4). Brik saw the figurative realism of AKhRR as completely redundant in the light of the possibilities of photography to record the present day. Of what use was a painted portrait when there was photography? He stressed that photography should not emulate painting but should be treated as a medium in its own right. He wrote of Rodchenko, 'His main task is to move away from the principles of painterly composition of photographs and to find other, specifically photographic laws for their making and composition' (Brik, 'Photography versus painting', p.91). The camera angle, for instance, was a photographic device that could be exploited – as in Rodchenko's photograph of Stepanova (Plate 112). In his photograph of Brik of 1924 (Plate 113), Rodchenko placed the sign of the LEF in one of the lenses of his glasses, thus halting any reading of the photograph that does not admit its made aspect. The idea that the eye was mediated through the camera eye, through the lens, was a device Rodchenko also used in his cinema posters for Sergei Eisenstein's film

Plate 112 Aleksandr Rodchenko, photograph of Varvara Stepanova at her desk, 1924. Photograph by courtesy of Aleksandr Lavrentiev and the Rodchenko Family Archive, Moscow.

Plate 113 Aleksandr Rodchenko, photograph of Osip Brik, 1924. Photograph by courtesy of Galerie Gmurzynska, Cologne.

Plate 114 Aleksandr Rodchenko, poster for *Battleship Potemkin*, 1925. Photograph by courtesy of the Society for Co-operation in Russian and Soviet Studies, London.

Battleship Potemkin (Plate 114) and for Dziga Vertov's *Cinema-Eye* series of documentary films (Plate 115). Photography was used in the service of 'social command', but also as a means of addressing contemporary reflection theories head on. For even when photography, or 'factography' in literature, seemed at its most 'transparent', it was treated as an artificial medium, a set of materials to work with.

Plate 115 Aleksandr Rodchenko, poster for Dziga Vertov, *Kino Glaz* (*Cinema-Eye*), 1923. Photograph by courtesy of the Museum of Modern Art, Oxford.

Disembodied form: construction and the gendered self

Women artists and the role of constructor

The two photographs by Rodchenko to which I've just referred (Plates 112 and 113) staged the new types – Stepanova as the artist-constructor, and Brik as Constructivist critic, Formalist and exemplary LEF member. The aura of the individual, expressive artist was shed, as an anachronistic bourgeois type, in favour of new models. The impetus behind Constructivism was to 'depersonalize' form and make it part of a language of construction. In the same spirit, the Formalists made the biography of a writer, and the writer's personal traits, an outlaw of criticism; the writer was not important, *writing* was.

It is in the light of these priorities that I want to return to the question of the artist or producer, to ask: does it matter that in an apparently shared vocabulary, Plate 104 is the work of a man and Plate 116 the work of a woman? Wasn't the value of a line its technical neutrality, immune from inequalities of class or sex? And in the circumstances, isn't the question of gender at best marginal in the context of revolution and the massive upheaval that this entailed in terms of class, in the victory of the proletariat that followed 1917? Although sexual equality was on the revolutionary agenda – the Bolshevik feminist Aleksandra Kollontai was put in charge of the Ministry for Women, and radical measures such as the legalization of divorce were introduced – it was considered secondary to the question of class equality. Though Lenin addressed what he called the 'woman question' in terms of the need to emancipate women from slavery in the home and involve them in productive labour, there was always deep resistance in the Soviet Communist Party to the participation and the liberation of women. Yet a remarkable feature of the Russian avant-garde before and after the Revolution was that it counted among its numbers a greater proportion of women artists than any other avant-garde movement. (Even Surrealism, which is discussed in the next chapter, incorporated women artists only in its later phase.) Rather than chart the involvement of women artists in the Russian avant-garde, I shall consider here their role as constructors. In the light of the redefinition of the artist's 'self', what implication might there be for the 'gendered' self?

As we have seen, the concept of construction was established on the basis that certain elements were systematically excluded – the subjective, the decorative, the literary, the mystical, the creative, the figurative. The depiction of men and women, the depiction of different classes, fell under the yoke of the figurative and the literary, and thus represented 'alien' traits. The sensual, that which was 'of the body', might be the stuff of life, but it was certainly not the stuff of art as the Constructivists redefined it – hence the mechanizing of *faktura*, the mediation of the hand of the artist. The clearest articulation of this attitude was in the Formalist and Constructivist insistence on the rejection of the 'I' and subjectivism – the rejection of the self. When Brik referred to the worthlessness of the expression of the 'I', he was attacking Symbolism. The 'I' was shorthand for a whole aesthetic. Constructivist discourse eschewed any explicit reference to gender, but it is here in the attack on the Symbolist attitude to the self, and by implication to the gendered self, that we can get a sense of the undertow of questions of sexual difference.

Russian Symbolist aesthetics, as they were expressed by Vladimir Markov as late as 1912, aimed at the 'free manifestation of our "I"' ('The principles of the new art', p.36). The 'I' meant intuition, subjectivity and the inner psychology or world of the artist as a creator. Symbolist aesthetics acknowledged the formal aspects of representation because art was an outward manifestation of this subjective world of impulses. One of the mediating factors, then, was 'The outward function of the hands and, in general, of the body, which transmit that rhythm of the soul that it experiences at the moment of creation' (Markov, p.35). Constructivists countered this expression of the 'I', and the conflation of brush, hand and body, with alternative methods that allied their work with the processes of science

Plate 116 Lyubov Popova, *Constructivist Composition*, 1921, oil on panel, 93 x 62 cm. Private collection.

and rationality. Science and logic had been identified by Markov as exactly the processes hampering the expression of the 'I'. The art of individual creation was, for Markov, an art of nuance and suggestion:

> All these nuances of individual creation – nuances such as heavy, light, clumsy, graceful, cold, dry, vague, feminine, masculine, sharp, soft, etc. – are products of instinctive work, and they should be preserved and protected, and not persecuted and destroyed.
>
> (Markov, 'The principles of the new art', p.31)

Here 'masculine' and 'feminine' are listed as descriptive qualities, akin to terms to do with touching or feeling. By rejecting all of this, the Constructivists replaced one set of nuances by another. Symbolism had been attacked by the avant-garde in the early 1910s, but as late as 1923 Brik felt he had to refute it when he dismissed individualism; it was still necessary to deny the validity of creation, of the 'masculine' and the 'feminine', the hand and the body.

Popova's *Constructivist Composition* (Plate 116), shown at the *5 x 5 = 25* exhibition in 1921, can be regarded as a renunciation of just this sense of the artist's self. She used ruler-drawn lines to indicate a structure on the surface of the work; the painted areas in the angles demonstrate *faktura*, density of surface, in relation to the linear structure. The ruler-drawn lines are evidence of a 'mechanized' *faktura*, whereas the textured parts between the angles have been painted with a brush; even here, however, the paint is applied in such a way as to limit the sense of free, painterly 'handling'. Popova's treatment of the surface distinguishes the work from a conventional diagrammatic rendering of geometric solids; the textured areas treated with the brush do not designate volume, unlike the shaded parts in Plate 117, but instead draw attention to the surface of the wood as a worked surface. Likewise, the use of colour in the linear structure as well as in the areas of *faktura* makes it impossible to read this as a three-dimensional structure in space; it is a structure painted on the surface, an artistic construction. The title *Constructivist Composition* indicates how tentative the distinction between construction and composition was for Popova at this date. The point here is that the work does not imitate a mathematical diagram, or exemplify a scientific proposition of any sort, but refers rhetorically to the discourses of science.

The techniques that Popova used in her *Spatial Force Construction* (Plate 98) and her *Constructivist Composition* denoted the maker of the work, not as an artist or as a creator but as a constructor. Let me compare her use of techniques with some other images to clarify what I mean here. For Popova suggests the artist as constructor in a quite different way from El Lissitzky's *Self-portrait: The Constructor* (Plate 118) where various photographic elements are superimposed in a photomontage. The hand holding a pair of compasses lies over the eye; the palm of the hand both holds the eye and masks it; the hand is shown as an instrument of precision. It is through this overlaying of the attributes of construction – the compasses, the graph paper, the typographic elements, for example – that the artist is portrayed *as* a constructor. Even though this is a portrait with the photographed head of Lissitzky at its centre, it is the *parts* that carry the significance. In a later cover for the VKhUTEMAS magazine (Plate 119), the motif of the hand and the compasses is reused, but the other elements have been excised. This process of assigning meaning to the parts, such as the hand with compasses, can also be seen in the two photographs of Stepanova at work, taken by her husband Rodchenko. In Plate 112, Stepanova has been photographed in the studio, at work at her desk with the tools of construction around her – set square, ruler and so on. The photograph is taken at an angle, tilting the table up to emphasize the diagonal axis; Stepanova wears a fabric designed by Popova, transfigured by the same geometric vocabulary. In Plate 120, Stepanova is crouched over the design; the effect is to compress the head, the compasses, the drawn design – to stress, again, the shifts of meaning from part to part, across adjoining realms.

Plate 117 'Geometric solids' from *The Encyclopaedia Slovar* (generally known as *The Brockhaus Efron*), vol.34, opposite p.300, 1902. British Library 2108e. Reproduced by permission of the British Library Board.

In these photographs, the attributes of construction are shown and displayed. In *Constructivist Composition* (Plate 116), on the other hand, they are absent but there by association – as the implements that have marked the surface, and left their traces. Obviously, *Constructivist Composition* is not a self-portrait by Popova of the artist as constructor, in the way that Lissitzky's is. But what if we shift our terms of reference and compare it with another self-portrait (Plate 122), this time of a woman artist? In this painting of 1922, Zinaida Serebryakova represented herself at work: the painting she is shown working on is reflected in the mirror behind. Here the practice of painting represented is the conventional art of easel painting; that is what the artist is depicted as engaged in, that is what we are presented with, that is what hangs on the walls of the depicted interior. Serebryakova had studied under the Realist Repin, and exhibited with the World of Art group; the woman artist as Realist easel painter can be set against the woman artist as constructor, the implicit identification that we find in Popova's work.

Plate 118 El Lissitzky, *Self-portrait: The Constructor*, 1924, photomontage. Reproduced from S. Lissitzky-Küppers, *El Lissitzky: Maler, Architekt, Typograf, Fotograf*, Dresden, Verlag der Kunst, 1967.

Plate 119 El Lissitzky, cover of the yearbook of the VKhUTEMAS art school, *Arkhitektura VKhUTEMAS*, Moscow, 1927. Reproduced from S. Lissitzky-Küppers, *El Lissitzky: Maler, Architekt, Typograf, Fotograf*, Dresden, Verlag der Kunst, 1967.

Plate 120 Aleksandr Rodchenko, photograph of Varvara Stepanova working on a textile design, 1924. Photograph by courtesy of Aleksandr Lavrentiev and the Rodchenko Family Archive, Moscow.

Plate 121 Zinaida Serebryakova, *House of Cards*, 1919, oil on canvas, 65 x 75 cm. State Russian Museum, St Petersburg.

Plate 122 Zinaida Serebryakova, *Self-portrait*, 1922, oil on canvas, 69 x 56 cm. State Russian Museum, St Petersburg.

Part of what is signified by *Constructivist Composition* is the status of its maker, the 'not I' of the constructor. The individual, gendered self was broken down, and the maker recast; the woman artist has become a constructor. The term 'Constructivist' was ostensibly neutral, without gender, yet in its social usage it implied a male type – the engineer, the bourgeois specialist, the technical expert involved in industry. As we have seen, to adopt the role of constructor entailed rejecting the traditional role of the 'artist'; for a woman to adopt that role meant, in addition, a refusal to comply with conventional expectations of the 'woman artist'. Women's art and women's subject-matter had been categorized in fairly predictable ways by A.P. Novitsky in his history of Russian art, published in 1903. The terms he used to describe the work of women artists in the nineteenth century focused on its 'elegance' and its elements of 'fantasy'. Even after the Revolution, Serebryakova's paintings of children and domestic scenes (Plate 121) still fitted with this conception of the traditional treatment of genre, everyday subjects by women artists, where Popova's did not.

The hand-made and the machine-made

In discussing construction and gender, we need to consider not only *what* was painted (the subject-matter) but also *how* (the forms and techniques). Popova, Malevich and Rozanova had been among those in the early 1910s who had taken an interest in various forms and techniques of folk-art, including embroidery. They had Suprematist designs (Plate 123) embroidered by peasant women of the Verbovka region, and exhibited the results. The basic formal characteristic of peasant culture was seen as its geometricity – in, for example, the embroidered borders of peasant clothing (Plate 124). The formal correspondence between avant-garde and folk-art was later taken by some (including Kazimir Malevich) after the Revolution to support the view that geometric abstraction was a mass, collective art. Although the figurative depiction of 'peasant' subjects came to be seen as invalid by abstract artists, residual references to embroidery and to folk-art were sustained. The geometric elements of folk-art were assimilated by abstract artists, and reasserted in the fabric designs made by Stepanova and Popova in the early twenties – such as those made for the First State Textile Print Factory. The textiles industry was traditionally one in which women were involved, and the New Economic Policy of 1921

Plate 123 Lyubov Popova, embroidery design for the Verbovka region, 1917, collage on grey cardboard, 9 x 17 cm. State Pushkin Museum, Moscow.

Plate 124 Peasant embroidery, from *Bolshaya Sovetskaya Entsiklopediya*, 1929, vol.14, p.74. British Library 12214.e.1. Reproduced by permission of the British Library Board.

had opened a market for consumer goods such as fashions and textiles. Their work in textiles drew on what could be seen as 'women's work'; Novitsky had begun his section on women's art by drawing attention to the role of women in the tradition of embroidery. Popova and Stepanova used the source indirectly (Plate 111, for example) as opposed to the more explicit references of Nadezhda Lamanova. Lamanova was an established fashion designer who drew on the forms of peasant clothing (Plate 125): 'By combining the lively colours of peasant clothing with modern techniques of mass production,' she wrote in 1923, 'we will achieve the kind of clothing design which will answer the needs of contemporary life' ('Russian fashion', p.92). Popova's dress design (Plate 126) uses the principle of geometric borders but renders it asymmetric; a pattern similar to that traditionally used as a geometric border takes over the whole design, clothing the body in geometric forms. Working in a field where women had conventionally been employed, Popova did not simply duplicate the conventions and connotations of folk-embroidery; instead the associations of embroidery, of women's work, of the hand-made, are brought to bear on the symbolic order of modernity, of mass-production and the machine-made.

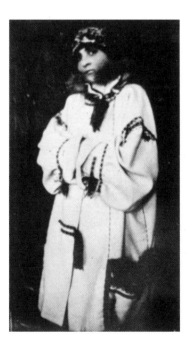

Plate 125 Nadezhda Lamanova, costume based on folk-design, 1923. Private collection. Reproduced from *Art into Production: Soviet Textiles, Fashion and Ceramics, 1917–1935*, p.86, 1984 by courtesy of Museum of Modern Art, Oxford.

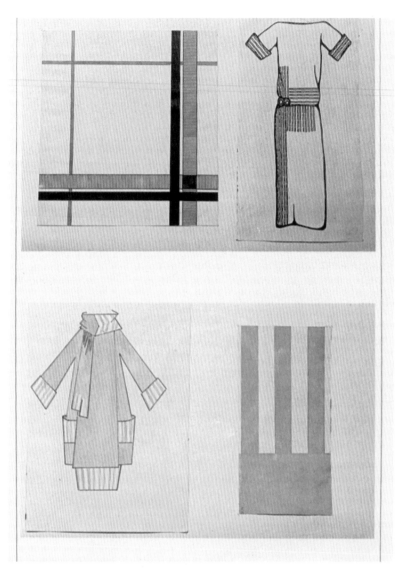

Constructivism proved to be a field in which women artists of the avant-garde could work productively. This was not because abstraction freed them from the constraints of gender, although to some extent they could work with abstract form to resist conventional expectations of what and how the woman artist should paint. Because construction involved making and unmaking, building and dismantling, it provided some leeway in which to negotiate the problems of the language and its associations. The associations were with the work of industry to which women did not traditionally have access, as well as with the world of women's work in clothing and textiles. By cultural and social convention, the languages of science, rationality and industry already implied the 'masculine', whereas certain aspects of folk-art, especially embroidery, implied the 'feminine'. So the common currency of associations projected upon Constructivism included expectations and assumptions about sexual difference. The very idea of a neutral, collective language was a refusal of certain conventional categories, and by that refusal it brought issues of sexual difference into play. Particular attitudes to the body were expressed in geometric forms, which aimed at symbolizing a new Soviet generation that would not adhere to gender stereotypes (for example, Plate 127).

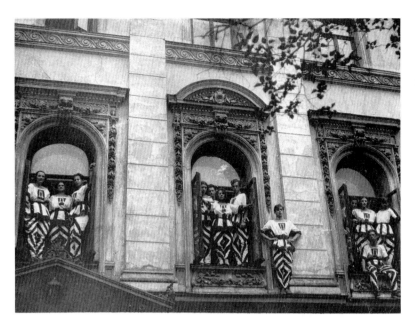

Plate 127 Students of The Academy of Social Education, *c.*1923, dressed in sports clothing designed by Varvara Stepanova. Reproduced by courtesy of Aleksandr Lavrentiev and the Rodchenko Family Archive, Moscow.

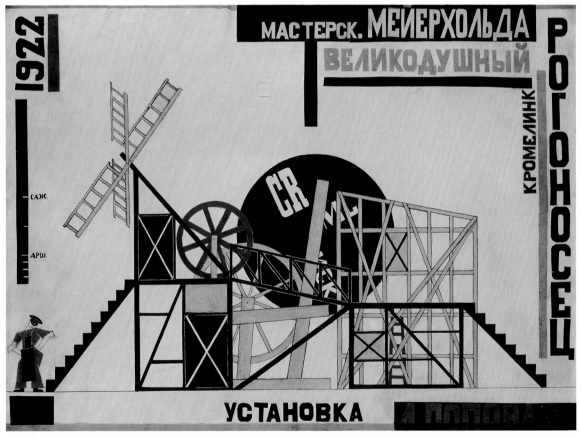

Plate 128 Lyubov Popova, *The Magnanimous Cuckold*, set design, 1922, gouache on paper, 50 x 69 cm. State Tretyakov Gallery, Moscow.

Plate 129 Lyubov Popova,
The Magnanimous Cuckold,
costume design for actor no.5,
1921, pasted paper, india ink,
gouache and collage on
cardboard, 34 x 25 cm.
Private collection, Moscow.

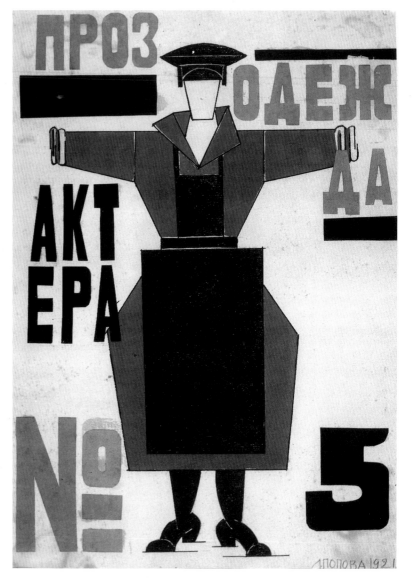

In 1922, Popova designed the costumes and set for the theatre director Vsevolod
Meyerhold's production of *The Magnanimous Cuckold* using basic geometric, coloured
elements (Plate 128). The body was treated as a unit, as a mechanical part, and Popova
introduced variations in her designs to identify the costumes for actor no.1, no.2, and so
on – actors numerically ordered rather than individually named. The play itself was a
nineteenth-century farce about jealous rivalry, the old tale of the cuckolded husband. It
was transformed by Meyerhold's avant-garde techniques, especially his mechanics of
gesture, where the actors' movements were broken down into a series of basic gestures
and stripped of all superfluous movements. The story of a rural village was also trans-
formed into an urban, metropolitan world through Popova's mechanistic set and the
proletarian costumes (Plate 129). The symbolic language of the staging derived from the
modern industrial process, radically reinterpreting a conventional farce. Popova's designs
transformed the body into a geometric construction. Having begun by refuting the 'I' of
artistic creation, the hand, the body and sexual difference, Constructivism projected its
geometric language back onto the body itself, recasting it in terms that were appropriate
to the new society.

Standards of efficiency

Modern production processes

I want now to broaden the discussion to consider other European contexts. For the problem remains: what was it about the geometric that could translate into different cultures and carry with it such potent mythologies of the modern? What could the language of construction mean in other European countries, without the change in conditions that the Revolution had brought?

As we have seen, artists, as constructors, aspired to the norms of industrial production and drew on the models and methods of mass-production. The language of 'norms' and 'standards' was very much part of the developing discourse of Constructivism in the twenties. These features of modernization were seen as exemplary expressions of modernity. The geometric designs of Stepanova's and Popova's clothing redefined the body as a component part within the collective, de-eroticized it and made it uniform; the emphasis was on a standard, a type, rather than the individual. What is striking here is that the language of modernization in a communist culture drew on capitalist prototypes of efficiency in industrial production. The leaders of the Russian Revolution were enthusiastic advocates of US models of rationalization in industry as a means of modernizing a backward economy. The two exemplary models of modernization were taken to be those of Henry Ford and Frederick W. Taylor. Ford had introduced the conveyor-belt system and standardization: the famous Model T Ford (Plate 130) was designed and produced on the basis of standard parts. Taylor's theory of scientific management was a system of organizing work in which the production process was broken down into its most basic components, and each segment or task measured and timed, to maximize efficiency and output. Both systems had been developed in the USA and were introduced into Europe as part of a general process of Americanization that was seen as synonymous with modernization.

When the LEF critic Arvatov wrote in 1923, 'The radical leading faction of our modern intelligentsia, the so-called technological intelligentsia, has been "Americanized"', he saw this development as a necessary part of modernization; he welcomed it (Arvatov, 'Art and class', p.43). It may seem odd that the epitome of Western capitalism was taken as a model of modernization in the twenties in Russia, but Lenin had made very clear the urgency of using all means available to modernize the Soviet Union, and this meant taking advantage of all that capitalism had left behind. It was vital to improve production, and Lenin believed that scientific management could be used to communist ends. He wrote:

> The Taylor system, the last word of capitalism in this respect, like all capitalist progress is a combination of the subtle brutality of bourgeois exploitation and a number of its greatest scientific achievements in the field of analysing mechanical motions during work, the elimination of superfluous and awkward motions, the working out of correct methods of

Plate 130 The First Model T Ford, 1909. Reproduced by permission of the Ford Motor Company.

work, the introduction of the best system of accounting and control, etc. The Soviet Republic must at all costs adopt all that is valuable in the achievements of science and technology in this field …

(V.I. Lenin, 'The immediate tasks of the Soviet government', p.259)

Various books were published on Taylorism in Russia in the early twenties, and another LEF critic, Boris Kushner, became involved in analysing how scientific management could be applied to industry. Arvatov also spoke of the theatre as a 'strictly utilitarian, Taylorized shaping of life, instead of the theatricalization of life' (Arvatov, 'Utopia or science', p.278). He envisaged the fusion of the theatre with science, technology and social life: Taylorist principles were taken to be those of efficiency, discipline and modernization. In this way, the language of efficiency, together with Ford's notion of standard types, entered the language of culture. Taylorism, which Lenin saw as the 'last word' in capitalism, was also seen by many in the West as the clearest expression of the process of rationalization, the key feature of modernity. The important point here is that Taylorism and Fordism were treated as exemplary models of the transformations in industrial production and social life. They were models of efficiency, which pervaded all aspects of social life. They became part of the popular imagination too: Taylorism became a sort of shorthand for a dehumanized, robotic mode of life. The references to Ford and Taylor were not necessarily accurate, but they articulated a range of attitudes to modern life, and focused on what were seen as key features of modernization – repetition, standardization, rationalization, efficiency, accuracy, precision, time-keeping. There is not the space here to go into the complex ways in which different European countries assimilated these US models of production and organization. All I shall do is draw attention to a powerful set of ideas about the character of modernity and modernization at this period. The geometric in art could signify an ethos of efficiency in industrial production that seemed to be sweeping the world, and to be pervading every aspect of social life.

In Germany, for example, Walter Gropius, the architect and director of the Bauhaus at Weimar, announced the school's new programme in 1923 as 'Art and technology – a new unity'. The new Bauhaus buildings in Dessau (where the school moved in 1925, Plate 131)

Plate 131 Lucia Moholy, photograph of the Bauhaus, Dessau, 1925–26. Reproduced by permission of the Bauhaus Archiv, Berlin.

were designed by Gropius to exemplify this ethos. Gropius had managed to steer the Bauhaus from its early roots in Expressionism, where mysticism had played a vital part through the work of Johannis Itten, to this uncompromising commitment to technology. Itten left in 1923, and was replaced by Moholy-Nagy, a keen supporter of the new programme. For Gropius, 'Standardization is not an impediment to the development of civilization but, on the contrary, one of its immediate prerequisites' (Gropius, *The New Architecture and the Bauhaus*, p.34). Moreover, standardization was a manifestation of the more general tendency of rationalization: 'We are approaching a state of technical proficiency when it will become possible to rationalize buildings and mass-produce them in factories by resolving their structure into a number of component parts' (p.39). The standardization of parts would lead to a greater efficiency in building, which would also meet modern aesthetic requirements for structural logic and simplicity. The same requirements would be met in all branches of art, architecture and design as they were approached at the Bauhaus. Even in the craft sections of the school, such as weaving, the same commitment to the geometric can be seen (Plate 132).

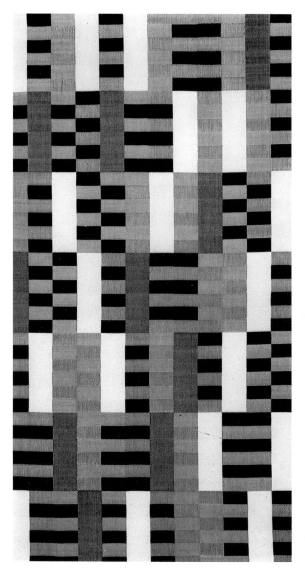

Plate 132 Anni Albers, wall hanging (double weave), *c*.1925–26, 222 x 122 cm. Bauhaus Archiv inv.1474.

This change in taste was seen to have occurred in all aspects, and at all levels of cultural life. The German critic Siegfried Kracauer noted how such changes in taste took place 'quietly', and often in the least likely places. Kracauer's interest was not in 'high art' but in the broader context of popular culture. In a critical essay of 1927, 'The mass ornament', he focused attention on what he would later term the 'spatial images' of modern life – the mass spectacles of physical culture in the sports stadium and modern popular dance formations. These were images and analogies that, as we shall see, artists also deployed in writing about their work, but Kracauer is of interest here because of the way in which he identifies the mass ornament with the modern production process. 'The mass ornament', he wrote, 'is the aesthetic reflex of the rationality aspired to by the prevailing economic system'. Under the prevailing economic system, work was organized in the service of the machine, where 'everyone goes through the necessary motions at the conveyor belt, performs a partial function without knowing the entirety' (p.70). And this mode of organization according to rational principles was simply taken to its final conclusion in the Taylor system. Mass spectacles articulated this range of symbols as a mythological cult – and the masses took a legitimate pleasure in them, more so than in an art 'which cultivates obsolete sentiments'.

Kracauer's central example is The Tiller Girls (Plate 133), the dance troupe imported into Europe in the 1920s. Although they were originally British, Kracauer saw them as typical products of American 'distraction factories [who] are no longer individual girls, but indissoluble female units whose movements are mathematical demonstrations … [performed with] geometrical exactitude' ('The mass ornament', p.67).

These spatial images were analogous with modern production processes, where human beings serviced machines. The Tiller Girls were no longer women, but units, component parts arranged in regular patterns, symbolically transformed. And Kracauer makes a comparison with earlier forms of ballet: though these, too, yielded 'ornaments' or spatial images, they still operated as symbols of the formation of erotic life. With The Tiller Girls, in contrast, 'the synchronized movement of the Girls is devoid of any such connections; it is a linear system which no longer has erotic meaning but at best points to the place where the erotic resides' (p.68).

Plate 133 Laurence Tiller Troupe, from *Folies Bergère* at London Palladium, 1925. Mander and Mitchenson Collection, Beckenham. Photograph by Eddie Richardson.

Kracauer believed that geometricity pervaded all forms of culture and that the modern production process provided, for better or worse, the symbols with which culture had to work; when large amounts of reality are obscured and thus made invisible, art has to work with what is left. High art, then, had no monopoly on these symbols but worked with them, and transformed them in particular ways. The distinctive character of art lies in the way in which it is able to draw attention to the conditions of its own making, its formal constituents; but it also draws on the symbolic trappings of modernity – modernity understood as rationalization. Thus, as Meyer Schapiro could point out in 1937,

> The older categories of art were translated into the language of modern technology; the essential was identified with the efficient, the unit with the standardized element, texture with new materials, representation with photography, drawing with the ruled or mechanically traced line, colour with the flat coat of paint, and design with the model or instructing plan.
>
> (M. Schapiro, 'The nature of abstract art', pp.209–10)

These observations certainly seem to be borne out by the French Purist journal *L'Esprit Nouveau*, to which I referred at the beginning of this chapter in the context of its particular view of modernity. Where *L'Esprit Nouveau* differs from the other examples we have considered so far is in its insistence on notions of the absolute, on the essential and the universal. In their article 'Esthétique et Purisme' ('Aesthetics and Purism') in the first number of *L'Esprit Nouveau*, Ozenfant and Le Corbusier wrote that 'forms and primary colours have standard properties (universal properties which allow the creation of a transmittable plastic language)'. That is, we see the language of absolutes, of certain universal forms, converging with Ford's model of the standardized unit.

In Jeanneret's painting *Still-life with Pile of Plates* of 1920 (Plate 18), the old category of the still-life was invested with the status of machine-made commodities, made by modern production methods. Still-life elements were represented as 'type-objects' in a photograph in *L'Esprit Nouveau* (Plate 134). They were standardized products that, for the Purists,

Plate 134 *Verrerie et faïence du commerce* (*Commercial Glassware and Crockery*), *L'Esprit Nouveau*, no.24, 1925. Da Capo Press Reprint, 1968, New York.

demonstrated the perfect adaptation of form to function. Drawing on developments in Social Darwinism, the Purists adapted Darwin's theory of natural selection, with its stress on the 'survival of the fittest', to apply to manufactured commodities. They called this process mechanical selection, and meant that an object's fitness for use would ultimately win out against the purely decorative, superfluous ornament of the badly designed *objet de luxe*. The assumption behind this was that modern production processes (and by implication the processes of capitalism) were, like nature, self-perfecting; they would inevitably tend in the direction of utility and rationality and away from luxury and fantasy. Although the pipe, the guitar and the book did not strictly fit into this category, in that they were not in the same way the results of mass-production, they could nevertheless be included as type-objects because their form was thought perfectly to fulfil their function. This was good enough to exemplify an ideal view of production. Moreover, the precision techniques used to make the picture signified that a painting, too, had become a precision object, totally logical in its construction and analogous with the artefact produced by the mechanical process.

The way in which the magazine was made, by juxtaposing texts and images from a wide variety of sources – from paintings to grain elevators to office furniture (Plates 135 and 136) – depended on the same kinds of analogy being made. The office furniture exemplified a Taylorist view of how the office should be organized; as in the factory, each task should be measured and rationalized to achieve maximum efficiency. Le Corbusier was captivated like so many others by the Taylor system. In *Après le Cubisme* ('After Cubism'), written with Ozenfant in 1918, he had recognized that this form of the division of labour took away from workers the capacity to see a job through to completion, but thought that their collective sense of pride at the perfection of the production process and the objects produced would compensate for the loss of craft skills. What appealed to Le Corbusier in the work of both Taylor and Ford was the idea that the production process emulated the machine in its rationality, and could permeate people's habits of mind. The filing cabinet demonstrated the efficiency of storing information in a logical, systematic way; and the design of the Taylorist office had the same systematic basis. This sense of precision and rationality was seen to be infectious and to enter and characterize a modern consciousness, being ideally expressed in modern architecture (Plate 137).

Plate 135 *L'Esprit Nouveau,* no.24, 1925. Da Capo Press Reprint, 1968, New York.

BESOINS TYPES

Meuble d'acier (Ronéo.)

membres-humains sont conformes à notre sentiment de l'harmonie, étant conformes à notre corps (1). Alors on est content..... *jusqu'au prochain perfectionnement de cet outillage.*

Voici l'art décoratif conduit à l'étape accomplie par l'art de l'ingé-

(1) Dès que la machine à écrire est née, le papier à lettres fut standardisé ; cette standartisation eut une répercussion mobilière considérable, conséquence de l'établissement d'un module, celui du *format commercial.* Les machines à écrire, les copies de lettres, les corbeilles à classement, les dossiers, les tiroirs à dossiers, les meubles à classement, en un mot toute une industrie mobilière, fut conditionnée par l'établissement de ce standard ; et les individualistes les plus intransigeants ne sauraient regimber. Une convention internationale s'établit. Ces questions sont si graves que des commissions internationales se réunissent régulièrement pour fixer les standards. Le *format commercial,* n'est pas une mesure arbitraire. Qu'on apprécie plutôt la sagesse (moyenne anthropocentrique) qui l'a établi. Dans toutes ces choses d'usage universel, la fantaisie individuelle s'incline devant le fait humain. Voici des précisions : le rapport de hauteur à largeur du format commercial est de 1,30. Celui de la feuille de papier Ingres est de 1,29. Celui des secteurs des plans de Paris établis par Napoléon Ier est de 1,33 ; des plans Taride 1,33. Celui de la plupart des revues 1,28. Celui des toiles à peindre — figure — (mesure séculaire) 1,30. Celui des journaux quotidiens de 1,3 à 1,45, celui des plaques photographiques 1,5 des livres 1,4 à 1,5, celui des tables de cuisine du Bazar de l'Hôtel-de-Ville 1,5 etc., etc.

Ceci est froid et brutal, mais c'est juste et vrai ; ce sont là les bases (Or'mo.)

Plate 136 *L'Esprit Nouveau,* no.24, 1925. Da Capo Press Reprint, 1968, New York.

Plate 137 Maison La Roche, Paris. Photograph by Tim Benton.

'A lesson in economy'

According to Purism, geometricity pervaded every aspect of life. Although Fernard Léger was never a Purist, he was fairly closely allied with the Purist view of modern technology in the early and mid-twenties. His large painting *Le Grand Déjeuner* (Plate 138), exhibited at the Salon d'Automne in 1921, was reviewed by Ozenfant in *L'Esprit Nouveau* and illustrated next to a photograph of the liner *Paris* (Plate 139). Ozenfant admired the way in which Léger had organized volumes on the surface of the picture; and by implication, that ordering of the picture was analogous, in Purist terms, with the disposition of volumes in the modern ocean liner. Typically, Ozenfant's comment on the ship could also apply to painting: 'What a lesson in *economy*, and how one can be persuaded of the fecundity of the Modern Spirit before such constructions' (*L'Esprit Nouveau*, no.13, p.1506). *Le Grand Déjeuner* is a large-scale figure painting depicting three female nudes, two reclining, one sitting. It is the most ambitious of a series of nudes that Léger painted in the early twenties. These paintings of odalisques (the female slaves in a harem) appear to deny the voyeuristic pleasure conventionally associated with representations of a sensual female body; instead they reinstate a different sort of pleasure, where the glint of moulded plastic stands in for hair, where the surfaces are hard and almost uniformly flat. There is a metropolitan or artificial quality to the figures, a mannequin-like sameness to them, a sense of the popular, and also a certain irony. When Ozenfant commented that Léger was an artist who displeased those who wanted art to be 'une chose aimable' ('a likeable thing'), he was pointing to something unremitting and harsh in the work, while missing the quirkiness that went with it. For in Léger's reinterpretation of the *Déjeuner* theme in modern painting, the nude's monumental proportions have a lumbering heaviness about them; limbs are treated with the clarity of curved metal, yet there is something ridiculous about those hands and feet, where a bunch of toes echoes a bulbous kneecap. This was not *quite* the high seriousness of the Classical tradition, reasserted in the post-war years, with its connotations of French nationhood and a French tradition.

However, Léger's painting does show, I think, the way in which a concern with the formal order of a painting, the use of geometric form and pattern, can refer to traditional artistic categories *and* at the same time to a view of modernity in which forms are standardized, translated into the norms of mass-production. This is not a case of 'either/or', but rather of more than one reading being possible at once, even of one working against another. For Léger to choose, for example, the motif of odalisques, current though this was in the early twenties, meant taking a theme traditionally associated with luxury, with the exotic and with voluptuousness in the French tradition, and transforming it into something close to a utilitarian object. In 'The machine aesthetic' (p.53), Léger wrote that 'It is undeniable that in the mechanical order the dominant aim is *utility*, strictly utility'. As it was for the Purists, this aim or tendency was exemplified by the positive virtues of mass-produced objects as against the negative terms of decoration and fantasy associated with *objets de luxe*.

In *Le Grand Déjeuner* the nude was represented as an object on display like a manufactured object, a shiny pristine commodity like any other, like the vase in the top-right corner, like the artefacts making up the still-life group at the centre. This treatment of woman as precision object was an aspect of Léger's refusal of the existing hierarchy of objects, and tied to his view of what a modern spectacle looked and felt like. Léger identified the spectacle of modern life in the art of window display, where the street was transformed into a permanent display of the modern according to a geometric sense of order (Plate 140). In this context, the view of woman as mannequin was an extension of

Plate 138 Fernand Léger, *Le Grand Déjeuner* (*The Meal, large version*, or *Three Women*), 1921, oil on canvas, 184 x 252 cm. Collection, The Museum of Modern Art, New York; Mrs Simon Guggenheim Fund. © DACS, London, 1993.

Plate 139 The liner *Paris* and Fernand Léger's *Le Grand Déjeuner*, *L'Esprit Nouveau*, no.13, pp.1504–5, 1923. Da Capo Press Reprint, 1968, New York.

Baudelaire's notion of the spectacle of the city – where now the nude is objectified, repeated, effaced, made to stand for another set of objects. The language of efficiency rendered the female form the product of the modern industrial process, on display and consumed in a spectacle of consumption. As a picture, *Le Grand Déjeuner* poses the problem in particular terms, in so far as this is not a picture of women but of women as signs for something else, in a new kind of mythology. Since they are placed in a geometric context, the female figures don't maintain the conventional link between the 'feminine' and 'nature', but instead are used as a sign of commodity production.

To sum up, the discourses of modernization could be marshalled in widely differing contexts: in the collective language of utilitarian Constructivism; in the 'new unity' of art, architecture and design at the Bauhaus; as exemplary of a change in taste in popular culture; as something to be addressed by 'high art' in its own distinctive way. It was 'translatable' in this sense into different cultures, but also from one form of culture to another. In the final two sections of this chapter, I shall look at the possible responses to rationalization; first, the pursuit of painting as the most resistant and resilient form of culture, and second the option of pursuing alternatives to high art in various mass cultural forms. I consider these as options open to artists in the inter-war period. My discussion of painting focuses on just two examples of paintings, one by Matisse and one by Mondrian, and asks how a geometric abstract art, identified with construction and utility,

Grands Magasins du Printemps

VITRINE DU BOULEVARD HAUSSMANN 1927

Plate 140 Shop window display, Boulevard Haussmann, *Bulletin de l'Effort Moderne*, 1927. Bibliothèque Nationale, Paris.

relates to the idea of the decorative. Finally, I point to some of the claims made for the abandonment of painting and in favour of photography and film, following the Russian example, which seemed to follow the logic of historical conditions.

Luxury, utility and the decorative

The constructive and the decorative in painting

I began this chapter by questioning what ground might be shared by two metal constructions (Plates 77 and 78), and what differences, despite the similarities in their appearance, might mark them apart. Now turning to consider two paintings, I want to suggest that while formal similarity may not necessarily unite works of art in a shared purpose, so formal difference may mask common interests. Henri Matisse's *Decorative Figure on an Ornamental Ground* (Plate 141) and Piet Mondrian's *Composition with Red, Yellow and Blue* (Plate 142) have conventionally been seen by art historians to exemplify two distinct tendencies in modern art, the 'decorative' and the 'constructive'. Where Matisse is often taken to be the supreme exponent of the 'decorative' in art, sometimes even, pejoratively, as a 'mere decorator', Mondrian's art is thought of as the antithesis of 'decoration' – stripped of ornament, and pure. It may be that by opening this opposition to scrutiny, we will find some common ground between works such as *Decorative Figure* and *Composition* that will shed a rather different light on the apparently pure and *un*decorative aesthetic of the constructive tradition. The observation that Mondrian's is as much a 'pattern' as Matisse's – the sort of observation often deemed uninformed – may actually take us further in working out the 'decorative' aspects of both, decorative aspects that may then be seen to carry particular associations. After all, the straight line is not inherently 'purer' than other configurations – but why it came to be seen so is the question.

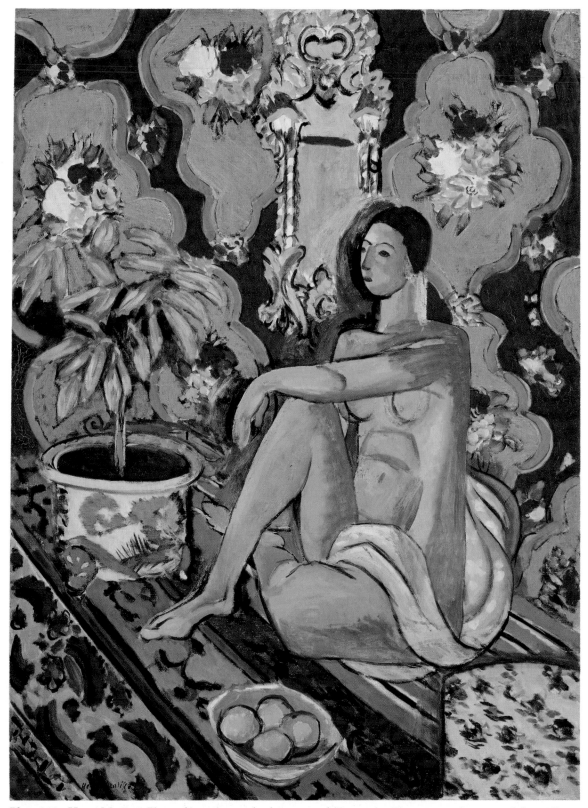

Plate 141 Henri Matisse, *Figure décorative sur fond ornemental* (*Decorative Figure on an Ornamental Ground*),
1925–26, oil on canvas, 130 x 98 cm. Musée National d'Art Moderne, Centre Georges Pompidou, Paris.
© Succession H. Matisse, Paris and DACS, London, 1993.

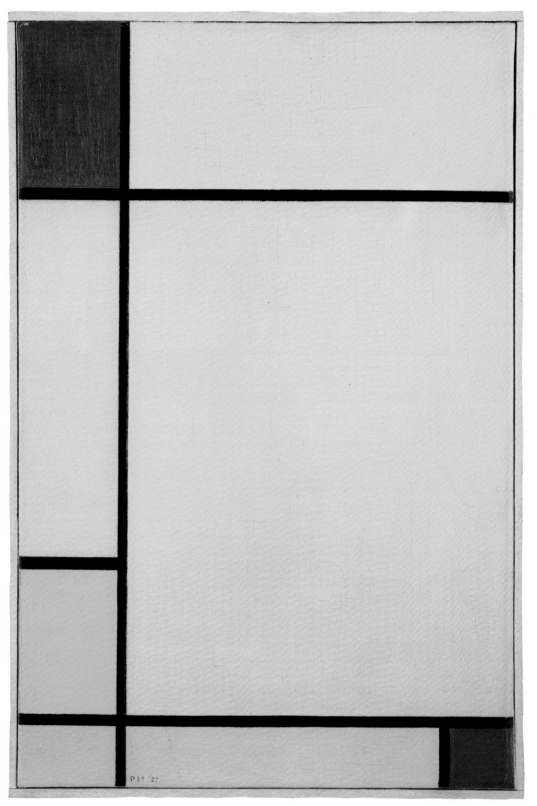

Plate 142 Piet Mondrian, *Compositie met rood, geel en blauw* (*Composition with Red, Yellow and Blue*), 1927, oil on canvas, 61 x 40 cm. Stedelijk Museum, Amsterdam. © DACS, London, 1993.

Where difference is most apparent is in the treatment of the surface of the works. It is not in the type of object they are: both are easel paintings, both were painted in oil on canvas, both have a vertical format although the Matisse is rather larger than the Mondrian, and both are by artists considered exemplary in the Modernist canon. Already this represents a significantly shared culture, for it sets these paintings apart from the kind of work we have been looking at – which broke away from easel art. What we shall need to decide is the significance we attribute to the differences of treatment.

A provisional description of these differences might go something like this: Mondrian's is an abstract work whereas Matisse's is figurative; Mondrian's composition is made up of straight black lines and three blocks of primary colour on white ground whereas Matisse has filled the canvas with pattern, much of it ornamental, curved and richly coloured; by comparison with this profusion of surface pattern, Mondrian seems to have emptied the canvas, leaving nothing at its centre. However straightforward this description might appear, it assumes a series of contrasts between abstraction and figurativeness, drawing and colour, line and curve, emptiness and profusion. Yet Matisse's *Decorative Figure* is at least as rigorously constructed as Mondrian's *Composition*. It is not simply made up of curved forms – the line of the back of the nude, for example, is quite straight; the angular form of the nude provides a vertical–horizontal axis against which the curves of the 'background' and the sharp diagonal of the carpet are set. The 'ornamental background' of the title does not recede but is represented as, and is, the palpable surface of the work. The apparent 'emptiness' of Mondrian's work is the surface of the canvas painted white: it may be empty of detail but not of substance. Although one of the works may be abstract and the other not, both may 'represent' the world in some way. A significant question to ask in this context is: why, if both Mondrian and Matisse are concerned with surface, is 'pattern' (a word that is supposedly neutral) used of Matisse's work yet considered inappropriate to describe the 'purer' forms of Mondrian?

There are certainly problems with using this orthodox series of oppositions to contrast the works, but nevertheless there is no doubt that Matisse and Mondrian use very different formal vocabularies. And it is not hard to see, at this superficial level at least, why Mondrian and Matisse have been thought of as representing two distinct tendencies in the development of modern art – the constructive versus the decorative. Rather than reproduce this kind of formal distinction, what I want to do here is to question the historical currency of the terms – of construction and decoration, of precision and pattern, of utility and luxury.

First, though, a few points about the use of the term 'decorative' need making.[6] For what is it to call the work of Matisse 'decorative'? Does it refer to the decorative surfaces that are depicted in the picture, such as the patterned wallpaper, or to the decorative surface of the picture itself? Though I don't rule out the significance of the type of objects that Matisse chose to paint, he undoubtedly made 'decorativeness' a property of the picture surface; it is the way in which those objects are depicted on the surface which forms the distinctive character of the work. So firstly, for Matisse, decorativeness was not equated with detail or profusion of detail; in the title, for example, Matisse drew a distinction between the 'decorative' figure and the 'ornamental' ground, where the figure is the most static and least detailed element in the composition. The 'decorative' and the 'ornamental' were not the same although they were often conflated in the discourse around 'construction' during this period.

In the tradition of Modernist criticism, value is attributed to 'decorativeness' as a property of the picture surface. Whatever reservations we may have of this view of modern art, one of its strengths is that it does not conflate decoration with ornament. In 'An essay in aesthetics' (pp.32–3), Roger Fry made the distinction between the 'merely decorative' (which satisfied a need for order – a sensual pleasure) and the elements that evoked emotion (those elements which distinguished 'art' from other decorative artefacts).

6 See also the discussion of decorativeness in Chapter 1 of Harrison *et al.*, *Primitivism, Cubism, Abstraction*.

Fry did not connect decoration with adornment: it was not 'surplus' to the work (as added, ornamental detail might be), but alone it was insufficient. Likewise Greenberg, writing later, used the term 'decorative' to apply, not to the ornament but to the treatment of the surface of the picture. He made a distinction between 'decoration pure and simple' and another, more significant form of decorativeness that was at the heart of the high Modernist project. 'Cubism', he wrote, achieved in the hands of Picasso, Braque, as well as Léger, a 'new, self-transcending kind of decoration by reconstructing the picture surface with what had once been the means of its denial' (Greenberg, 'Collage' p.80). This 'transfigured kind of decoration' was something Greenberg also identified in the work of Matisse: 'the distinction between the purely decorative and the pictorial had already been deprived of much of its old force by Matisse…' (Greenberg, 'Picasso at seventy-five', p.64). In these terms, it was possible for both Mondrian and Matisse to be engaged in the project towards flatness and thus 'decorativeness', taken in the sense not of ornamentation or adornment but of the quality of the surface. Although Mondrian may exclude from his work all vestiges of the ornamental, it may be quintessentially 'decorative' in the way the surface is laid bare. For Greenberg, it is not irrelevant to consider whether the artist has used a hard-edged technique or richly worked brushwork, for that is vital as part of the means of representation displayed; but it is not the factor determining whether the work is 'decorative' or not.

When I looked at the differences between the two works, my provisional description separated pure form from the decorative by conflating the decorative with curved forms, a profusion of detail and the ornamental. Greenberg does something quite different. He identifies the decorative with the material and formal qualities of the work and distinguishes it from other expressions of 'mere decorativeness' – such as might be found in decorative or applied art. While it has the virtue of showing Mondrian's work to be as decorative as Matisse's, it abandons the historical currency of decorativeness as it was understood at the time these two works were made. What I want to do here is to consider further how 'decorativeness', as the distinctive character of the work of art, related to other forms of decorativeness as they were understood in social life.

In the history of art, the distinction between the categories of luxury and utility dates back to antiquity; it had been the subject of a long-standing theoretical debate within the French Academy – and was central to, for example, competing claims for the relative virtues of colour and line. The forms they take here were derived in part from these traditional artistic categories, but they were reinterpreted and transformed in the context of the modern.

Mondrian

The distinctive character – and the decorative character – of Mondrian's work was gained at the expense of other types of decorativeness. *Composition with Red, Yellow and Blue* is made up of the barest minimum, straight lines and primary colours on a white ground. As Greenberg has noted, Mondrian's work showed that art could be made out of very little, even though he also noted that the black lines and coloured rectangles 'may seem hardly enough to make a picture out of' ('Modernist painting', p.8). By stripping down art in this way, Mondrian was testing its authenticity, by taking art to a point where reference to objects in the world appears to be completely resisted. It is an art that it seems entirely inappropriate to try to link with other kinds of social production and experience. Mondrian's work has become a sort of shorthand, a sign, for modern art as a whole. It serves as a sign for a whole range of meanings – the fashionably 'modern', the incomprehensibly 'modern', the seriously 'modern', i.e. a series of received ideas about 'modernity'. But is 'modernity' a property of the formal qualities of art? Or does the exclusion of certain kinds of reference engender another set of associations that signify modernity and modernization in social life? There may be no 'subject-matter' in Mondrian's work of the

kind found in figurative work, but the technique he used had powerful associations. At least this is how Schapiro saw it in his essay of 1937, 'The nature of abstract art':

> ... the forms of 'pure' abstract art, which seem to be entirely without trace of representation or escapist morbidity – the Neo-Plasticist works of Mondrian and the later designs of the Constructivists and Suprematists – are apparently influenced in their material aspect, as textures and shapes, and in their expressive qualities of precision, impersonal finish and neatness (and even in subtler informalities of design) by the current conceptions and norms of the machine.
> (Schapiro, 'The nature of abstract art', p.206)

This does not simply reproduce the familiar formal divisions (Schapiro was taking issue with the ahistorical and purely formal categories put forward by Alfred Barr to explain the development of abstract art), but tries to account for them. 'Apparently influenced' is a fairly loose way of connecting art with current views of the machine and technology, but he seizes on the suggestiveness of certain forms, while emphasizing the 'material aspect' of the works. This is not to claim that abstract works have a subject-matter, as veiled or hidden representations of the machine: for Schapiro, it is the abstract elements and the way in which they are painted that have symbolic force. It is not only subject-matter that carries meaning, but also forms and techniques.

As we have seen, the aversion to individual subjectivity, to decoration, ornament and luxury, was seen by many in the twenties as *the* characteristic feature of 'construction' in art. In the Dutch magazine *De Stijl*, J.J.P. Oud argued that the struggle of the modern artist was the struggle against feeling, where 'feeling' stood for the subjective, which was 'arbitrary, the unconscious, the relatively indeterminate' ('Art and machine', pp.96–8). It stood for the individual, as against the collective. Mondrian argued that modern painting was marked by 'a quest for *freedom from individuality*', and that by expressing the *universal*, as opposed to the individual, Neoplasticism was the 'plastic *expression of the contemporary age*' (Mondrian, 'From the natural to the abstract', p.70). At work here, it seems, is a potent mythology of the modern, and one in which a vocabulary of geometric forms was seen as characteristic of modern life. The mythology was marked by particular clusters of categories, which, as Schapiro remarked, depended on current conceptions. If, for example, we turn for a moment to the connotations of the 'decorative' in the debates about the decorative arts from the end of the last century, we find that the antithesis between luxury and utility was linked to that between the hand-made and the machine-made. Decoration was generally associated with luxury and the hand-made. Advocates of mechanization made utility and simplicity virtues of machine production. Critics of machine production, on the other hand, such as those involved in the Arts and Crafts Movement, objected to the fussy decoration of *machine*-made goods; Oud thought the cardinal error of John Ruskin and William Morris was that they had brought the machine into disrepute by stigmatizing an 'impure' use of its 'essence'. For the De Stijl group the language of absolutes, of purity, of essence, was harnessed to modern production processes, and this in turn stigmatized the decorative.

The world of commodities, both machine- and hand-produced, surrounded people with a range of available associations and meanings about the desirability and otherwise of decoration. Then, as now, it was not simply a matter of individual taste – that some people preferred heavy damask and highly furnished interiors while others preferred a simpler design – but a question of values, beliefs and attitudes. One theory of why people discriminated between objects had been put forward at the turn of the century by the US sociologist Thorstein Veblen. He thought that the way people chose between objects implied a social stratification of objects based on class. In *The Theory of the Leisure Class* (1898), Veblen referred to the 'physiognomy of goods', which Marx had identified earlier in his discussions of commodity fetishism in *Das Kapital*. Veblen's was a theory of commodity consumption which stigmatized decoration by allying it to the leisure classes'

(unconscious) desire to display what he called 'conspicuous waste' – to show that they were consumers without being producers, leisured and thus untarnished by the world of productive labour. In dress, for example, Veblen saw the 'insignia of leisure' as rendering that class incapable of productive labour – taken to extremes in corsetry that made women permanently unfit for work (*The Theory of the Leisure Class*, p.121).

Veblen argued that it was exchange-value (cost) that made certain kinds of object seem desirable, rather than use-value (how suited the object was to its purpose). Hand-made objects were more desirable because they were expensive, even though cheaper, machine-made products might actually have 'greater perfection in workmanship and greater accuracy in the detailed execution of the design' (p.115). Luxury goods were seen as superior by the upper-middle class even though they might be 'imperfect' and less accurate. Underlying this view was the idea that luxury and decoration were 'backward' tastes, while machine production was progressive.

Although by the twenties it was not the case that highly decorative objects were the most expensive, 'decorativeness' could still have connotations of backwardness, ostentation and vulgarity. Le Corbusier, writing in 1925, observed:

> Previously, decorative objects were rare and costly. Today they are commonplace and cheap. Previously, plain objects were commonplace and cheap; today they are rare and expensive … Today decorative objects flood the shelves of the Department Stores; they sell cheaply to shop girls.
>
> (Le Corbusier, *The Decorative Art of Today*, p.87)

Decoration remained tainted, partly by its appeal to women, partly by its appeal to the working and lower-middle classes. 'Trash', he wrote (p.87), 'is always abundantly decorated; the luxury object is well-made, neat and clean, pure and healthy, and its bareness reveals the quality of its manufacture'. Decoration was a disguise for poor-quality work. The correlation implied is of decoration with unhealthiness and dirt, and the plain, modern object with hygiene and health. When Le Corbusier entitled his book *The Decorative Art of Today,* he was, of course, ironic. For, as he wrote:

> this is the paradox: why should chairs, bottles, baskets, shoes, which are all objects of utility, all *tools*, be called *decorative art*? … this is the world of *manufacture*, of industry; we are looking for a standard and our concerns are far from the personal, the arbitrary, the fantastic, the eccentric; our interest is in the norm and we are creating type-objects.
>
> (Le Corbusier, *The Decorative Art of Today*, p.84)

The book appeared at the time of the 1925 exhibition and was based on a series of articles anticipating the preference for the art deco style prevalent there (these articles had been published in *L'Esprit Nouveau*). Le Corbusier illustrated the kinds of object that embodied utility, efficiency and convenience, such as the Hermès leather products (Plate 143), the simple boater (Plate 144), the brogue shoe (Plate 145). The implicit connotations of class and gender continue: as opposed to the shop-girl's taste for decoration, these objects demonstrate the taste of the well-heeled, bourgeois gentleman.

Le Corbusier's view of decoration owed much to that of Adolph Loos, whose essay 'Ornament and crime' he reprinted in the second number of *L'Esprit Nouveau* in 1920. For Loos, ornament represented wasted labour, wasted material and wasted capital. Furthermore, the modern form of luxury *was* utility. For the modern man to be dressed correctly, he argued elsewhere, was to be dressed in the least noticeable way. He saw utility and the exclusion of ornament as the sign of civilization:

> Happily the grandiose development in which our culture has taken part in this century has overcome ornament … The lower the culture, the more apparent the ornament … The march of civilization systematically liberates object after object from ornamentation.
>
> (A. Loos, 'Ladies' fashion', p.102)

Plate 143 *L'Esprit Nouveau,*
no.24, 1925. Da Capo Press
Reprint, 1968, New York.

Articles de série

Plate 144 *L'Esprit Nouveau*, no.24, 1925
('mass-produced items'). Da Capo Press Reprint,
1968, New York.

Plate 145 *L'Esprit Nouveau*, no.24, 1925. Da Capo
Press Reprint, 1968, New York.

Loos made this comment in an essay on women's fashions, where he contrasted women's clothing – trapped in an earlier phase – with men's clothing, which was the epitome of utility, stripped of all ornament. In Loos's model, ornament is gendered by implication.[7] 'Modernity' is represented by the simple, precise and understated masculine mode of dress. The model also underlies Le Corbusier's discussion of the decorative. When Le Corbusier went on to describe the shop-girl who bought cheap decorative trash, he dressed her in a flowery cretonne dress, as if 'feminine' decorativeness in fashion was synonymous with surplus ornament. He also compared her to an apparition from the showcases of the costume department in an ethnographic museum (*The Decorative Art of Today*, pp.89–90), bringing together notions of femininity, decorativeness and the 'uncivilized' (see also Chapter 1 of Harrison *et al.*, *Primitivism, Cubism, Abstraction*).

Like Loos, Le Corbusier and many others, Mondrian in his writings drew on an analogy with contemporary fashion. He did not distinguish between different types of fashion and their relative merits, as Le Corbusier did, but used the analogy to suggest general parallels between art and social life. The fashion analogy is linked, by association, with the machine: 'More and more, the *machine* displaces natural power. In fashion we see a characteristic tensing of form and intensification of colour, signifying the departure from

[7] For an interesting discussion of these issues, see P. Wollen, 'Cinema/Americanism/the robot', and his earlier discussion of the decorative in 'Fashion/Orientalism/the body'.

the natural' (Mondrian, 'Neoplasticism in painting', p.64). For Mondrian, this all-important departure from the natural had consequences for representation: 'The capricious forms of rural nature become tautened in the *metropolis*...' ('The realization of Neoplasticism in the distant future and in architecture today', p.166). Metaphors of 'straightening' and 'tightening' are linked with metropolitan, mechanized forms. And the force of the fashion analogy is that 'the contours of the human figure cannot be straightened except by clothing...' ('The realization of Neoplasticism...', p.165). Nature and the body are de-natured and de-eroticized.

To exclude anything remotely evocative of 'nature', the artist had to concentrate on the most basic elements of formal difference, the vertical and the horizontal, the flat planes within the frame, the primary colours plus black and white. Yet the exclusion of one set of meanings brought with it another, a set of analogies and metaphors that gave extraordinary force to the straight line. The line in an asymmetric grid became the emblem, for Mondrian, of modernity and of the transformations in modern social life. It is not the literal equivalent of social life, but emblematic in that the straight lines as they are painted on the canvas are saturated with associations with a particular view of modern social life. This attitude to modernity grouped together certain areas of social life: these were picked out and revealed as connected, adjacent and dependent on one another. To the machine, the metropolis and fashion, Mondrian added popular forms of dance: 'In *modern dance steps* (boston, tango, etc.) the same tensing is seen: the curved line of the old dance (waltz, etc.) has yielded to the straight line...' ('Neoplasticism in painting', p.64). However arbitrary, or even eccentric, the connections may appear, the fact that they could have been made at all reveals some underlying set of beliefs about what the 'modern' entailed, and at some level enabled Mondrian to produce the work that he did (far more complex work, though, than the sum of such statements).

In his writings, Mondrian made an analogy between formal configuration and what he termed the 'male' and 'female' elements. Mondrian saw his as an art in which dualities were reconciled, including the male/female duality. The 'male' element he associated with 'spirit', 'abstraction' and 'inwardness'; the 'female' element with 'nature', 'representation' and 'outwardness'. 'In naturalistic painting', he wrote, 'the plastic expression was predominantly female outwardness, for natural colour and the capricious undulating line were the expressive means' (Mondrian, 'Neoplasticism in painting', p.92). He saw a progression from the predominantly 'female' character of representation to the predominantly 'male' character of abstraction:

> In painting, domination by the female element was abolished when the male element in our mentality became more determinate. The art changed its expression: *representation* faded and the *plastic itself* grew increasingly towards female–male equilibrium.
> (Mondrian, 'Neoplasticism in painting', p.93)

Mondrian believed that, in Neoplasticism, these dualities (male/female, mind/matter, inwardness/outwardness) could be reconciled. The point to note here is that these are conventional, rather than absolute, oppositions – and part of a system of beliefs that was cultural rather than natural. As stereotypical elements in a mythology of the modern, they refer both to a gendered, modern mentality, reminiscent of Loos, and to the gendered identification of certain formal properties in art – for example, in the way nature has been represented. To imbue an undulating line with 'femaleness' was to follow a path well-trodden in academic discourses on art. To eschew all other geometric forms apart from the straight line was, however, to risk accusations of arbitrariness, particularly in the context of analogies with the machine: machines obviously don't use only straight lines. When Mondrian considered the circle (a form, as he acknowledged, to be found in factory installations, machinery and wheels), he added a rider: 'Roundness in such cases usually takes the form of a pure circle, which is far from nature's capriciousness' ('The realization of Neoplasticism...', p.169). The distinction is clearly artificial, and in Mondrian's work

the oppositions are artificial in the literal sense: they are made on the canvas using the line and the plane as the basic constituents of painting.

Mondrian's *Composition* (Plate 142) signified one myth of modernity, eschewing as it did the curve and other conventional symbolic attributes and signs of the body (for instance, the erotic, the natural), in favour of the geometric aspect of rationalization. In this respect, it was constructed as much out of the spectral image of Matisse's *Decorative Figure* as out of the positive signs of machine production and the selective forms of popular culture that it drew on. If by pattern we mean a formal configuration of lines and surfaces, then Mondrian's use of pattern was as decorative as that of Matisse. For the decorative surface questioned the identity of art, the limits of the medium, and the power and artificial character of modernity itself. Mondrian wrote that 'Art is already in partial disintegration – but its end *now* would be premature. Since its *reconstruction-as-life* is not yet possible, a new art is still necessary; but *the new cannot be built out of old material*' ('The realization of Neoplasticism in the distant future and in architecture today', p.167). In this context, the 'new material' can be seen as both the material of art and of social life. The work was both saturated with popular forms of decorativeness, as in contemporary configurations of modernity, and distinguished from them by the relentless pursuit of 'decorativeness' in the pictorial sense, as a property of the surface of the painting. This was its critical character as art.

Matisse

So far, I have concentrated on the implications of 'decorativeness' for interpreting Mondrian's work. Before we move on, I want to make just a few comments on the implications for Matisse's *Decorative Figure* (Plate 141). Although Matisse's work may initially seem to put 'luxury', as opposed to 'utility', on display, the nature of the display is far from straightforward. Some critics argue that Matisse's work at this period (when he was working in Nice) lapsed into complacency, that it was a sort of lacuna between the best work, done before 1920, and the later work. They argue that it had lost its earlier direction, to become an art of mere virtuosity. It is seen as an art of sensual pleasure and luxury – either, according to one view, because Matisse simply lost his artistic grip or, according to another, because these qualities corresponded with Matisse's own position, as himself a representative of a leisured class with more or less the same taste and view of the world as his audience.[8] The implication here is that the artist had succumbed to decorativeness as luxury, in terms akin to Veblen's notion of 'conspicuous waste'. In this light, *Decorative Figure* represents luxury as the antithesis of work and productive labour; the nude signifies *un*productive labour: she is a sign of indolence, placed in an interior crammed with *objets de luxe*, herself just one of several such objects.

However, this fails to take account of a number of issues. First, this is a *painting*. Second, as we have seen, 'decorativeness' was not necessarily associated with costliness, but also with popular taste, the tacky, the vulgar. The objects Matisse represented included not merely the trappings of the bourgeois interior, the oriental, the archaic, but also the cheap knick-knack. This was partly material that Matisse had around him – the interior in which he worked (Plate 146) – and partly material that he acquired especially for his art. The photograph of Matisse at work shows an interior that is quite different from the environment in which Mondrian chose to work (Plate 147). It was the Surrealist writer Louis Aragon who referred to Matisse's repertoire of objects as so many 'props', and to his 'palette of objects'. He wrote: 'We should study the contents of his warehouse of props. We should question the painter, as to the accidents that brought them together, the reveries that led to their selection' (Aragon, *Matisse*, vol.1, p.227). At Aragon's request, Matisse sent him a photograph of vases, pots and other containers, adding a note on the back: 'Objects which have been of use to me all my life' (Plate 148). These were exactly the

8 For a discussion of Matisse's work at this period, see K. Silver, 'Matisse's "Retour à l'ordre"'.

Plate 146 Man Ray, photograph of Henri Matisse with model Henriette Darricarrère, *c.*1920. Reproduced by courtesy of M. Lucien Treillard / Association des Amis et Défenseurs de l'Œuvre de Man Ray, Paris. © DACS, London, ADAGP, Paris, 1993.

sort of 'decorative' objects of which Le Corbusier disapproved, as indicative of the taste for the 'decorative' that he set out to correct in his own selection of mass-produced 'type-objects' for the photograph in *L'Esprit Nouveau* that we've already discussed (Plate 134). Le Corbusier's bottles and glasses were props too, of course, but from a different play.

Matisse returned again and again to the same repertoire of objects – the rococo paper, the oriental ceramic planter, the carpet – in various combinations. And the elaborate Venetian mirror in *Decorative Figure* had also been used in an earlier painting of 1917, *The*

Plate 147 André Kertéz, photograph of Piet Mondrian's studio, 1926. Present whereabouts unknown. Reproduced from M. Seuphor, *Piet Mondrian: Life and Work*, Abrams, New York, 1956.

Plate 148 Hélène Adant, photograph of Henri Matisse's objects, vases, etc., 1946. Private collection. Reproduced in L. Aragon, *Henri Matisse: un roman*, Paris, Éditions Gallimard, vol.1, 1971.

Painter and his Model (Plate 149). Other paintings of this period show the same female models being used and reused, as part of a similar repertoire, and adopting different guises. Many of these were French models dressed as odalisques. The relationship between the representation of the body and the representation of objects, materials and surfaces is a crucial one for Matisse's work. In Plate 141, the nude is on display like the other objects in the picture, most obviously perhaps the bowl of fruit; or, put another way, the material objects may be displayed, like the nude, as objects of desire. The attention to the overall surface of the painting does not allow the nude to have priority over the other objects represented or, indeed, to have the monopoly on desire. The hierarchy is not so much broken down as opened to scrutiny.

Although many of Matisse's 'props', including the nude with its references to the odalisques of Ingres and Delacroix in the nineteenth century, denote the oriental, this is a painting of a French interior. Or rather, this is a painting in which a French bourgeois interior is represented *as* oriental, *as* voluptuous, *as* a harem. Matisse had said that his odalisques were not 'make-believe' because he had seen odalisques in Morocco, so he knew they existed. Yet here, the 'make-believe' element, the sense of paraphernalia, of trappings, is palpable in the artifice of the construction of the painting. Conspicuous display is treated as artificial and, consequently, as *representation*.

Within traditional, fine-art categories, the French term *luxe* had connotations of voluptuousness and eroticism as well as costliness; it had to do with desire. Yet the normal object of desire, the nude woman, is treated awkwardly, with an angularity of drawing that contrasts with the treatment of the setting. Instead, the nude competes for attention with the spectacular patterning of her surroundings; she is not set against a background, for Matisse denies her recession in space – even the black shadow between the face and the mirror serves to focus attention on the surface of the painting. To return

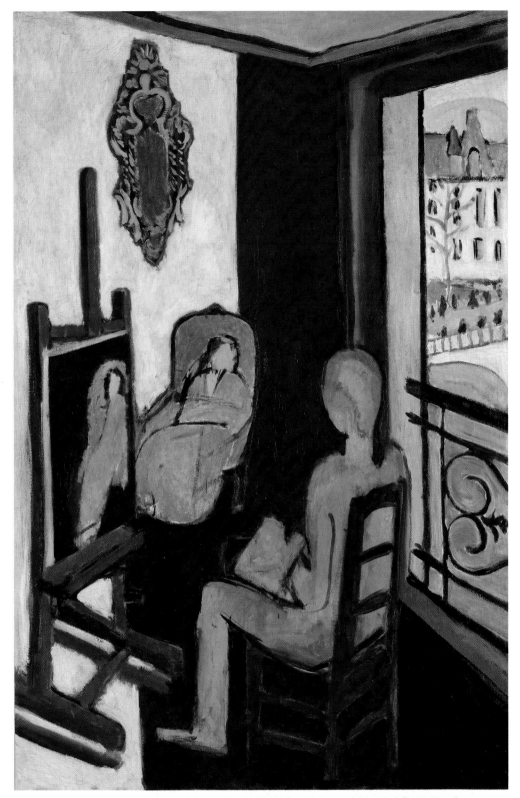

Plate 149 Henri Matisse, *Le Peintre et son modèle* (*The Painter and his Model*), 1917, oil on canvas, 146 x 97 cm. Musée National d'Art Moderne, Centre Georges Pompidou, Paris. © Succession H. Matisse, Paris, and DACS, London, 1993.

to Matisse's distinction in his title for the work (*Decorative Figure on an Ornamental Ground*), it is the ground that is 'ornamental', not the figure. The body is treated differently from the other surfaces, and yet is subject to the associations of the ornamental and of luxury of those parts of the canvas that surround it. The surfaces adjacent to the nude inflect it with meanings and associations; these are displaced onto the female body, rather than inherent in it. These associations work forcefully, so a fairly schematic odalisque figure may seem to be imbued with full harem regalia. Yet the awkwardness of the form of the body remains, drawing attention to this relation. This is not to say that the body is de-eroticized, but rather that the representational process of eroticizing the body (by association with the objects depicted around it) is part of what the picture is about. An aspect of representation that was highly conventional in many ways is shown as a fabrication.

This brief discussion of Mondrian's *Composition* and Matisse's *Decorative Figure* has drawn attention, I hope, to the continually shifting ground on which the discourse on utility and luxury was played out in modern art. It should also have shown that the formal vocabularies used by Mondrian and Matisse were inflected with meanings – meanings that were not inherent in either the straight line or the curve, but that were acquired in particular historical circumstances.

Rationalization and ritual

The 'iron cage' of modern culture

The view of modernity that I have discussed in this chapter is one that identifies modernity with rationalization. It is a view in which modern life, in all its spheres, is seen to be pervaded and controlled by a single calculable logic. This has been a powerful idea in both the writing about modern culture in the twentieth century and in the work and ideas of artists, particularly those who advocated 'construction' as the keystone of their practice. What is at stake is not simply a conflict between rationality and irrationality, between reason and unreason. Those dualities have been a preoccupation of many periods, whereas the historical process of *rationalization* is specifically related to capitalism, as the economic system that has underpinned the development of a modern culture since the late eighteenth century. It was the German writer Max Weber who, in *The Protestant Ethic and the Spirit of Capitalism* in the early years of this century, spoke of the 'iron cage' of modern culture, and who most clearly identified 'rationalization' as its typical feature. He argued that the ethos of modern capitalism was rationalized, routinized, disciplined and ascetic. Moreover, he argued that these salient features of economic life extended to every other sphere of life – including art and religion – and thus that culture was linked to the economic mode of society. Under capitalism, the accumulation of wealth was morally sanctioned if it were accompanied by industriousness, saving and reinvestment, an ethos inherited from Protestantism (this kind of acquisition was different from the kind that aimed at luxury and an idle life). Indeed, 'That powerful tendency toward uniformity of life, which today so immensely aids the capitalistic interest in the standardization of production,' wrote Weber, 'had its ideal foundations in the repudiation of all idolatry of the flesh' (*The Protestant Ethic and the Spirit of Capitalism*, p.169).

The greater purpose of economic efficiency was set against personal greed, and wealth could be compatible with religious belief. The emergence of rationalization predated the emergence of capitalism, but without it capitalism – and the rational organization of labour it entailed – could not have come about. It had been embodied in Puritanism with its 'antagonism to sensuous culture of all kinds' (Weber, p.105). Here rationalization is connected to Weber's idea of 'de-magicization' (*Entzauberung*), or the

elimination of magic from religion and consequently from all aspects of social and economic life – although never completely, and everywhere there are archaic and quasi-magical elements that remain in residual forms. Later writers such as Kracauer, Adorno, Benjamin and others of the Frankfurt school basically accepted Weber's view of rationalization as the salient characteristic of modern culture under capitalism.

The process of rationalization was increasingly evident in industrial production – in factory organization, in the conveyor belt, in the assembly line and in Taylorist methods. Rather than seeing technological changes as reflected in art itself (in paintings of factories or machines, for example), Walter Benjamin turned his attention to the way in which technological change, in particular the inventions of photography and film, had thrown art itself into crisis. In his essay 'The work of art in the age of mechanical reproduction', written in 1936, he argued that the invention of photography had transformed the entire nature of art. The rationalization of the means of production in photography and film rendered 'art' an archaic form of culture. Painting simply could not survive other than as an inadequate anachronism, as a form of ritual incompatible with modern life.

As a Marxist, Benjamin analysed how a society's culture was determined by its basic economic and technical means of production. He called the ritual value of the art object its 'aura', which he argued had been a property of art since its origins in magic and ritual; but it had necessarily lost this aura in an age of mass-produced images. Benjamin drew no historical distinctions between ritual objects and 'fine art': his point was that they served the same purpose, and could be contrasted to non-archaic forms of culture, echoing Weber's process of de-magicization. The unique, authentic 'aura' of the individual art work was the residue of the past, and easel painting was now an irrelevance (but politically dangerous, as the 'aura' and quasi-cultic elements were used under Fascism to aestheticize reactionary politics). It was in film that Benjamin saw the greatest critical

Plate 150 Detail of the bridge sequence from Sergei Eisenstein, *October*, 1927. Photograph by courtesy of the National Film Archive, British Film Institute.

possibilities of contemporary culture (Plate 150). Again echoing Weber's metaphor of the 'iron cage' of modernity, Benjamin wrote:

> Our taverns and our metropolitan streets, our offices and furnished rooms, our railroad stations and our factories appeared to have us locked up hopelessly. Then came the film and burst this prison-world asunder by the dynamite of the length of a second, so that now, in the midst of its far-flung ruins and debris, we calmly and adventurously go travelling.
>
> (Benjamin, 'The work of art in the age of mechanical reproduction', p.238)

According to this view, modernity was a world that incarcerated its inhabitants, a crumbling culture. Not only did film make the picture more precise, it allowed its audience to perceive new structural formations that could not have been evident before. He talked about the 'shock effect' of the film which cut into the narrative, and saw in this an allegory of contemporary ways of perceiving the world: 'In the decline of middle-class society, contemplation became a school for asocial behaviour; it was countered by distraction as a variant of social conduct' (p.240). Here Benjamin was linking contemplative experience with the 'aura' (the old magic of the art work), and 'distraction' and a state of distractedness with the effects of rationalization. This state of distractedness was a peculiarly modern state. This was very different from the way in which rationalization was understood by, say, the Purists, who believed that even everyday objects of machine production shared the virtues of Classical buildings and artefacts with their balance and proportion (for a discussion of this, see Chapter 1).

Distraction

Benjamin's argument was disputed on many points by another member of the Frankfurt school, Theodor Adorno; and, later, Benjamin returned to some of the same issues in a much more subtle form in his essay 'Some motifs in Baudelaire' of 1939 (*Charles Baudelaire*). Responding to Adorno, but also in the light of the complexity of his own responses to works of art, Benjamin modified his view of high art, which he had virtually dismissed in the earlier essay. There he had mentioned almost in passing that the work of Dada seemed to show the destruction of the 'aura' itself; for example, the inclusion of fragments of photographic material in photomontage (Plate 151) might exemplify art's own dissolution. It was this line of enquiry he pursued in the far less deterministic piece on Baudelaire. Where previously he had treated the 'mass' cultural forms of photography and film as the only appropriate means of cultural production, he now found room for the 'high art' of Baudelaire's lyric poetry within the schema of rationalization. Like Dada, but at an earlier stage, Baudelaire had expressed the disintegration of the 'aura', and both this and the forms of mass culture Benjamin celebrated elsewhere could be seen as responses to rationalization in culture.

In the later essay, Benjamin took issue with those who tried to identify 'true' experience *in opposition* to the experience of social life – by which he meant 'the kind which manifests itself in the standardized, denatured life of the civilized masses' ('Some motifs in Baudelaire' in *Charles Baudelaire*, p.110). For Benjamin, the starting-point could only be life in society, and that meant taking into account the effects of mechanization and large-scale industrialization. But rather than regarding these effects as continuous, resolved or Utopian, he identified the experience of modern life as dislocated and discontinuous. Benjamin gave various instances of these effects – for example, in the 'snapping' of a photograph, in the way a telephone receiver could now simply be lifted rather than cranked, and in the experience of moving through traffic which 'involves the individual in a series of shocks and collisions' (p.131). Familiar with both contemporary German and Soviet cinema, he saw these effects as analogous to the 'shock effects' of film, where 'the

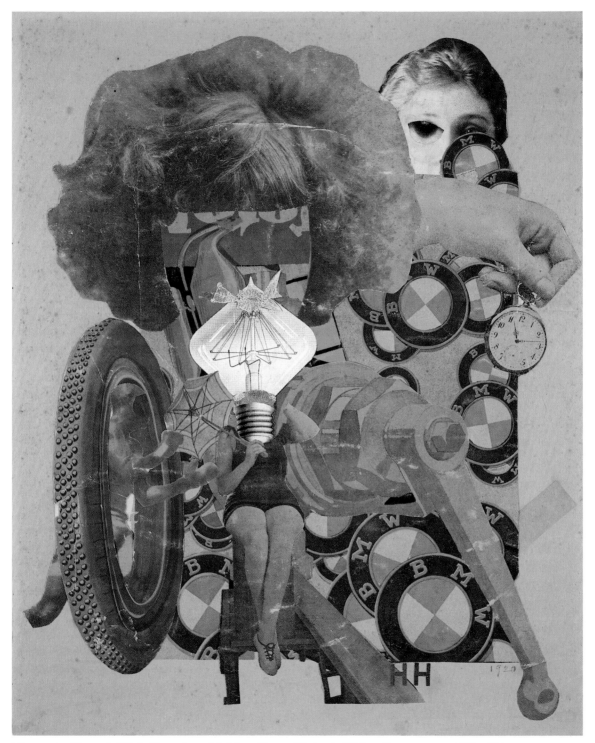

Plate 151 Hannah Höch, *Das schöne Mädchen* (*Pretty Woman*), 1920, collage on paper, 35 x 29 cm. Private collection.

Plate 152 Stills from Dziga Vertov, *Man with a Movie Camera*, 1925. Photographs by courtesy of the National Film Archive, British Film Institute.

rhythm of production on a conveyor belt was analogous to rhythm of reception in film' (p.132) (Plate 152). A worker on an assembly line worked on a product that moved to his or her position and then moved off just as arbitrarily. This differs from the view that the assembly line was characterized by a logical sequence of actions, because from the point of view of the individual worker the effect was of incompleteness, where a single action was stripped of its relation to other actions in the sequence. Benjamin compared this sense of arbitrariness to the experience of the crowd and to gambling, in which one operation was screened off from another in a similarly incomplete way. By extending his analysis to the everyday experience of modern life, the decline of the 'aura' was extended to all forms of culture. For what the 'aura' stood for was a sense of reciprocity, where looking was seemingly (of course only seemingly) returned by the object being looked at, i.e. there was a sense of unity and completeness between the viewer and the object being viewed. This was lacking in modern life – as in, say, photography: 'the camera records our likeness without returning our gaze' (p.147).

Benjamin saw traditional high art as hidebound by the 'aura'; for Adorno it was popular culture that was 'fetishistic'. Despite their fundamental differences, both saw ritual as the antithesis of advanced culture. Where Benjamin saw the distractedness of the cinema as a form of emancipation, Adorno saw what he called this 'deconcentration' more pessimistically as devaluing the individual. For example, Adorno argued that contemporary popular music such as jazz or tin-pan alley merely dulled the innovations of high culture and stripped them of any critical value. In his argument for advanced high art that was serious and critical, he opposed Benjamin's for mass culture. Moreover, for Adorno, advanced art had to be marked by asceticism: 'if asceticism once struck down the claims of the aesthetic in a reactionary way, it has today become the sign of advanced art' ('The fetish character of music and regressive listening', p.274). He advocated 'art music' such as that of Schönberg and Webern over the illusory, fetishistic character of the popular. In some of his late writings, Adorno pursued the idea of the form that rationalization took in modern culture (and which it necessarily takes): 'In aiming at pure logical consistency, construction strains towards ideology' (Adorno, *Aesthetic Theory*, p.83). It could not help but be inflected by 'the untruth of the repressive totality', yet it was the only possible shape art could take. What he picks out about 'objective art', the term he used to describe the ascetic tendency in modern art, is first the way that 'it debunks the notion of art as a product of human labour' (*Aesthetic Theory*, p.86) *and yet* 'retains a distinctive character unto itself rather than being a thing among things. Basically, then, objective art is a contradiction in terms. The development of this oxymoron, however, is the core element of modern art' (p.86). Rationalization was an 'iron cage', but culture could not be separate from it, or afford to disregard it.

Conclusion

My discussion in this chapter has been wide-ranging to convey a sense of the differing meanings attached to the language of construction in different contexts. The 'blizzard of associations' it involves, to recall Shklovsky's phrase, cannot be confined to a single definition. Shklovsky had used these words to describe the effects of Tatlin's *Monument to the Third International*, envisaged as a great iron structure spiralling high over the Petrograd sky, a symbol of liberation. Yet we end with the metaphor of the 'iron cage' of modern culture. The metaphor has some force in the context of this chapter; it conjures up an image of a formal pattern, of straight parallel lines, of metal bars, which is somehow characteristic of the modern, and yet which is also constraining, a form of entrapment. It suggests that the overriding emblem of modernity is not, after all, the factory, but the prison. And far from countering archaic, ritualistic forms of a pre-modern culture, it may be that the language of construction necessarily, and in diverse ways, involved its own forms of myth-making. From this point of view, perhaps the industrial and utilitarian objects displayed in *L'Esprit Nouveau* (such as Plates 134–6) were the ritual objects of a new kind of cult, a new 'language of the gods'.

References

ADORNO, T.,'The fetish character of music and regressive listening' in A. Arato and E. Gebhardt (eds and introduction), *The Essential Frankfurt School Reader*, Oxford, Blackwell, 1978.

ADORNO, T., *Aesthetic Theory*, London, Routledge and Kegan Paul, 1984 (first published 1970, in German).

ARAGON, L., *Henri Matisse: A Novel*, vols 1 & 2, translated by J. Stewart, London, Collins, 1972.

Art into Production, exhibition catalogue, Oxford, Museum of Modern Art/Crafts Council of England and Wales, 1984.

ARVATOV, B., 'Art and class', 1923, in S. Bann (ed.), *The Tradition of Constructivism*, London, Thames and Hudson, 1974.

ARVATOV, B., 'The proletariat and leftist art' in J.E. Bowlt (ed.), *Russian Art of the Avant-Garde: Theory and Criticism*, New York, The Viking Press, 1976.

ARVATOV, B., 'Utopia or science' in *Screen Reader 1: Cinema/Ideology/Politics*, London, Society for Education in Film and Television, 1977 (first published in LEF, vol.4, 1924, pp.16–21).

BENJAMIN, W.,'The work of art in the age of mechanical reproduction', 1936, in *Illuminations*, London, Fontana, 1973 (an edited version is reprinted in Harrison and Wood, *Art in Theory, 1900–1990*, section IV.d.6, and in Frascina and Harris, *Art in Modern Culture*).

BENJAMIN, W., *Charles Baudelaire: A Lyric Poet in the Era of High Capitalism*, London, New Left Books, 1973.

BOWLT, J.E. (ed.), *Russian Art of the Avant-Garde: Theory and Criticism*, New York, The Viking Press, 1976 (revised 1988).

BRIK, O., 'From pictures to textile prints', 1924, in J.E. Bowlt (ed.), *Russian Art of the Avant-Garde: Theory and Criticism*, New York, The Viking Press, 1976 (reprinted in Harrison and Wood, *Art in Theory, 1900–1990*, section III.d.11).

BRIK, O., 'The so-called "formal method"' in *Screen Reader 1: Cinema/Ideology/Politics*, London, Society for Education in Film and Television, 1977 (reprinted in Harrison and Wood, *Art in Theory, 1900–1990*, section III.d.10).

BRIK, O., 'Into production' in D. Elliot (ed.), *Alexander Rodchenko*, Oxford, Museum of Modern Art, 1979.

BRIK, O., 'Photography versus painting', 1926, in D. Elliot (ed.), *Alexander Rodchenko*, Oxford, Museum of Modern Art, 1979.

ERLICH, V., *Russian Formalism*, The Hague, Mouton, 1980 (first published 1955).

L'Esprit Nouveau, 1920–25, vols 1–28, New York, Da Capo Press, 1968 (facsimile reprint).

FRASCINA, F. and HARRIS, J. (eds), *Art in Modern Culture: An Anthology of Critical Texts*, London, Phaidon, 1992.

FRISBY, D., *Fragments of Modernity: Theories of Modernity in the Work of Simmel, Kracauer and Benjamin*, Polity Press, Cambridge, 1985.

FRY, R., 'An essay in aesthetics', *Vision and Design*, London, Chatto and Windus, 1920 (reprinted in Harrison and Wood, *Art in Theory, 1900–1990*, section I.b.6).

GAN, A., 'Constructivism' in S. Bann (ed.), *The Tradition of Constructivism*, London, Thames and Hudson, 1974 (an edited version is reprinted in Harrison and Wood, *Art in Theory, 1900–1990*, section III.d.7).

GREENBERG, C., 'Picasso at seventy-five' in *Art and Culture*, Boston, Beacon Paperback, 1965 (first published 1961).

GREENBERG, C., 'Collage' in *Art and Culture*, Boston, Beacon Paperback, 1965 (first published 1961).

GREENBERG, C., 'Modernist painting' in F. Frascina and C. Harrison (eds), *Modern Art and Modernism*, London, Harper and Row, 1983 (reprinted in Frascina and Harris, *Art in Modern Culture*, and in Harrison and Wood, *Art in Theory, 1900–1990*, section VI.b.4).

GROPIUS, W., *The New Architecture and the Bauhaus*, London, Faber and Faber, 1935.

HARRISON, C. and WOOD, P. (eds), *Art in Theory, 1900–1990*, Oxford, Blackwell, 1992.

HARRISON, C., FRASCINA, F. and PERRY, G., *Primitivism, Cubism, Abstraction: The Early Twentieth Century*, New Haven and London, Yale University Press in association with The Open University, 1993.

ISAKOV, S., 'On Tatlin's counter-reliefs', in L. Zhadova, *Tatlin*, London, Thames and Hudson, 1988.

JAKOBSON, R., 'Phonological studies: retrospect' in *Selected Writings*, five vols, The Hague, Mouton, 1962–75.

KANDINSKY, V., 'Content and form' in J.E. Bowlt (ed.), *Russian Art of the Avant-Garde: Theory and Criticism*, New York, The Viking Press, 1976.

KASSÁK, L. and MOHOLY-NAGY, L., *Új Müvészek könyve. Buch neuer Künstler*, published in Hungarian and German, Vienna, 1922 (facsimile edition, with a postscript by Éva Körner, Budapest, Corvina, 1977).

KHAN-MAGOMEDOV, S.O., *Rodchenko: The Complete Work*, London, Thames and Hudson, 1986.

KRACAUER, S., 'The mass ornament', 1927, translated by B. Cowell and J. Zipes, with an introduction by K. Witte, *New German Critique*, 2, 1975, pp.67–76 (an edited version is reprinted in Harrison and Wood, *Art in Theory, 1900–1990*, section IV.c.9).

LAMANOVA, N., 'Russian fashion' in *Art into Production*, exhibition catalogue, Oxford, Museum of Modern Art/Crafts Council of England and Wales, 1984 (first published in *Krasnaya Niva*, no.30, 1923).

LAVRENTIEV, A., *Varvara Stepanova: A Constructivist Life*, London, Thames and Hudson, 1988.

LE CORBUSIER, *The Decorative Art of Today*, 1925, translated and introduced by J.I. Dunnett, London, The Architectural Press, 1987.

LEF, 1923–25, The Hague, Mouton, 1970 (facsimile edition).

LÉGER, F., 'The machine aesthetic: the manufactured object, the artisan and the artist' in E.F. Fry (ed. and introduction), *Functions of Painting*, London, Thames and Hudson, 1973.

LENIN, V.I., 'The immediate tasks of the Soviet government', *Izvestia*, 28 April 1918, in V.I. Lenin, *Collected Works*, vol.27, London, Lawrence and Wishart, 1974.

LENIN, V.I., 'The achievements and difficulties of the Soviet government' in *Collected Works*, vol.29, London, Lawrence and Wishart, 1974.

LODDER, C., *Russian Constructivism*, New Haven and London, Yale University Press, 1983.

LOOS, A., 'Ornement et crime', *L'Esprit Nouveau*, no.2, 1920.

LOOS, A., 'Ladies' fashion' in *Spoken into the Void: Collected Essays 1897–1900*, Cambridge Massachusetts, and London, MIT Press, 1982.

MARKOV, V., 'The principles of the new art' in J.E. Bowlt (ed.), *Russian Art of the Avant-Garde: Theory and Criticism*, New York, The Viking Press, 1976.

MONDRIAN, P., 'Neoplasticism in painting' in H.L.C. Jaffé (ed.), *De Stijl*, London, Thames and Hudson, 1970 (first published in *De Stijl*, vol.1, no.5).

MONDRIAN, P., 'From the natural to the abstract: from the indeterminate to the determinate' in H.L.C. Jaffé (ed.), *De Stijl*, London, Thames and Hudson, 1970 (first published in *De Stijl*, vol.1, no.9).

MONDRIAN, P., 'The realization of Neoplasticism in the distant future and in architecture today' in H.L.C. Jaffé (ed.), *De Stijl*, London, Thames and Hudson, 1970 (first published in *De Stijl*, vol.5, no.3).

NAKOV, A., *2 Stenberg 2: The 'Laboratory' Period (1919–21) of Russian Constructivism*, London, Annely Juda Fine Art, 1975.

NESBIT, M., 'Ready-made originals: the Duchamp model', *October*, no.37, summer, MIT Press, 1986.

NOVITSKY, A.P., *Istoriya Russkovo Iskusstva*, Moscow, vol.2, 1903.

NOVY LEF, 1927–28, The Hague, Mouton, 1970 (facsimile edition).

OUD, J.J.P., 'Art and machine' in H.L.C. Jaffé (ed.), *De Stijl*, London, Thames and Hudson (first published in *De Stijl*, vol.1, no.3(4)).

OZENFANT, A. and JEANNERET, C.-E., *Après le Cubisme*, Paris, Éditions des Commentaires, 1918.

POPOVA, L., 'Statement from the catalogue of the Tenth State Exhibition: Non-Objective Creation and Suprematism', 1919, in J.E. Bowlt (ed.), *Russian Art of the Avant-Garde: Theory and Criticism*, New York, The Viking Press, 1976.

PUNIN, N., 'The monument to the Third International' in L. Zhadova, *Tatlin*, London, Thames and Hudson, 1988 (an edited version is reprinted in Harrison and Wood, section III.d.4).

RODCHENKO, A., 'The line', 1921, in S.O. Khan-Magomedov, *Rodchenko: The Complete Work*, London, Thames and Hudson, 1986.

Rodchenko and Stepanova Family Workshop, London/Glasgow, New Beginnings/The Serpentine Gallery, 1989.

RUDENSTINE, A.Z. (ed.), *Russian Avant-Garde Art: The George Costakis Collection*, preface G. Costakis, London, Thames and Hudson, 1981.

SARABIANOV, D.V., and ADASKINA, N.L., *Liubov Popova*, London, Thames and Hudson, 1990.

SCHAPIRO, M., 'The nature of abstract art', 1937, in *Modern Art: Selected Papers*, vol.2, London, Chatto and Windus, 1978.

SHKLOVSKY, V., 'Art as technique' (alternatively known as 'Art as a device'), 1917, in L.T. Lemon and M.J. Reiss (translated and introduction), *Russian Formalist Criticism: Four Essays*, Lincoln and London, University of Nebraska Press, 1965 (an edited version is reprinted in Harrison and Wood, *Art in Theory, 1900–1990*, section III.c.2).

SHKLOVSKY, V., 'On *faktura* and counter-reliefs', 1921, in L. Zhadova, *Tatlin*, London, Thames and Hudson, 1988.

SHKLOVSKY, V., 'The monument to the Third International' in L. Zhadova, *Tatlin*, London, Thames and Hudson, 1988.

SILVER, K.E., 'Matisse's "Retour à l'ordre"', *Art in America*, June 1987.

De Stijl, 1917–32, 2 vols, Amsterdam and The Hague, Mouton, 1968.

TARABUKIN, N., 'From the easel to the machine', translated by C. Lodder, in F. Frascina and C. Harrison (eds), *Modern Art and Modernism*, London, Harper and Row, 1983.

TAYLOR, F.W., *Scientific Management*, London, Harper and Row, 1964.

UDALTSOVA, N., 'How critics and the public relate to contemporary Russian Art', 1919, in *Women Artists of the Russian Avant-Garde: 1910–1930*, Cologne, Galerie Gmurzynska, 1979.

VALKENIER, E., *Russian Realist Art in the State and Society: The Peredvizhniki and Their Tradition*, New York, Columbia University Press, 1989.

VEBLEN, T., *The Theory of the Leisure Class*, London, Unwin Books, 1970 (first published 1898).

WEBER, M., *The Protestant Ethic and the Spirit of Capitalism*, London, Allen and Unwin, 1976 (first published as a two-part article in 1904–5). (An edited version of one chapter is reprinted in Harrison and Wood, *Art in Theory, 1900–1990*, section II.a.2.)

WOLLEN, P., 'Fashion/Orientalism/the body', *New Formations*, no.1, spring, 1987.

WOLLEN, P., 'Cinema/Americanism/the robot', *New Formations*, no.8, summer, 1989.

Women-Artists of the Russian Avant-Garde 1910–1930, Cologne, Galerie Gmurzynska, 1979.

ZHADOVA, L., *Tatlin*, London, Thames and Hudson, 1988.

Plate 153 Joan Miró, *Peinture* (*Painting*), 1927, water soluble background with motifs in oil, on canvas, 97 x 130 cm. Tate Gallery, London. © ADAGP, Paris and DACS, London, 1993.

CHAPTER 3
SURREALISM, MYTH AND PSYCHOANALYSIS

by Briony Fer

Introduction: Surrealism and difference

Rather than begin with what might hold Surrealism together, I want to start with its diversity and with the idea of difference. For it seems to me that ideas of diversity and difference are central to its character, and are certainly among its most interesting features. Surrealist work can be regarded, from this point of view, as a shifting terrain of representation that constantly uses difference to generate meaning. I'm thinking here of the differences we find between Surrealist works themselves,[1] as well as the differences produced across a range of representations – for example, between Surrealist works and those loosely termed 'constructive' as discussed in the previous chapter.

One of the ways in which difference was expressed within Surrealism was through the metaphor of the 'feminine', and I would go so far as to say that the 'feminine' was Surrealism's central organizing metaphor of difference. In 1945 André Breton wrote that

> the time should come to assert the ideas of woman at the expense of those of man, the bankruptcy of which is today so tumultuously complete. Specifically it rests with artists, even if it is only in protest against this scandalous state of affairs, to ensure the supreme victory of all which derives from a feminine system in the world in opposition to the masculine system ...

(Breton, quoted in R. Parker and G. Pollock, *Old Mistresses*, p.138)

We shall be looking at how the 'feminine', and what this stands for, is played out in Surrealism – both in the work of the male and female artists, and as part of a fantasy of the modern that was at odds with the rationalist view considered in the previous chapter. The sexual aspect of modernity was a key concern for the Surrealists, and I want to look at this from the point of view of our concerns, today, with issues of sexual difference. I shall try to make clear as I go along the distinctions between the Surrealist concerns and my own more contemporary ones – for example, the distinction between 'their' Freud and the Freud of more recent psychoanalytic theory.

From the beginning, Surrealism was a heterogeneous movement. It included writers, painters, poets and photographers; and later, towards the end of the twenties, it diversified into the making of objects and films. In addition, the Surrealists produced a number of magazines, using them as a platform for debate. Even if we confine ourselves to Surrealist painting, we find that there was never stylistic unity. In particular, the Surrealists didn't prescribe whether abstract or figurative art held more value. Paintings that looked, in formal terms, quite different – such as Joan Miró's 1927 *Painting* (Plate 153)

[1] Two exhibitions at the Hayward Gallery, London, marked turning points in the interpretation of Surrealism. Dada and Surrealism Reviewed (1978) was organized around magazines and reviews to show an extraordinary range of interests and artefacts (D. Ades, *Dada and Surrealism Reviewed*). L'Amour fou (1986) examined Surrealist photographs, and explored their preoccupation with sexuality and desire (R. Krauss and J. Livingston, *L'Amour fou*). I am indebted here to the work of both Ades and Krauss.

Plate 154 Salvador Dali, *Les Accommodations des désirs* (*Accommodations of Desires*), 1929, oil and collage on board, 22 x 35 cm. The Jacques and Natasha Gelman Collection. Photograph by Malcolm Varon, courtesy of The Metropolitan Museum of Art, New York. © DEMART PRO ARTE BV/DACS, London, 1993.

and Salvador Dali's *Accommodations of Desires* of 1929 (Plate 154) – could be seen as part of the same project.

In Miró's *Painting*, a tenuous line is trailed across the vivid blue surface of the painting, leaving suggestions of forms, such as that of the breast on the right-hand side of the picture, but never allowing the imagery to become resolved or fixed: it always remains at the level of suggestion. In Dali's painting, on the other hand, a dream landscape is painted in detail, with forms placed in an illusionistic space, albeit an illogical one. Images of lions, ants, oddly formed boulders, figures embracing, may be recognizable, but the relations between them are deliberately enigmatic, as in a dream. These works had in common, then, the effect of disorienting normal expectations. The desired effect was to reveal the unconscious in representation, and to undo prevalent conceptions of order and reality. This was not only a matter of questioning 'reality', but also of how 'reality' was normally represented.

In the First Surrealist Manifesto of 1924, it was left open as to how 'psychic automatism in its pure state' should be expressed – through the word 'or in any other manner' ('Manifesto of Surrealism', 1924, p.26). Breton, its author, was himself a writer and poet, which explains his starting point in literature, surrounded as he was by the group of poets, such as Louis Aragon and Paul Éluard, who had been involved in the *Littérature* group. But the refusal to be prescriptive was also part of the Surrealist commitment to invention, to the unexpected, and to allowing as little intervention as possible by the conscious mind. It may seem odd that when Breton discussed the relationship of painting to Surrealism, in an essay that appeared over four issues of *La Révolution Surréaliste* between 1925 and 1927, he began, not with a 'Surrealist' painter but with Pablo Picasso (Plate 155). André Masson, one of the artists involved in the Surrealist group, objected to

Plate 155 Pablo Picasso, *Homme à la moustache* (*Man with a Moustache*), 1913, oil and pasted textile on canvas, 66 x 47 cm; reproduced in *La Révolution Surréaliste*, no.4, p.26, 1925 as *Étudiant* (*Student*). Musée Picasso, Paris. Photograph: Réunion des Musées Nationaux Documentation Photographique. © DACS, London, 1993.

this, not only because Picasso was unconnected with the group but also because, at that time, his work was associated with the revival of Classicism. It appears that Breton's aim in his essay, 'Surrealism and painting', was to demand that Surrealism had to pass 'where Picasso has passed and will pass again'. He made clear, though, that he would 'always be opposed to a label', the mistake that Cubism had long since made – 'even if', he added in a footnote, 'it was a "Surrealist" label' (*La Révolution Surréaliste*, no.4, p.30).

Masson, 'one so close to us' as Breton had called him in the First Manifesto, produced numerous 'automatic' drawings from the mid-twenties, many of which were reproduced in *La Révolution Surréaliste*. The drawings work on many levels of suggestiveness, some referring quite explicitly to artistic sources (such as the work of Picasso), and others, like *Quare de vulva eduxisti me* (Plate 156), obsessively delineating the body of a woman … or is it two women, or a woman and a man? This state of ambiguity is the condition imposed on our reading of the image. The image consists of an ink line scrawled over the page, returning frequently to the erotic points of the body – for example, to the scratched marks that stand for pubic hair. Sometimes the pen flows freely, elsewhere it is jerky and awkward. The erotic analogy is almost forced on the viewer, even though Masson's line only hints at the parts of the body, which are never clearly defined. Two bodies, the man's indicated by a male head, are intertwined and hardly separable. The ambiguity is necessary, for the image deals in fragments, in parts standing in for the whole. To look at the image is to move from fragment to fragment, each clue displaced by a further one. This condition corresponds with Breton's idea of Surrealism as a 'complete state of distraction'. And the use of the hand-drawn line, the connotation of 'doodling' even, marked out an approach quite at odds with the precision technique and ruler-drawn lines that we considered in the previous chapter. For Breton, again, 'in this dizzying race the images appear like the only guideposts of the mind', making desires manifest.

Plate 156 André Masson, *Quare de vulva eduxisti me* (*Why didst thou bring me forth from the womb?*), 1923, pen and ink on paper, 27 x 20 cm. Private collection. © DACS, London and ADAGP, Paris, 1993.

To take a rather later example: Meret Oppenheim made *Objet: déjeuner en fourrure* (Plate 157) when asked to contribute to an exhibition of Surrealist objects at the Galerie Charles Ratton in Paris in 1936. She bought the cup, saucer and spoon from Uniprix, the department store, and covered these everyday items with the fur of a Chinese gazelle. The work was exhibited in a cabinet full of objects, some found, some ready-made and some, like this one, assembled. It was given its title, which translates as 'fur breakfast', by Breton. The title plays on the theme of the *déjeuner* in modern painting, from Édouard Manet's *Déjeuner sur l'herbe* through to Fernand Léger's *Le Grand Déjeuner* (Plate 138) in which modernity was projected onto the nude female figure. Here, however, the everyday, mass-produced object, of the kind that had been celebrated as emblematic of the rational, geometric order of modern life by Léger and the Purists in the twenties, was transformed into something quite different – a sort of modern fetish. It is the ubiquity of crockery that matters here, not its mass-produced character; the familiarity of the form of the cup and saucer is shattered by the unexpected material, the fur of which it appears to be made, and the sexual connotations. The conjunction is deliberately absurd, and there is a refusal to recognize the utility or supposed rationality of the mass-produced object. An apparently random and incongruous motif was thought by the Surrealists to defy the logic of the rational mind and to express a deeper sort of logic, that of the unconscious.

Object: Fur Breakfast became an icon of Surrealism almost as soon as it was produced. Man Ray and Dora Maar took photographs of the piece (Plates 158 and 159), and both use

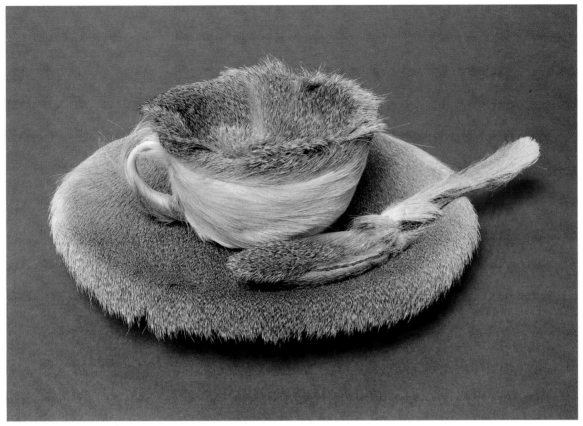

Plate 157 Meret Oppenheim, *Objet: déjeuner en fourrure* (*Object: Fur Breakfast*), 1936, fur-covered cup, saucer and spoon, cup 11 cm in diameter, saucer 24 cm, spoon 20 cm in length (overall height of object 7 cm). Collection, The Museum of Modern Art, New York. © DACS, London, 1993.

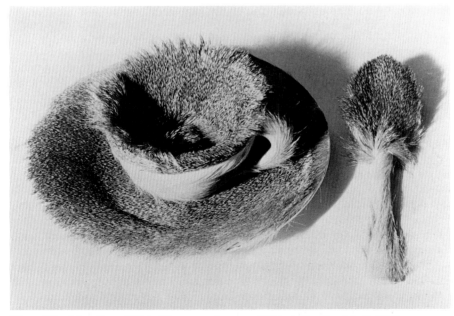

Plate 158 Man Ray, *Objet: déjeuner en fourrure* (*Object: Fur Breakfast*), 1936, photograph. Private collection. Reproduced by courtesy of Mme Bürgi.

Plate 159 Dora Maar,
Objet: déjeuner en fourrure
(*Object: Fur Breakfast*), 1936,
photograph. Private collection.
Reproduced by courtesy
of Mme Bürgi.

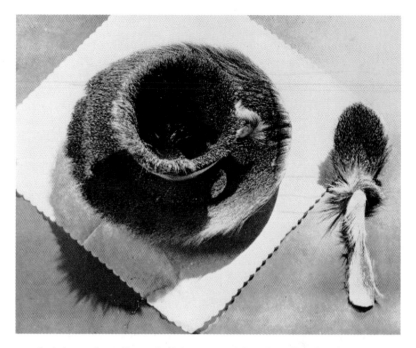

photographic means to heighten the effect of disjuncture. Man Ray has lit the cup and saucer from the front, so that the shadow falls behind it, reproducing the effect of the 'ordinary' place-setting which jars with the extraordinary material out of which it is made. Dora Maar emphasizes this still further by placing the object, viewed from above, on a square napkin. The object has been staged in the photographs to appear as a demented form of the familiar. This desire to shock, to confuse normal expectations, was certainly an important aspect of Surrealist practice. But it was also part of a broader strategy – Surrealism's attempt to work *from the point of view* of the unconscious. Although the Surrealists celebrated Freud's 'discovery' of the unconscious, a point to which I shall return shortly, Freud himself was less enamoured of their interpretation of his work. In a brief correspondence with Breton, it becomes clear that Freud dismissed Surrealism mainly because, to him, any attempt deliberately to contrive the effects of the unconscious mind was a contradiction in terms. Strictly speaking, in Freud's terms, this must be the case. But in the cultural context in which the Surrealists worked, the most effective strategy available to them appeared to be to speak *from* the position of the *ir*rational, to attempt to speak of madness 'from the place of madness itself'[2] rather than from the point of view of reason.

'Woman', women and desire

Women, for the Surrealists, were closer to that 'place of madness', to the unconscious, than men were; and it is through a particular construction of 'woman' that Surrealist concerns with fantasy and the unconscious were enacted. For example, Oppenheim herself had been one of Man Ray's subjects in a series of photographs produced in the Surrealist magazine *Minotaure* in 1934 (Plate 160). Her hand and arm are smeared with printers' ink, and her nude body pressed against the printers' wheel. The erotic and the machine are combined here in a way that militated against the rationalist view of modernity. Surrealism valued and drew attention to all that the 'call to order', discussed in Chapter 1, had repressed – the underside of modernity, the erotic, the bizarre, the unconscious material of mental life. 'Woman' was made the object of desire, who also stood as a sign for desire.

2 E. Roudinesco, quoted in J. Rose, *Sexuality in the Field of Vision*, p.144, in the context of Surrealism's relationship with psychoanalysis and medical institutions.

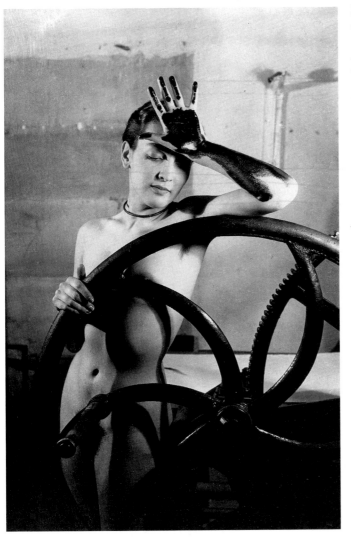

Plate 160 Man Ray, *Érotique voilée*
(Meret Oppenheim à la presse)
(Veiled Erotic (Meret Oppenheim at the
Press)), 1933, photograph. Musée National
d'Art Moderne, Centre Georges
Pompidou, Paris. © ADAGP, Paris and
DACS, London, 1993.

Oppenheim was one of several women artists working with the Surrealist group in
the 1930s; and in Man Ray's photographs she was also a model upon which the fantasy
life of Surrealism was projected (Plate 160). I shall be writing, here, about some aspects of
that 'fantasy life' as it was enacted in representation, and also, later in the chapter, about
how some women artists came to work within the framework of Surrealism. There may be
a tension involved here that sheds light on contradictory aspects within Surrealism itself.

Symbolically, Surrealism placed 'woman' at its centre, as the focus of its dreams. The
first and last issues of the magazine *La Révolution Surréaliste* illustrated this symbolic
scenario fairly vividly. Plate 161 is from the first issue in 1924 and places photographs of
Surrealists, together with Freud and other mentors, around a central image of the woman
anarchist Germaine Berton. The words at the bottom of the page read: 'It is woman who
casts the biggest shadow or projects the greatest light in our dreams', a quote from Charles
Baudelaire. Berton had assassinated an extreme right-wing politician; and in a short note
elsewhere in the same issue, Aragon celebrated her as 'that *perfectly* admirable woman
who represents the greatest defiance against slavery, the most beautiful protest before
world opinion against the hideous lie of happiness' (Aragon, 'Germaine Berton'). She
stood as a powerful symbol of transgression (note how Aragon uses the terms 'defiance'
and 'protest', rather than simply making her a symbol of freedom).

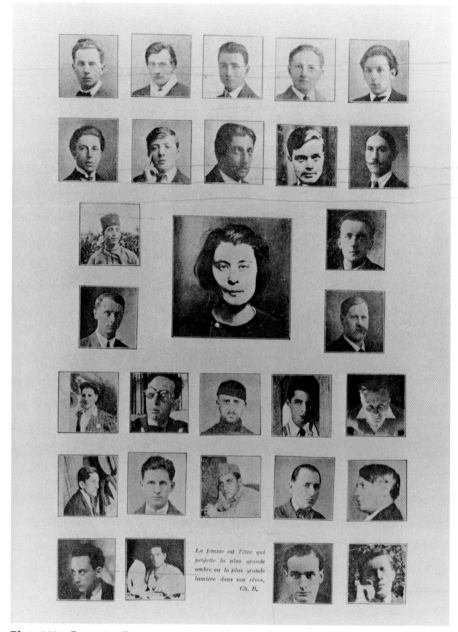

Plate 161 Germaine Berton, surrounded by photoportraits of the Surrealists and those they admired including Sigmund Freud (lower right, next to Germaine Berton), *La Révolution Surréaliste*, no.1, p.17, 1924. Arno Press Reprint.

Plate 162 is from the last issue of the magazine, published in 1929. The page appeared in the context of an inquiry into love. It shows the Surrealist group, photographed with their eyes closed, arranged around René Magritte's painting *I Do Not See the (Woman) Hidden in the Forest*. Their common fantasy (which they see in their dreams) centres on the female body that is represented by the painting, where the nude stands in for the absent word in the sentence. She is circumscribed by language, yet denotes what is 'hidden' in a 'forest' – the obscure and tangled landscape of the unconscious. The woman as the poet's 'muse', and the woman as 'other', are stock motifs in Surrealist thinking that we shall

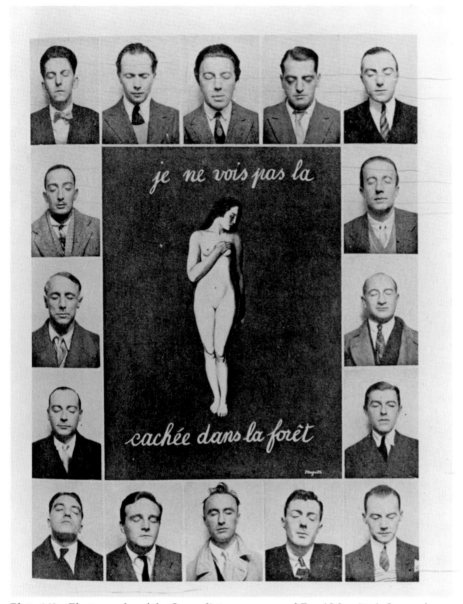

Plate 162 Photographs of the Surrealist group around René Magritte's *Je ne vois pas la (femme) cachée dans la forêt* (*I Do Not See the (Woman) Hidden in the Forest*), *La Révolution Surréaliste*, no.12, p.73, 1929. Arno Press Reprint. © ADAGP, Paris and DACS, London, 1993.

encounter again in this chapter. But the object of their fantasy is also, as shown here, a painting, a representation, a fabrication even, compared with their own photoportraits that surround it. The dreams that escape in Surrealism may involve the dreams and fantasies of the male unconscious, but the way in which they are revealed is always a matter of representation. How women artists negotiated the symbolic structure at the heart of Surrealism further complicates the nature of the imaginary with which Surrealism dealt.

Unlike the 'constructive' tendency discussed in the previous chapter, Surrealism placed sexuality and desire at the centre of its concerns. It is this aspect of Surrealism that I shall discuss here, from the point of view of questions of sexual difference. Of course my

focus is partial, but I suggest that far from divesting Surrealism of its political aspect, the Surrealist insistence on the relationship between modernity and sexuality was far-reaching in its political implications. For the Surrealist concern with sexuality called into question what was repressed by the 'constructive' tendency. Associativeness and sugges-tiveness were positively courted in Surrealist imagery, which may also call into question the apparent purity of the 'functional' form or material so dear to the Purists, for example. Characteristic of Surrealist practice in all its diverse forms – poetry, paintings, objects, photographs – was a preoccupation with what Aragon called 'a mythology of the modern' (*Paris Peasant*, p.130) which, I shall argue, drew attention to the mythic character of other types of representation, especially those claimed to have a firmer grip on 'reality'. And the mythology that Surrealism constructed for itself both focused on 'woman' as 'other', as closer to the unconscious than men, and attempted to inhabit the world of 'otherness', of the unconscious, from beyond its boundaries, in order to question what it saw as a morally bankrupt world.[3]

This meant looking beyond mere appearances, and understanding that beneath these lay a range of psychic and social forces over which individuals have little or no control. This helps explain the Surrealists' interest in Sigmund Freud and Karl Marx, both of whom, in differing ways, had argued that relations between people or between social groups were veiled and hidden by what was normally accepted as 'reality'. The Surrealists saw the ideas of both men as a means to criticize the existing social order and the domi-nant culture that they saw as repressive. This state of repression, they believed, had both a psychic and a social dimension. Nowadays, Marxism and psychoanalysis are often seen as polar opposites, the one concerned with economic and social determinants on social life, the other with the asocial, psychic realm of the mind. Yet at times in the past both have been seen as radical forms of inquiry and related to one another, albeit in complex ways. Surrealism is one such historical moment. Although this chapter concentrates on Surreal-ism in relation to psychoanalysis, I want to try to keep in mind this critical conjuncture of the psychic and the social which was at the heart of the Surrealist project.

Freud and the unconscious

The most literal way in which the Surrealists drew upon Freud was to use many Freudian motifs. For example, Max Ernst took the character of Oedipus as his subject in the collage (Plate 163) reproduced in the magazine *Le Surréalisme au service de la Révolution* in 1933. Oedipus' desire for his mother and jealous hatred of his father, in Greek tragedy, had been proposed by Freud as one of the central dramas of psychic life. But even in this image, where we find a fairly obvious Freudian motif, Ernst's work goes beyond mere illustration and uses collage to assemble an androgynous and sphinx-like figure, fabricated out of composite parts.

However, it was not only motifs that Surrealism took from Freud, but more import-antly a poetic sense of the mechanisms involved in the dreaming process. *La Révolution Surréaliste* regularly included accounts of dreams experienced by members of the group. And the force of the idea of the dream was that it stood for all that had come to be repressed in waking life. It was Freud who had said that 'the dream as a whole is a distorted substitute for something else, something unconscious, and … the task of inter-preting a dream is to discover this unconscious material' (Freud, *Introductory Lectures on Psychoanalysis*, p.144). And the processes that Freud identified as operating in 'dream work' were crucial for the Surrealist approach. Freud had argued that in the dream, there is both 'manifest' and 'latent' content; the manifest is what appears, the latent is the unconscious speaking, what the mind does not mean to show. 'Condensation' is the process by which the latent content is condensed or compressed into the manifest content;

[3] See Gill Perry's discussion of the idea of 'otherness' in Chapter 1 of Harrison *et al.*, *Primitivism, Cubism, Abstraction*.

Plate 163 Max Ernst, *Œdipe* (*Oedipus*), collage, *Le Surréalisme au service de la Révolution*, no.5, 1933. © ADAGP/SPADEM, Paris and DACS, London, 1993.

this might occur, for example, in the kinds of composite structure found in dreams where several people, things or events may be substituted by a single element. 'Displacement' is the process by which the focus is shifted in the dream from an important element to a seemingly insignificant one, through censorship. Dreams unlocked the unconscious in a way not possible in waking life – as did connected phenomena such as day-dreams, slips of the tongue, and memory lapses. The Surrealists were interested in these areas because they were in pursuit of what Breton called the 'arbitrary to the highest degree' (Breton, 'Manifesto of Surrealism', 1924, p.38).

For Freud, the unconscious was the first and most important assertion of psycho-analysis – that 'mental processes are in themselves unconscious, and that of all of mental life it is only certain individual acts and portions that are conscious' (*Introductory Lectures*, p.46). The unconscious is regarded by Freud as having its own structure and modes of expression, which are different from those at work in the conscious mind. It has its own impulses, which are only revealed occasionally in necessarily indirect ways. What is unconscious, for Freud, is also what is infantile – what has been repressed from our early life by the part of us that is conscious. In order to explore the mechanisms at work in the unconscious, the Surrealists explored the language of dreams and the processes of dream work. They looked inside themselves for what was infantile, but they also sought to explore the memory lapses, the repressions, of a whole culture; they looked back to the past, or to earlier myths, to question the present and imagine their way out of present conditions – as a means to transgress established boundaries of representation.

Although Breton had become interested in Freud's work while working as a medical auxiliary during the First World War, and Freud's ideas were widely known, translations of Freud's major works only started to appear in France during the 1920s. For example, *The Interpretation of Dreams*, originally published in 1900, was not published in French until 1925; *The Psychopathology of Everyday Life* of 1901 appeared in 1922, *Totem and Taboo* of 1912–13 in 1924, and *Three Essays in the Theory of Sexuality* of 1905 only in 1927.[4] This suggests that there was in France in the 1920s an additional contemporary vividness to Freud's texts, since French readers could encounter them at first hand. And, although, as is often remarked, Freud's work developed out of turn-of-the-century Vienna and the neuroses of the Viennese bourgeoisie, Freud was still producing important work right through the twenties and thirties; indeed it was not until 1924 that Freud turned to consider the specific character and problems of female sexuality. It is also a feature of Freud's work that it dealt not only with individuals but also with the broader organization of society (*Civilization and its Discontents* being perhaps the most obvious example). In this way his theoretical work differed from the clinical interests of French psychiatrists (such as Jean-Martin Charcot and Pierre Janet) who, especially initially, most influenced Breton. And this is why it was Freud, and only Freud, whom Breton credited in the First Manifesto (p.10) as having brought back to light 'that part of our mental world which we pretended not to be concerned with any longer'.

These rather brief comments give a sense, I hope, of why Freud and psychoanalysis had some historical urgency for the Surrealists' sense of revolt. Freud offered a model of what it meant to reveal what is repressed, to explore the 'latent' rather than the 'manifest' content of their times (to borrow Freud's terms from his analysis of dreams). Partly, this entailed looking to the 'underside' of modernity, focusing on sexuality, desire, and the ambiguities of sexual difference. And this leads me to my final point in this introduction. For how are we to understand how questions of sexuality were treated in Surrealism without the aid of psychoanalytic theory itself? The psychoanalytic work of Freud and others provides a theory of sexuality. Because it is a theory that addresses the differences between men and women, between masculinity and femininity, psychoanalytic theory has been used and developed by feminist writers and critics as a way of exploring the relations between the sexes and the basic inequalities that exist in a society where men have power over women. Freud's work is sometimes seen as powerfully anti-woman, as 'phallocentric', excluding the 'feminine' except as subordinate to the masculine. But other feminists have seen in Freud a radical form of inquiry into sexuality and have interpreted Freud's work, as well as later psychoanalytic developments such as the work of Jacques Lacan, from a feminist point of view. They have done so on the assumption that what sociological theories of sexuality fail to explain is how certain patterns of behaviour, certain norms and attitudes, are *internalized* by human beings; these theories tell us how gendered roles may be socially determined, but not how sexual differences are reproduced internally and unconsciously in psychic life.

Although Freud is sometimes seen as reinforcing the idea that there are essential differences between men and women, his work had a more radical aspect: he offered a theory of sexuality in which the differences between men and women were seen to be made in *culture*, rather than in nature and as simply biologically determined. It is in the working through of symbolic relationships within the family that these sexual identities are constructed. Family relationships have been taken to be a model for power relations as they exist in a patriarchal society. Crudely put, where Marx diagnosed the ills of capitalism, Freud diagnosed the ills of patriarchy. In the course of this chapter, I shall be using elements of a psychoanalytic method, and my aim is to show some of the ways in which psychoanalysis might shed light on the symbolic realm with which Surrealism worked, on both its social and psychic aspects. Although Freud himself thought of psychoanalysis as a new science, the Surrealists were clearly not interested in his ideas as scientific principles.

[4] The dates of these translations are taken from Ades, *Dada and Surrealism Reviewed*, p.224.

Here I certainly do not wish to claim a scientific basis for psychoanalysis, or discuss its clinical application. Rather, I shall stress the metaphorical force of some of the psychic dramas and motifs set out by Freud, and that seized the Surrealist imagination. Indeed part of the interest of Freud's ideas seems to me that they are themselves a sort of mythological construction, but one that claims to have some explanatory force.

Before I go on to consider the crucial importance of Freud for Surrealism, I want to look at a Surrealist story that pursues the theme of desire, and that vividly sets itself in contrast to prevailing representations of modernity, notably that of rationalization.

Breton's Nadja

'The most dreamed-of of their objects'

In an essay called 'Surrealism: the last snapshot of the European intelligentsia', written in 1929, Walter Benjamin discussed the Surrealists' interest in objects that were becoming outmoded, that 'have begun to be extinct' (p.229). In the old-fashioned and obsolescent lurked the more bizarre coincidences that haunted and hence characterized the experience of modern life. 'At the centre of this world of things', Benjamin went on, 'stands the most dreamed-of of their objects, the city of Paris itself' (p.230). The focus of Benjamin's discussion is Breton's book *Nadja*, published in the previous year. Breton's text is an account of a chance encounter with a woman, Nadja – whose name, as she tells Breton, is the first part of the Russian word for hope. For Breton, Nadja represents the promise of love; although the affair ultimately fails, Nadja was the embodiment of the *possibility* of love, with desire as the driving force that impels the text forward – not always logically in the sense of clear narrative sequence, but following the structure of Breton's fantasy.

Breton meets Nadja as he wanders aimlessly through the city. In ordinary French usage, *flâner* means to stroll or dawdle; the *flâneur* is someone who loafs about or loiters, wasting time. Although Breton does not use the term, his aimless meandering in *Nadja* is the typical activity of the *flâneur*, as Baudelaire had defined it in the mid-nineteenth century. The *flâneur* had been, for Baudelaire, a compulsive observer of modern life, always on the outside, distracted and fragmented by the experience of modern life. The *flâneur* was of bourgeois origins, but *déclassé* ('outside class') to the extent that he could never fully participate in bourgeois social life or with the life of the masses – he could mingle with the crowd but never be part of it. With Nadja, Breton wanders from place to place, mostly within Paris itself, and Breton gives us the particular streets, quarters and landmarks of the city. The Surrealist photographer Jacques-André Boiffard was commissioned to provide photographs of some of these places, and his deliberately uneventful, low-key photographs are scattered through the text (Plates 164 and 165). Nadja – of whom Breton says, 'Even while I am close to her, I am closer to the things which are close to her' (p.104) – becomes a sign for these shifts of places and things. Intimacy is always mediated, for Breton, by the displaced objects of desire, those objects – be they Nadja's glove, her clothes, or the city itself – on which he focuses attention (Plate 166).

The aimlessness of the *flâneur* is used as a strategic device by Breton. It is part of what the Surrealists celebrated as a necessary giving up of conscious control, and the submission to whatever may happen, to risk. This was a fantasy of submission to Paris, to the city, to the particular woman Nadja, and to Woman in general. Nadja is a particular woman, as well as Breton's muse, but she eludes definition. When Breton first meets her she is very poorly dressed; another time they meet, she looks immaculate. She has dubious assignations with other men, but her status is deliberately ambiguous. She and Paris are at once separate and linked. Breton says of Nadja (as he might have said, as a *flâneur*, of Paris): 'It seems to me that I observe her too much, but how could I do otherwise?' (p.104). Desire, which is the main subject of the book, is tied up with looking, observing. It also involves submission – to danger or to endless possibility.

Boulevard Magenta devant le « Sphinx-Hôtel »... *(p. 122)*.

(Photo J.-A. Boiffard

Plate 164 Jacques-André Boiffard, *Boulevard Magenta devant le Sphinx-Hôtel (Boulevard Magenta, outside the Sphinx Hotel)*, photograph in A. Breton, *Nadja*, Paris, Éditions Gallimard, 1928. © DACS, London, 1993.

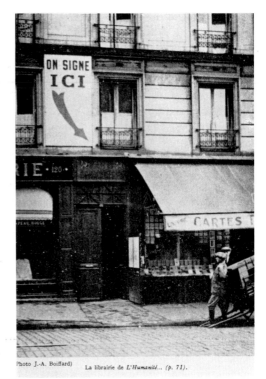

Photo J.-A. Boiffard) La librairie de *L'Humanité*... *(p. 71)*.

Plate 165 Jacques-André Boiffard, *La Librairie de* L'Humanité (*The* Humanité *Bookshop*), photograph in A. Breton, *Nadja*, Paris, Éditions Gallimard, 1928. © DACS, London, 1993.

Plate 166 Anon., *Gant de femme aussi* (*A Woman's Glove as well*), photograph in A. Breton, *Nadja*, Paris, Éditions Gallimard, 1928.

Gant de femme aussi... *(p. 65)*.

Desire is necessarily elusive and distracted. The object being pursued becomes, for Breton, almost secondary to the pursuit itself: 'Pursuit of what, I do not know, but *pursuit* in order to engage every artifice of mental seduction' (pp.127–8). This, of course, corresponds with the paths taken around the city itself, the pursuit not of an *essence* but of distraction. The pursuit could bring into play 'every artifice'; at best it could enable an escape from the ordinary into a 'marvellous dazed state', the fleeting moments that he

experienced with Nadja. These moments were out of the ordinary and yet couched in banality, both of the over-familiar sections of the city through which they passed and of Nadja's tales of her previous lovers.

Breton recounts all this in a fragmented narrative, which is close to collage, and it includes his own diary entries, Nadja's direct speech, thoughts on his Surrealist colleagues, and summary comments about the places on the circuits around Paris. It is an account of the experience of the encounter with Nadja and with Paris itself. 'It is possible', wrote Breton, 'that life needs to be deciphered like a cryptogram' (p.133), and so does Breton's text. For the reader is placed in a position of encountering, as if arbitrarily, the events that take place. 'Events' is to over-invest what happens, which is actually very little, with meaning. Furthermore, there is little or no explanation of what happens, except psychically, and the reader is given up to 'the fury of symbolism, a prey to the demon of analogy' (p.128), as Breton is to the experiences he finds himself in. So, in an odd way, the reader is also placed as a sort of *flâneur*.

The way in which the reader 'comes across' Boiffard's photographs is an interesting example of this. They correspond with the places that Breton cites in his text; they are seemingly unrhetorical photographs of places, not drawing attention to themselves as photographs. Yet in their way, they are, as Benjamin wrote of Surrealist writing, 'demonstrations, watchwords, documents, bluffs, forgeries if you will' ('Surrealism: the last snapshot of the European intelligentsia', p.227). Benjamin also points out that photography intervenes in a strange way in *Nadja*: using the convention of quotations and their page numbers as subtitles beneath the photographs, 'it makes the streets, gates, squares of the city into illustrations of a trashy novel' (p.231). This makes them 'bluffs' of sorts. They are also hard to reconcile with Breton's apparent purpose of using them to replace descriptive writing – since he regarded such writing as inappropriate to the Surrealist attempt to subvert realist narrative and descriptive techniques. On one level, the photographs illustrate the text, in so far as they are of places where Breton finds himself – such as the bookshop run by the Communist newspaper *L'Humanité* where he begins (Plate 165), and from which he immediately turns, 'aimlessly setting off in the direction of the Opéra' (p.71). The sign over the *Humanité* bookshop, *on signe ici* ('sign up here'), points to a shadowed, unspecified doorway, although Breton veers away in quite another direction. Yet despite their banality, the photographs create a peculiar atmosphere; they share certain features, particularly their lack of people; they act as traces of where Breton, or Breton and Nadja, have been.

In addition to photographs, *Nadja* is illustrated with Nadja's drawings (Plates 167 and 168). These intervene in Breton's text equally strangely. I have already mentioned how Breton used much of Nadja's direct speech: the reader is faced with the 'actual' words she spoke, the 'real' Nadja. It is she, on the whole, who not only instigates actions but who gives voice to (Breton's) desire. She describes Breton as the sun, which doubtless feeds some narcissistic pleasure, and acknowledges him as her teacher. Unlike Boiffard's photographs, these drawings are described by Breton. In one, described as 'a symbolic portrait of her and me'), Nadja is depicted as the siren, and Breton a monster with the head of an eagle (Plate 167). To another, the words *L'Attente* ('waiting'), *L'Envie* ('longing'), *L'Amour* ('love'), *L'Argent* ('money') are added (Plate 168). For Breton, these were 'automatic' drawings that revealed the workings of the feminine unconscious. By the end of the book, Nadja has entered a mental asylum. 'Woman' was linked to madness, hysteria, and by extension the primitive, as closer to the irrational and as the constant 'other'. This was a condition the Surrealists not only condoned but aspired to and celebrated – as the 'feminine' side to the personality that had been repressed. The fantasy, then, was not only about femininity, but also about men's desires and masculinity.

The representation of Nadja is the structural key to Breton's fantasy. The Nadja of Breton's text is not a real woman but a representation, despite the semblances and even

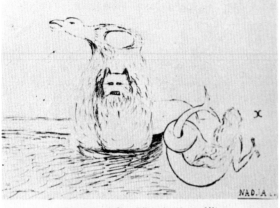

Un portrait symbolique d'elle et de moi... *(p. 140)*.

Plate 167 *Un portrait symbolique d'elle et de moi* (*A Symbolic Portrait of Her and Me*), drawing in A. Breton, *Nadja*, Paris, Éditions Gallimard, 1928.

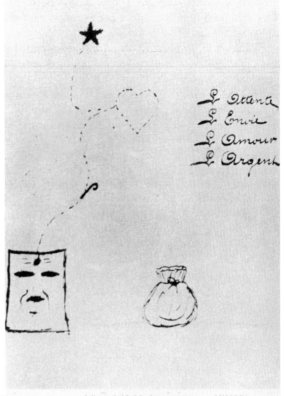

A l'exception du masque rectangulaire dont elle ne peut rien dire... *(p. 124)*.

Plate 168 *A l'exception du masque rectangulaire dont elle ne peut rien dire* (*With the Exception of the Rectangular Mask, which she can say nothing about*), drawing in A. Breton, *Nadja*, Paris, Éditions Gallimard, 1928.

the words that appear, as if transcribed, of a woman he knew. She is the object of his desire but she also articulates the workings of his fantasy; she answers to his needs, as Breton, late on in the book, remembers one of her phrases: 'If you wanted, I could be nothing to you, or only a trace' (p.137). The fantasy requires that Nadja is a 'free spirit', the muse that leads the poet on. She has a mobility that makes her seem almost like a *flâneur* herself, free to roam the streets of Paris, where she feels most at home. Yet the Baudelairean *flâneur* had been a masculine type: it had been impossible for the bourgeois woman to wander the streets of Paris, because of the strictures on her class and sex. By the 1920s women had a greater mobility, particularly in the female type of the *garçonne* which became fashionable. And certainly the strictures on bourgeois women never applied in the same way to the working-class woman, and a woman like Nadja was not a bourgeoise. Yet the *flâneur* needed to be in control of the gaze, since 'gazing', Benjamin had recognized, was one of the characteristic activities of the *flâneur*.

This meant having possession of the gaze rather than being the object of it. Yet Nadja wandered the streets of Paris enjoying the gazes of other men: 'She responds to these sorts of compliments with pleasure and gratitude. There is never a shortage of them and she seems to set much store by them' (p.115). A further part of Breton's fantasy is that this receptiveness gives her a power over men. Breton chose a woman who was on the margins, impoverished yet who could adopt the appearance of a bourgeois, who was on the edges of respectability. This was a woman who fantasized about being a *boulangère*

(who serves in a baker's shop), and who adopted her own masquerades of femininity. For Baudelaire, the prostitute had been the nearest female equivalent to the *flâneur*, and Breton's construction of Nadja as an ambiguous figure (in respect of how she may use her sexuality) seems to draw on Baudelaire in an almost anachronistic way. He rewrites the nineteenth-century model of the prostitute in a modern context; again he seeks the 'outmoded'. Although it may seem at first that the *flâneur* denies the active masculine role in his desire to submit to whatever may happen, this should be distinguished from the woman's experience. No doubt you have to have control before you can, in the terms of the *flâneur*, let go of it.

We should remember here that, as Benjamin wrote, this was 'the gaze of alienated man' and therefore not really free (*Charles Baudelaire*, p.170). Control, either social or psychic, was seen by the Surrealists as a form of oppression – hence their view that in so-called normality could be found the neurotic symptoms of a sick society. In madness, on the other hand, they saw the possibility of liberation. When Breton wondered what it might be like for Nadja in the asylum, he questioned whether there would be an extreme difference for her being on the inside or the outside. This is clearly a line of thought that is more easily pursued when one is not incarcerated oneself, and Breton did admit that of course there would be a difference when the key turned in the lock. As Benjamin wrote of Baudelaire's *flâneur*, 'The crowd is not only the newest asylum of outlaws. It is also the latest narcotic for those abandoned' (p.55). This idea, of modern life itself as a sort of asylum, refers back to the Surrealists' fundamental scepticism about the kind of freedom possible under present conditions.

Baudelaire, Benjamin, Breton

Benjamin's view of Baudelaire was undoubtedly influenced by his interest in Surrealism. His account is redolent of the Surrealist reworking of Baudelaire's models. With this in mind, I want to say something more here about the Baudelairean construction of the *flâneur* as it was interpreted by Benjamin. For Baudelaire, the *flâneur* was the modern hero, unquestionably a masculine type, in his dress of greys and blacks, his spats and cravats. The *flâneur* was necessarily a role taken up by a man of leisure, free to roam and to bestow his gaze on the city (p.170). As the modern city developed, it used *flânerie* to sell goods in the department store. In his study of Baudelaire, Benjamin focuses on the department store and the arcade because it is there that is found at its clearest the relationship between the *flâneur* and commodity fetishism: it is here that 'the intoxication to which the *flâneur* surrenders is the intoxication of the commodity around which surges the stream of customers' (p.55). The poet was not exempt from these relations; the true situation of the man of letters was, he wrote, that 'he goes to the market place as a *flâneur*, supposedly to take a look at it, but in reality to find a buyer' (p.34). Baudelaire had even seen the poet as like the prostitute in that he took 'cold cash for his confession' (p.34). In addition he was a 'bohemian', in a constant state of revolt against bourgeois society.

Baudelaire had been concerned with the city as the site of the erotic. One of the main poems discussed by Benjamin is Baudelaire's *A une passante* ('To a woman passing by'). This is about the desire for a woman, a widow in black passing in the crowd. The image of the woman is fleeting, lost almost as soon as it appears. As in *Nadja*, the crowd does not figure explicitly in the poem, but it is there by implication. Benjamin makes the point that the crowd does not obliterate desire, but is a condition for it:

> Far from eluding the erotic in the crowd, the apparition which fascinates him is brought to him by this very crowd. The delight of the city-dweller is not so much love at first sight as love at last sight. The *never* marks the highpoint of the encounter.
>
> (Benjamin, *Charles Baudelaire*, p.45)

In Breton's text, the loss of Nadja is perhaps a necessary part of the fantasy, and the anticipation of this loss an aspect of his desire.

Such a chance encounter occurs in a crowd, where the object of desire is picked out from a multitude of others. The object of desire is 'happened upon' in Baudelaire, in the same way as it is by Breton later. I have already mentioned how I think the reader of *Nadja* is put into the same kind of position, confronted with fragments, partial views, glimpses of the past, blind-alleys in the present. In a similar vein, Benjamin (p.98) compared Baudelaire's writing to a map of the city, 'in which it is possible to move about inconspicuously, shielded by blocks of houses, gateways, courtyards'. Finding one's way about is a disconcerting process. For Benjamin, this was what it was like to roam through the ruins of the bourgeoisie; he cites Balzac as the first to speak of this, but adds that 'it was Surrealism which first allowed its gaze to roam freely over it' (p.176).

Benjamin discussed the *flâneur* as an historical figure who was already disappearing in the latter part of the nineteenth century, and whose last outpost was the department store. Yet this was the implicit motif that Breton chose for himself in structuring *Nadja*. Maybe this was partly to do with being drawn to the outmoded, but I think it also had another strategic purpose, and that was to counter prevailing assumptions. According to Benjamin, the demise of the *flâneur* had to do with the fact that F.W. Taylor's watchword, 'Down with dawdling', had carried the day (p.54). When Nadja had told Breton how she fantasized about what people in a second-class Métro carriage did for a living, he had upbraided her for her preoccupation with work (*Nadja*, p.78). This was not merely a case of favouring idleness over work, but to do with Breton's position in relation to a culture 'maximized' by efficiency and rationality in the Taylorist sense.

Flânerie was a strategic response to the dominant culture of rationalization exemplified by Taylor's *Scientific Management*. As such, it was part of the Surrealist sense of revolt, turning on its head the notion of the modern as rational, ordered and efficient. Instead, 'the vertigo of the modern' – as Aragon redefines it in *Paris Peasant* (p.129) – was to be found in the lost corners of the city, the *passé*, those places where 'the legend of modernity has its intoxications' (p.131). This was a view of modernity as myth, but no less important for that. The places Aragon describes are very much those that Benjamin identified as the sites of the *flâneur*, particularly the arcades of shops – again showing how his view of the nineteenth century was mediated by his Surrealist reading. Aragon wrote about one arcade in particular that was about to be demolished. The window-displays of objects set in train, for Aragon, reveries that were only half-conscious. They triggered responses that were entirely different from, say, Léger's celebration of window-displays as examples of a rational, modern call to order (Plate 140). Where Léger saw the repetitive effects of display as exemplifying a peculiarly modern taste for logical, formal order, Aragon found almost hallucinatory experience.

When Benjamin quotes Taylor's watchword as 'Down with dawdling', he gives his source as a text by the sociologist, Georges Friedmann. In the 1930s Friedmann discussed the changes in industrial production that had followed the First World War and the organization of new factories,

> based on principles very near to those of Taylor and Ford, which matched the spread of a sort of religion of 'scientifically' organized Production, across a very wide sector of the bourgeoisie.
>
> (Friedmann, *La Crise du progrès*, p.117)

Friedmann stressed the immense influence that Ford's theories and Taylor's theory of scientific management had had in the post-war years: 'The obsession of Taylor, his collaborators and his successors is *guerre à la flânerie*' (p.76). Literally, this means 'war on *flânerie*', on the idleness that Taylor saw as endemic in the system his theory sought to correct. The translation of *flânerie* as 'dawdling' in the English edition of Benjamin's essay is somewhat eccentric in this context. Taylor's original term was 'soldiering', meaning marking time or loafing (Taylor, *Scientific Management*, p.30).

Taylor's *Principes d'organisation scientifique des usines* was published in French in 1920 (first published as *The Principles of Scientific Management*, Harper, 1916). Here Taylor discussed the measures necessary to counter *la flânerie naturelle et la flânerie systématique* ('natural and systematic soldiering'). According to Taylor's system, the individual worker was given a task, and this task, endlessly repeated, constituted the worker's job. Each component part or task was individualized, and all these tasks put together made, collectively, a more efficient working process. Friedmann makes the point that to separate each worker from other workers in this way is a necessary condition of the Taylor system, in order to develop personal ambition and competition. Taylor had no use for class struggle, and indeed saw unions as unhelpful to workers because they had restricted output by imposing 'soldiering, that scourge of the modern industrial world'.[5] *Flânerie*, then, could be seen as a thorn in the flesh of a Taylorized vision of the world.

A masculine fantasy of 'woman', and with it a fantasy of masculinity, is also played out in Aragon's novel *Paris Peasant* of 1926. Aragon arrives, after some preamble, at the brothel. Because, he says, his attitude to love itself has been seen by some to be entirely undermined by his celebration of prostitution, he feels it necessary to explain:

> Is it not to misunderstand the nature of love to believe it incompatible with this degradation, this absolute negation of adventure which is still a venture for my own self, the man jumping into the sea, the renunciation of all masquerade: a process that is overpoweringly attractive for the true lover?
>
> (Aragon, *Paris Peasant*, p.117)

This appears to be the confession of a man who can only attach himself to women as commodities to be bought like any other commodity; yet the delusion that he could divest himself of 'all masquerade' is only symptomatic of his enslavement to his own fantasy (and, by extension, the enslavement of all women to it too.). What Benjamin had to say on this question of masquerade is apposite, and contrary to Aragon's view. Benjamin described Baudelaire thus:

> Because he did not have any convictions, he assumed ever new forms of himself. *Flâneur, apache* [ruffian], dandy and ragpicker were so many roles to him. For the modern hero is no hero; he acts heroes. Heroic modernism turns out to be a tragedy in which the hero's part is available.
>
> (Benjamin, *Charles Baudelaire*, p.97)

This idea of acting the part suggests that 'masculinity' itself is also a question of masquerade, of taking up a series of guises. The Nadja of Breton's text may be, in these terms, a projection of his own faltering identity, where he consistently fails to focus on the woman and instead displaces his attention onto the objects around her.

The 'uncanny'

'Époque des mannequins, époque des intérieures'

Images of mannequins and other automata can be found scattered through the pages of various Surrealist magazines. On the cover of the fourth issue of *La Révolution Surréaliste*, Man Ray's photograph of a fashion mannequin was placed between the two terms of the slogan *et guerre au travail* ('and war on work'), where the mannequin acts as a figure of desires and dreams (Plate 169). Plate 170 was one of four photographs by the older photographer Eugène Atget illustrated in *La Révolution Surréaliste* during 1926. Atget had made photographs of numerous shop windows, such as this one of a corsetry shop on the

5 This was a point Taylor made about the USA in *Scientific Management*, p.81.

N° 4 — Première année 15 Juillet 1925

LA RÉVOLUTION SURRÉALISTE

ET AU

GUERRE TRAVAIL

SOMMAIRE

Pourquoi je prends la direction de la R. S. :
André Breton.

POÈMES :
Louis Aragon, Paul Éluard.

RÊVES :
Max Morise, Michel Leiris.

TEXTES SURRÉALISTES :
Philippe Soupault, Marcel Noll, Georges Malkine.

Les parasites voyagent : Benjamin Péret.

La baie de la faim : Robert Desnos.

Glossaire (*suite*) : Michel Leiris.

Nomenclature : Jacques-André Boiffard.

CHRONIQUES :

Fragments d'une conférence : Louis Aragon.

Le surréalisme et la peinture : André Breton.

Note sur la liberté : Louis Aragon.

Exposition Chirico : Max Morise.

Philosophies. L'étoile au front : Paul Éluard.

Correspondance.

ILLUSTRATIONS :

Giorgio de Chirico, Max Ernst, André Masson,
Joan Miro, Pablo Picasso, Man Ray, Pierre Roy, etc.

ABONNEMENT,
les 12 Numéros :
France : 45 francs
Étranger : 55 francs

Dépositaire général : Librairie GALLIMARD
15, Boulevard Raspail, 15
PARIS (VII°)

LE NUMÉRO :
France : 4 francs
Étranger : 5 francs

Plate 169 Cover of *La Révolution Surréaliste*, no.4, 1925, with a photograph by Man Ray, of a mannequin. Arno Press Reprint. © ADAGP, Paris and DACS, London, 1993.

Boulevard de Strasbourg, taken in 1912. The photograph was uncredited (at the request of Atget himself who, it seems, was not keen to be associated with the Surrealist group) and set in the 'dreams' section of the magazine. By implication, Atget's photograph also acts as a fragment from a dream narrative, focusing on the compulsive repetition of the sequence of dummies in the shop window. It was the uncanny effect of such images that interested the Surrealists, especially here in the old-fashioned, lost corners of the city that so drew Breton, as we have seen, in *Nadja*; and in *Paris Peasant,* Aragon refers to a 'geography of

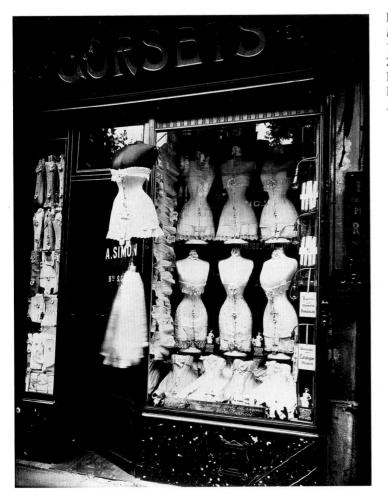

Plate 170 Eugène Atget, *Boulevard de Strasbourg, corsets*, 1912, albumen-silver print, 24 x 18 cm. Collection, The Museum of Modern Art, New York. Print by Chicago Albumen Works, 1984.

pleasure' in the city, where he is irresistibly drawn to 'the simulacra on display in the shop window', as he puts it. The mannequin was associated with automata, to which a whole article was devoted in *Minotaure* (Plate 171), with photographs drawn from a 1928 history of automata by Alfred Chapuis and Édouard Gélis. The idea that the female figure in particular could be invoked in this way, as merely a semblance of the real, a simulacrum, to be endlessly repeated around the streets of Paris, was the ultimate expression of the idea of woman as object, which also triggered the most uncanny of effects.

In the First Manifesto, Breton had written that 'The marvellous is not the same in every period of history: it partakes in some obscure way of a sort of general revelation, only the fragments of which come down to us: they are the romantic *ruins*, the modern *mannequin*', symbols that elicit a smile but that also portray 'incurable human restlessness' ('Manifesto of Surrealism', p.16). And in his essay 'Surrealism and painting' of 1925, he again referred to the mannequin in his discussion of Giorgio de Chirico (Plate 172). He drew attention to the mysterious effect of, among other features, *époque des mannequins, époque des intérieures* as 'the age of mannequins, the age of interiors' (*La Révolution Surréaliste*, no.7, p.3). It was largely under de Chirico's influence, and in the light of Breton's admiration of his work, that these elements – the mannequin, the interior, the street – came to occupy such a prominent position within Surrealism. And more specifically, it was de Chirico's bringing together of these disparate elements in numerous paintings that set in train the mysterious effect.

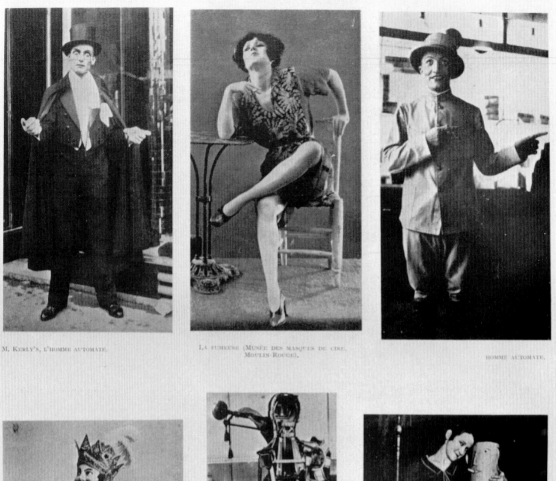

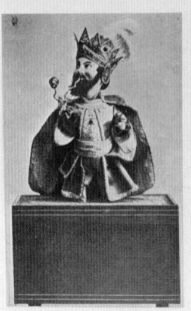

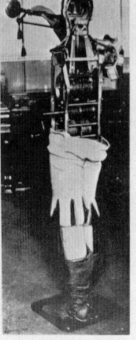

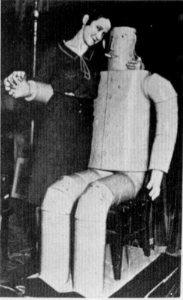

Plate 171　Photographs in B. Peret, 'Au paradis des fantômes', *Minotaure*, no.3/4, p.33, 1933. Arno Press Reprint, by permission of Éditions d'Art Albert Skira.

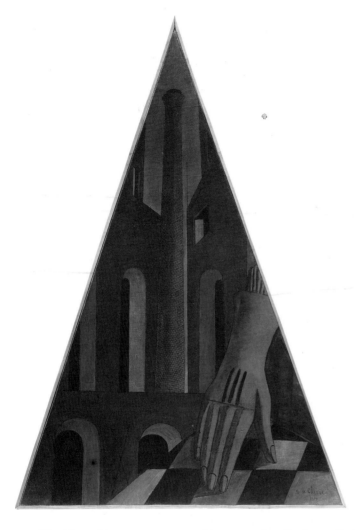

Plate 172 Giorgio de Chirico, *L'Énigme de la fatalité* (*The Enigma of Fatality*), 1914, oil on canvas, 138 x 96 cm. Emanuel Hoffmann-Foundation, Kunstmuseum, Basel. © DACS, London, 1993.

The idea of estrangement, or *dépaysement* as Breton called it, was a crucial function of Surrealism. And this had partly, at least, to do with the indeterminacy of images, either in the kind of dream narrative Breton saw in de Chirico's work, or through the automatist techniques used by others, such as Masson and Miró. In *Vision Induced by the Nocturnal Aspect of Porte Saint-Denis* of 1927 (Plate 173), Ernst characteristically used a combination of both. La Porte St Denis, dedicated to the patron saint of Paris and once marking the edge of the city, would be one of the places Breton passed through in *Nadja*, where the monument, 'very beautiful and very useless' (Plate 174), would serve as a pretext for a tangential train of thought – the memory of a ludicrous film, *The Embrace of the Octopus*, that Breton had once seen in a cinema near by.

Like Breton, Ernst treated the monument as a point of refraction. La Porte Saint-Denis is represented by Ernst as the site of a vision where, using both *frottage* ('rubbing') and *grattage* ('scraping'), the wood-grained impressions are allowed to come to the surface as if the product of a dream. These techniques were thought to circumvent the mediations of the conscious mind, triggering unconscious reverie. Without wishing to force the comparison too far, we might bear in mind that the French terms *automatique* and *automatisme*, in ordinary usage, referred to mechanical movements, like those of automata. Although the term *automatisme* is usually, correctly, regarded as deriving from the 'automatic' writing techniques used in therapeutic practice, its more commonplace allusions to the

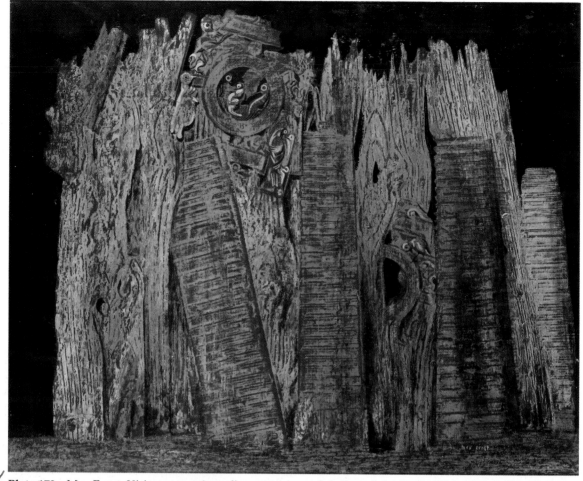

Plate 173 Max Ernst, *Vision provoquée par l'aspect nocturne de la Porte Saint-Denis* (*Vision Induced by the Nocturnal Aspect of Porte Saint-Denis*), 1927, oil on canvas, 65 x 81 cm. Private collection. Reproduced by courtesy of Sotheby's. © ADAGP/SPADEM, Paris and DACS, London, 1993.

'mechanistic' add a further layer of irony, and symbolically replace the rational machine by a mechanical doll.

Through the inconclusiveness of the imagery (Plate 173), Ernst suggests that the city is also a place that harbours fear. In *The Horde* of the same year (Plate 46), this sense of dread is even more apparent. Paint is scraped off the prepared canvas over textured surfaces in the treatment of the monstrous figures that haunt dream life or, more generally, the unconscious; the effect is the more unexpected as the vivid blue of the 'background' does not recede but has evidently been added later. The figures appear as old spirits that lurk behind the façade of contemporary social life, and appear to rise up in the painting, a revolt of the mind – with connotations, critical within Surrealist thinking, of social revolution. During the thirties, Ernst painted a series of pictures called *The Entire City*, of which Plate 175 is an example, again concerned with the city as a sort of labyrinth, with strata and substrata, rather than the ideal view of the modern city espoused by contemporaries such as Le Corbusier. Rather than as an ideal of unity and order, the city is represented as a primordial site, overcome by luxurious but threatening forms of vegetation. It is a desolate vision of the city in ruins, haunted by the past – the sort of metaphorical ruins that also concerned Breton in his critique of contemporary bourgeois culture.

Plate 174 Jacques-André Boiffard,
*Non: pas même la très belle et très inutile Porte
Saint-Denis* (*No: not even the very beautiful and
very useless Porte Saint-Denis*), photograph in
A. Breton, *Nadja*, Paris, Éditions Gallimard,
1928. © DACS, London, 1993.

Plate 175 Max Ernst, *La Ville entière* (*The Entire City*), 1935–36, oil on canvas, 60 x 81 cm. Kunsthaus, Zurich.
© ADAGP/SPADEM, Paris and DACS, London, 1993.

This sense of the past haunting the present was also related by Ernst to childhood memories. He even traced back his discovery of automatist methods such as *frottage* to moments in his early life. In *La Révolution Surréaliste* in 1927, he published three 'Visions de demi-sommeil' ('Visions of daydreams'). The first, which told of a 'vision' he had experienced as a small boy, is sparked off by a woodgrained panel: 'I see in front of me', he wrote, 'a panel very crudely painted with large black strokes on a red ground, imitating the grain of mahogany and provoking associations of organic forms (a menacing eye, a long nose, a large head of a bird with thick black hair, etc.).' The vision develops into a terrifying image of the artist's father, wielding a pencil, which turns into a stick and ultimately a whip. The daydream is couched in terms of Freud's repertoire of sexual imagery, in a narrative that makes public the artist's early fantasies and fears of punishment by his father. At home, in bed, the small child finds that the familiar – the imitation wood panel – takes on the unfamiliar and frightening forms of that fantasy. By using automatist techniques in his paintings of the city, Ernst gave those infantile fantasies a social aspect, and at the same time represented the city as a site of infantile fantasy. The city is an extension of the home, in that symbolic and psychic relationships are played out in it. And as we have seen, in *Nadja* in particular, the city is treated in Surrealism as the dwelling place of the modern unconscious.

Freud's view of the 'uncanny'

The two aspects – of the mannequin, and the dread of a repressed memory – come together in Freud's notion of the 'uncanny'.[6] This, unlike concepts in other classic texts by Freud such as *The Interpretation of Dreams*, was not influential on Ernst. But I discuss it here because it sheds some light, I think, on the set of preoccupations within Surrealism. Freud's term *unheimlich*, translated into English as 'uncanny', is the opposite of *heimlich* ('homely' or 'familiar', and so 'not strange'). He quotes F.W.J. von Schelling's definition of *unheimlich*: 'the name for everything that ought to have remained ... secret and hidden but has come to light' (Freud, 'The "Uncanny"', p.345). What interests Freud is this sense of the uncanny combining with a sense of the familiar: it is an ambiguous term in that it also implies its opposite. He discusses the way in which the uncanny is evoked in *The Sandman*, a story by E.T.A. Hoffmann that includes the original of Olympia, the doll that figures in the first act of Jacques Offenbach's opera, *Tales of Hoffmann*. Olympia is only a doll, an automaton, but she has the appearance of a living woman, so much so that the hero of the story falls in love with her. But for Freud, it is not primarily Olympia who is responsible for the effect of uncanniness in the story, but rather the figure of the 'Sandman', the father image who punishes children by tearing out their eyes. As a nice piece of symmetry in the story, the other father figure, Coppola, who has made the automaton Olympia, is also an optician, a maker of spectacles. This appealed to Freud who saw the fear of losing one's sight as symbolic of the dread of castration. Olympia may look like the root of the uncanny effect, but in the end is only a sort of alibi; the real dread lies with the fear of the father, and father's vengeance on the son, in castration.

It was after seeing Offenbach's *Tales of Hoffmann* that Hans Bellmer began producing his series of dolls (Plate 176) with dismembered limbs, which have subsequently been read, in Freudian terms, as playing out castration anxiety (Krauss, *L'Amour fou*, p.86). Certainly the theme of the eye is recurrent in Surrealist imagery, notably in the opening sequence of *Un Chien Andalou*, a film by Bunuel and Dali where an eyeball is slashed (Plate 177). What is more interesting here, I think, is not so much the direct links to be made, as the key idea that the uncanny is something secretly familiar. It is something that has been repressed, since for Freud the prefix 'un' in *unheimlich* was the token of repression. Within the framework, dismembered limbs might evoke the uncanny, but so might a 'dismembered' text or image, where the pieces are collaged together in unfamiliar ways.

6 The idea of the uncanny has been discussed by R. Krauss in her important work on Surrealist photography, 'Corpus Delicti', p.85.

Plate 176 Hans Bellmer, *Poupée* (*Doll*), 1935, photograph. Private collection. © ADAGP, Paris and DACS, London, 1993.

So might – and here we return to Freud's text – a 'double', such as a mirror, or a guardian spirit, or a repetitive image.

The uncanny leads back to the animistic and to magic, such as Ernst's monstrous forms in *The Horde*, or the haunted forest, or the figure of Loplop (Ernst's own mythical guardian spirit), or the indeterminate forms of *The Fragrant Forest* (Plate 178). Here the forest becomes a metaphor, like the city, for the unconscious – where memory lurks, where secrets are hidden. But there is also a social aspect to the uncanny, to the idea of the

Plate 177 Frames from Luis Bunuel, *Un Chien Andalou* (*An Andalusian Dog*), 1928, scripted by Salvador Dali. Photographs by courtesy of the National Film Archive. Reproduced by permission of Contemporary Films.

Plate 178 Max Ernst, *La Foresta Embalsamata* (*The Fragrant Forest*), 1933, oil on canvas, 163 x 254 cm. Collection of Adelaide de Menil, New York. Photograph by Paul Hester. © ADAGP/SPADEM, Paris and DACS, London, 1993.

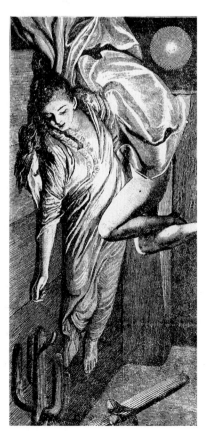

Plate 179 Max Ernst, *The Hundred Headless Woman opens her August Sleeve*, from *La Femme 100 têtes* (*The Hundred Headless Woman*), Paris, Éditions du Carrefour, 1929. © ADAGP/SPADEM, Paris and DACS, London, 1993.

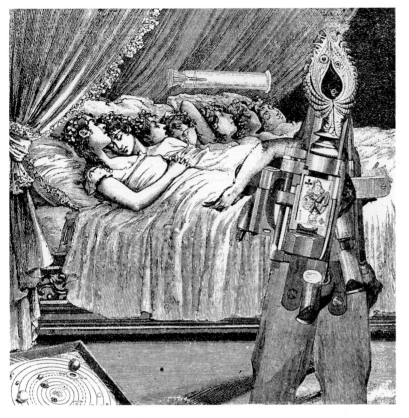

Plate 180 Max Ernst, *Here all together are my seven sisters, often living on liquid desires and perfectly resembling sleeping leaves. One sees more than one notary pass, letting his voice fall in cadences,* from *La Femme 100 têtes* (*The Hundred Headless Woman*), Paris, Éditions du Carrefour, 1929. © ADAGP/SPADEM, Paris and DACS, London, 1993.

'unhomely'. In Ernst's collage novel *La Femme 100 têtes*, images of bourgeois interiors, culled from nineteenth-century engravings, are assembled in order to turn their sense, as it were, inside out (Plates 179 and 180). The interior, or home, is made strange or *unheimlich*, and is the site in which fantasies are played out. The cut-out fashion plate engravings of female figures are like two-dimensional equivalents of mannequins, that act as alibis for the main drift of the story. Baudelaire had called the city the home of the modern man, who only feels 'at home' on the streets – where, again, the city can be taken as a site of psychic drama (as we saw with Breton's *Nadja*). The sense of the uncanny implies, in Freud's terms, its opposite – the familiar repressed within it. In a similar vein, the title of Ernst's collage novel *La Femme 100 têtes* contains a dual meaning, punning on '100' (in French, 'cent') and 'without' (in French, 'sans'); the hundred-headed woman (a Medusa-type image) is made one with the loss of the head – two Freudian motifs for castration used fairly explicitly by Ernst.

I am not interested here in a 'psychobiography' of Ernst, or in the effect of his early childhood on his art. More telling, I think, is that Ernst, like other Surrealists, put these childhood memories in the public forum – such as we saw in the 'Visions de demi-sommeil'. Ernst later wrote of himself that he was 'a young man who aspired to find the myths of his time' (Ernst, 'An informal life of M.E. (as told by himself to a young friend)', quoted in M. Gee, *Ernst*, p.9). Publicizing his personal history, and using a Freudian repertoire of symbols to do so, was to suggest some kind of collective fantasy or set of myths that prevailed in contemporary social and psychic life. Ernst treated such fantasies as if they were common currency or, as has been suggested by Dawn Ades of Dali, 'as though [psychoanalysis] were common property, in the way that religious iconography was common property in the Middle Ages' (*Dali*, p.76).

Le Jeu lugubre

Dali joined the Surrealist movement in 1929. *The Lugubrious Game* (Plate 181) was painted that year and was the centre-piece of Dali's first exhibition at the Camille Goeman Gallery in November. *Accommodations of Desires* (Plate 154) was also exhibited there and bought by Breton, who wrote the preface to the exhibition catalogue. In *The Lugubrious Game* Dali used the dream narrative, and juxtaposed incongruous elements and monstrous forms; he also used various motifs (such as the grasshopper) as the objects of an obsessional phobia of his own. In contrast with his later work, which places the dream narrative in an illusionistic, three-dimensional space, Dali's use here of a 'landscape' setting is more fragmented. The bare treatment of the steps to the right, of the ground and of the monument is reminiscent of de Chirico's unpeopled, empty streets and cities (Plate 182). And the central 'figure' has exploded into fragments; the body distends upward to a head that is torn open to reveal stones, shells, heads and hats. There is no coherent unity to the figure: it is only the sum of these fragmented parts. But it is not only this figure that is 'dismembered'; in addition to some real elements of collage stuck on to the canvas, the painting as a whole deploys a collage-like technique to assemble fragments and parts. (In Chapter 1 David Batchelor discusses this type of 'collage' effect, comparing it with the automatist techniques of Masson and Ernst.)

Like Ernst, Dali used a Freudian repertoire of motifs and concentrated on sexual imagery. Uppermost is perhaps the theme of masturbation, and its attendant guilt that preoccupied Dali and that is hinted at in the spattered pants of the male figure in the foreground, the large hand of the statue, the hand covering the eyes of the statue, and the sexual symbolism with which the picture is crammed. Breton, in his preface, wrote that 'The art of Dali, the most hallucinatory known until now, constitutes a real menace'. Menace, that is, to the accepted order and appearance of things, but with a critical force: 'With the coming of Dali, it is perhaps the first time that the mental windows have opened really wide, so that one can feel oneself gliding up towards the wild sky's trap' (Breton, 'The First Dali Exhibition', preface to the catalogue in *What is Surrealism?*, p.45).

Breton's sense of Surrealism's plumbing the depths of what is hidden and secret coincides with this idea of revelation. It can be related to the sense of being hidden and strange *and* revealed that we found in the uncanny. Indeed, although *lugubre* is often translated as 'dismal' or 'lugubrious', it is one of the words Freud found as a French equivalent for the *unheimlich* or 'uncanny'. (When Freud's essay came to be translated into French in the 1930s, it was entitled 'L'inquiétante étrangeté'.[7]) In Breton's description of the effect of Dali's work as *une joie sombre* ('a dismal or melancholic joy'), or even when he talks of the power of 'voluntary hallucination', we can recognize some of the same state of contradiction that always appears to be in play.

Dali's painting was caught in the cross-fire between André Breton and Georges Bataille. While so far I have concentrated on Breton as the driving force within Surrealism, I now want to introduce the figure of Bataille. Although he was never closely involved in the Surrealist group as such, he had met them in 1925. He later referred to this ambivalent position by calling himself Surrealism's 'old enemy from within' (quoted by Ades, *Dada and Surrealism Reviewed*, p.229). He and Breton were always at odds in views and approach, and their differences were sharpened in 1929 when a renegade group attached itself to Bataille. As an archivist at the Bibliothèque Nationale, Bataille had diverse interests – from ancient manuscripts to popular culture to modern painting, a diversity reflected in the magazine *Documents*. (I discuss Bataille's involvement in *Documents* in the next section.)

[7] My thanks to David Lomas for pointing this out to me.

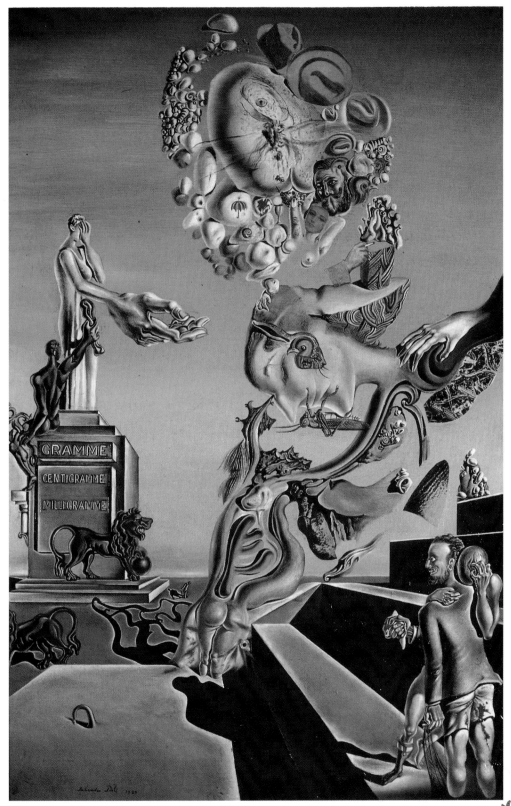

Plate 181 Salvador Dali, *Le Jeu lugubre* (*The Lugubrious Game*), 1929, oil and collage on card, 44 x 30 cm. Private collection. Reproduced by courtesy of Robert Descharnes. © DEMART PRO ARTE BV/DACS, London, 1993.

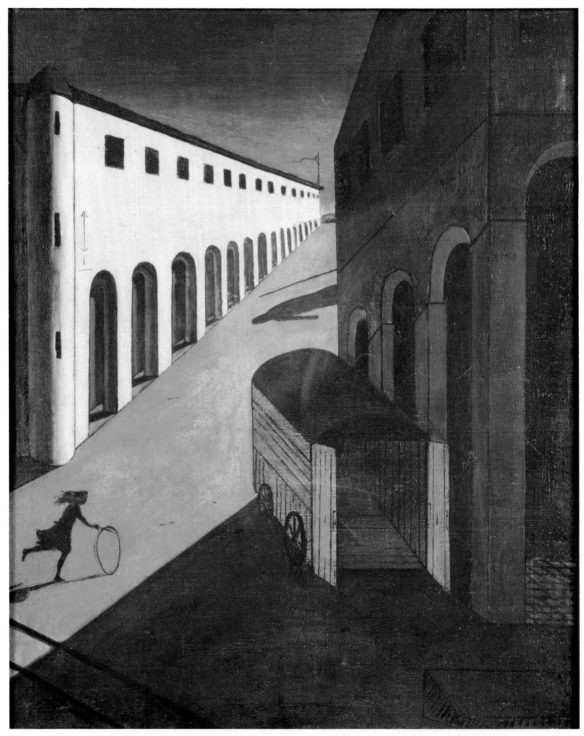

Plate 182 Giorgio de Chirico, *Mistero e malinconia di una strada* (*Mystery and Melancholy of a Street*), 1913, oil on canvas, 87 x 71 cm. Private collection. Photograph by Luca Carra, courtesy of Index. © DACS, London, 1993.

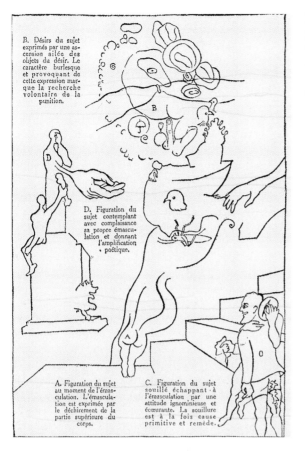

B. Désirs du sujet exprimés par une ascension ailée des objets du désir. Le caractère burlesque et provoquant de cette expression marque la recherche volontaire de la punition.

D. Figuration du sujet contemplant avec complaisance sa propre émasculation et donnant l'amplification poétique.

A. Figuration du sujet au moment de l'émasculation. L'émasculation est exprimée par le déchirement de la partie supérieure du corps.

C. Figuration du sujet souillé échappant à l'émasculation par une attitude ignominieuse et écœurante. La souillure est à la fois cause primitive et remède.

Plate 183 Georges Bataille, *Schéma psychanalytique des figurations contradictoires du sujet dans 'Le Jeu lugubre' de Salvador Dali* (*Psychoanalytic Plan of the Contradictory Representations in Salvador Dali's 'The Lugubrious Game'*), *Documents*, no.7, 1929.

Under Breton's influence, Dali refused Bataille permission to reproduce *The Lugubrious Game* in an essay on the painting in *Documents*. Although Dali's sentiment, 'beauty is only the degree of consciousness of our perversions', parallels the sorts of interest to be found in Bataille's writings, and Dali was undoubtedly influenced by Bataille's erotic novel *L'Histoire de l'œil* ('History of the Eye', written under the pseudonym Lord Auch in 1928), Breton persuaded him to stay with the Surrealist group.

Bataille began his essay on *The Lugubrious Game* with the words, 'Intellectual despair leads neither to apathy nor to dreaming, but to violence'. For Bataille, Dali was far from opening windows wide; rather, Bataille saw 'Dali's abominable mirror'. And where 'Picasso's paintings are hideous ... those of Dali have an appalling ugliness'; violence, bestiality, disgust, horror, excrement – all these represented the underbelly, the unconscious of the 'civilized'. Bataille saw in *The Lugubrious Game* diverse and contradictory aspects and figures, schematically noted in Plate 183. Identifying castration as the theme of the painting, Bataille begins with the central figure, in which the upper part of the body is torn from the lower, symbolic of the moment of 'emasculation' (A); the fragmented, dispersed forms in the upper part of the canvas represent desires, shown in the upward movement or 'ascension' of 'objects of desire' (using the format of a religious assumption or apotheosis), through which punishment is sought out (B); the figure in the lower right-hand corner, with soiled pants, tries to escape emasculation by adopting 'an ignominious and sickening attitude' (C); finally, in the statue to the left, the figure contemplates his own emasculation 'with equanimity' (D). Bataille, focusing on the dismembered limbs, identifies castration and its dread as the psychoanalytic theme of the painting. Dismemberment, and the fragmentation of the picture, are thus linked to the Oedipal scenario, and ultimately to the Oedipal origins of modern painting.

Breton and Bataille

Divisions: 1929

While Breton's Surrealism explored the 'forest of symbols' underlying prevalent conceptions of reality, we could see the work of Bataille as occupying the shadows that restrained even Breton. While Breton searched for the 'gleam of light', Bataille pursued obscurity. When Bataille uses the metaphor of light, it is so dazzling that it is blinding; sight gives way to blindness, the field of vision tainted by the *tache aveugle* ('blind spot'). No surprise, then, that Breton saw Bataille as entrenched in incurable pessimism. Although the commentary is one-sided (Breton alludes to Bataille, but Bataille rarely responds), Bataille regarded Breton and the Surrealists as simply deluded by incurable idealism.

The split between Breton and Bataille occurred in 1929, where a single month saw the publication of both Breton's 'Second Manifesto of Surrealism' in *La Révolution Surréaliste* and Bataille's 'Le "Jeu lugubre"' in *Documents*. The crisis of that year involved many Surrealists, some of whom were expelled from the group by Breton, while others – such as Masson – became distanced from him. Bataille was Breton's most vociferous opponent and, with Michel Leiris and others, became a key figure in the rival magazine *Documents*, set up in 1929. Although never one to organize groups, Bataille came to represent, with fellow dissidents, an alternative camp set up outside the boundaries set by Breton.

Breton criticized Bataille for his 'vulgar materialism', which he contrasted with his own view of Surrealism's 'dialectical materialism' derived from Marx. Breton was not referring here to the vulgar materialism that gained ground under Stalin, in which art simply 'reflected' society and class interests (although, in the Second Manifesto, he certainly did attack the dictates of the Communist Party). Breton had joined the French Communist Party in 1927, but later left, disillusioned by the party's unwillingness to accept the relative autonomy of Surrealism's position, and its refusal to admit the avant-garde's prerogative to experiment. His and other Surrealists' commitment to a Trotskyist platform – which, among other things, allowed the committed intellectual to be in advance of conventional culture – was irreconcilable with the Stalinist position adopted by the French Communist Party. The party's position could be seen as one kind of misrepresentation of materialism as it had been defined by Marx but, specifically in his attack on Bataille, Breton was targeting another kind of misrepresentation – Bataille's reduction of materialism, literally, to crassness, to dirt, to its basest form.

For Breton, it was crucial that Surrealism find a theoretical framework that took account of both Marx and Freud, in a strategy that would address the social and psychic repression operating under capitalism. In the Second Manifesto, Breton insisted:

> To be sure, Surrealism, which as we have seen deliberately opted for the Marxist doctrine in the realm of social problems, has no intention of minimizing the Freudian doctrine as it applies to the evaluation of ideas.
>
> (Breton, 'Second Manifesto of Surrealism', p.159)

The defence of Freud is here so explicit because the party had refused to entertain the 'great discovery' of the unconscious that Breton had always acknowledged as his greatest debt to Freud. But we might also note, here, how Breton insists on the *conjunction* of Freud and Marx, of the psychic with the social. To Breton, Bataille's approach represented the loss of Marx from the equation. And the loss of Marx meant the loss of revolution too. As Breton wrote:

> Our allegiance to the principle of historical materialism ... there is no way to play on these words. So long as that depends solely on us – I mean provided that communism does not look upon us merely as so many strange animals intended to be exhibited strolling about and gaping suspiciously in its ranks – we shall prove ourselves fully capable of doing our duty as revolutionaries.
>
> (p.142)

This sounds defensive, and it was: in reality Breton's criticisms of Bataille, which were premised on Surrealism's allegiance with Marxism, were made in the context of Breton's marginalization by the French Communist Party.

In the 'Second Manifesto of Surrealism', Breton's diatribe against Bataille is one of many directed against those whom he saw as defectors and deserters from the principles of Surrealism and who threatened his leadership and domination of the group. Many of these 'defectors', we've seen, were regrouping around Bataille. Breton wrote: 'What we are witnessing is an obnoxious return to old anti-dialectical materialism, which this time is trying to force its way gratuitously through Freud' (p.183). The problem for Breton was not Freud, as such, but the use made of his psychoanalytic ideas. In this respect, as Denis Hollier has written, there were 'two uses for Freud, two positions for literature in relation to psychoanalysis, each of which can be represented by Bataille and Breton, respectively'. In their theoretical positions, Hollier identifies a difference between Breton's attempt theoretically to negate 'the distinction between normality and pathology' and Bataille's 'real practice of imbalance, a real risk to mental health' (Hollier, *Against Architecture*, p.108). Where Breton's interest in psychoanalysis was diagnostic, Bataille succumbed to the fantasies it described.

Breton was critical of Bataille's preoccupations with the corrupt, the vile and the rank, where 'horror does not lead to any pathological complaisance and only plays the role of manure in the growth of plant life, manure whose odour is stifling no doubt but salutary for the plant' (Bataille, quoted by Breton, p.184). What is striking here is that, in vilifying Bataille, Breton uses terms similar to those that had been levelled at Surrealism itself:

> It is to be noted that M. Bataille misuses adjectives with a passion: befouled, senile, rank, sordid, lewd, doddering, and that these words, far from serving him to disparage an unbearable state of affairs, are those through which his delight is most lyrically expressed.
> (Breton, 'Second Manifesto of Surrealism', p.184)

Plate 184 *Mariage, Seine et Marne, vers 1905* (*Wedding, the Seine et Marne area, c.1905*), photograph in 'Figure humaine' ('Human face'), *Documents*, no.4, 1929. Photograph by courtesy of the Courtauld Institute Book Library.

Breton also invoked the last lines from Bataille's essay from *Documents*, 'Figure humaine', in which Bataille had called on his readers 'to run absurdly with *him* – his eyes suddenly become dim and filled with unavowable tears – toward some haunted provincial houses, seamier than flies, more depraved, ranker than barber shops' (Breton, 'Second Manifesto of Surrealism', p.181). One of the illustrations that accompanied 'Figure humaine' was a photograph of a provincial bourgeois marriage from the turn of the century (Plate 184), respectable on the surface but, for Bataille, a scene of buried perversion. In some respects the preoccupation with anachronistic images, the idea of latent beneath manifest meaning, the terrible lying beneath the outwardly respectable and ordered – in short, the uncanny – may seem quite in keeping with broader Surrealist concerns. And yet the difference is that Bataille refused to entertain available images of liberation (whether Marxist or otherwise), preferring to participate in its trauma, to engage in 'baseness' with no claim for objective distance. It is an important feature of his writing that it tends to act out the perverse strategies that it describes. His essay 'Le "Jeu lugubre"', for instance, though taking its title from Dali's painting, is also a kind of 'lugubrious game' that does not retain a distance from its subject as Breton might have wished, but submits to its own metaphors of 'an appalling ugliness'. For Bataille, against idealism there is only bestiality: 'It is impossible', he wrote, 'to behave differently to the pig rooting in the slop-heap.' For Breton, in contrast, 'Man ... is still free to *believe* in his freedom' (Breton, 'Second Manifesto of Surrealism', p.187). There is always, for Breton, some residual hope (encapsulated, remember, in Nadja's name), while for Bataille illumination is necessarily accompanied by a Fall from Grace. Breton held on to a conception of beauty – of what he termed 'convulsive beauty'. For Bataille, too, there is also beauty but only in the moment of obsolescence, which is indelibly linked with rot and decay and, ultimately, death (his metaphors of dust, spit, even the abattoir, suggest different forms of putrefaction).

Bataille's *bassesse*

Bataille was interested in *bassesse*, or baseness, as a mechanism that triggered rot and decay – the characteristic processes of the *informe* ('formlessness'), or the process by which form is 'undone'. In his 'Critical dictionary', published in *Documents* in 1929, Bataille deliberately parodied the idea of a dictionary as a series of definitions. Instead, the words he selects, such as *œil* ('eye'), *informe*, *abattoir*, *la bouche* ('mouth') and *matérialisme* are sketched in a way that stops the words being fixed in their meanings. They follow the form of a dictionary, but undo that form at the same time. The photographs that accompany the texts do not provide definitions but add a further layer of suggestiveness (Plates 185 and 186). That is, the words are displaced from any absolute definition and are further displaced by the images (that were produced by, among others, Boiffard and Éli Lotar). In the same issue as his dictionary entry for *œil*, Bataille also illustrated Dali's painting *Blood is Sweeter than Honey* of 1927, together with an old detective comic *Police Eye* (Plate 187). Many of Bataille's terms in the dictionary and elsewhere refer to parts of the body as a dismembered anatomy of the modern.

Bataille, like Breton, regarded Picasso as a crucial figure. But while Breton saw Picasso's work as a 'way through', where Surrealism also had to pass, Bataille stressed its hideousness, what we might call a 'way down', where 'the dislocation of forms drags thought down with it' (Bataille, 'Le "Jeu lugubre"', p.86). Likewise, both the Surrealist group and Bataille celebrated the work of the Marquis de Sade. In *La Révolution Surréaliste*, and more particularly in *Le Surréalisme au service de la Révolution*, de Sade is discussed as a hero of Surrealism (for instance, Paul Éluard's hommage to de Sade, 'D.A.F. de Sade, the fantastic and revolutionary writer'), as a man who spent most of his life in prison for his beliefs, and who deserved to be celebrated as an atheist, a revolutionary and a writer who had liberated the erotic imagination. In this the Surrealists followed Apollinaire who, in

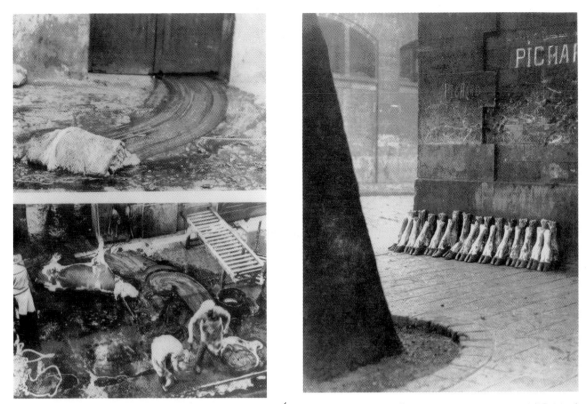

Plate 185 'Abattoir', two pages of photographs by Éli Lotar from G. Bataille, 'Dictionnaire critique' ('Critical dictionary'), *Documents*, no.6, 1929. Photographs by courtesy of the Courtauld Institute Book Library. © DACS, London, 1993.

Plate 186 'Bouche' ('Mouth'), photograph by Jacques-André Boiffard from G. Bataille, 'Dictionnaire critique' ('Critical dictionary'), *Documents*, no.3, 1929. Photograph by courtesy of the Courtauld Institute Book Library. © DACS, London, 1993.

Plate 187 Page from *Documents*, no.4, 1929, with *Police Eye* and Salvador Dali, *Le Sang est plus doux que le miel* (*Blood is Sweeter than Honey*), 1927, painting lost. © DEMART PRO ARTE BV/DACS, London, 1993.

L'Œil de la Police, pages de la couverture en couleurs. — 1908, N° 26.

Salvador Dali, Le sang est plus doux que le miel (1927).
Barcelone, Coll. privée.

the introduction to his 1909 edition of de Sade's work, had proclaimed 'The Marquis de Sade, that most free of all spirits to date'. Bataille shared this sense of de Sade's importance, but stressed his 'feeling for the terrible', the violence and cruelty of his writing (a provisional title for his essay 'Le "Jeu lugubre"' had been 'Dali and Sade scream together').

Bataille thought that, following Freud's discoveries, the differences between the cruelty of the sacrificial rites of ancient peoples and the scandalous claims of de Sade were only superficial. He considered that de Sade was an exemplary precursor of the modern unconscious who, like the Spanish artist Goya, exposed 'the terrible faces of dreams' beneath the appearance of things. In his view of modern art Bataille internalized Sadean

principles. Miró's work, for example – which decomposed the image and broke up its unity – was, like Dali's, indicative of the principle of destruction at work in modern art. In his rather later book on Manet (1955), Bataille elaborated this idea to argue that modern art began with Manet because he was the first to 'destroy' the subject of painting. With Manet began the obliteration of the 'text' – that is, the story that might have been the painting's pretext. In the case of *Olympia*, the 'text' of prostitution is repudiated or cancelled out by Manet's handling, making the 'text' and the painting 'part company': 'the picture *obliterates* the text', wrote Bataille, 'and *the meaning of the picture is not in the text behind it but in the obliteration of that text*' (Bataille, *Manet*, p.62).

It is too easy when making comparisons between Breton and Bataille to lose sight of the ground that they shared. They clearly had more in common than they did with preva-lent conceptions of reality, or with the kind of 'constructive' machine aesthetics discussed in the previous chapter. Partisans of either figure often tend to exaggerate their differ-ences, which undoubtedly existed, in order to vilify one at the expense of the other – to claim, for example, that Breton represents 'unity' to Bataille's sense of 'disunity' or 'decentredness', or that Bataille simply represents Surrealism without politics as opposed to Breton's revolutionary credentials. Surrealism, itself many-faceted, has become a site of conflicting accounts of what the modern means. It is Breton who has dominated the litera-ture about Surrealism, both as the most powerful voice of Surrealism's revolutionary aims and as the organizational leader of the movement. Breton's model of Surrealism engages directly with revolutionary politics and has been influential in attacking the view that art can be autonomous from social and political concerns. Bataille's ideas no more asserted an independence for art or culture than did Breton's, nor idealized art as free from politics. But certainly Bataille's attitude towards politics was different: Utopian fervour, all hope of 'liberation', is turned in on itself in a terminal state of trauma. For Bataille, if psychic disorder was to be merely *imitated* – even as a mode of critique – all was lost.

The role of psychic disorder in the Surrealist aesthetic

Hysteria

Dali published an illustrated article in *Minotaure* in 1933 on the theme of 'dreadful and edible beauty' in art nouveau. The dual idea of 'dread' and 'edibility' was a typically Daliesque conjunction, applied here to the forms of decorative art. The article appeared opposite the photographer Brassaï's *Sculptures involontaires*. These were photographs of found objects and scraps, such as a folded bus ticket, or a crumpled piece of paper, isolated and displaced from their normal contexts (Plate 188). By using close-ups, Brassaï captured the unusual forms of these pieces of urban ephemera, which represented the discarded waste of the modern city. They related to his other photographs of the unexpected facets and strata of Paris, which appeared elsewhere in *Minotaure*, such as the 'prehistoric drawings' – the *Graffitis Parisiens* (Plate 189). Dali's article, on the other hand, was a celebration of Antonio Gaudí's architecture in a Catalan city, Barcelona (Plate 190), illustrated by photographs by Man Ray. He remarked on the way in which the 'right-angle formula' and the 'golden section' had been replaced by the formula of 'convulsive undulation'. This was a feature of Gaudí's architecture that Dali compared, through visual analogy, with a photograph taken by Brassaï of an art nouveau entrance to the Paris Métro (Plate 191). And there was a further parallel to be found in Gaudí's 'hysterical sculpture', the female heads of which showed 'erotic ecstasy'. Dali's collage *The Phenomenon of Ecstasy* (Plate 192), which used details of sculptures from Gaudí's buildings, related back to the long established Surrealist interest in hysteria, hailed as the greatest poetic discovery of the nineteenth century (*La Révolution Surréaliste*, no.11, 1928, pp.20–22).

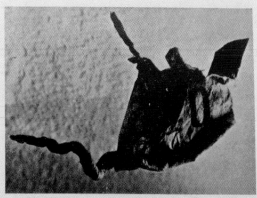

BILLET D'AUTOBUS ROULÉ "SYMÉTRIQUEMENT", FORME TRÈS RARE D'AUTOMATISME MORPHOLOGIQUE AVEC GERMES ÉVIDENTS DE STÉRÉOTYPIE.

NUMÉRO D'AUTOBUS ROULÉ, TROUVÉ DANS LA POCHE DE VESTON D'UN BUREAUCRATE MOYEN (CRÉDIT LYONNAIS); CARACTÉRISTIQUES LES PLUS FRÉQUENTES DE "MODERN'STYLE".

LE PAIN ORNEMENTAL ET MODERN'STYLE ÉCHAPPE A LA STÉRÉOTYPIE MOLLE

MORCEAU DE SAVON PRÉSENTANT DES FORMES AUTOMATIQUES MODERN'STYLE TROUVÉ DANS UN LAVABO.

LE HASARD MORPHOLOGIQUE DU DENTRIFICE RÉPANDU N'ÉCHAPPE PAS A LA STÉRÉOTYPIE FINE ET ORNEMENTALE.

ENROULEMENT ÉLÉMENTAIRE OBTENU CHEZ UN "DÉBILE MENTAL".

SCULPTURES INVOLONTAIRES

Plate 188 Brassaï, *Sculptures involontaires*, photographs, *Minotaure*, no.3/4, 1933. Arno Press Reprint by permission of Éditions d'Art Albert Skira. © DACS, London, 1993.

Plate 189 Brassaï, *Graffitis Parisiens*, photograph, *Minotaure*, no.3/4, 1933. Arno Press Reprint by permission of Éditions d'Art Albert Skira. © DACS, London, 1993.

Plate 190 Man Ray, photograph of Gaudí's architecture, in Dali, 'De la beauté terrifiante et comestible, de l'architecture modern' style', *Minotaure*, no.3/4, 1933. Arno Press Reprint by permission of Éditions d'Art Albert Skira. © DEMART PRO ARTE BV/DACS, London, 1993.

We repeatedly find that the Surrealists, in bringing to light the hidden world of unconscious desires, focus on instances of psychic and social failure, where laws falter or break down. One example of this was Breton's celebration of Nadja's 'madness', which eventually brought her to an asylum; another is the Surrealist interest in hysteria. In a two-page spread commemorating the 'Fiftieth anniversary of hysteria', in *La Révolution Surréaliste* in 1928, Breton and Aragon had written: 'Hysteria is by no means a pathological symptom and can in every way be considered a supreme form of expression' (no.11, p.20). Their article was accompanied by photographs of an hysteric studied by Charcot in 1878. The young woman patient, 'Augustine', had been photographed in a series of involuntary states, subtitled 'attitudes passionnelles' ('postures of passion') (Plate 193). Unlike Charcot and his pupil Freud, the Surrealists tended to celebrate hysteria as a passionate rather than a pathological condition. To Breton and Aragon, the condition of Charcot's hysteric exemplified the breaking down of repressive laws: 'Hysteria is a mental state that is more or less irreducible and that is characterized by the subversion of the relations between the subject and the world of morality, with which it takes issue, outside any system of delirium' (*La Révolution Surréaliste*, no.11, p.22). Subversion, in this context, means an unconscious protest, which, in more recent feminist interpretations of Freud, has been taken to mean a protest against patriarchal law: 'In the body of the hysteric, male and female, lies the feminine protest against the law of the father' (J. Mitchell, *Psychoanalysis and Feminism*, p.404). Certainly the Surrealist preoccupation with female hysteria can be seen to reinforce a stereotypical view of woman as 'mad' and 'devouring'. But her 'protest' is also important, and the emphasis on psychic failure sheds a rather different light on the Surrealists' use of the stereotype.

I am not suggesting, of course, that the Surrealists knowingly used Freud in this way, merely that the position occupied by hysteria in the Surrealist aesthetic was complex. The reasons why they were so drawn to photographs of Charcot's patients involved their own views of female sexuality, and the role that female psychic disorder came to play in their aesthetic. Their knowledge of hysteria was largely derived from Charcot and another experimental psychologist Pierre Janet; but hysteria was also, as they recognized, central

CONTRE LE FONCTIONNALISME IDÉALISTE, LE FONCTIONNEMENT SYMBOLIQUE-
PSYCHIQUE-MATÉRIALISTE.

IL S'AGIT ENCORE D'UN ATAVISME MÉTALLIQUE DE L'ANGÉLUS DE MILLET.

MANGE-MOI !

MOI AUSSI

Plate 191 Brassaï, photographs of railings of the Paris Métro, in Dali, 'De la beauté terrifiante et comestible, de l'architecture modern' style', *Minotaure*, no.3/4, 1933. Arno Press Reprint by permission of Éditions d'Art Albert Skira. © DEMART PRO ARTE BV/DACS, London, 1993.

to the work of Freud (the early case of 'Dora', for instance, was a famous example of female hysteria). For Freud, hysteria was characterized by both 'exaggerated sexual craving and excessive aversion to sexuality' (Freud, 'Three essays on the theory of sexuality', p.79). Illness was seen as a way of escaping from this conflict 'by transforming [...] libidinal impulses into symptoms' (p.79).

Plate 192 Salvador Dali, *Le Phénomène de l'extase* (*The Phenomenon of Ecstasy*), collage, *Minotaure*, no.3/4, 1933. Arno Press Reprint by permission of Éditions d'Art Albert Skira. © DEMART PRO ARTE BV/DACS, London, 1993.

Whereas hysteria is often seen as a nineteenth-century phenomenon – the century's greatest discovery, as we have seen, for Breton and Aragon – it is worth remembering that Freud's major work on female sexuality dates from the 1920s and 1930s, when hysteria still played an important role in his view of the pathology of women. In his essay of 1931, 'Female sexuality', Freud developed the idea that female sexuality was distinct from that of men – rather than, as he had implied previously, simply its reverse. Hysteria, Freud suggests, is particularly common in women because it is rooted in the girl's pre-Oedipal phase of attachment to the mother. The particular problem for the girl is that she needs to make the transition from the mother as love-object to the father as love-object (and thereby to all men). Paranoia in women was another condition that stemmed from this early period of dependence on the mother. Crucial here were the differing ways in which boys and girls experienced the Oedipus complex. Where previously Freud had not differentiated between the sexes in relation to this vital phase, he now wrote:

> One thing that is left over in men from the influence of the Oedipus complex is a certain amount of disparagement in their attitude towards woman, whom they regard as being castrated … Quite different are the effects of the castration complex in the female. She acknowledges the fact of her castration, and with it, too, the superiority of the male and her own inferiority; but she rebels against this unwelcome state of affairs.
> (Freud, 'Female sexuality', p.376)

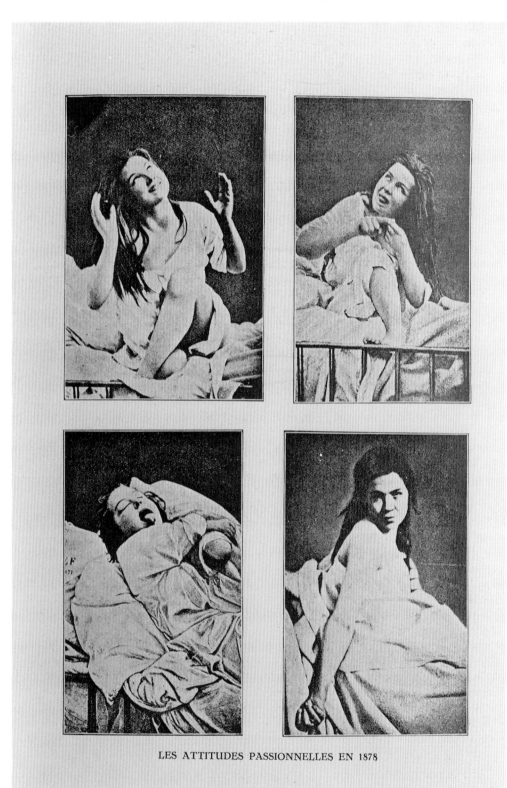

LES ATTITUDES PASSIONNELLES EN 1878

Plate 193 'Le cinquantenaire de l'hystérie, 1878–1928' ('The fiftieth anniversary of hysteria'),
La Révolution Surréaliste, no.11, 1928. Arno Press Reprint.

He goes on,

> We should probably not be wrong in saying that it is this difference in the reciprocal rela-
> tion between the Oedipus and the castration complex which gives its special stamp to the
> character of females as social beings.
>
> (p.377)

Some feminist psychoanalysts and theorists have developed the view that Freud's theoryis *de*scriptive of power relations *as they exist* under patriarchy, rather than *pre*scriptive.[8]From this point of view, the critical power of Freud's theory lies partly at least in hisanalysis of how sexual difference is not a biological given but is made in culture. TheOedipus complex, for instance, retains its crucial importance because it enacts symboli-cally what the psychoanalyst Jacques Lacan was to term 'the law of the father', which hasbeen taken as emblematic of the power structure under patriarchy. And Freud gives anaccount of how these differences are played out symbolically. It is important to recognizehere the symbolic rather than the literal value of Freud's theory, where the 'law of thefather' stands metaphorically for the domination of men over women. Lacan lateracknowledged that the character of the 'feminine sexual attitude' had been pinpointed inthe term 'masquerade', which was introduced into the debate on female sexuality in 1929with the publication of the psychoanalyst Joan Rivière's essay, 'Womanliness as a mas-querade'. Here Rivière questions what womanliness is by looking at the case of a womanwho is successful in her career, and who in Rivière's terms strives to be 'like a man' in herwork, yet who also compensates by adopting a masquerade of femininity. Rivière con-cludes that 'womanliness' is itself a representation and, as such, one and the same thing asa masquerade. The acting out of a received idea of 'femininity' again reinforces the ideathat significant sexual differences are made in culture, not nature. Hysteria has been seenin this context as failed masquerade.[9] From a psychoanalytic point of view, then, hysteriais a specific condition that raises general problems about the relationship between thesexes, and between 'masculinity' and 'femininity'.

The symbolic realm with which Surrealism dealt fluctuated between masquerade (thefantasy of femininity) and its moments of failure (in hysteria, for example), as two sides ofthe same coin. Surrealism does not 'unmask' womanliness so much as find its masksdesirable, and in so doing privileges the male erotic viewpoint. In his essay 'La beauté seraconvulsive' ('Beauty will be convulsive', the last line of *Nadja*), Breton makes it clear thatin his view aesthetic response is integrally tied to his experience of erotic pleasure. Thisessay was later incorporated into *L'Amour fou* and, in it, Breton discussed the erotic effectof the 'forest of signs', in both animate and inanimate forms. One of the three elements of'convulsive beauty' was *érotique voilée* ('veiled erotic') – the process of representation atwork in nature where, for example, one animal might imitate another, or where theinanimate borders on the animate, or where one thing comes to look like something else,as in the photographs of rock crystals by Brassaï reproduced in the essay (Plate 194). Buthe also reproduced there, and with the caption *érotique voilée*, Man Ray's photograph ofMeret Oppenheim (Plate 160), where the forms of the female body and the machine areshown in a state of transition, with the image of the woman bordering on the identity ofthe machine. The purpose is not to unmask some essential femininity, so much as toheighten the erotic effect through the inconclusiveness, through the veil itself.

Another element in Breton's notion of convulsive beauty was the *explosante-fixe* – forexample, the freezing of the wild movement of dance in the frame of another photographby Man Ray (Plate 195) in order to capture 'the exact expiration of movement' ('Mad love'in *What is Surrealism?*, p.162). It is in the nature of convulsive beauty, according to Breton,that it could not 'have reached us by normal logical channels'. In these terms, 'delirium'

[8] J. Mitchell originally put forward this view in *Psychoanalysis and Feminism*, which has been highlyinfluential on subsequent feminist uses of Freud and Lacan in particular.

[9] S. Heath makes and discusses this point in 'Joan Rivière and the masquerade', p.51.

Plate 194 Brassaï, photograph of rock crystals, in A. Breton, 'La beauté sera convulsive' ('Beauty will be convulsive'), *Minotaure*, no.5, 1934. Arno Press Reprint by permission of Éditions d'Art Albert Skira. © DACS, London, 1993.

Plate 195 Man Ray, *Explosante-fixe* (*Fixed-explosive*), photograph, in A. Breton, 'La beauté sera convulsive' ('Beauty will be convulsive'), *Minotaure*, no.5, 1934. Arno Press Reprint by permission of Éditions d'Art Albert Skira. © ADAGP, Paris and DACS, London, 1993.

was a state to be striven for, because it threw into question what was 'normal'. Thus even where Breton, in a text such as this one, does not speak directly of hysteria or other psychic disorders particularly associated with women, they are always implied in his aesthetic. The term 'convulsive', for example, was derived from the involuntary bodily movements engendered by conditions such as hysteria. And as Whitney Chadwick has noted, *l'amour fou* was the term Pierre Janet had applied to the state of ecstasy experienced by the female hysteric (*Women Artists and the Surrealist Movement*, p.35). Breton makes this a principle of the Surrealist aesthetic.

Paranoia

Another instance of psychic failure that interested the Surrealists was the case of the Papin sisters, that was commented on in *Le Surréalisme au service de la Révolution*, where two photographs of the sisters, 'before' and 'after', also appeared (Plate 196). The sisters had been brought up in a convent at Le Mans and then placed by their mother in domestic service in a bourgeois home. For six years they endured with perfect submission unreasonable demands and insults; eventually fear, exhaustion and humiliation bred hatred of their employers whom they killed, pulling out their eyes and crushing their heads. Then they washed themselves carefully and went to bed. Paul Éluard and Benjamin Peret end the story with the words (p.28), 'They emerged fully armed from a song by Maldoror' – suggesting, by the reference to the Comte de Lautréamont's *Les Chants de Maldoror*, that their actions were poetic rather than criminal.

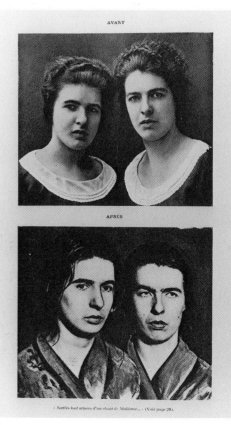

Plate 196 The Papin sisters, *Le Surréalisme au service de la Révolution*, no.5, 1933. Arno Press Reprint.

Again, this gruesome story provided a narrative onto which the Surrealists could project their own preoccupations, such as their construction of woman as 'mad', as 'other'. (Breton, for example, had discussed Nadja, incarcerated in an asylum, as somehow closer than men to the unconscious.) The sisters' action, the massacring of their oppressors, also stood, for the Surrealists, as the ultimate protest against a social structure in which they were imprisoned and enslaved. Thus such instances of madness could be regarded as a protest against the family, against Catholicism and against sexual and social oppression. Indirectly, this is echoed by an illustration in the same issue, Ernst's *Oedipus* (Plate 163), providing the classic instance of protest against the law of the father.

The way in which this short piece on the Papin sisters was laid out in the magazine is also revealing. It was placed alongside an unconnected article by the Belgian Surrealist Paul Nougé, called 'Les images défendues' ('Prohibited images') and dealing with the mechanism of metaphor. It was set above a drawing by Magritte that combined the images of the Virgin Mary and a prostitute in a blasphemous gesture of anticlericalism. The celebration of female psychic disorder, blasphemous gesture, and Nougé's view of the role of scandal in 'the refusal of the established order' (P. Nougé, 'Les images défendues', p.28) are drawn together as simultaneous commentaries. And in another image (in the same issue), which can also be read in part as an attack on the Catholic church, Man Ray framed a photograph of buttocks within the shape of an inverted cross and dedicated it to the Surrealist hero, the Marquis de Sade (Plate 197).

The psychoanalyst Lacan was involved with the Surrealist group in the thirties. He published two articles on paranoia in *Minotaure*, one of them (in the same issue as Dali's Gaudí article) on the Papin sisters. For Lacan, the Papin sisters had committed the ultimate 'paranoiac crime'; paranoia was a morbid state, characterized by delirium and delusions of persecution, but as a condition applied to the creative imagination it could be revelatory. In another article on the problem of style, Lacan made the point: 'Now, some of these forms of lived experience, known as morbid, appear particularly fertile in modes of symbolic expression' (Lacan, 'Le problem [*sic*] du style et la conception psychiatrique des formes paranoïaques de l'expérience', pp.68–9). Like hysteria earlier, paranoia now

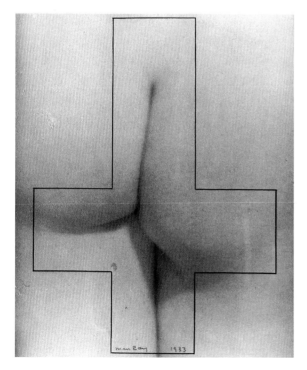

Plate 197 Man Ray, *Monument à D.A.F. de Sade*, 1933, photograph, reproduced in *Le Surréalisme au service de la Révolution*, no.5, 1933. Collection of Arturo Schwarz. © ADAGP, Paris and DACS, London, 1993.

entered the Surrealist aesthetic, through Dali in particular. Though not an exclusively female disorder by any means, the association of paranoia with the Papin sisters was not incidental for the Surrealists, who took up the pair as the most recent in a long line of anti-heroines dating back to Germaine Berton. By the time Dali became interested in Lacan's work, paranoia had already entered his vocabulary – and his 'paranoiac-critical' interpretation of Jean François Millet's painting *Angelus* preceded Lacan's essay. When Dali read Lacan's doctoral thesis on paranoiac psychosis, he found that it reinforced his own interests. In 1931, for example, Dali had produced his 'paranoiac face' (Plate 198), where a photograph of an African village is turned on its side and transformed into the profile of a face. This shows, again, the Surrealist interest in metaphor, the idea that one thing could simultaneously be read as another while never losing its original identity entirely. For Dali, 'paranoiac images are due to the delirium of interpretation' (Ades, *Dali*, p.124). They could also be endlessly proliferated: 'Paranoiac phenomena', he wrote, are 'common images having a double figuration; the figuration can theoretically and practically be multiplied' (Ades, p.126).

Dali developed his own 'paranoiac-critical method' in painting. His painting *Suburb of the Paranoiac-critical Town* (Plate 199) is reminiscent of de Chirico's imagery of the solitary girl running in empty streets (Plate 182). The idea of the city as an archaeological site of dreams and memories, like the unconscious, was a constant interest for the Surrealists, as

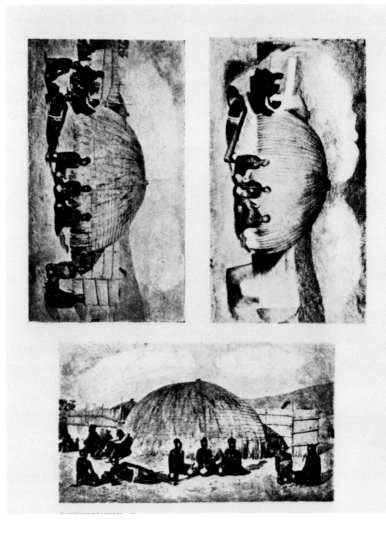

Plate 198 Salvador Dali, interpreted photograph from 'Communication: visage paranoïaque' ('Communication: paranoiac face'), *Le Surréalisme au service de la Révolution*, no.3, 1931. Arno Press Reprint.
© DEMART PRO ARTE BV/DACS, London, 1993.

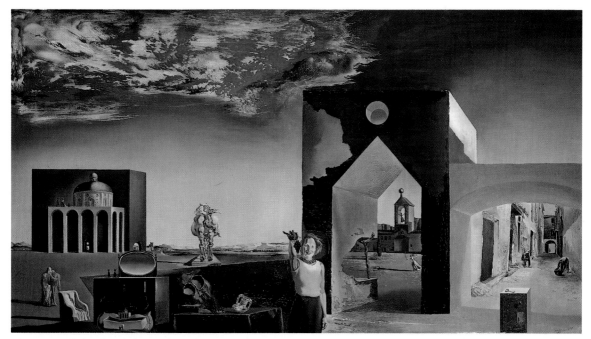

Plate 199 Salvador Dali, *Banlieue de la ville paranoïaque-critique; après-midi sur la lisière de l'histoire européenne* (*Suburb of the Paranoiac-critical Town; Afternoon on the Outskirts of European History*), 1936, oil on panel, 46 x 66 cm. Private collection. Photograph: Christie's Colour Library. © DACS, London, 1993.

we have seen. Rather than use images of Paris, Dali used Spanish townscapes, the suburbs of the French title referring to the marginalized, outlying area of Europe. The links between forms are suggested in the likenesses between details – the grapes, skull and equestrian statue, for example – or in the cloud patterns that continue onto the stone arch. A 'collage' of disparate images is used, where the figure of the woman is symbolically mapped onto the suburban landscape – or, rather, onto a disjointed series of sites and views – as the landscape of the unconscious.

Objects of desire

The Exhibition of Surrealist Objects, 1936

In 1936, the year in which he painted *Suburb of the Paranoiac-critical Town*, Dali contributed to an Exhibition of Surrealist Objects that was held at the Galerie Charles Ratton in Paris. From the installation photograph of the exhibition (Plate 200) it is possible to get a sense of the Surrealist range – as well as of the type of display, where the use of glass cabinets suggested an ethnographic museum. Primitive masks (upper left) were juxtaposed with work by Picasso (relief) and with Surrealist objects, such as Alberto Giacometti's *Suspended Ball* (lower left and Plate 201); ready-mades by Marcel Duchamp (Plate 202) were displayed along with Surrealist objects such as Meret Oppenheim's *Object: Fur Breakfast* (Plate 157). 'Mathematical objects' from the Institut Poincaré in Paris were also included (Plate 203). As items of 'logic', these objects were conceptually, as it were, turned on their heads, as if to bring home Roger Caillois's point from his article

Plate 200 Installation of the Exhibition of Surrealist Objects, Galerie Charles Ratton, 1936. Reproduced by courtesy of Galerie Charles Ratton and Guy Ladrière, Paris.

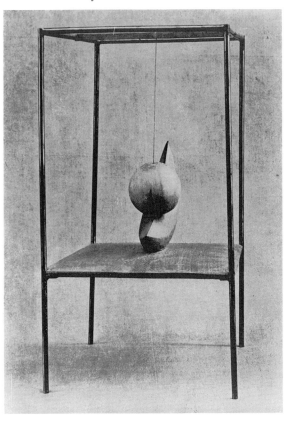

Plate 201 Alberto Giacometti, *Boule suspendue (Suspended Ball)*, *Le Surréalisme au service de la Révolution*, no.3, 1931. Arno Press Reprint. © ADAGP, Paris and DACS, London, 1993.

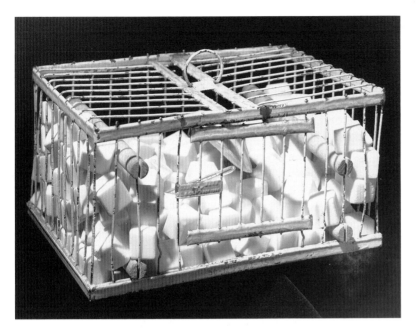

Plate 202 Marcel Duchamp, *Why not sneeze Rrose Sélavy?*, ready-made, 1921, marble blocks in the shape of lumps of sugar, thermometer, wood and cuttle shell in a small birdcage, 11 x 22 x 16 cm. Philadelphia Museum of Art; Louise and Walter Arensberg Collection 50.134.75. © ADAGP, Paris and DACS, London, 1993.

'Spécification de la poésie' – that the Surrealist desire to bring reality into disrepute can only be understood if it is seen to be in opposition to the prevailing view, and that Surrealism valued all that the industrial and the rational had tried to suppress (p.31). The point was to destabilize established divisions and categories, rather than to promote universal and absolute ones. The inclusion of the 'mathematical objects' was meant to suggest that the rationalist opposition between scientific and poetic objects was redundant.

'The objects that form part of the Surrealist exhibition of May 1936', Breton wrote in 'Crisis of the object', 'are of a kind calculated primarily to *raise the interdict* resulting from the stultifying proliferation of those objects that impinge on our senses every day and attempt to persuade us that anything that might *exist* independently of these mundane objects must be illusory' (p.279). That is, habitual responses were thrown into crisis and

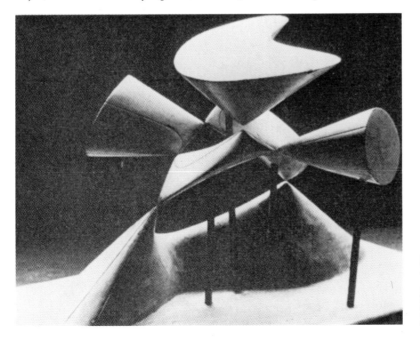

Plate 203 Man Ray, study of a 'mathematical object', *c.*1936, photograph. Private collection, Paris. © ADAGP, Paris and DACS, London, 1993.

customary definitions were questioned by the change of role these objects had undergone. The ready-mades had been diverted from their normal function and reascribed to a signed name; found objects allowed for interpretations that were different from their original ones; Surrealist objects assembled often familiar objects in unfamiliar ways. These redescriptions resulted from a process of 'perturbation and deformation' (p.280).

Disparate elements are brought together in Meret Oppenheim's *Object: Fur Breakfast* (Plate 157), which plays on the disjunction between 'cup, saucer and spoon' and 'fur'. The material does not fit the object; it is a peculiarly bristly fur, the exact opposite of the shiny surfaces of crockery and cutlery. The title extends this visual and tactile incongruity to the metaphor 'fur breakfast'. The connotations of 'fur' and 'cup, saucer and spoon' are brought into conflict. But they are also brought to bear on one another, in order that the everyday object is seen in its sexual aspect, through the connotation of fur, one of the sexual symbols discussed by Freud. The sexual connotation of fur, for Freud, was (like velvet), 'a fixation of the sight of the pubic hair, which should have been followed by the longed-for sight of the female member' (Freud, 'Fetishism', p.354). A particular material might come to bear a sexual meaning by association, and in a certain context. For though the Surrealists at times drew on Freud's theory of dream symbolism, nevertheless it was an important part of his work that these symbols had the capacity to be ambiguous, to shift and to vary – to change their meanings according to context. Elsewhere, for instance, Freud stresses the bisexual nature of symbols that defied simple polarities, which were neither exclusively 'male' nor exclusively 'female'. And in his essay, 'Fetishism', he emphasized the idea of 'a fixation of the sight of' an object. A glance, which is unlikely to be consciously remembered, may be repeated and become a fixation. The object of the fixation is always to some extent a random choice, or at least follows no consciously rational pattern. Fetishism, in these terms, is as much to do with looking at an object as it is with the object of desire itself. Some objects lend themselves to being fetishized more easily than others, but in general anything at all may be fetishized.

Symbolic functions

Giacometti's *Suspended Ball* of 1930–31 (Plate 201) was reproduced in *Le Surréalisme au service de la Révolution* in 1931 in connection with Dali's article, 'Surrealist objects'; the wooden version of this piece had been bought by Breton. Dali describes how the wooden ball suspended on a violin string is 'marked by a feminine hollowness' that skims the ridge of the crescent form ('Objets Surréalistes', p.17). This was the first time that Giacometti included a movable part in his sculptures, which he called 'mobile and mute objects' in a piece following Dali's in the same issue (pp.18–19). Dali included Giacometti's sculpture in his 'objects with a symbolic function'. Again, the symbolic function of objects was basically sexual, and derived from the 'phantasms and representations' of the unconscious. Other objects included by Dali were by Breton, Gala Éluard (Plate 204), Valentine Hugo (Plate 205), and by himself (Plate 206). Dali's own *Scatological Object Functioning Symbolically* of 1931 was a composite of objects dislocated from their normal context to function in an abnormal way. It included a shoe, a cup of lukewarm milk, paste the colour of excrement, a piece of sugar on a pulley painted with a small image of a shoe, pubic hair and a small erotic photograph. To Dali, the Surrealist object was the incarnation of desire:

> The incarnation of these desires, their means of objectification through substitution and metaphor and their symbolic expression constitute the typical process of *sexual perversity*, which is in every way similar to the process of poetic creation.
> (Dali, 'Objets Surréalistes', p.16)

Substitution was the characteristic mechanism of fetishism, and metaphor was seen as its linguistic equivalent. The object as a whole, then, rather than just the individual objects included within it, could be seen as a series of substitutions for desire, and as part of a ritualistic object that became the obsessive, if displaced, focus of those desires.

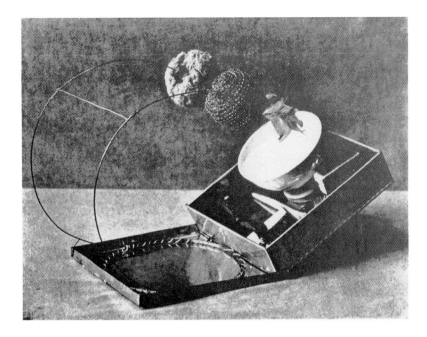

Plate 204 Gala Éluard, object, *Le Surréalisme au service de la Révolution*, no.3, 1931. Arno Press Reprint. © DACS, London, 1993.

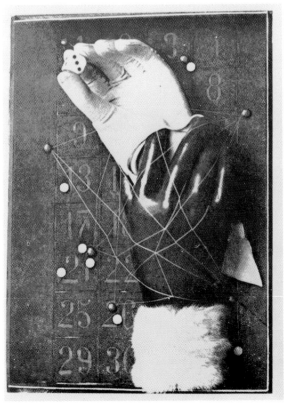

Plate 205 Valentine Hugo, object, *Le Surréalisme au service de la Révolution*, no.3, 1931. Arno Press Reprint. © DACS, London, 1993.

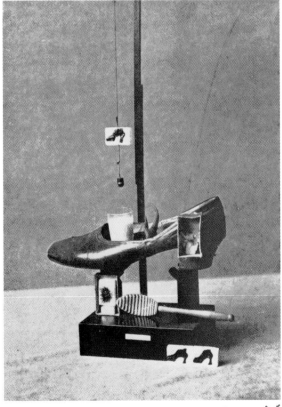

Plate 206 Salvador Dali, object, *Le Surréalisme au service de la Révolution*, no.3, 1931. Arno Press Reprint. © DEMART PRO ARTE BV/DACS, London, 1993.

Plate 207 Joan Miró, *Poetic Object*, 1936, assemblage: stuffed parrot on a wooden perch, stuffed silk stocking with velvet garter and doll's paper shoe suspended in a hollow wood frame, bowler hat, hanging cork ball, celluloid fish and engraved map, 81 x 30 x 26 cm. Collection, the Museum of Modern Art, New York; gift of Mr and Mrs Pierre Matisse. © ADAGP, Paris and DACS, London, 1993.

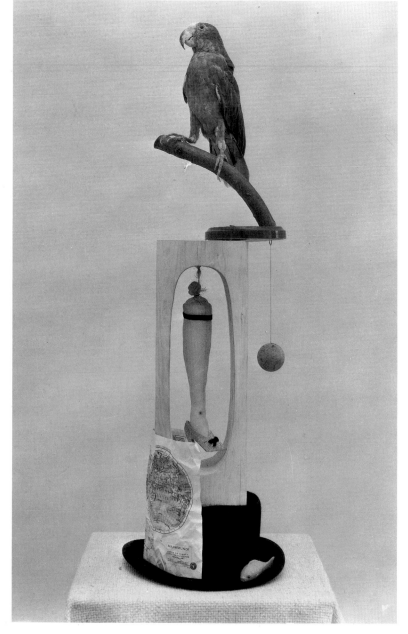

Miró, too, constructed works out a variety of found objects, as in his *Poetic Object* of 1936 (Plate 207) where a stuffed parrot and a stocking are among the objects placed on a bowler hat. Incoherent elements are combined in a 'chance encounter', to use Lautréamont's phrase. More obliquely, the idea of the entire art object as an object of fetishization can be seen in Miró's *Object with Grill* (Plate 208). Here the 'found' objects are not things in the sense of shoes or sugar cubes, but materials and scraps that themselves carried associations. Ambiguous phallic forms are painted on a small piece of wood and hung on a piece of wire mesh, which also acts as a surrogate frame. Elsewhere, Miró used asbestos and other materials in composite objects, with the object being dependent on the same kind of obsessive looking as the fetish.

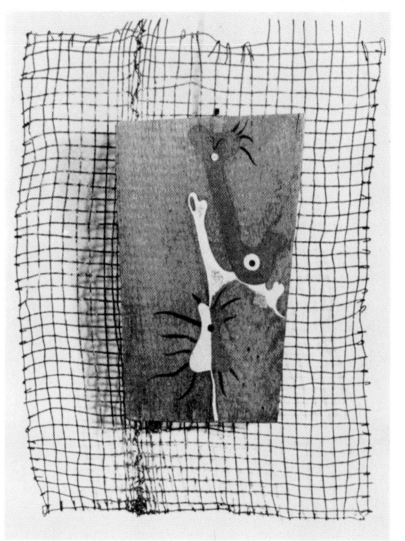

Plate 208 Joan Miró, *Objet avec grille* (*Object with Grill*), 1931, oil on wood fixed to a wire mesh, 36 x 26 cm. Collection of Henriette Gomes. © ADAGP, Paris and DACS, London, 1993.

For the Surrealists, the idea of the object as fetish could range from the examples of African and Oceanic art that they collected and exhibited, to 'found' objects, to the art object itself – any object, in fact, on which their desiring gaze chose to fix. This is not to suggest that the appeal of the fetish was as a universal, transcendent category, but that it lay in the sorts of mechanism and process that were compounded in the idea of the fetish. In Freud's view the fetish is always a substitute for something else, and in Surrealism's terms is an obsessional object. But we should bear in mind the point made earlier, that it is the sight of the object, the process of fixation, which also establishes one thing as a fetish over another. An object or image may be repeatedly used to show this obsessional aspect or, equally significant, the emphasis may be on the angle of the look.

Photography and fetishism

The idea of the angled look, which is at once obsessive and isolates the image from its familiar context, was characteristic of Surrealist photography. Man Ray's series of photographs of hats (Plates 209–210) were produced to accompany Tristan Tzara's article 'On a certain automatism of taste' in *Minotaure* in 1933. This article dealt with the contemporary

Plate 209 Man Ray, *Untitled*, 1933, photograph.
Collection Rosabianca Skira. © ADAGP, Paris and
DACS, London, 1993.

Plate 210 (*right*) Man Ray, *Untitled*, 1933,
photograph. Collection Rosabianca Skira. © ADAGP,
Paris and DACS, London, 1993.

fashion in women's hats for the fedora (similar to the trilby) and other styles, which fol-
lowed the form of male attire but where the split in the crown was taken as a metaphor for
the female genitals. Indeed, to Freud, the hat was an obscure symbol capable of either a
male or a female significance, and this ambiguity was exploited by Man Ray. The photo-
graphs focus on the form of the hat rather than on the hat as an accessory or an adjunct of
the head, and the camera angle skews the form to make the metaphor, thereby putting a
sexual construction on an everyday object of clothing.[10]

Where Breton, in *Nadja*, had been drawn to the old-fashioned, almost obsolete corners
of Paris, Man Ray follows Tzara's article by finding metaphors of sexual difference at
work in the up-to-date, the smart even. Tzara appears to have taken many of the key
points of Freud's essay 'Femininity', published at the beginning of 1933, and applied them
to the female consumer of fashion. Freud had begun this essay with a quotation from the
poet Heinrich Heine:

> Heads in hieroglyphic bonnets,
> Heads in turbans and black birettas,
> Heads in wigs and thousand other
> Wretched, sweating heads of humans ...

For Freud (p.577), Heine was one of the poets who 'knock their heads against the riddle of
femininity'. And in his essay for *Minotaure*, Tzara seems to have seized upon Freud's
evocation of this conjunction between hats, heads and the unconscious mind. This can be
regarded as a metonymic chain, one that moves by association or seems to slip from one
adjacent realm to another. In Man Ray's photographs, there is something excessive in the
undue attention given to a part, and in the way the objects are angled to reveal the meta-
phorized form of the female genitals. It is as if the camera angle reproduces the fixation of
the sight of the hat, concealing the face and symbolically invoking the female body
without even depicting it. The capacity of the photograph to focus on either an unfamiliar

[10] See R. Krauss's discussion of these photographs in Krauss and Livingston, *L'Amour fou*, p.95. In this
section I also draw on her discussion of fetishism and Surrealist photography.

angle or on a part of the whole, to disconnect the object from surrounding objects and give it undue attention, makes photography particularly susceptible to, and able to express, the process of fetishism.

Boiffard's photographs for Bataille's text 'The big toe' (Plates 211–212) also substitute the part for the whole; the toe stands in for the foot, and is again given the same compulsive treatment. The photographs draw attention to the idea of the angled look that is intrinsic to the fetishistic process. However, rather than looking at the smart or urbane, Boiffard's photographs focus on a toe as a protrusion, almost unsightly in its obsessive web of hair and wrinkled skin. For Bataille, 'the big toe is the most *human* part of the body' because, he claimed, the human toe is most unlike the corresponding part in other animals. Thus he began the article with a claim that is the opposite of lofty: he distinguishes humans from other animals only to state that the toe was the quintessentially human part because the foot rests 'in the dirt'. Bataille's inversion of the head to the toe, from top to bottom, corresponded with his views of 'baseness' that I outlined earlier.

The preoccupation with the angled look in photography was not, of course, confined to Surrealism. A concern with camera angle, as one of the specific properties of the photographic process, was shared by photographers such as the Constructivist Aleksandr Rodchenko working in Russia at the same time, or László Moholy-Nagy in Germany, and many others. Theirs was primarily a commitment to the particular language of photography, which had to find new ways to represent new political and social realities. Within Surrealism, Breton's notion of *dépaysement* or estrangement can be compared with Victor Shklovsky's idea of 'defamiliarization'. The crucial difference in Surrealism was that sexuality and desire were central in the process of deflection from reality. For Brassaï, for

Plate 211 Jacques-André Boiffard, photograph, in G. Bataille, 'Le gros orteil' ('The big toe'), *Documents*, no.6, 1929. Private collection. © DACS, London, 1993.

Plate 212 Jacques-André Boiffard, photograph, in G. Bataille, 'Le gros orteil' ('The big toe'), *Documents*, no.6, 1929. Musée National d'Art Moderne, Centre Georges Pompidou, Paris. © DACS, London, 1993.

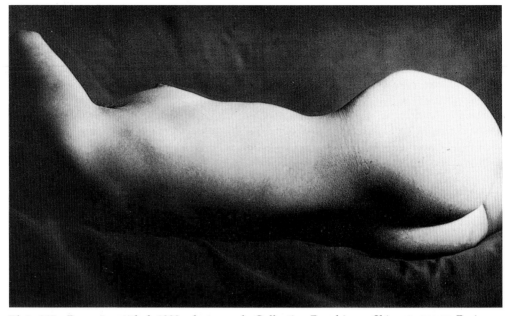

Plate 213 Brassaï, untitled, 1933, photograph. Collection Rosabianca Skira. © ADAGP, Paris and DACS, London, 1993.

example, in his series of nudes (Plate 213), the focus is on the torso of a body, photographed in such a way as to make ambiguous the categories of the 'masculine' and the 'feminine', with a woman's body represented as a phallic form. And the particular properties of the photographic medium (for example, the use of close-up and camera angle) seem almost to mimic the processes of fetishism.

'Fetishism' is central not only to the language of Freud, but also to that of Marx. Although the meanings given are different, the cluster of ideas around 'fetishism' and 'commodity fetishism' (as the term appears in Marx) is interesting in the light of the Surrealist attempt to draw together the ideas of Marx and Freud. For in both there is a central concern with the veiling of meaning, with the need to go beyond the surface to discover the deeper mechanisms at work. Although the Surrealists did not specifically use the concept of commodity fetishism in their commitment to Marxism and to revolutionary politics, there are aspects of their approach to the object that are relevant. It was Benjamin, writing in the 1930s, who developed Marx's notion of commodity fetishism and applied it to cultural practice under capitalism, particularly to his analysis of the nineteenth-century phenomenon of the *flâneur* that I discussed in an earlier section.

For Marx, commodities were things that had an exchange value, and that were exchanged in the world for money. 'Commodity fetishism' described the ritualistic value that is ascribed to such goods because of their exchange or monetary value. For Marx it is a pejorative term, indicating that, under capitalism, value is given to things rather than to people. In this context, the actual use-value of goods recedes into the background, and all commodities act symbolically as 'social hieroglyphs' (*Capital*, p.47). For Marx, this over-investment of things with commodity status extends to social life in general. For the Surrealists, the art-object-as-fetish tended to reify desire – to convert it into a ritual object of exchange, like any other commodity – through the process of displacement. In the fetish, the social and the psychic could meet.

In his essay 'The crisis of the object', written to accompany the 1936 exhibition, Breton did not discuss the ideas of Marx and Freud explicitly, but instead questioned the relationship between art and science, and the normal boundaries between them. He referred on the one hand to the way in which the 'best organized systems – including social

systems – seem to have become petrified in the hands of their advocates' (p.277), and on the other to the need for Surrealism to engage with 'surrationalism' (p.276), to engage with the 'latent possibilities' of the object (p.279). He had hoped, since the 1924 Manifesto, that the Surrealist treatment of the object 'would entail the depreciation of those objects of often dubiously accepted *usefulness* that clutter up the so-called real world' (p.277). The attempt to break out of 'hidebound rationalism' through the Surrealist object might even be seen to call into question where – if not in the manufactured object as the supreme emblem of modernization – the *real* fetishism of modern culture lay.[11] Yet for Bataille it was not only a matter of redefining and reascribing use and symbolic value to objects, but precisely that the full force of the fetish was lacking in Surrealism. Without specific reference to Breton's view of the Surrealist object – which I imagine Bataille would have regarded as too much an emulation of unconscious processes, not enough of an identification with them – Bataille, in his critique of Surrealism 'The modern spirit and the play of transpositions', wrote: 'I defy any amateur of paintings to love a canvas as much as a fetishist loves a shoe' (p.200).

Muse/artist

Gradiva

André Masson's *Gradiva* (Plate 214) was painted in 1939. It was one of a series of paintings on the theme of metamorphosis that he produced in the late thirties. These paintings were far more explicit in their use of imagery than Masson's earlier 'sand' paintings (Plate 216), where he'd considered that the suggestion of an image or a figure resulted from, but did not determine, the automatist technique he used. Indeed Masson – rightly according to Breton ('Surrealism and painting', *La Révolution Surréaliste*, no.9/10, p.43) – had always been 'distrustful of art' and the conventional medium of oil painting, preferring drawing, or sand, or other alternatives. But he had returned to the medium of painting in the 1930s, a time when many Surrealists – though involved in making objects – were also producing paintings. It is almost as if this kind of diversity, encouraged and fostered within Surrealism, could enable Masson to return to the medium of oil.

Masson was one of the Surrealists to have broken with Breton in the crisis of 1929 and to have joined with Bataille. He had been responsible for the original engravings for Bataille's *L'Histoire de l'œil* in 1928; and his series of drawings of massacre and mutilation (Plate 215), which were reproduced in the first number of *Minotaure*, were closely allied with the sort of violent themes that concerned Bataille. By the late thirties, however, Masson and Breton made peace, and Breton wrote an article called 'Le prestige d'André Masson' that appeared in *Minotaure* in 1939, on the theme of the Metamorphosis paintings. In the context of war, his opening sentence was this: 'It is a damning fact that art in France, at the beginning of 1939, appears to be mainly concerned with hiding the sickness of the world under a carpet of flowers.' Where other artists simply failed to engage with 'this epoque's tragic sense of dread', Masson, he argued, had emerged 'triumphantly' through the contrast of 'his sense of disquiet' and his readiness to take risks. Through eroticism, which must, according to Breton, be considered the 'keystone' of his work, Masson achieved 'a general sense of dizzinesss'. And technically he achieved this 'by plastic metaphor in its pure state, by which I mean a literally uninterpretable metaphor'. Breton saw the perfect example of this as the mannequin that Masson exhibited for the International Surrealist Exhibition in January 1938, with 'the mannequin's green gag with a pansy for a mouth' (Plate 217).

[11] T. Gronberg has produced interesting work on this question, in particular in her paper 'Speaking volumes: the Pavillon de *L'Esprit Nouveau'* given at the Association of Art Historians' Conference, London, 1991.

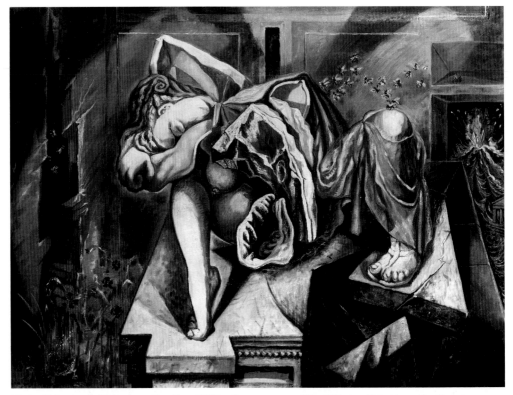

Plate 214 André Masson, *Gradiva*, 1939, oil on canvas, 97 x 130 cm. Private collection. Photograph courtesy of Galerie Louise Leiris. © DACS, London, 1993.

Plate 215 André Masson, *Massacres*, 1928, *Minotaure*, no.1, 1933. Arno Press Reprint by permission of Albert Skira. © DACS, London, 1993.

Plate 216 André Masson, *Figure*, 1926–27, oil and sand on canvas, 46 x 27 cm.
Collection, The Museum of Modern Art, New York; gift of William Rubin. © DACS,
London, 1993.

Plate 217 Raoul Ubac, *Mannequin,*
1937 (photograph of Masson's
mannequin). Galerie Adrien Maeght,
Paris. © DACS, London, 1993.

What was meant by 'metaphor', here, was a state of ambiguity, the idea that the juxta-position of 'two more or less distant realities'[12] engendered a clash, a collision of terms, rather than their resolution. And the force of metaphor, for Surrealism, was that it involved a dislocation of conventional patterns of interpretation. This is what Breton had admired in Masson's work at the beginning, as he had praised the value introduced in Picasso's and Braque's work through the insertion of newspaper cuttings ('Surrealism and painting', *La Révolution Surréaliste*, no.4, p.29). It was that condition of ambiguity and distraction that Masson's earlier automatist technique, like that of Miró, had induced.

By the thirties, Masson's work had, I think, lost some of that earlier, highly nuanced state of ambiguity, in favour of a more explicit and imagistic sense of metaphor – notwithstanding the fact that Breton, in the circumstances, saw Masson as an artist concerned with the 'gaps' in contemporary consciousness, who personified the 'perfect accord between the artist and the revolutionary'. And the violence required of the artist to correspond with the needs of an epoque was incurred, symbolically, on the female body as it is depicted in Masson's painting *Gradiva* (Plate 214). In a fractured, Cubist space, Masson portrays a female figure as half-flesh, half-statue. The divided female is half the classically draped female figure reminiscent of Picasso's monumental nudes of the twen-ties (Plate 64), half entrails spilling onto the broken classical plinth on which she reclines. The 'inside' of the body-cum-cast is positioned at the centre of the painting, and the body is turned toward the viewer, revealing a gaping vagina – rather than reclining in the usual way as the upper delineating line suggests it should. On one level, the image negated the calm, statuesque female figures of earlier representations. However, that such an overtly sexualized and violated image of the reclining figure should signify the 'violence' of an epoque also shows how the female body was treated as a suitable terrain for disfigure-ment and metaphorical decimation.

[12] Pierre Reverdy used this phrase in *Nord-Sud* in March 1918, and it was quoted by Breton in the 'Manifesto of Surrealism', 1924, p.20.

To draw attention to Masson's war-torn imagery is to begin at the point where the 'Gradiva' imagery of the 1930s ended – crumbling and ravaged. But, as Chadwick has argued, from 1930 onwards the mythical figure of Gradiva was represented as the ideal muse and inspiration to Surrealist poets and artists.[13] Dali had said of Gala Éluard, the woman he would later marry: 'she is Gradiva the woman who advances. She is, according to Paul Éluard, "the woman whose glance pierces walls".' Breton's essay of 1937, called, again, 'Gradiva', centred on the theme of metamorphosis, from life into death, unconscious to conscious – on the idea of a transition from one thing to another, from one state to another, i.e. the condition of metaphor that preoccupied Surrealism.

The name 'Gradiva' comes from *Gradiva: A Pompeian Phantasy*, a story by the German writer Wilhelm Jensen, published in 1903. The Surrealists would probably have passed the story by had it not been drawn to their attention by Freud's study of it, 'Delusions and dreams in Jensen's "Gradiva"', published in 1907 but not translated into French until 1931, when it was read by Breton. Jensen's novel is the story of a young archaeologist, Hanold, who fell in love with a classical relief that he first saw in a museum of antiquities in Rome (Plate 218). He obtained a plaster-cast of the relief, which he named Gradiva or 'the girl who steps along', and hung it in his study. Captivated by the graceful gait of the figure as she walks along in her flowing robes, he convinced himself that she would be found in Pompeii. Labouring under this delusion, he believed that he found Gradiva in Pompeii, stepping calmly along with her characteristic gait 'without his having suspected it, living as his contemporary' (quoted in Freud, 'Delusions and dreams in Jensen's "Gradiva"', p.38). The woman whom he meets turns out to be his childhood sweetheart, Zoe, who by appearing to accept his delusion fully, actually works to bring about his cure.

Freud's interest in the narrative was in the latent content embedded in 'the cobweb of delusion' (p.62), and he sought to reveal the repressed material lying behind it. The young archaeologist's task is to transform a deluded love for a stone relief into the love for the woman he had known in childhood; it was this love that he had repressed earlier and that had been buried within the delusion. The task is to turn the love for a muse into the love for a woman, who is an active participant in life. Significantly for Freud, the woman happens to be a physician and effects the young man's cure by using, in her conversations with him, the same symbolism as in his dream,

> the equation of repression and burial, and of Pompeii and childhood. Thus she is able in her speeches on the one hand to remain in the role for which Hanold's delusion has cast her, and on the other hand to make contact with the real circumstances and awaken an understanding of them in Hanold's unconscious.
> (Freud, 'Delusions and dreams in Jensen's "Gradiva"', p.108)

Freud draws an analogy between excavation and the process of analysis itself, a digging beneath the surface. Pompeii, as an ancient city that had been buried and then recovered through archaeological excavation, was a metaphor for psychic repression and the recovery of unconscious material through psychoanalysis. The Surrealists' interest in Freud's analysis should, by now, be clear enough – repressed desire, the role of dreams, the unconscious workings of the mind, the two-fold character of Gradiva/Zoe, and the precarious state of ambiguity between the muse and the 'real' woman. Freud had also stressed that art (in the form of Jensen's novel) and science could both reveal unconscious processes and shed light on the workings of the unconscious, a point that Breton had been keen to emphasize in his essay 'Crise de l'objet' and through the Exhibition of Surrealist Objects at the Galerie Charles Ratton.

[13] In this section I draw on Whitney Chadwick's discussion of the Surrealist construction of woman, in *Women Artists and the Surrealist Movement*.

Plate 218 Sigmund Freud's plaster-cast of 'Gradiva', bought by Freud at the Vatican Museum in 1901. Freud Museum, London.

When, in 1937, the Surrealists opened their own gallery, of which Breton was the director, they called it 'Gradiva' (Plate 219). Situated on the Rue de Seine, the silhouette of the male and female figures on the glass doors was designed by Marcel Duchamp. Breton seems to have opened the gallery largely because he was short of funds. The poster, which announced its opening, read:

> Gradiva. This title, borrowed from Jensen's marvellous work, means above all: 'She who advances'. What can be 'She who advances' if not the beauty of tomorrow … ?
> (quoted in Ades, *Dada and Surrealism Reviewed*, p.324)

Plate 219 The Surrealist Gallery, 'Gradiva', 1937, in A. Breton, *La Clé des champs*, Paris, Éditions du Sagittaire, 1953.

The 'stepping forward' of the Gradiva figure in the ancient relief was treated as a metaphor for 'advanced' art, the progressive movement forward of the Surrealist avant-garde. Again we find a calculated reversal of available models of modernity: an ancient relief of a female figure stepping along is taken as a sign for cultural advancement, in opposition to contemporary forms of modernity such as the modern male dress that, earlier in the twenties, Le Corbusier used; opposed also to the prevalence of 'engineer' and 'constructor' metaphors; and opposed even to Andrei Zhdanov's 'engineer of human souls', the role for the Socialist Realist artist that Breton and others saw as pernicious. So Gradiva could personify various aspects of the Surrealist project – the concern with the release of the unconscious, ideas of metaphor and metamorphosis, notions of avant-gardism, and the theme of the woman as the artist's muse (reminiscent of Nadja's role for Breton, 'I am the wandering soul': *Nadja*, p.82). A fairly suitable name for a Surrealist gallery, at any rate.

Frida Kahlo

Beneath the lettering 'Gradiva', on the front of the gallery, appeared a series of women's names – all first names, Gisèle, Rosine, Alice, Dora, Inès and Violette – prefixed by the word *comme* ('like'). As Chadwick has noted, the names were those of women either involved in Surrealism – such as the photographer Dora Maar (Plate 220), the poet and painter, Alice Paalen (Plate 221) and Gisèle Prassinos – or celebrated by the group. Those celebrated included Violette Nozières, who had been condemned to death in 1933 for poisoning her parents – an 'anti-heroine', as Chadwick calls her (*Women Artists and the Surrealist Movement*, p.43), reminiscent of the Papin sisters or of the anarchist Germaine Berton. This conjunction, of the mythical figure of Gradiva with the names of some of the women involved in Surrealism, suggests something of the problematic distinction in Surrealism between the woman as muse and the woman as artist. As much as it celebrates the fusion of the muse with the woman, the Gradiva myth also points to an unsettled problem for Surrealism – to move from the woman as muse to the idea of the woman herself as an artist. Woman as muse, as anti-heroine, as artist, lived together uneasily, but centrally, within Surrealism.

During the thirties, many women artists and poets became associated with the Surrealist group; also at this period, Breton and others focused their idea of the female muse on the *femme-enfant*, where the child-like woman was seen to be closer to the unconscious than men were. Prassinos, who was taken up by the Surrealists, was only fourteen when her first stories were published (Chadwick, p.46). Engaging with childhood images and

Plate 220 Dora Maar,
Le Simulateur (*The Simulator*),
1936, photograph. Musée
National d'Art Moderne, Centre
Georges Pompidou, Paris.

tokens, she lived out the roles of both muse and maker. This dual role was imposed upon other women artists involved with Surrealism, such as Oppenheim, in the examples I introduced at the beginning of this chapter. It can also be seen to affect the work of Leonora Carrington, an English writer and artist who went to Paris in the 1930s. Carrington's *Self-portrait* (Plate 222) is an example of the kind of fantastic Surrealism, with a

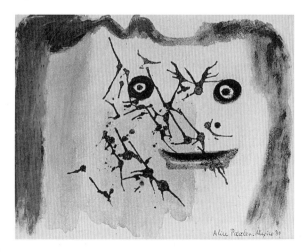

Plate 221 Alice Paalen (née Rahon), *Le Sourire de la mort* (*The Smile of Death*), 1939, gouache, 20 x 26 cm. Collection of M. Louis Felipe del Valle Prieto, Mexico.

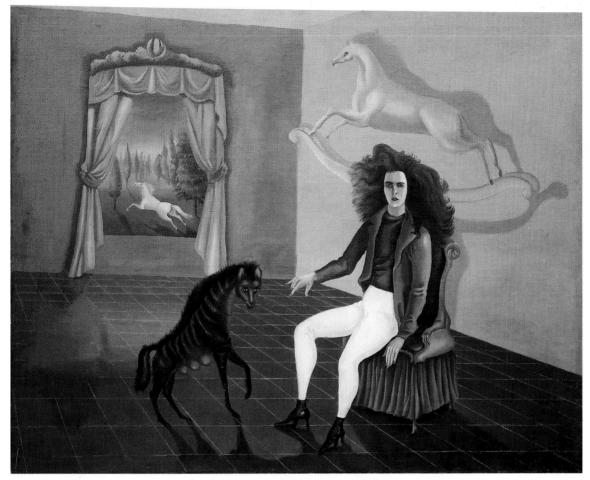

Plate 222 Leonora Carrington, *Self-portrait: 'A l'Auberge du Cheval d'Aube'*, 1936–37, oil on canvas, 65 x 81 cm. Private collection. Photograph by courtesy of Pierre Matisse Gallery Corporation.

preference for child-like imagery, that is markedly different from the work of Oppenheim. Carrington has painted herself in an interior, with a rocking horse suspended in space casting a shadow on the far wall, and with a fantastic creature at her feet; a magical horse can be seen in an almost ethereal landscape in the distance. Oppenheim's object *My Nurse* (Plate 223), on the other hand, used childhood memory differently; she claimed the work was made to revenge a nurse who had tied her feet together as a child, but she resists the child-like connotations suggested by Carrington in favour of the unfamiliar, displaced object and its fetishistic character. The shoes, trussed like a chicken, are served up on a silver platter. Like Hugo's object (Plate 205), where the gloved hand of a mannequin is enmeshed in net, *My Nurse* seems to work within the framework of fetishism, and to suggest that the fetish involves some form of entrapment.

Rather than survey the work of women artists involved in Surrealism, I shall concentrate here on the work of the Mexican artist Frida Kahlo. She was celebrated by Breton, and I shall look at his account of her work, which gives a sense of some of these conflicting attitudes involved in making the move from 'muse' to 'artist'. When Breton went to Mexico in 1938, he visited Leon Trotsky (the Bolshevik leader exiled by Stalin), Diego Rivera and others. Kahlo was married to Rivera, and Trotsky was staying in their house. In *Minotaure* in 1939 Breton wrote a long account of Mexico, the revolutionary struggle going on there and the work of Rivera. His article on Kahlo was the only essay on a woman artist published in his book *Surrealism and Painting* of 1945, which included the original

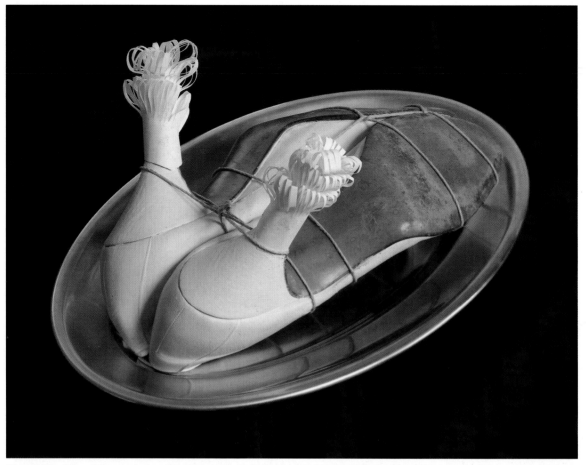

Plate 223 Meret Oppenheim, *Ma Gouvernante* (*My Nurse*), 1936, white heels with paper ruffles, presented on an oval platter, 14 x 21 x 33 cm. Moderna Museet, Stockholm. Photograph: Statens Konstmuseer. © DACS, London, 1993.

essay of that title as well as other essays on individual Surrealist painters. On his return from Mexico, he included her work in an exhibition that he organized at the Galerie Pierre Colle, called simply Mexique (1939).

Breton went to Mexico, as Laura Mulvey and Peter Wollen have observed, 'as to a dreamland' (*Frida Kahlo and Tina Modotti*, p.7). He began his essay on Kahlo with a description of the effect that country had on him: 'There is a country where the world's heart opens out, relieved of the oppressive feeling that nature everywhere is drab and unenterprising … [a country that is apart from] modern society's all-embracing economic laws' (Breton, 'Frida Kahlo de Rivera', p.141). And yet, despite this impression of 'fragmentary images plucked from the treasure chest of childhood', Mexico left him conscious of certain gaps, of what he did not know, such as the 'statuettes of Colima' – modelled out of earth, and evidence of a culture of which he was ignorant. And lastly, he was till that moment ignorant of Frida Kahlo, who resembled 'these statuettes in her bearing'. She was, to Breton, like a statuette; she was also the wife of that 'great fighter', Rivera, who derived strength from her 'enchanting personality' (p.143).

This is the frame into which Breton introduces Kahlo's work, a frame that has its echoes in the Gradiva myth. He writes that he had long since admired Kahlo's self-portrait that hung on the walls of Trotsky's study (Plate 224): 'She has painted herself in a robe of

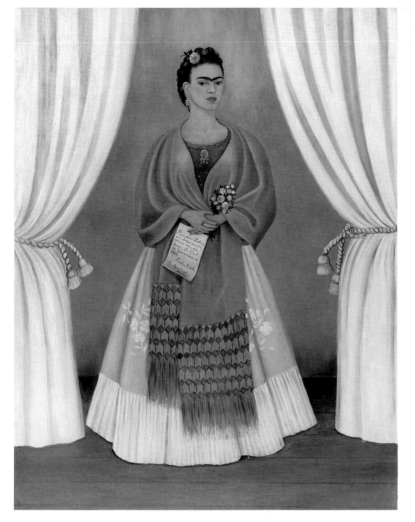

Plate 224 Frida Kahlo, *Self-portrait dedicated to Leon Trotsky*, 1927, oil on canvas, 76 x 61 cm. National Museum of Women in the Arts, Washington; gift of the Hon. Clare Boothe Luce. Reproduced by permission of the Instituto Nacional de Bellas Artes y Literatura.

wings gilded with butterflies, and it is exactly in this guise that she draws aside the mental curtain.' This is the point in Breton's account where Kahlo as a muse figure and Kahlo as artist are most clearly conflated, where a woman 'endowed with all the gifts of seduction' is also an artist 'delicately situated at that point of intersection between the political (philosophical) line and the artistic line' (p.144).

Breton was impressed that Kahlo's work had blossomed 'into pure surreality', although she had had no contact with the Surrealist group in France, and had no prior knowledge of their concerns. Though she was loyal to a Mexican tradition, Breton saw a link between her work and Surrealism. One picture, which she was just completing, *What the Water Yields Me* (Plate 225), struck Breton in particular. It seemed to him (p.144) to illustrate perfectly a phrase from *Nadja*: 'I am the thought of bathing in the mirrorless room.' This picture, also illustrated in the last issue of *Minotaure*, includes images derived from earlier paintings Kahlo had done, which emerge from the water as memory and dream. It is a sort of self-portrait, but one that inverts the normal conventions of portraiture by depicting not a head, but the lower half of her body beneath the surface of the water, overlaid by symbolic references to family, birth, sexuality and death.

Although Breton remarked that Kahlo's work was 'perfectly *situated* in time and space', he also saw no art as more 'exclusively feminine'; that is, none was more capable of

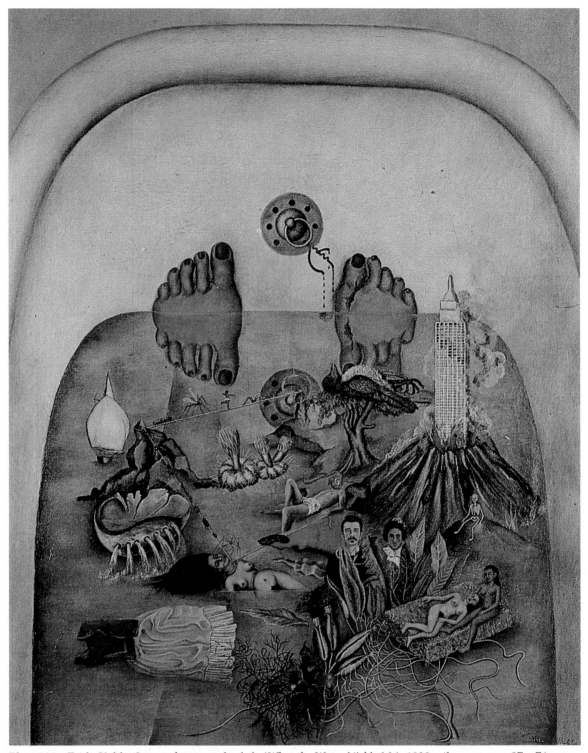

Plate 225 Frida Kahlo, *Lo que el agua me ha dado* (*What the Water Yields Me*), 1938, oil on canvas, 97 x 76 cm. Private collection. Photograph by CENIDIAP. Reproduced by permission of the Instituto Nacional de Bellas Artes y Literatura.

representing the 'other' of the Western, male unconscious, of representing the feminine side of all human beings. This combination meant that 'The art of Frida Kahlo is a ribbon around a bomb'. It was in the margins of her work, then – in the feminine, the Mexican, the naïve – that Breton saw the liberating qualities of the unconscious that nevertheless reinforced that sense of otherness. Mexico, like Pompeii, could reveal what had been repressed in modern Western society. It could reveal both psychic and revolutionary force, treasuring – rather than questioning – its marginality.

Although untrained, Kahlo was not a 'naïve' artist. She used, as Breton noted, specifically Mexican traditions, and deployed them in knowing and sophisticated ways; she drew upon various conventions, from traditional Mexican religious and popular imagery to medical dictionaries. *My Grandparents, My Parents and I (Family Tree)* (Plate 226), for example, superimposed the schematic form of a family tree from popular imagery onto a landscape, while including a self-portrait of herself as an unborn child, in the form of an image of a foetus from a medical textbook.

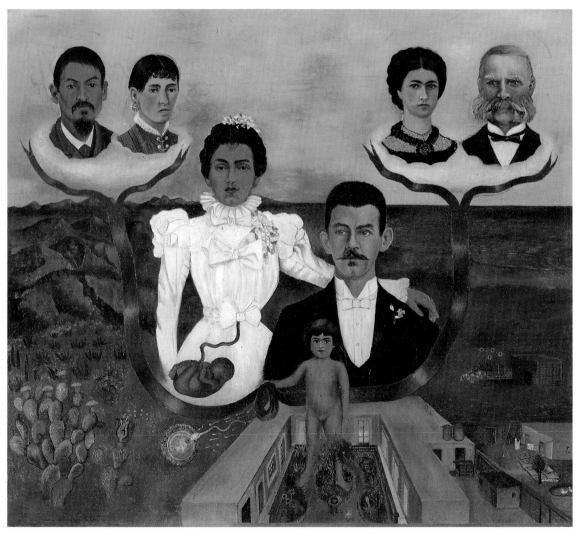

Plate 226 Frida Kahlo, *Mis abuelos, mis padres y yo (árbol genealógico)* (*My Grandparents, My Parents and I (Family Tree)*), 1936, oil and tempera on metal panel, 31 x 35 cm. Collection, the Museum of Modern Art, New York; gift of Allan Roos, MD and B. Mathieu Roos. Reproduced by permission of the Instituto Nacional de Bellas Artes y Literatura.

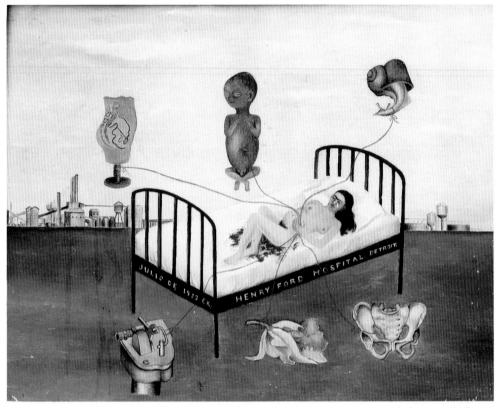

Plate 227 Frida Kahlo, *Henry Ford Hospital*, 1932, oil on metal, 30 x 38 cm. Collection Dolores Olmedo, Mexico City. Photograph by CENIDIAP. Reproduced by permission of the Instituto Nacional de Bellas Artes y Literatura.

Kahlo's work represents another side of the struggle from Rivera's. Where he was committed to a politically engaged form of social realist mural painting on a vast scale, hers were small-scale and unheroic paintings. Kahlo depicted herself in the majority of her paintings, not as the object of the gaze but with the body as a terrain of suffering and pain. The paintings relate closely to her own experience, her many operations on her severely damaged spine, her inability to bear children. But like other Surrealists, Kahlo dealt with fantasy, not purely as a personal experience but also as a kind of mythology heavily laden with the conventions of different forms of representation. In *Henry Ford Hospital* (Plate 227), the industrial landscape is depicted on a small scale, on the horizon, compared with Rivera's heroic treatment of industrial themes such as his Detroit murals (Plates 229 and 230). Various emblems are depicted surrounding the bed – fragments of bodily organs, a ritualistic statuette, a mechanical part. It is not only, then, the unusual subject-matter that is of interest in Kahlo's work, but the way in which she mixed modes of representation to suggest a conflicting set of myths around her own femininity. Certainly, the idea of dismemberment or disfigurement, represented in Kahlo's paintings of the female body, is very different from the kind of disfigurement that interested Masson in Plate 214. Neither represents the female body unified, but the ways in which fragments are used by each show how the realm of the feminine may be contested.

Beginnings, again

Just as Freud had collected objects, such as the plaster-cast of 'Gradiva', so too did Lacan. One of the objects from Lacan's collection, a Roman statuette of a temple prostitute, was illustrated by Bataille in his book *Eroticism*. And over the desk in Lacan's study after the Second World War hung a painting by Masson that traced the schematic forms of another picture, like a map (similar, perhaps, to Bataille's schematic rendering of Dali's *The Lugubrious Game*). That other picture was hidden beneath it in an ingenious box made by Masson. It was Courbet's notorious *The Origin of the World*, which had been lost for many years, a painting of the splayed legs of a female figure, cut off at the torso and revealing the female genitalia.[14] There was a secret mechanism that undid the box, like a puzzle. This scenario, suggestive as it is of the dual processes of hiding and revealing, and of the female body as a focus of both desire and fear, evokes the Oedipal origins of modern painting where images of the past offer a kind of prehistory of the modern unconscious. We might ponder, finally, the implications of one painting, an abstract painting, tracing over and concealing another, one that can be seen to represent the 'origins of the world' in a fantasy of sexual difference.

Let me end by turning back to look briefly at a painting close to Surrealism's origins in the mid-twenties. Miró had painted *The Birth of the World* (Plate 228) in 1925, a year after Breton's First Manifesto. It recalls the circumstances in which Surrealism emerged, the period of Reconstruction following the First World War. In those early years, it was the plumbing of the depths beneath the apparently ordered surface of things that seemed to hold out most promise, rather than the ravaged sense of mortality that we find later – for example, in Masson's *Gradiva* (Plate 214). And it was the historical circumstances of war that in the end led Breton to accept the kind of violence involved in Masson's version of Gradiva's 'stepping forth', an underlying cruelty that Masson, like Bataille, had long since seen as only superficially veiled by 'civilization'.

Yet Miró's painting *The Birth of the World* does not depict, as Courbet's image had, the female body; far from confronting the viewer with explicit imagery, it is made up of abstract marks – a circle here, a geometric form there, some lines punctuating a surface splashed with a thin wash of dark paint. It does not hide, like Masson's work in Lacan's study, *another* picture, one that is far more explicit as a male erotic fantasy. Surely here, in Miró's work, we must concede that ambiguity and obscurity may be a condition of painting, which cannot be 'looked through' to a more fixed and recognizable image. Yet the scene in Lacan's study does seem to me to reiterate one of the questions raised in this chapter – the question of the symbolic origins of modern painting in sexual difference. But those origins are not to be found elsewhere, in a clearer, more lucid or even more violent rendering of 'another' picture, real or imagined.

Plate 228 was one of Miró's 'dream paintings' from the mid-twenties, which were rarely exhibited but were known to the Surrealist group. It was given its title by either Breton or Éluard (Miró, in a later interview, could not remember which, but he found the title appropriate). This large painting was quite possibly one of the works that had prompted Breton to see Miró as 'perhaps the most Surrealist of us all'. It was also one of the paintings that was hanging in Miró's studio (which was next to Masson's in a building on the Rue Blomet) when Bataille was introduced to the Surrealist circle. Bataille, as we have seen, wrote in metaphors, and when he described some late paintings by Miró, he wrote of their surface as a *couvercle* or lid that concealed 'a box of tricks'. Yet it is not a 'lid' that can simply be taken off to reveal what lies beneath, since the force of Miró's work, for Bataille, is to be found in the way the surface of the painting is 'decomposed', characterized by *taches informes* ('formless marks') (Bataille, 'Joan Miró: peintures récentes', p.399).

[14] See Linda Nochlin's note in S. Faunce and L. Nochlin, *Courbet Reconsidered*, pp.176–8, and Tamar Garb's reference to this painting in Chapter 3 of F. Frascina *et al.*, *Modernity and Modernism*.

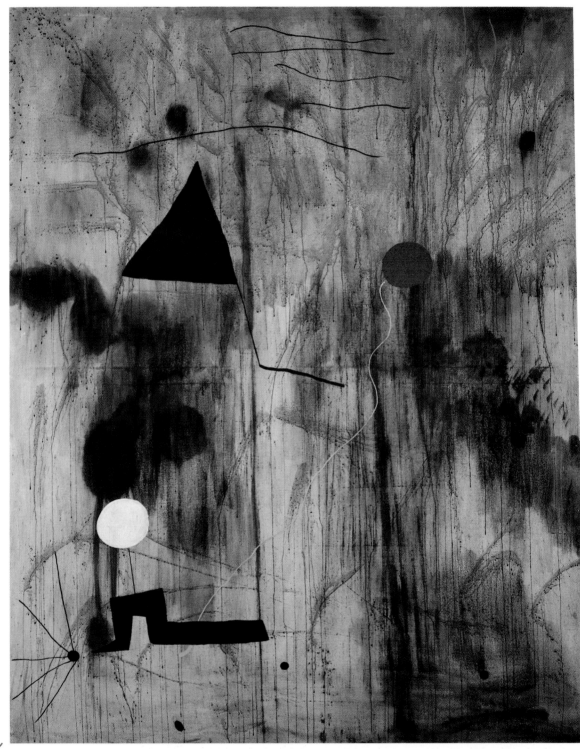

Plate 228 Joan Miró, *La Naissance du monde* (*The Birth of the World*), 1925, oil on canvas, 251 x 200 cm. Collection, The Museum of Modern Art, New York; acquired through an anonymous fund, the Mr and Mrs Joseph Slifka and Armand G. Erpf Funds, and by gift of the artist. © ADAGP, Paris and DACS, London, 1993.

This process of 'unforming' goes against the grain of fixed categories, and undermines the idea that everything can be reduced to a straightforward polarity between the 'masculine' and the 'feminine'. Sexual difference is played out on a shifting ground of representation.

If we look at how Miró painted *The Birth of the World*, we can see that he began by splashing dark paint onto the canvas, which he left to drip, and which he overlaid with a series of both black and brightly coloured symbols and marks. Miró had originally covered the canvas with glue to which the subsequent layers of paint adhered unevenly, leaving an impression of stains and spots. The geometric figures of the line, the circle, the triangle, are deliberately hand-drawn; the precision of the geometric is parodied in the irregularities of a line or an edge, and set in a relationship with the formless washes of paint that fill the rest of the canvas. The fusion of the symbolic forms is left in a state of suspension; where some forms are revealed, others are veiled by the skeins and drips, and almost erased. What comes to light is often, in the process, obscured.

References

ADES, D., *Dada and Surrealism Reviewed*, London, Arts Council of Great Britain, 1978.

ADES, D., *Dali*, London, Thames and Hudson, 1982.

ARAGON, L., 'Germaine Berton', *La Révolution Surréaliste*, no.1, 1924, p.12.

ARAGON, L., *Paris Peasant*, London, Picador Classics Edition, 1987 (first published as *Le Paysan de Paris*, 1926).

BATAILLE, G., 'Figure humaine', *Documents*, no.4, 1929.

BATAILLE, G., 'Le gros orteil', *Documents*, no.6, 1929.

BATAILLE, G., 'Le "Jeu lugubre"', *Documents*, no.7, 1929 (reprinted in Harrison and Wood, *Art in Theory, 1900–1990*, section IV.c.13).

BATAILLE, G., 'Dictionnaire critique', *Documents*, no.7, 1929 (an edited version is reprinted in Harrison and Wood, *Art in Theory, 1900–1990*, section IV.c.12).

BATAILLE, G., 'Joan Miró: peintures récentes', *Documents*, second year no.7, 1930.

BATAILLE, G., 'L'esprit moderne et le jeu des transpositions', *Documents*, second year no.8, 1930.

BATAILLE, G., *Manet*, Paris, Éditions Skira, 1955.

BATAILLE, G., *Eroticism*, London, Calder and Boyars, 1962 (first published in French in 1957, Paris, Éditions de Minuit).

BATAILLE, G., *Documents*, B. Noël (ed.), Paris, Mercure de France, 1968.

BATAILLE, G., *L'Histoire de l'œil*, Paris, Gallimard, 1970 (published as *The Story of the Eye*, New York, Berkeley Books, 1982, translated by J. Neugroschal).

BATAILLE, G., *Visions of Excess: Selected Writings, 1927–1939*, A. Stoekl (ed. and introduction), Minneapolis, University of Minnesota Press, 1985.

BENJAMIN, W., *Charles Baudelaire: A Lyric Poet in the Era of High Capitalism*, London, New Left Books, 1973.

BENJAMIN, W., 'Surrealism: the last snapshot of the European intelligentsia', 1929, in S. Sontag (ed.), *One-Way Street and Other Writings*, London, Verso Paperback, 1985.

BRETON, A., 'Surrealism and painting', *La Révolution Surréaliste*, no.4, pp.26–30, 1925; no.6, pp.30–32, 1926; no.7, pp.3–6, 1926; no.9/10, pp.36–43, 1927 (an edited version is reprinted in Harrison and Wood, *Art in Theory, 1900–1990*, section IV.c.4).

BRETON, A., *L'Amour fou*, Paris, Gallimard, 1937.

BRETON, A., *Nadja*, Paris, Éditions Gallimard, 1964 (first published 1928; translated by R. Howard, New York, Grove Press, 1960).

BRETON, A., 'Manifesto of Surrealism', 1924, in *Manifestos of Surrealism*, translated by R. Seaver and H.R. Lane, Michigan, Ann Arbor Press, 1972 (an edited version of The First Surrealist Manifesto is reprinted in Harrison and Wood, *Art in Theory, 1900–1990*, section IV.c.2).

BRETON, A., 'Second Manifesto of Surrealism', 1929, in *Manifestos of Surrealism*, translated by R. Seaver and H.R. Lane, Michigan, Ann Arbor Press, 1972 (an edited version is reprinted in Harrison and Wood, *Art in Theory, 1900–1990*, section IV.c.5).

BRETON, A., 'The prestige of André Masson' in *Surrealism and Painting*, translated by S. Watson Taylor, London, Macdonald, 1972.

BRETON, A., 'Frida Kahlo de Rivera' in *Surrealism and Painting*, translated by S. Watson Taylor, London, Macdonald, 1972.

BRETON, A., 'The crisis of the object' in *Surrealism and Painting*, translated by S. Watson Taylor, London, Macdonald, 1972.

BRETON, A., *What is Surrealism? Selected Writings*, in F. Rosemont (ed. and introduction), London, Pluto Press, 1978.

CAILLOIS, R., 'Spécification de la poésie', *Le Surréalisme au service de la Révolution*, no.5, 1933.

CAWS, M.A., KUENZLI, R.E. and RAABERG, G. (eds), *Surrealism and Women*, Cambridge Massachusetts, and London, MIT Press, 1991.

CHADWICK, W., *Myth in Surrealist Painting, 1929–39*, Ann Arbor, UMI Research Press, 1980.

CHADWICK, W., *Women Artists and the Surrealist Movement*, London, Thames and Hudson, 1985.

CHAPUIS, A. and GÉLIS, E., *Le Monde des automates: étude historique et technique*, vols 1 and 2, Paris, 1928.

DALI, S., 'Objets Surréalistes', *Le Surréalisme au service de la Révolution*, no.3, 1931.

Max Ernst, New York, The Museum of Modern Art, 1961.

FAUNCE, S. and NOCHLIN, L., *Courbet Reconsidered*, New York, The Brooklyn Museum, 1988.

La Femme et le Surréalisme, exhibition catalogue, Lausanne, Musée Cantonal des Beaux Arts, 1987.

FRASCINA, F., BLAKE, N., FER, B., GARB, T. and HARRISON, C., *Modernity and Modernism: French Painting in the Nineteenth Century*, New Haven and London, Yale University Press in association with The Open University, 1992.

FREUD, S., 'Femininity', 1933, in J. Strachey (ed.), *The Complete Introductory Lectures on Psychoanalysis*, London, Allen and Unwin, 1971.

FREUD, S., *Introductory Lectures on Psychoanalysis*, London, Pelican Freud Library, vol.1, 1973.

FREUD, S., 'Fetishism' in *On Sexuality*, London, Pelican Freud Library, vol.7, 1977.

FREUD, S., 'Three essays on the theory of sexuality', 1905, in *On Sexuality*, London, Pelican Freud Library, vol.7, 1977.

FREUD, S., 'Female sexuality', 1931, in *On Sexuality*, London, Pelican Freud Library, vol.7, 1977.

FREUD, S., 'Delusions and dreams in Jensen's "Gradiva"', 1907, in *Art and Literature*, London, Pelican Freud Library, vol.14, 1985.

FREUD, S., 'The "Uncanny"', 1919, in *Art and Literature*, London, Pelican Freud Library, vol.14, 1985.

FRIEDMANN, G., *La Crise du progrès: esquisse d'histoire des idées, 1895–1935*, Paris, Gallimard, 1936.

GEE, M., *Ernst: Pietà, or Revolution by Night*, London, Tate Gallery, 1986.

HARRISON, C. and WOOD, P. (eds), *Art in Theory, 1900–1990*, Oxford, Blackwell, 1992.

HARRISON, C., FRASCINA, F. and PERRY, G., *Primitivism, Cubism, Abstraction: The Early Twentieth Century*, New Haven and London, Yale University Press in association with The Open University, 1993.

HEATH, S., 'Joan Rivière and the masquerade' in V. Burgin, J. Donald and C. Kaplan (eds), *Formations of Fantasy*, London and New York, Methuen, 1986.

HOLLIER, D., *Against Architecture: The Writings of Georges Bataille*, Cambridge Massachusetts, and London, MIT Press, 1989.

Frida Kahlo and Tina Modotti, London, Whitechapel Art Gallery, 1982.

KRAUSS, R., 'Corpus Delicti', *L'Amour fou: Photography and Surrealism*, London, Arts Council of Great Britain, 1986.

KRAUSS, R. and LIVINGSTON, J., *L'Amour fou: Photography and Surrealism*, London, Arts Council of Great Britain, 1986.

LACAN, J., 'Le problem [*sic*] du style et la conception psychiatrique des formes paranoïaques de l'expérience', *Minotaure*, no.1, 1933.

LACAN, J., 'Motifs du crime paranoïaque', *Minotaure*, no.3/4, 1933.

MARX, K., *Capital*, London, J.M. Dent, 1930.

MITCHELL, J., *Psychoanalysis and Feminism: A Radical Reassessment of Freudian Psychoanalysis*, London, Allen Lane, 1974.

MULVEY, L., *Visual and Other Pleasures*, Basingstoke, Macmillan, 1989.

MULVEY, L. and WOLLEN, P., *Frida Kahlo and Tina Modotti*, exhibition catalogue, Whitechapel Art Gallery, 1982 (an edited version of Mulvey and Wollen's catalogue essay is reprinted in F. Frascina and J. Harris (eds), *Art in Modern Culture: An Anthology of Critical Texts*, London, Phaidon, 1992).

NOUGÉ, P., 'Les images défendues', *Le Surréalisme au service de la Révolution*, no.5, 1933.

PARKER, R. and POLLOCK, G., *Old Mistresses: Women, Art and Ideology*, London, Routledge and Kegan Paul, 1981.

La Révolution Surréaliste, 1924–29, Paris, Éditions Jean-Michel Place, 1975 (facsimile reprint).

RIVIÈRE, J., 'Womanliness as a masquerade', 1929, in V. Burgin, J. Donald and C. Kaplan (eds), *Formations of Fantasy*, London and New York, Methuen, 1986.

ROSE, J., *Sexuality in the Field of Vision*, London, Verso, 1986 (an edited version of the essay 'Sexuality in the field of vision' is reprinted in Harrison and Wood, *Art in Theory, 1900–1990*, section VIII.c.5).

RUBIN, W., *Miró in the Collection of The Museum of Modern Art*, New York, The Museum of Modern Art, 1973.

SULEIMAN, S.R., *Subversive Intent: Gender, Politics, and the Avant-Garde*, Cambridge Massachusetts, and London, Harvard University Press, 1990.

Le Surréalisme au service de la Révolution, Paris, Éditions Jean-Michel Place, 1976 (facsimile reprint).

TAYLOR, F.W., *Scientific Management*, London, Harper and Row, 1964.

TZARA, T., 'D'un certain automatisme du goût', *Minotaure*, no.3/4, 1933.

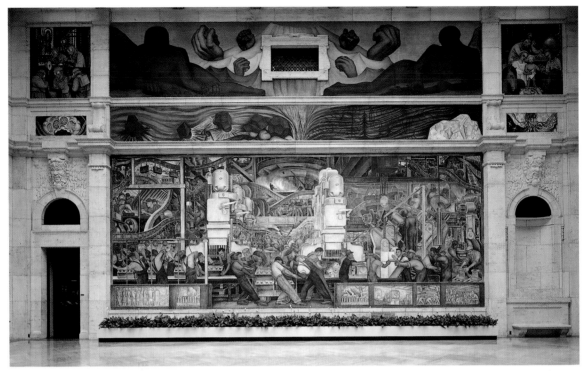

Plate 229 Diego Rivera, *Detroit Industry*, *North Wall*, 1932–33, fresco. The Detroit Institute of Arts, Founders' Society Purchase, Edsel B. Ford Fund and gift of Edsel B. Ford.

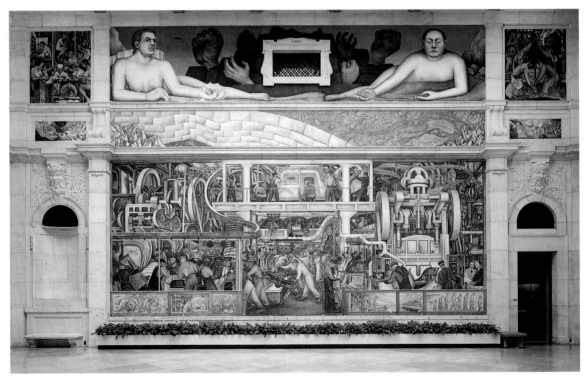

Plate 230 Diego Rivera, *Detroit Industry*, *South Wall*, 1932–33, fresco. The Detroit Institute of Arts, Founders' Society Purchase, Edsel B. Ford Fund and gift of Edsel B. Ford.

CHAPTER 4
REALISMS AND REALITIES

by Paul Wood

Realism in the 1930s

Detroit industry

Henry Ford's new plant, at the River Rouge in Detroit, opened at the end of 1927 to produce the new Model A car. The previous factory, at Highlands Park, which had produced fifteen million Model Ts, closed in May; and in the intervening six months 60,000 workers were laid off with no unemployment pay. The new factory was one of the largest in the world, and like its predecessor was based on the moving assembly line. Such assembly lines were not simply pieces of machinery: through the extreme division of labour, as well as the meticulous management of time, they amounted to a qualitative change in the social relations of production. This rationalization of production, theorized as Scientific Management by Frederick Taylor, had been implemented at Ford's since 1913. More than anything else it came to be the hallmark of modernization. Fordism was rapidly implemented in Europe – for example, at the Citroën plant in Paris – and was copied even by the Bolsheviks in Russia after the Revolution of 1917. It was an epochal development in production, and was not the 'possession' of any specifically US political form, as the interest shown in corporate-Fascist Italy and Communist Russia demonstrated. The Italian Marxist philosopher and politician Antonio Gramsci, writing his *Prison Notebooks* in a Fascist gaol in the early 1930s, saw Fordism as setting the preconditions for 'a transformation of the material bases of European civilization'. This, he argued, would not only 'bring about the overthrow of the existing forms of civilization' but could potentially stimulate 'the forced birth of a new' (A. Gramsci, 'Americanism and Fordism', p.317). More than a decade before, even Lenin had, after earlier opposition, come round to believing that 'the Taylor system combines – as do all advances of capitalism – the refined bestiality of bourgeois exploitation with a series of the most valuable achievements' (V.I. Lenin, quoted in R. Traub, *Lenin and Taylor*, pp.82–92).

Most likely it was this double-edged prestige – as an emblem both of capitalism and simultaneously of its potential transcendence, a symbol of modern production as the route to future emancipation – that led Diego Rivera in 1932 to accept a commission to depict the Rouge plant as part of a cycle on Detroit industry. The revolutionary Mexican mural-painter is commonly seen as one of the most eminent representatives of twentieth-century realism in art. The paradoxes and tensions of the concept of 'realism', however, are nowhere as evident as in Rivera's pictures of Ford's factory, and of the production process of the new luxury car, the V8, launched just before he began work.

The mural scheme is complex, covering all four walls of the Detroit Institute of Arts' Inner Garden Court, a grand classicized space in the Beaux-Arts mode. It is painted in 'true fresco' – in the Renaissance manner whereby paint is applied to wet plaster rather than to a dry surface. In total there are 27 panels of varying sizes. The two main panels, on

the north and south walls, depict the interior of the Rouge plant and are themselves subdivided, most obviously with a monochrome 'predella' running along the base of each (Plates 229 and 230). The predella contains scenes from a worker's day. Around the main panels, which are concerned with the factory, is a mixture of allegorical images of birth, the races of the Americas and the interdependence of North and South, as well as more generalized meditations on the progressive and deleterious consequences of technology.

It is worth noting that the surrounding explicitly allegorical panels, and even the factory scenes, are not wholly naturalistic. Partly this is a result of the generally cleaned-up appearance of the factory, the absence of electric lighting, and so on. More remarkable, however, is that the machines are transformed into versions of Aztec deities: the drilling machines that put the valve ports into the engine block, on the north wall, are based on the Atlantes, warrior figures from an Aztec pyramid at Tula; the stamping press on the south wall is transfigured into a mechanical version of a three-metre statue of the Aztec goddess Coatlicue from the city of Tenochtitlan (Plate 231). Equally unusual from the point of view of a Marxist conception of realism, one would think, is the juxtaposition of a worker and a manager in apparent harmony, or at least complementarity, in panels on the West wall on either side of the door – not to mention, on the South wall, the predella panel

Plate 231 The Aztec goddess Coatlicue, from Tenochtitlan, *c.*1487–1521, marble, height 350 cm. Museo Nacional de Antropologia, Mexico City. Photograph: Werner Forman.

(the third from the left) depicting a trade-school class where workers are attentively learning about the engine from Henry Ford himself.

Realism, however it is defined, is usually contrasted with a sense of the Modern, which is seen as individualistic (or subjective), as expressionistically distorted (or abstract), as 'pure' – attributes that are frequently, if not always happily, summed up in the formula of 'art for art's sake'. Rivera himself certainly saw the contrast in these terms. Fifteen years previously, around the end of the First World War, he had been a prominent Cubist painter in Paris, a member of the 'crystal' Cubist group that included Juan Gris (Plate 14) and Jean Metzinger. Yet for Rivera, his desire to produce an art with an obvious social resonance meant that he had to abandon this Cubist avant-garde – despite its well-rehearsed and varied claims that it *was* 'realist'. In an article written at the same time as he painted his Detroit murals, he condemned the avant-garde tradition for being 'appreciated only by a very limited number of superior persons'. Instead he allied himself with what he saw as an alternative tradition, of Honoré Daumier and Gustave Courbet – 'heroic exceptions', as he put it, to the run of nineteenth-century art. These were artists who saw their subjects 'through class-conscious eyes', who saw 'not only a figure but a whole connection with life and labour and the times'. For his own part, Rivera concluded his article with the following credo:

> I want to be a propagandist of Communism, and I want to be it in all that I can think, in all that I can speak, in all that I can write, and in all that I can paint. I want to use my art as a weapon.
>
> (D. Rivera, 'The revolutionary spirit in modern art', p.64)

It would indeed be hard to conceive a view of art much further removed from Henri Matisse's desire to have his work function as an armchair for a tired businessman (Matisse, whom the eminent Modernist critic Clement Greenberg was later to cite as the 'pre-eminent painter of our epoch'). And in fact Matisse did criticize Rivera's views, on a visit to New York that coincided with the controversial destruction – by the Rockefellers who had commissioned it – of another of the Mexican's political murals :

> Art should rise above politics, the realities of one little epoch. Art is an escape from reality ... I do not agree with Mr Rivera, if he is quoted correctly, that every art must have its political viewpoint.
>
> (H. Matisse, quoted in Rochfort, *The Murals of Diego Rivera*, p.70)

Yet that mention of Rockefeller should alert us to the fact that all is far from simple in the matter of a politically committed realist art. Why *was* a Mexican revolutionary, recently returned from the Soviet Union, painting murals for US capitalists? Why, before the Ford and Rockefeller commissions, had he completed another for the luncheon club of the San Francisco Stock Exchange? Another facet of the paradox is that the sketchbook of drawings that Rivera had done in Moscow during the May Day celebrations of 1928 – celebrating on this occasion the anniversary of the Revolution – was bought in 1931 by Aby Aldrich Rockefeller. Yet less than three years later his *Man at the Crossroads* mural at the Rockefeller Centre in New York was destroyed, supposedly for depicting Lenin. Further, what was Rivera attacking when, in addition to criticizing art-for-art's-sake, he made the following claim?

> Reaction in art is not merely a matter of theme. A painter who conserves and uses the worst technique of bourgeois art is a reactionary artist, even though he may use this technique to paint such a subject as the death of Lenin or the red flag on the barricades.
>
> (Rivera, 'The revolutionary spirit in modern art', p.60)

And to return to the original example: what was realist or 'proletarian' about an art that depicted clean and well-fed workers in apparent harmony with management as well as with the latest technology, producing cars they could scarcely afford, in a plant where production was down to one-fifth of 1929 levels and that only a few weeks before Rivera's

arrival had been the target of a 3,000-strong Communist-organized hunger march that ended at the factory gates in the shooting of three workers and injury to a score of others?

Definitions and oppositions

Such questions do not have simple answers. Realism is not a simple subject. It has frequently been, in twentieth-century art, a site of contestation. The most basic answer would perhaps start by distinguishing the concept of 'realism' from the common sense of a picture's being 'realistic'. Being 'realistic' – achieving a believable figurative illusion of some people and objects as they occur in the world – is, however, commonly identified with 'realism'. The problem with this is that such a conflation – of 'realistic' with 'realism' – often carries with it a sense of being defined *against* something else, namely against 'abstraction' in art. In that sense 'Realism and Abstraction' becomes one of the great oppositions informing – or rather mis-informing – orthodox ideas about meaning in twentieth-century art. Yet the very notion of 'abstract' art is as problematic as the notion of an art of 'realism'. That pair of conventional assumptions (equating 'realism' with 'realistic'; and the consequent sense of 'realism' as the opposite of something called 'abstraction') obscures any sense of the density, and indeed interest, of the diverse historical debate over realism. It diverts attempts to address the problems that the various actors in that historical debate did try to face.

The very term 'realism' seems to suggest an orientation on, a rather direct connection with, reality. In fact, competing definitions of reality are at stake. In a world where reality is perceived very differently by different interest-groups, where there is a constant process of struggle against hegemonic definitions of what the world is like, 'realism' is always going to reverberate beyond some bare conception of 'styles of art'.

Realism, that is to say, is not necessarily congruent with 'naturalism' – a term that has often been used since the nineteenth century to denote the achievement of a 'realistic' appearance in art, particularly when the subject-matter has been drawn from daily life. The mere depiction of recognizable bodies doing recognizable things was not what made an art 'realist'. Furthermore, many artists after the First World War turned to a kind of figuration in an apparent search for the tried and true after all values had been challenged by the war itself, as well as by anarchic responses such as Dada. Rivera was far from alone in his (re-)turn to figuration. Yet not all this work has been commonly seen as 'realist'. If realism cannot be considered a synonym for 'naturalism', neither has the term been applied to the kinds of figurative painting that emerged in the post-war work of Gino Severini or André Derain (Plates 5 and 7), principally because of their 'classicizing' tendency. For though on the one hand realism cannot be reduced to the naturalistic achievement of figuration, those very properties that *have* seemed to draw it close to naturalism – such as a preoccupation with the lived realities of daily life – are the very ones that have made 'realism' seem an inappropriate designation for an art built upon the idea of unchanging universal values, such as the 'Classical'.

Likewise in the 1930s in Nazi Germany, an officially approved, classicizing, figurative style (Plate 232) replaced the work of the avant-garde, which was condemned as 'degenerate'. But this classicizing style was not described by the Nazis as 'realism' even when it was used to represent modern subjects. We can get a clue as to why this should be from the other term of abuse that the Nazis reserved for the avant-garde – *Kulturbolschewismus* (cultural, or artistic, bolshevism). If the art of the avant-garde was somehow seen as linked to the Russian Revolution by its 'degeneracy', then the subsequent quest for an art of realism, by those committed to building a new society after that very revolution, was enough to disqualify 'realism' as a term of approval for the Nazis. The fact that many of those who did search for such a social 'realism' also opposed the legacy of the avant-garde – as we have seen in the case of Rivera – is one of those perplexing 'crossovers' that bedevil our inquiry.

Plate 232 Ivo Saliger, *Le Jugement de Paris* (*The Judgement of Paris*), 1939, oil on canvas, 160 x 200 cm. Property of the German Federal Government. Photograph by courtesy of Musée National d'Art Moderne, Centre Georges Pompidou, Paris.

The question of the avant-garde does, however, allow us to consider another key aspect of a realist art. Official Academic art was a public affair, an important site in which the ideologies, the self-images, of bourgeois society were rehearsed and negotiated. The Modern tradition in art, by contrast, has almost entirely centred on the private. There is of course a sense in which the personal became the central sustaining ideology of modern, Western, bourgeois society (a factor that adds weight to realist denunciations of Modernism as the ideology of Western capitalism). But the distinction is still worth making, if only to point up the prolonged crisis of the social, and of a shared public space, in developed capitalist societies. In the late twentieth century, the official ideology of these societies – particularly the Anglo-American versions – has called into question the very notion of social rights and responsibilities. It can often seem in this situation that the only permissible sense of collectivity is that derived from being subject to more or less transparent commercial and class interests, where 'social rights' become reduced to the 'rights' of the consumer. The attempt to address public issues has been a persistent feature of the attempt to sustain a realism in the modern period. It may in fact be the very elusive, fractured sense of the 'public' sphere in modern life that has led to the apparent hollowness or failure of so many realisms, their reduction as it were to the level of rhetoric. The story they tell is frequently more of a longing for sociality than its actual existence. This is another reason for the prominent role played in twentieth-century realism by the official art of the Stalinized post-revolutionary societies of the Soviet Union, Eastern Europe and elsewhere. For nowhere else was such a premium put on the collective and public, at the expense of the private and subjective, than in those peculiarly

managed cultures. It is even arguable that the failure of those societies is bound up with the failure of their 'realism'. This does not mean, however, that their art lacks interest or all contact with reality, any more than it means that the Western, 'modern' tradition has been devoid of an address to the social – whatever *its* managers might say.

Undoubtedly 'realism' and 'modern art' *have* simply been seen as opposites, with each representing the official art of one half of a divided world. And yet we can also recognize that embedded in the arguments supporting them from their respective sides were competing definitions of what it was to *be* 'modern'. To its proponents – whether these were the Bolshevik internationalists of 1917, or the supporters of Stalin's Five-Year Plans in the 1930s dedicated to building Socialism in One Country – the Revolution was not a step back. It is impossible to understand the vehemence and persistence of arguments over realism if one merely remains within the conventional Western avant-garde wisdom that realism is something from which modern art liberated itself. As Rivera put it in the 1932 article already referred to, when avant-garde or 'leftist' art was marginalized in the Soviet Union during the 1920s, 'It was not that the proletariat of Russia was telling these artists: "You are too modern for us". What it said was: "You are not modern enough to be artists of the proletarian revolution"' (Rivera, 'The revolutionary spirit in modern art', p.59) – a doubtful proposition, but one with considerable historical force.

The international situation

From this tangle we can select some points of reference about the problems and practice of realism between the two world wars. One is that there was a constituency for committed realist art in the USA (Plates 229, 230 and 233). A second and equally important point, however, is that this turn to notions of realism was not simply a response to US conditions. It was profoundly influenced by, in fact scarcely conceivable without, events on the other side of the globe. In the wake of the Russian Revolution, there were intense debates about the nature of an appropriately revolutionary, or proletarian, or socialist art – debates that were increasingly dominated by the term 'realism'. A comparable situation existed in France and Britain (Plate 234). In the latter, in addition to a well-publicized survey of Soviet art (C.G. Holme, *Art in the USSR*), and published debate over the requirements for a 'revolutionary' art (B. Rea, *Five on Revolutionary Art*), the Artists' International Association was formed in 1933. One historian of the AIA has claimed to detect at least 'five distinct strands of practice' ranging from public mural art, through documentary work, to art either exemplifying or strongly influenced by notions of a 'proletarian' culture, all circum-scribed 'within the territory of Socialist Realism' (R. Radford, *Art for a Purpose*, p.73). In 1937 Anthony Blunt wrote that 'The only hope for European painting at the present time is the development of a new realism' (A. Blunt, quoted in L. Morris and R. Radford, *The Story of the Artists' International Association, 1933–1953*, p.15).

In Western histories, Socialist Realism is so often presented as merely arid and hidebound that it is hard to conceive how it ever had an influence. For much of the 1920s a rhetoric of militant 'proletarianism' had indeed been uncongenial to many artists who, although seeing a role for art in social revolution, none the less were suspicious about the idea of a specifically 'proletarian' art. Things changed, however, in the 1930s as the concept of a 'Socialist Realism' was formulated and fleshed out. In fact, after Hitler had come to power in Germany in 1933, Socialist Realism was widely perceived as a doctrine that could draw together artists throughout the world concerned by the spread of Fascism. As such, it can be seen as the artistic component of a wider movement, the Popular Front that aimed to draw together people from all walks of life into a common resistance to Fascism. The credentials of the Popular Front were seriously questioned, both at the time and later – from the Right by liberals and conservatives who saw the movement merely as a front for the Communists, and from the Left by Trotskyists and anarchists who saw it as an arm of the Soviet bureaucracy rather than an authentic form of socialist resistance to

Plate 233 Reginald Marsh, *Tattoo and Haircut*, 1932, egg tempera on masonite, 118 x 122 cm. Photograph: © Art Institute of Chicago; gift of Mr and Mrs Earle Ludgin, 1947.39.

Fascism. But whatever the justice of these criticisms, the Popular Front was a powerful international movement. In consort with it, the demand for a social or even 'Socialist' realism in art found an echo in many artists. Concerned at the rise of Fascism, the world crisis of capitalism and, latterly, the course of the Spanish Civil War, they felt drawn to participate *as artists* in what offered itself as a plausible world-wide movement for social justice. Realism also seemed to promise to connect their commitment with the high ground of the European bourgeois (i.e. post-Renaissance) tradition, whereas a militant 'proletarianism' had previously undermined that connection. Socialist Realism, in sum, offered to concerned artists a rather warmer place in the cold 1930s than many post-war histories have seemed to realize.

The avant-garde tended to be patronized by, if anyone, the haute bourgeoisie. It lacked wider social resonance, and was overall a riskier business than many artists were willing to attempt. Many must have felt that Mondrian's work, for example (Plate 142), scarcely qualified as art at all in a society animated by mass movements and the clash of ideologies that appeared to demand that one stand up and be counted – even though Mondrian himself thought that his work was highly relevant to the social problems of its

Plate 234 Clive Branson, *Selling the 'Daily Worker' outside Projectile Engineering Works*, 1937, oil on canvas, 41 x 51 cm. Collection of Mrs Noreen Branson, London. Photograph: A.C. Cooper.

age. On the other side, the fate of the Surrealists would have given pause to anyone who felt committed to a socially radical art yet wished to plough a furrow beyond the influence of the Popular Front and Communist parties. For despite an unwavering commitment to Marxism, Breton and his allies were increasingly isolated as the thirties progressed. Accused of irrelevance, of sexual deviation and – most damagingly of all – of Trotskyism, they were gradually closed off, by the Communist parties and their cultural apparatus, from being part of the international social struggle. For artists who wanted their art to have some place in a world that increasingly demanded commitment of one kind or another, who had no wish to be crucified along with the Surrealists, nor misread as the providers of superior decor for the international bourgeoisie, there were not many sites of production to gravitate towards, apart from social realism.

Yet not all artists were happy with the doctrinaire aspects of a Socialist Realism, even though most of them felt the value of being attached to realism of some sort. An instance of their complex response can be found in France, highlighted in debates at the Maison de la Culture in Paris that were organized by the Communist Party in the mid-thirties. Louis Aragon, who had been a leading Surrealist but had 'converted' to orthodox Communism, articulated the Socialist Realist view. On the other side the architect Le Corbusier argued that an abstract, or what he preferred to call a 'concrete', art was the appropriate form for

Plate 235 John Heartfield, *Millionen stehen hinter mir!* (*Millions Stand Behind Me!*), cover of *AIZ* (*Arbeiter Illustrierte Zeitung* (*Workers' Illustrated Paper*)), 16 October 1932. Akademie der Künste, Berlin. © DACS, London, 1993.

the modern world. In between these two positions, however, a third was articulated by
Fernand Léger. Léger was concerned to fill out a notion of an alternative 'New Realism'.[1]
For Léger, 'each art era has its own realism'. A new realism 'has its origins in modern life
itself' and, more contentiously, in modern *art*: it is held to be precisely in this 'struggle to
free themselves from certain old bonds' that modern artists 'have freed colour and
geometric form', and it is in this that the new realism lies. This is obviously a different
sense of realism from one of illusionistically depicting the realities of modern life. None
the less Léger was convinced that the play of formal contrasts in a work of art could,
without losing sight of a relation to modern 'objects', be used to achieve more appropriate
representations of the condition of modernity. The work of art would be an equivalent, a
sort of analogue in its own right, for the wider play of forces in the world, rather than an
attempt to illustrate it according to the conventions of an academic art that was itself *not*
of that modern world.

It is this attempt to connect up the social concerns of realism with the more reflexive
concerns of the artistic avant-garde that marks off Léger's 'New Realism' from Aragon's
'Socialist Realism'. It is also this aspect that brings Léger's concept close to the ideas of the
German playwright Bertolt Brecht. Brecht's views on realism came to constitute the main
left-wing opposition to Socialist Realism in the inter-war period. In a word, the new
realism had to be 'won' – from a world of new materials, shop-window displays, films
and technology; and, significantly, won despite the fact that, as Léger argued, 'it's always
easier to look backward, to imitate what is already done, than to create something new'.

In France the debate about the relation of art to society, and the concept of realism,
was stimulated by the election of a Popular Front government in June 1936 after a wave of
mass strikes and factory occupations. Almost immediately, the 40-hour week was
introduced, as well as paid holidays, supported by a new government department
responsible for sport and leisure. Artistic responses to a new public role for art ranged
from party-line Socialist Realism, to Léger's more complex efforts to produce a new
realism related to avant-garde practice. Montage, rooted in Cubist collage and stimulated
by John Heartfield's successful anti-Fascist photomontages, became something of a test
case (Plate 235). Though Aragon praised Heartfield, he didn't agree with Léger that
montage generally could be part of a realist art, and argued that it was disqualified by its
roots in the avant-garde. Léger, on the other hand, went so far as to call technically
conservative conceptions of realism an 'insult' to the masses: 'It is officially to pronounce
them incapable of rising to the level of that new realism that is their age' (Léger, 'The New
Realism goes on', p.115). Accordingly, montage was a prominent feature of the extensive
commissions he undertook for the Universal Exhibition in Paris in 1937. Large public
panels by him were installed in five of the French pavilions. These included *Work* (Plate
236) in the Pavilion of Education, which featured photographic enlargements of pylons
and other examples of modern technology, with a worker placed to the right of centre,
operating equipment. For the Palace of Discovery there was also a large painting, *Le
Transport des Forces* (Plate 237), concerning the development of hydro-electric power.
Again, though painted, the composition uses montage-like devices in juxtaposing the
elements of pylons, scaffolding and flowing water.

All in all, the whole question of realism was exemplified in the Universal Exhibition,
which offered a starkly posed climax of the debate in all its aspects – both formal and
technical questions, and issues of art's relation to society. In addition to Léger's numerous
projects, the National Socialist German pavilion, with its vast classicizing Aryan heroes
(Plate 238), directly faced the Soviet pavilion topped by Vera Mukhina's monumental
Socialist Realist figures of *The Worker and the Collective Farm Woman* (Plate 239). More akin
to Léger's example – but raising the issue far more forcefully through its focus, not on

[1] The various views are given in: L. Aragon, *Pour un Réalisme Socialiste*; Le Corbusier, 'The quarrel with
realism'; and F. Léger, 'The New Realism goes on'.

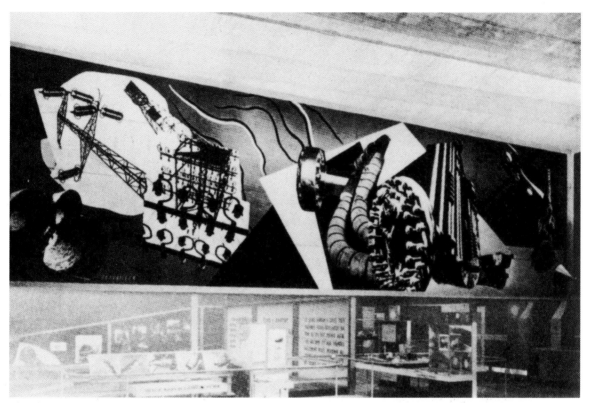

Plate 236 Fernand Léger, *Travailler* (*Work*), 1937, photomontage (now destroyed), installed in the French Pavilion of Education, Universal Exhibition, Paris, 1937. Photograph: Roger-Viollet, Paris. © DACS, London, 1993.

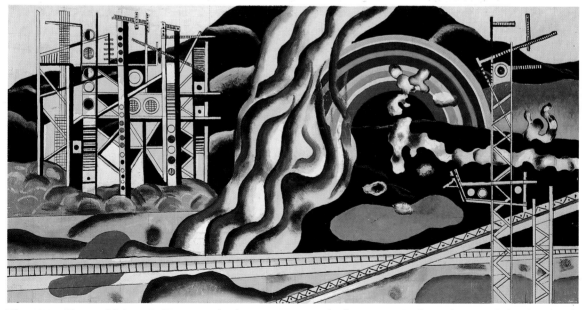

Plate 237 Fernand Léger, *Le Transport des forces*, 1937, gouache for a painting (now destroyed) for the French Palace of Discovery, Universal Exhibition, Paris, 1937. Musée National Fernand Léger, Biot. © DACS, London, 1993.

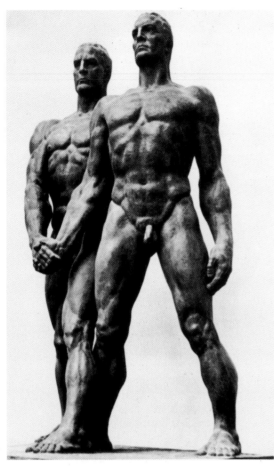

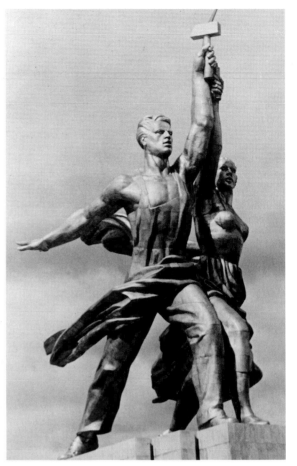

Plate 238 Josef Thorak, *Kameradschaft* (*Comradeship*), 1937, bronze, height 670 cm, for the National Socialist German pavilion, Universal Exhibition, Paris, 1937. Photograph: Roger-Viollet, Paris.

Plate 239 Vera Mukhina, *The Worker and the Collective Farm Woman*, 1937, bronze, height *c*.12m, for the USSR pavilion, Universal Exhibition, Paris, 1937. Photograph: Society for Co-operation in Russian and Soviet Studies, London.

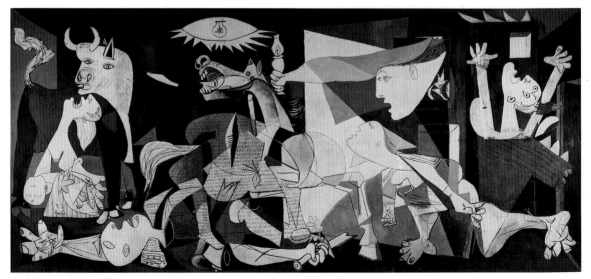

Plate 240 Pablo Picasso, *Guernica*, 1937, oil on canvas, 349 x 777 cm. Museo del Prado, Madrid. © DACS, London, 1993.

peace, production and leisure but on war – was the Spanish Republic's installation, in its pavilion, of Picasso's portable mural *Guernica* (Plate 240). This commemorated the destruction of the Basque capital by the German Condor Legion – the first aerial bombardment of an urban civilian population – on 26 April 1937 during the Spanish Civil War. At the end of the war against Fascism in 1945, Picasso wrote down a statement about art and politics. He had by then joined the Communist Party, and circumstances were in general quite different, but one can assume that his remark applies at least to *Guernica* among his pre-war works. The avant-garde had been repeatedly cast as both apolitical and bourgeois by Socialist Realist commentators. Yet in terms strikingly similar to Rivera's argument that we looked at earlier, Picasso (the inveterate avant-gardist) now wrote: 'Painting is not done to decorate apartments. It is an instrument of war for attack and defence against the enemy' (written statement to Simone Téry).

Realism and Socialist Realism

A picture emerges, then, of a widespread interest in and commitment to a notion of realism by many artists in the 1930s – in Mexico, the United States, and throughout Europe. Time and again, though, debates in these places refer back to practices and debates taking place elsewhere – particularly in Russia. The irony is that, generally speaking, the lessons being learned in the thirties did not lead much further. Socialist Realism marked less a point of view in an on-going and multifarious debate about the nature of art's relation to society, than its terminus. If we are to recover the complexity of the debate, rather than the 'straw' positions of 'heroic' Socialist Realism versus 'bourgeois' avant-gardism, if we are to recover, that is, a genuine sense of difference and contestation, we must look back – back to the Russian Revolution of 1917 itself and the decade or so that followed it. For the Soviet positions of the thirties emerged out of a much more fluid situation in the 1920s. Both then, and after the Nazi takeover in Germany in 1933, these debates also included the distinctive voice of German artists and theoreticians relating to the developments both in the Soviet Union and in Weimar Germany itself.

In summary, then, the dominant conception to emerge from these debates, and to influence others world-wide, was Socialist Realism. It is important, however, to note that Socialist Realism was a position won, or imposed, over a range of others. *All* of these valued realism to some extent, and disapproved to some extent of a wilful, or subjective, or elitist, or 'spiritually' inclined version of avant-gardism.

Though it's an oversimplification, it may for the time being be useful to bear in mind the following opposition. On the one hand Socialist Realism became a rigid dogma, if less so in the work of important thinkers such as Georg Lukács, then certainly in the hands of bureaucrats such as Stalin's cultural commissar Andrei Zhdanov. While it hasn't been the lifeless effigy that Western theory has so insistently maintained, neither has it been by any stretch of the imagination a risky or adventurous art. Yet within its limits, imposed quite consciously (and, in its own terms, correctly) by a view of social responsibility – rather than, say, by the limits of the medium – it has exhibited multiple accents.

But on the other hand – and this is the point – this official 'Realism' never went wholly uncontested. Many objected to its relative stasis, arguing that realism must respond dynamically to an unprecedented modernity. They regarded this modernity as determined not so much by the overt trappings of technology as by social relations, and particularly the relations between classes: technological change and so on followed from social relations, not the other way round. This view of realism was most cogently summed up by Brecht during an exchange with Lukács in the 1930s: 'Realism is not a mere question of form ... Reality changes; in order to represent it, modes of representation must also change' (Brecht, 'Popularity and Realism', pp.79–85).

This dialectic is close to the heart of the problematic of realism. On the one hand a sense of art being animated by an address to a world beyond art (and as such resisting

incorporation as the leisure activity of a privileged class); yet on the other hand that address having of necessity to be made through the prism of some medium. A sense that *how* that world outside of art was addressed preceded and in no small part determined *what* could be said about it. In the dialectical interplay of these two emphases lay realism. And in the neglect of either one lay the antipodes of an over-secure art-for-art's-sake, uncritically failing to consider the grounds of its own autonomy, or a dogmatic, instrumental art, more concerned in the end with prodding its audience into particular responses than prompting reflection upon the conditions of response themselves.

Soviet Russia

Realism and the avant-garde

Socialist Realism was a doctrine about figurative art and its relation to society that emerged in the Soviet Union in the 1930s. What it emerged from, however, was a complex debate that ran throughout the 1920s about what was to constitute an appropriate revolutionary art. In this long-running debate, figuration gradually established dominance over tendencies associated with the avant-garde. It is beyond our scope here to survey these avant-garde tendencies in detail. Yet we must establish some brief sense of how they related to realism. The reason for this can be simply put. Conventional approaches to realism that identify it with figuration tend to treat the more abstract types of art associated with the avant-garde as foreign to realism, even as a threat to it. As late as the 1970s a Soviet art historian was able to write of the 1920s:

> These were the years when realism was opposed by various creative trends beginning with salon art and ending with abstractionism … [they] proclaimed the principle of the 'independence of art from politics', thus placing themselves in opposition to the tasks assigned to art by the revolution.
>
> (O. Sopotsinsky, *Art in the Soviet Union*, p.7)

Western theorists of the Modern Movement in art maintained this notion of polarity – that avant-garde art and realist art faced each other antagonistically across an unbridgeable gap. They, however, praised the avant-garde while criticizing 'realistic' figurative art as retrograde. Neither side acknowledged that avant-garde art could *be* a form of, or could at least be illuminated by requirements of, realism. That possibility, which neither of the contending orthodoxies appeared to understand, was perhaps understood by a third, minority tradition.

We will content ourselves here with two examples. Kazimir Malevich wrote of Suprematism, the abstract art movement he pioneered during the First World War, that 'Painting is paint and colour … such forms will not be repetitions of living things in life but will themselves be a living thing. A painted surface is a real, living form' (K. Malevich, 'From Cubism and Futurism to Suprematism: the new painterly realism', pp.129–30). This is compatible with Modernist views about the autonomy of art. Yet note the word 'Realism' in the title that Malevich gave to his article, which he published in 1915 to coincide with the first exhibition of Suprematist paintings. His position was essentially a philosophical idealism, in that primary forms discovered by the operation of what he called 'intuitive reason' – notably the square – are not secondary to the actual forms of the world but constitute a harmonious equivalent to them (Plate 241). In contrast with the deficient 'realism' of figurative painting, which for Malevich is a mere copy of an existing reality whose depth and richness it can never match, the forms of Suprematism exist alongside the forms of nature: 'The new painterly realism is a painterly one precisely because it has no realism of mountains, sky, water' (Malevich, p.133).

Plate 241 Kazimir Malevich, *Red Square: Painterly Realism of a Peasant Woman in Two Dimensions*, 1915, oil on canvas, 53 x 53 cm. State Russian Museum, St Petersburg.

Malevich persistently referred to his pursuit of a pure plastic art as a quest for a transformed realism – 'Cubo-Futurist Realism', 'Transrational Realism', and later the 'new painterly realism' of his Suprematist work. Furthermore, he adapted his practice to the collective ethos of the Revolution when in 1920 in Vitebsk he set up the group UNOVIS (translated as 'Union of the New Art' or 'Affirmers of the New Art'). UNOVIS supporters applied Suprematist techniques to the demands of the situation – in brochures for conferences, in street decorations and in such designs as a backdrop for a conference. This activity continued to be conceived as part of a 'new realism', as can be seen from a UNOVIS poster (Plate 242) issued in November 1920, illustrating a design for a speakers' rostrum – of the kind referred to as a 'Lenin' rostrum, originally designed by Malevich's student and collaborator, El Lissitzky. Its caption identifies it as an example of the 'new realism'.

Plate 242 UNOVIS, Vitebsk Art Committee Handbill, no.1, 20 November 1920. State Russian Museum, St Petersburg. Reproduced by courtesy of Stedelijk Museum, Amsterdam.

Malevich used a transformed concept of 'realism', a notion that art was its own reality and that only as such (rather than as a pale imitation) could it represent modern experience. This was tantamount to saying that it was the very autonomy of art that conferred the possibility of 'realism' upon it, a notion clearly at odds with prescriptions about the need for art to depict visible social reality. This may seem a strange and contradictory idea. It is, however, worth noting both that Malevich held it, and that it is not, despite its rootedness in abstraction and in an autonomy claim, an argument for art-for-art's-sake. For Malevich, realism – albeit of this unusual and little-understood kind – was a goal worth pursuing, not something to be written off as irrelevant to the art he was making, either in his Suprematist phase or when he later returned to more recognizable subjects.

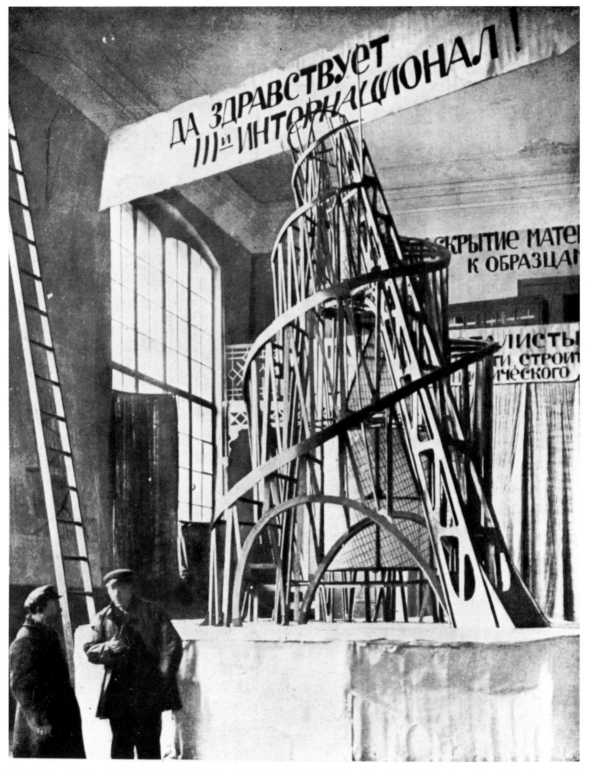

Plate 243 Vladimir Tatlin, model for *Monument to the Third International*, 1920, wood, cardboard, wire, metal and oil paper, height *c*.5m. Photograph by courtesy of Moderna Museet, Stockholm.

A second example, referred to in Chapter 2, also suggests the possibility of an interesting relationship, rather than a gulf, between the avant-garde and realism. This example also bears, perhaps more closely, upon Brecht's argument mentioned above: as reality changes, ways of representing it must also change. Vladimir Tatlin's ambitious *Monument to the Third International* may at first sight seem to have little to do with realism (Plate 243). Never actually constructed, it existed as a model about five metres high. It consisted of a double spiral of wooden laths containing in its centre a range of basic forms made from wooden frames covered with paper – a cube, a cylinder, a pyramid and a hemisphere. The fact that the monument proper was meant to be higher than the Eiffel Tower, and the geometric forms glass-walled rooms hosting conferences and other meetings, does not stop the model from looking more like a work of contemporary abstract art (Tatlin's own, or that of younger artists in the OBMOKhU group, for example Plate 81) than a realistic monument. Yet in 1918 Lenin himself, impelled by the conviction that reality had indeed changed – with the Revolution – commissioned a range of propagandist monuments intended to replace the old images of princes, generals, tsars and so on with images of prominent figures from the socialist tradition. These monuments were obviously intended by Lenin to be 'realistic' in a conventional sense. The project failed, however. Partly this was because many of the artists involved had been affected by avant-garde ideas and proceeded to produce distorted ('abstracted') images that people found offensive. Partly it was because the maquettes, the models, were produced in cheap materials such as plaster and were simply unable to withstand the weather when put on temporary display in their proposed locations (Plate 244).

There was also a deeper problem: the 'realistic' statue is by its nature a monument to an individual, whereas the socialist or Communist Revolution, by *its* nature, was a collective achievement. Thus the form was at odds with the content it was supposed to represent. It seems that Tatlin's plan for a monument, not to an individual but to an institution, was an attempt to resolve this problem. For the same reason it was not to be made by traditional methods of modelling or carving, and not from traditional materials such as clay or bronze, but 'constructed' out of iron and glass. The Revolution, then, was a collective endeavour – a movement of classes and organizations, as distinct from the

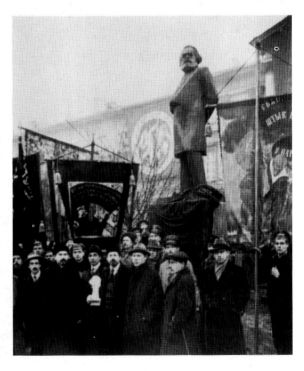

Plate 244 Aleksandr Matveiev, Karl Marx memorial, Petrograd, 1918, gypsum (now lost). Reproduced from M. Guerman, *Art of the October Revolution*, London, Collets, 1979 by permission of Aurora Art Publishers, St Petersburg.

bourgeois preoccupation with the rounded, self-possessing individual. It was also international in scope. Accordingly, one of the most important decisions taken by the Bolsheviks was to inaugurate a new, Third International, an organization intended to co-ordinate and spread the Revolution abroad. Tatlin's plan therefore had a dual aspect; while on the one hand intended as a monument to this new organization as opposed to some individual, it was also an attempt to escape the relative passivity of the role imposed by the traditional form of the 'monument'. By attempting to put into practice the principles of a synthesis of painting and sculpture with architecture, thereby intervening in the lived environment rather than standing to one side of it, it was to be not merely a monument *to* the Third International but its working headquarters – the site *of* the world Revolution.

Many avant-garde artists sought a role in the revolutionary process, whether that lay in furthering it, as in the Soviet Union, or in helping bring it about, as in Germany. Both

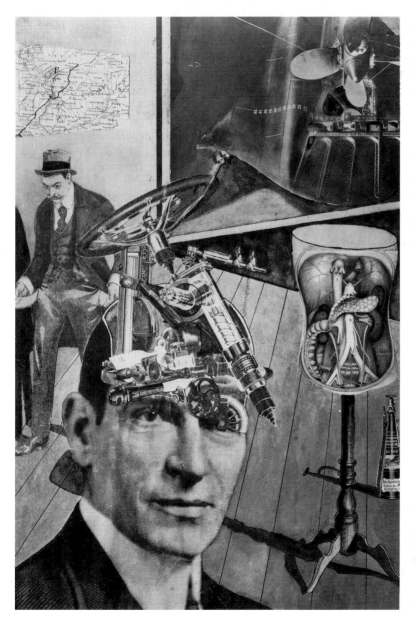

Plate 245 Raoul Hausmann, *Tatlin at Home*, 1920, photomontage, 41 x 28 cm. Moderna Museet, Stockholm. © DACS, London, 1993.

Tatlin's ambitious project, and the wider conception of an art practice that it embodied, became influential models. The tower and its maker seem to have constituted a particularly appropriate modern subject for representations by artists who themselves aspired to a 'realist' imagery of the modern. As with Tatlin, the technique used in such images had its origins in avant-garde Cubism. Montage seemed to offer one of the most productive devices for representing the 'simultaneous' or 'fractured' aspects of modern experience. Such aspects of modernity and technology are evident in a montage by Lissitzky, based on photographs taken during the actual making of the model of the tower. Another example is Hausmann's *Tatlin at Home* (Plate 245). This formulates its 'portrait' of the modern artist through the suggestion of mechanism and calculation rather than instinct and improvisation; and, through the substitution of a photograph of an anonymous 'modern man' for Tatlin's face, conveys his status as part of a collective rather than individualist process.

Bearing in mind Brecht's dictum, then, it is possible to see Tatlin's tower, like Malevich's Suprematism, not as remote from artistic realism but as influenced by it. But, it is important to note, this approach sees artistic realism, not as a given, particular quality (such as 'likeness') but as something that needs to be transformed, just as art and reality themselves had changed so profoundly.

Since its inception, the avant-garde had had an uneven relationship with social and political emancipation. Sometimes (in the case of Renoir, for example) it was indifferent. Sometimes it was reactionary – from the Catholic revivalism of Maurice Denis to the more or less explicit Fascism of Marinetti or Wyndham Lewis. That said, a powerful strain of the avant-garde had from the beginning aspired to at least walk in step, and sometimes more than that, with a liberation that went beyond the merely formal or aesthetic; and that strain had usually laid claim to, or had claimed for it, the sobriquet 'realist'. As well as figures such as Courbet and Pissarro, this tradition can be seen to include Manet, Degas and, in one view at least, Cubism itself. Despite the undeniable fact that the atomizing forces of capitalist culture have marginalized and privatized art in the modern period, one cannot rid realism of this social dimension and be left with something worthy of the term. That remains the case even if that 'dimension' becomes reduced to a process of negation – of the correction and refusal of social mystification. It could indeed be that in a *culture* of mystification, such negation is all that remains.

Proletarian culture

The confrontation between such an avant-garde tradition of realism as a critical device, and a more orthodox sense of realism as a depiction of reality, was leavened by a third idea. This concept performed an important intensional function in cutting across the divide of social realist and avant-garde views. But it was also *ex*tensive, spreading beyond the country of origin of the proletarian revolution, having a particular impact in Germany and in a wider sense flavouring the debate internationally. This is the concept of 'proletarian culture', embodied during the revolutionary period in the organization Proletcult. The Proletcult's basic theoretical proposition was that

> All culture of the past might be called bourgeois, that within it – except for natural science and technical skills (and even there with qualifications) – there was nothing worthy of life, and that the proletariat would begin the work of destroying the old culture and creating the new immediately after the revolution.
>
> (A.V. Lunacharsky, Soviet commissar for education and the arts, 1922, quoted in S. Fitzpatrick, *The Commissariat of Enlightenment*, p.92)

The problem here is that the position closest to this 'proletarian' rejection of the 'bourgeois' past was that of the avant-garde. Figures as diverse as Malevich, Tatlin, their followers Lissitzky and Rodchenko – as well as the circles around the poet Vladimir Mayakovsky, the organizer of LEF (the Left Front of the Arts) – were united in rejecting the methods of past art. Yet Proletcult also condemned the avant-garde itself as 'bourgeois',

both for its origins in European artistic culture – however much it might now claim to support the Revolution – and for its notorious incomprehensibility. For Proletcult, first and foremost, proletarian art had to be 'clear and understandable to everyone' (I. Trainin, 1919, quoted in L. Mally, *Culture of the Future*, pp.145–6). The upshot was a kind of three-cornered fight. The 'official' Marxism of the Bolshevik Party leadership was directed against the avant-garde for its bourgeois origins and for the difficulty experienced by most people in comprehending it. But the leadership also criticized Proletcult for rejecting the past, whereas Lenin and Trotsky (just as much as Marx and Engels before them) considered that a Communist art and culture would have to be built *upon* the achievement of the European bourgeois tradition. Yet the LEF and the Constructivist avant-garde clearly considered themselves to be Marxists, and to be the most appropriate carriers of the revolutionary message in the field of art. For them it was precisely those artistic trends relying on what Nathan Altman called the 'pernicious intelligibility' of a traditional figurative realism that were 'bourgeois', that carried the taint of the old order, and that were unfit to serve as models for a revolutionary art.

There is no doubt that this is muddy water. Whatever the difficulties it posed, however, the notion of a 'proletarian culture' was an extremely resonant one. Even after the actual organization had withered, the idea lived on in the later twenties and thirties. So if we omit it from the realism debate, we will lose sight of one of the debate's most important constituents – the implication of realism in art with the social struggle of the working class against the divisions, discriminations and inequalities of the bourgeois societies created by modern capitalism.

Realism and figuration

If the approach to a notion of realism surveyed in the previous subsection had its roots in a Western avant-garde, its principal rival – a resurgent figurative realism – traced its origins to the Russian nineteenth century. This is not to say that there is an insurmountable barrier between these traditions. After all, Marx and Engels – themselves *the* guarantors of 'realism' both literary and pictorial within the Communist tradition – rooted their claim powerfully in *French* literature, particularly the novels of Honoré de Balzac.

In Russia, Nikolai Chernyshevsky had published *The Aesthetic Relations of Art to Reality* in the 1850s, and the enormously influential novel *What is to be Done?* in 1863. His ideas about art criticism were matched in art practice when a group broke away from the Petersburg Academy. By 1870 the group had consolidated into the Association of Travelling Art Exhibitions, The Wanderers (*Peredvizhniki*), dedicated to taking art to the people. One of the central problems that such realism in art took from discussions of realism in literature was that of *typicality*. For Chernyshevsky and for Engels himself, realist art needed to generalize from the specific motif in hand, and moreover to do so consistently. Thus Engels, in 1888: 'Realism to my mind implies, besides truth of detail, the truthful reproduction of typical characters under typical circumstances' (letter to Margaret Harkness, in L. Baxandall and S. Morawski, *Marx and Engels on Literature and Art*, p.115).

Typicality in art was seen as embodied in the practice of Ilya Repin, notably in his painting of the return of a political prisoner from Siberia. For the critic Vladimir Stasov writing in 1884, *They Did Not Expect Him* (Plate 108) was 'definitely the *chef-d'œuvre* of the entire Russian school', principally because of the way in which the specific incident set up possibilities for generalization: by establishing a 'characteristic type', it permitted the 'expression of profound ideas' (A. Hilton, 'The revolutionary theme in Russian Realism', p.121).

However, with the increasing modernization of Russia in the late nineteenth century, the resulting development of a capitalist middle class, and the concomitant impact of Western ideas (notably, in art, those of the avant-garde), a Wanderers-type realism of

committed subject-matter had declined in influence for several decades before the Revolution of 1917. From about 1890 onwards, first Symbolism, and then a succession of avant-garde '-isms', from Primitivism to Futurism, had dominated artistic debate. But as we have seen, the political revolution released a welter of ideas about culture and society, especially about the class nature of the existing culture and, under the rubric of a 'proletarian culture', an interconnected set of claims about the purpose of art and its accountability to ordinary people. In the revolutionary maelstrom itself, conflicting currents were able to coexist. But the relative stabilization of the situation in the early 1920s with the New Economic Policy saw a re-emergent figurative 'realism' in an increasingly strategic position, ideologically as well as materially.

The great virtue of figurative approaches was that they had a reasonably sound basis in tradition. Learning the skills to make pictures was, after all, what artists had always done (something manifestly *not* the case with nailing together bits of wood, or drawing circles and squares with a ruler and compass as the avant-garde had done). But the trouble with figuration in general was that, despite the continued assertion of its realism, at least in the sense of having resisted avant-gardism or abstraction, it hardly seemed to register the momentous events that were going on all around. A partial exception to this is Boris Kustodiev's *The Bolshevik* of 1920 (Plate 246): he has retained the snowy rooftops and the Lilliputian figures of his earlier work (Plate 247), but through them all is wading a Bolshevik Gulliver, his red flag billowing to the horizon. Some sense of the elasticity of the concept of 'realism', even as it came to be articulated in the 1930s, can be gained from the fact that at the large exhibition of 1933 entitled Fifteen Years of Art in the USSR, this far from 'realistic' depiction was praised for 'symbolizing the party as the leader, guide, the

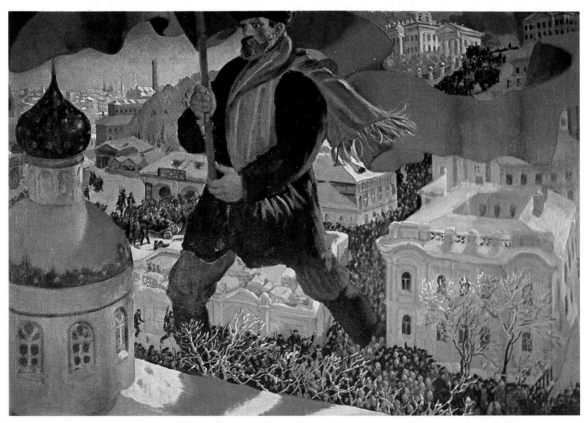

Plate 246 Boris Kustodiev, *The Bolshevik*, 1920, oil on canvas, 101 x 141 cm. State Tretyakov Gallery, Moscow. Photograph by courtesy of the Society for Co-operation in Russian and Soviet Studies, London.

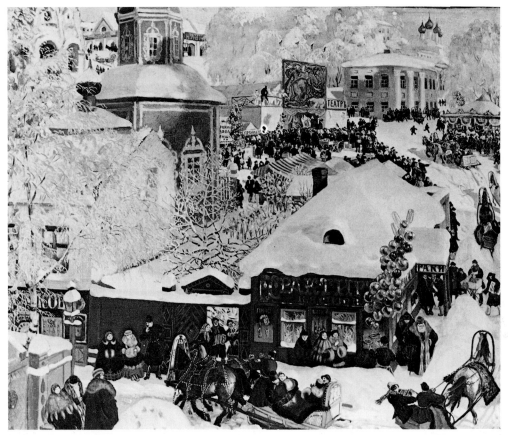

Plate 247 Boris Kustodiev, *Shrove Tide*, 1919, oil on canvas, 88 x 105 cm. Collection of I.A. and Ya.A. Rzhevsky, by courtesy of Dr Valery Dudakov.

central force of the revolution' and representing thereby the correct politics (B. Uitz, quoted in The Open University, *Russian Art and the Revolution*, p.31). It is at most an allegorical solution to the requirement to represent the Revolution, owing more to the conventions of illustration than the tradition of a 'realist' art. However memorable an image, neither Kustodiev's graphics nor the moderately academic survivors of the Wanderers, such as Abram Arkhipov's *Woman in Red* (Plate 248), offered a long-term solution to the need to provide whatever it was felt the avant-garde wasn't offering. Newer groups began to emerge in 1921: former pupils of Malevich and Tatlin organized themselves into the New Society of Painters, as well as into a group calling itself Objective Reality. But the significant development came in 1922.

The AKhRR

The catalyst was the forty-seventh Wanderers' exhibition in January 1922. Out of it arose a new artistic group, The Association of Artists Studying Revolutionary Life. By the opening of their first exhibition – Pictures by Artists of the Realist Direction in Aid of the Starving – on International Labour day, 1 May, of the same year, it was renamed The Association of Artists of Revolutionary Russia (AKhRR). With various changes such as retitling itself the Association of Artists of the Revolution (AKhR) in 1928, the organization quickly became the dominant artistic grouping of the decade. Throughout this period it was in a state of open, highly sectarian warfare with the avant-garde – which virtually

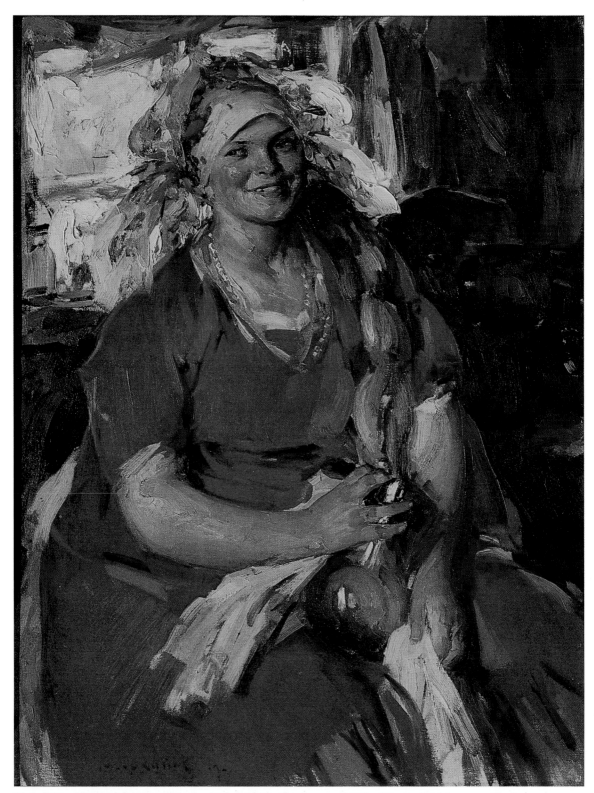

Plate 248 Abram Arkhipov, *Woman in Red*, 1919, oil on canvas, 115 x 85 cm. Art Museum, Gorky.
Photograph: Vneshtorgizdat, Moscow.

from the moment of the AKhRR's inception was on the retreat. By the second half of the 1920s AKhRR had attracted direct government support; more traditional realists, notably Arkhipov, Mashkov and Kustodiev, had been drawn into its ranks; it had a youth section, the OMAKhR; it had a publishing house, and from 1929 its own journal, *Art to the Masses*. There were also plans, announced in the 'Declaration' accompanying the group's 1928 exhibition, 'to unite the revolutionary artists of all countries in a single organization – INTERNAKhR' (quoted in Bowlt, *Russian Art of the Avant-Garde*, pp.271–2).

To a significant extent AKhRR also set the tone for what was eventually to become Socialist Realism, the official doctrine outside of which art did not get made from 1934 onwards. At the heart of AKhRR's burgeoning artistic empire, however, lies something of a vacuum; yet paradoxically it may be just in this vagueness that the potency lay. For despite the rhetoric, nothing precise in terms of doctrine was enunciated. In marked contrast to the quite detailed attempts of the avant-garde to engage in a debate of technical concerns and priorities, AKhRR's formulation amounted to little more than a slogan. The brief 'Declaration' of summer 1922 accompanying the AKhRR's second exhibition of Studies, Sketches, Drawings and Graphics from the Life and Customs of the Workers' and Peasants' Red Army, argued that:

> We will depict the present day: the life of the Red Army, the workers, the peasants, the revolutionaries, and the heroes of labour. We will provide a true picture of events and not abstract concoctions discrediting our Revolution in the face of the international proletariat … The day of revolution, the moment of revolution, is the day of heroism, the moment of heroism, and now we must reveal our artistic experiences in the monumental forms of the style of heroic realism.
>
> (AKhRR, 'Declaration', 1922, pp.266–7)

Only a few further clues are given: heroic realism is to be achieved 'artistically and documentarily'; it is 'content' that is the 'sign of truth in a work of art'; crucially, and in direct contrast to the avant-garde, 'heroic realism' is seen as a product of 'acknowledging continuity in art' as well as 'basing ourselves on the contemporary world view'. The 'contemporary world view' is a coded reference to Marxism. Yet many Constructivists would also have claimed that they were Marxists. AKhRR's remaining points about 'documentation', 'content' and 'continuity' are a set of dicta that partly refurbish the figurative tradition of the nineteenth century. The stated aim of AKhRR, and of other emergent 'realist' groups that it absorbed, was for art 'to become social' – again, in principle, hardly at odds with the Left. The difference arises with how this is to be achieved – by focusing on 'the content or subject-matter of art' (declaration by the group Objective Reality, quoted in C. Lodder, *Russian Constructivism*, p.185).

This is in fact a crucial slippage, and may well constitute *the* fault line, so to speak, that has divided 'figurative' and 'Modernist' conceptions of realism – with incalculable consequences. The equation of 'content' with 'subject-matter' has the effect of condemning work lacking manifest subject-matter, which is to say most of the work of the avant-garde, to the status of something that has no content. Apparently 'contentless', abstract work is reduced to the status of meaningless pattern or decoration. 'Decoration' is itself a complex issue, but the AKhRR and others are accusing 'abstract' art of failing to address real issues in social life, and instead merely adorning the lives of those sections of society that had the leisure and privilege to indulge in contemplation of the aesthetic. By equating content and subject-matter, they rule out the very possibility of an 'abstract' work performing a critical function, of having a critical content. The idea that an avant-garde practice may be striving in difficult and transformed conditions of modernity to obtain an adequately 'modern' purchase *on* that modernity, simply becomes void of meaning. ('How could it? It lacks content. It isn't "about" anything.')

AKhRR, then, is not so much saying that artists should follow a particular style, as adopting a general orientation. And this orientation was fuelled by a mixture of im-patience and fear – impatience with the avant-garde's seemingly endless theoretical

debate, and fear of isolation from the wider processes of social revolution. These attitudes went hand in hand with a disposition to 'serve', to volunteer art (represented by themselves) to perform its 'rightful' social tasks in that developing revolutionary process. Such a disposition, quite correctly in its own terms it should be said, was not shy of manoeuvring itself alongside the powers that be. This is not meant as a harsh judgement with the benefit of hindsight: the dominant social ideology was one of pulling together to build the new society, and 'the powers that be' were generally admired as well as respected. The point is, rather, that politicians tend to value art for what it can achieve in political and social terms; and the new groups were willing to let their work be limited by this instrumentality masquerading as a genuine social demand rather than risk unpopularity by addressing the technical problems that followed from recognizing art as a medium. For them, art was a relatively transparent achievement, a given set of skills and techniques applicable to this or that end. What had changed was the end. The avant-garde perception about the materiality of representations, the production *in* the representation of that which is represented, essays at its best a dialectic of means and ends; of form and content; ultimately of art and politics. With the new figurative 'realism', the traffic is all one-way.

Presumably one reason why Western art historians have paid relatively little attention to AKhRR is that – in addition to feeling moral distaste for it, because of its absolute commitment to a social task rather than to the defence of art's aesthetic autonomy – they have also seen it as intellectually or theoretically simplistic. Yet although AKhRR's declarations are by no means as complex as those of, say, UNOVIS or the Constructivists, they do offer some theoretical interest as well as leaving room for a measure of diversity in practice. This can be seen at its simplest in the range of types of subject dealt with. Not all were overtly heroic: Mashkov's *Still-life with Samovar* of *c.*1919 (Plate 249) is an

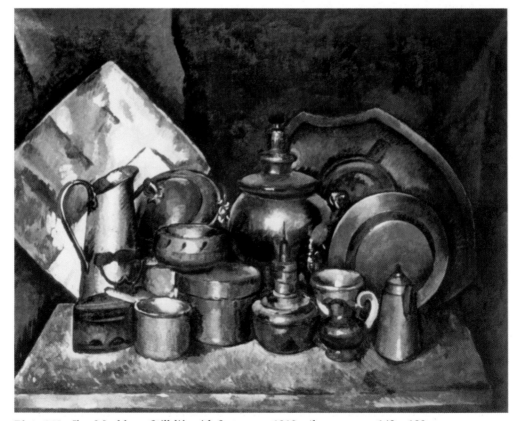

Plate 249 Ilya Mashkov, *Still-life with Samovar, c.*1919, oil on canvas, 142 x 180 cm. State Russian Museum, St Petersburg.

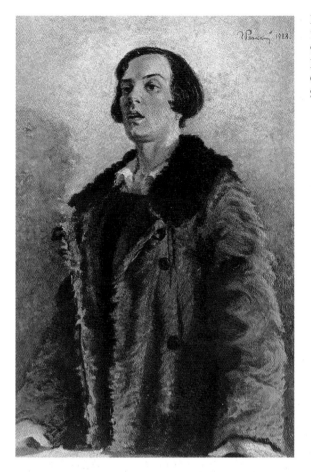

Plate 250 Giorgy Ryazhsky, *The Chairwoman*, 1928, oil on canvas, 99 x 61 cm. State Tretyakov Gallery, Moscow. Photograph: Society for Co-operation in Russian and Soviet Studies, London.

example. Another still-life by Mashkov, however, was exhibited in AKhRR's 1925 exhi-bition Revolution, Everyday Life and Labour under the more 'heroic' title *Moscow Victuals*. Less immediately apparent, but equally significant, was a certain latitude in technique. Again, there is nothing on the scale of the avant-garde's technical experimentation, but neither was there the imposition of complete homogeneity. For example, Giorgy Ryazhsky's *The Chairwoman* (Plate 250) of 1928 obviously sets out to evoke sensations of heroism and seriousness of purpose. A large part of this is due to the composition, with the figure placed against an empty ground, and angled as if she were the sole focus of attention for a spectator who is placed as if in the front row of the meeting that the female party orator is addressing. The technique used is itself relatively free. The resulting surface is both appropriate to the actual fur of the coat and expressive of a certain activity and mobility – a kind of functionality in the paint echoing the open-necked shirt and bobbed hairstyle in the subject. This can be contrasted with the use of a more 'photographic' technique, as in Yevgeny Katzman's *The Kaliazin Lacemakers* (Plate 251). Here the finish both establishes the individual figures (allowing psychological inquiry by the spectator) and also, because of its equal distribution across the whole of the picture, contributes to emphasizing them as typical – working women, of different ages. These collective portraits, the female figures of the lacemakers as well as Katzman's male Communists listening at a meeting (Plate 252), deploy a highly wrought academic technique producing an effect of stasis that emphasizes the desired physical and moral solidity and plainness sought in the Type. 'Heroic realism', it seems, is not the prerogative of one technique but can function as a practice across the middle ground of an academi-cally heightened naturalism or a restrained expressiveness.

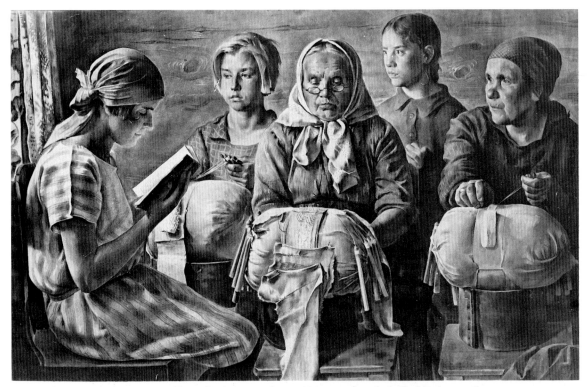

Plate 251 Yevgeny Katzman, *The Kaliazin Lacemakers*, 1928, pastel, red chalk, black pencil on paper, 91 x 142 cm. State Tretyakov Gallery, Moscow. Photograph: Vneshtorgizdat, Moscow.

It goes almost without saying that AKhRR condemned the avant-garde for refusing to stay within the traditional norms of technical skill. Their attack was also aimed, however, at its theory. They contrasted the 'analysis' of the avant-garde with their own quest for a 'synthetic form': it is this that they called 'heroic realism'. It is important to note that, when AKhRR rejected the avant-garde's focus on form, and asserted that subject-matter

Plate 252 Yevgeny Katzman, *Listening (Members of the Communist Faction from the Village of Baranovka)*, 1925, charcoal, dimensions unknown. State Tretyakov Gallery, Moscow. Photograph: Vneshtorgizdat, Moscow.

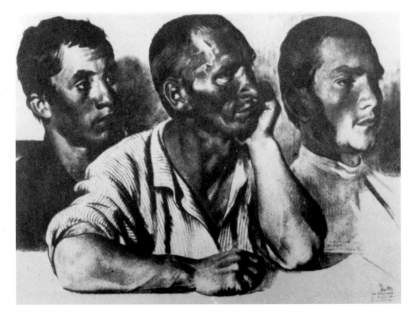

should instead have priority, it was not that they did not care about the relation of form and content. Nor, when they said that realist art must have 'continuity' with its nineteenth-century antecedents, were they implying that there is an eternal form that can be merely applied to the appropriate subject-matter. The *skills* are constant, but the forms that they will be used to produce have to be developed. The AKhRR position, rather than merely failing to see the avant-garde point about the mediation of form, in fact inverts it. The AKhRR *do* seek 'the unity of form and content in art'. But their argument is the other way round: the correct form will be determined by the subject-matter. This subject-matter is the life of the Revolution, and the new thematics will both (a) dispense with old 'fractured' forms, ascribed to 'the masters of the French school', their 'frayed lost forms and lacerated colour', and (b) organize a 'new colour', 'synthetic form' and 'compositional structure' (AKhRR, *The Immediate Tasks of AKhRR*, pp.268–71). Far from form and content becoming disconnected by AKhRR's refusal of the avant-garde's thinking of that relation, 'artistically perfect realistic form' is seen as being, or needing to be, 'organically engendered' by the 'profound content' of the work (AKhR, 'Declaration', 1928, p.272). Characteristic terms used to evoke 'heroic realism' are 'severe', 'power', 'strong', 'precise' – as well, of course, as 'heroic' itself. These do not, as they stand, prescribe a style in detail. None the less, by reiterating such terms within a nexus of military metaphors common in the writing of the time, they do appear to set up guidelines for notions of Typicality and Generalization.

A further key notion in this realist aesthetic – and, once again, one that was not peculiar to AKhRR but featured prominently in avant-garde debate – is 'organization'. The term 'organization' refers to two things. First, it concerns the function of a work in 'organizing' the ideas of its viewers, the 'creation of an art that will have the honour of shaping and organizing the psychology of the generations to come' (AKhRR, *The Immediate Tasks of AKhRR*, p.270). Secondly, it concerns the constitution of the works themselves, how they 'organize' forms in accord with the new revolutionary reality. Precisely *how* AKhRR's forms are meant to 'organically' express the new reality isn't specified; what there is instead is a rhetoric of 'power' and 'strength', 'authenticity' and 'seriousness', rooted in traditional painterly competence. None the less it would not quite do justice to their argument to say that all is then left hanging at the level of analogy. A crucial shift does happen. It is one that the avant-garde would reject, but there is a sense in which it secures the relation of new 'content' to 'form'. The attributes that AKhRR regards so highly – strength, typicality and so on – are ascribed to the *subjects*, whose depiction is achieved *by means of* traditional competences. These traditional competences are used to evoke 'deep' space, deep in both the physical *and* psychological senses so that the spectator can imaginatively enter the pictorial space and construct a narrative from the cues provided.

The key difference, and this is what constitutes AKhRR's 'new unity', is that instead of having the psychologically believable *individuals* of a bourgeois social situation, with their particular actions and attributes, we now have more collective subjects – the 'mass', the 'people', 'workers', and so on. Thus the development of skills to produce a convincing illusion is not seen as historically contingent and specific (as it was by the avant-garde) but as an achieved given in the history of art. That is to say, for the avant-garde, illusion was a thing of the past, a coin in which a modern art simply could not trade if it were to have any claim to realism. For AKhRR, by contrast, the mastery of such traditional skills and competencies was not transient, or outmoded: it was what being an artist *meant*. Failure to deploy these skills amounts to either incompetence or bad faith. So far this is a traditional Academic 'realist' response. But for AKhRR, on the basis of the deployment of these skills, a *new* range of psychological (or, strictly, non-psychological – more 'socio'-logical) attributes is to be evoked, deemed more appropriate to the collective subject in a revolutionary or post-revolutionary situation. This, it seems, is what distinguishes 'heroic' realism from bourgeois, not to say Academic, realism, and it is this aspect that was to be developed into Socialist Realism in the 1930s.

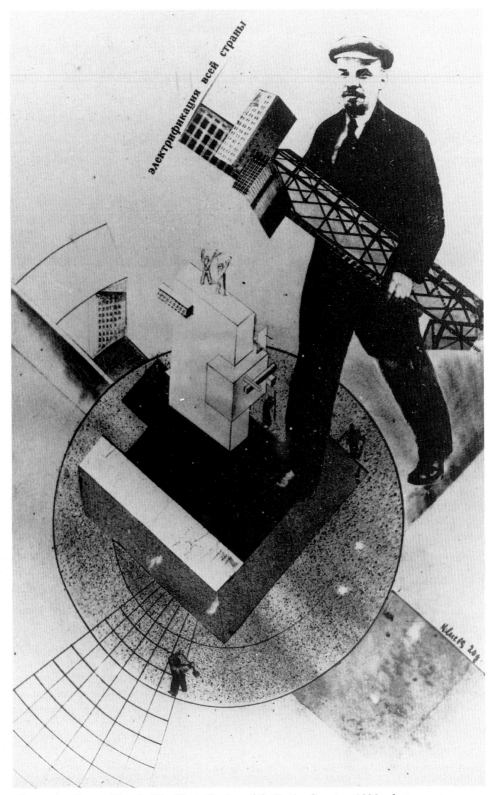

Plate 253 Gustav Klutsis, *The Electrification of the Entire Country*, 1920, photomontage, 46 x 31 cm. Costakis Collection.

A comparison

To illustrate these points, it will be useful to compare two portrayals of Lenin – one from the avant-garde, one from AKhR. Gustav Klutsis's montage, *The Electrification of the Entire Country* (Plate 253), was constructed in 1920. It shows a photograph of Lenin dressed in ordinary clothes and wearing a flat cap striding purposefully forward and – presumably the direction is deliberate – towards the left. His figure is, however, detached from its background and placed against a new one, relative to which his figure becomes monumental. The background is produced by using modern technical drawing equipment, and shows a modern building and a predominantly diagonal array of straight lines and a circle that hovers somewhere between a Suprematist painting and a technical representation of a sphere. This part of the composition is developed from Klutsis's Suprematist montage of the previous year, *The Dynamic City* (Plate 254), which in turn derived from a completely abstract Suprematist painting of the same title (Plate 255). In the Lenin montage, it is open to conjecture whether the diagonal array is an abstract design, a quasi-architectural road plan of some sort, or a metaphor for the globe itself. Whatever, its diagonal composition ensures a certain dynamism. Small figures are positioned in this 'modern landscape', and the large Lenin figure appears to be holding more of it – buildings and a pylon of some kind. Across the top of these items is a slogan.

This verbal description imposes too much continuity on the image: the point of the montage is to produce an impact precisely out of the fact that it is not seamless, and that it disrupts a continuous spatial illusion, thereby interrupting the semantic flow too. The slogan is from the campaign just announced by Lenin: 'To build socialism requires soviets

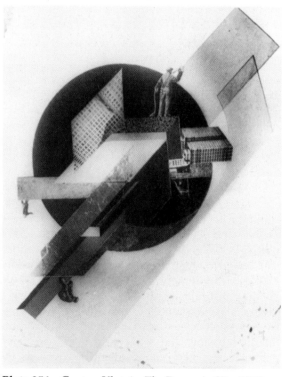

Plate 254 Gustav Klutsis, *The Dynamic City*, 1919, photomontage, 46 x 41 cm. State Art Museum, Riga.

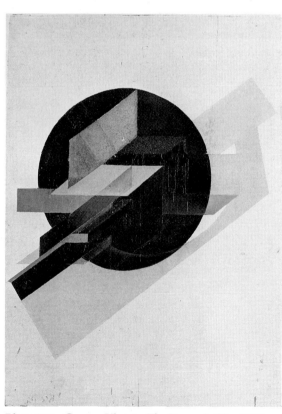

Plate 255 Gustav Klutsis, *The Dynamic City*, 1919, oil, sand and concrete, 87 x 65 cm. Costakis Collection.

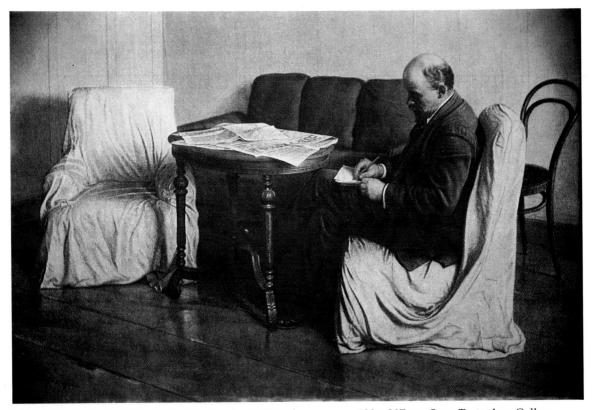

Plate 256 Isaak Brodsky, *Lenin at the Smolny*, 1930, oil on canvas, 190 x 287 cm. State Tretyakov Gallery, Moscow. Photograph: Society for Co-operation in Russian and Soviet Studies, London.

plus electrification' (i.e. workers' control of production and new technology). The montage attempts to embody this leap between two spheres in the dynamics of its own structure by using, so to speak, *its* new technology. The ambiguities in the image leave its precise meaning open: they leave the spectator with some work to do. Moreover, by its contemporaneity (of both form and content) it constitutes itself as an intervention into the campaign – to be, to use the language of the time, an 'organizer' of it.

The AKhR artist Isaak Brodsky painted *Lenin at the Smolny* (Plate 256) in 1930. It is pertinent to ask what *this* representation 'organizes', and how it does so. There are two immediate differences from the Klutsis: first, the event depicted is not contemporary with its depiction; second, the illusion is sustained and seamless over its whole surface. The entire picture, which is large (around life-size), is intended to present a powerful unified image. In this it succeeds dramatically. The image of Lenin is a specific one – both historically and in terms of the meanings it evokes. A contemporary Russian observer would have known without thinking that the Smolny Institute was the disused seminary taken over by Bolsheviks to co-ordinate the October Revolution in 1917. As such the place was a hive of activity, with meetings constantly in session, armed workers and soldiers milling about, delegations arguing, reporting and discussing, and leaders such as Lenin and Trotsky working around the clock, catching a rest here and there on a couch as the opportunity presented itself. Brodsky depicts the bare rooms, the rudimentary furniture, the dust covers, but he does not depict the babel. Instead, what is produced through the muted colours and the large, evenly distributed masses is a static image of quiet and calm. Lenin, again in ordinary, even shabby, clothes that look as if they might have been slept in (which we may suppose they had), is jotting down some notes out of a newspaper in a few moments before going on to address yet another meeting. The viewer passes so to speak

straight through the surface of the painting to construct a narrative around its depicted elements, and the preferred reading is quite clear. No incongruity or ambivalence, spatial or semantic, is permitted. The message is simple, unitary and – to a contemporary viewer – clear, confirming and pleasurable. The effect is of an unpretentious bit of work getting done. Yet it is no ordinary work. In the context supplied by the viewer, Lenin is the working man, making the workers' revolution, quintessentially the calm at the centre of the storm. These Ten Days may have shaken the world, but the implication is that they didn't shake Lenin: the revolution is in safe hands.

This is fine as far as it goes. Any socialist is likely to find this image powerful. The point is, what is it organizing in 1930? The year 1930 is the middle of the first Five-Year Plan; Lenin has been dead for six years; Leon Trotsky is in exile; the Stalinist bureaucracy is in control; and the propaganda machine is at full bore, advertising the headlong drive to collectivization of agriculture and heavy industrialization, on the altar of which any vestige of workplace democracy has been sacrificed. In short, a second revolution is in progress – the revolution to establish Socialism in One Country, the revolution that for some historians is effectively counter-revolution, the burial of 1917 and the beginning of the bureaucratic monolith that persisted at least until the *perestroika* of the late 1980s. Lenin by this time had been mummified and put on display, and was in the process of being converted into the infallible, god-like figure whose prestige would bestow validity on his successor Stalin – as a variety of images over the following years testify. In essence, then, the 'organizational' work of Brodsky's painting is to enlist the prestige of Lenin and the October Revolution of 1917 behind Stalin and the emerging state power.

It is the construction of this kind of powerfully convergent reading to which the AKhRR's heroic realism aspires, and which was shortly to be developed into the fully-fledged doctrine of Socialist Realism. It should, however, be added that photomontage itself became increasingly devoted to such unified messages in the thirties – not least in the hands of Klutsis. There is nothing about photomontage that in principle prevents it from serving a propaganda end or makes it always a device of critical realism, just as there is nothing in painting *per se* that disqualifies it from a critical role or lays it uniquely open to totalitarian exploitation.

Weimar Germany

Expressionism, realism and 'tendentious' art

Commentators have often seen the realism debate in Germany as polarized between Neue Sachlichkeit, which came onto the agenda in the early 1920s, and the Expressionist avant-garde, which was in existence earlier. Yet in making such a distinction they tend to rely on the 'illusionistic' definition of realism that we have already found inadequate – the notion that realism is a matter of producing convincing depictions of people and objects as they exist in the world.

Neue Sachlichkeit was a term used to characterize a varied tendency, or cluster of tendencies, in German figurative art, and even its meaning was imprecise. Other terms that were used in the literature of the time included 'neo-naturalism', 'new naturalism', 'new realism', 'new objectivity', as well as 'magic realism' and 'verism'. Attempts to catch the flavour of the name in translation have included 'new sobriety' and 'new matter-of-factness'. Expressionism, by contrast, is often viewed as paradigmatically *a*social, the voice above all of the individual. The notion of a resurgent mimetic art seems to have been broached as early as 1920 in response to an important exhibition of Italian Pittura Metafisica paintings in Berlin (Plate 182, for example). Later a special issue of the journal *Kunstblatt* by Paul Westheim in September 1922 was devoted to the 'new realism'. And

then the term *die neue Sachlichkeit* was first used by G.F. Hartlaub in a circular of May 1923; he hoped to mount an exhibition in the autumn by 'those artists who have remained – or who have once more become – avowedly faithful to positive tangible reality' (G.F. Hartlaub, quoted in *Neue Sachlichkeit and German Realism of the Twenties*, p.9). Hartlaub's show finally happened in the Mannheim Kunsthalle between June and September 1925 under the title Neue Sachlichkeit: German Painting since Expressionism. It was a large exhibition, showing 124 pictures by 32 artists. It was, moreover, accompanied by a book by Franz Roh that attempted to theorize the new work under the title *Post-Expressionism: Magical Realism, Problems of Recent European Painting*.

Once we move beyond a simple illusionistic-mimetic definition of realism, however, the distinction between 'realism' and 'expressionism' is not so easy to sustain, as the career of George Grosz demonstrates. Grosz is usually seen as the central figure in Weimar debates about artistic realism. Previously, however, he had been associated with Expressionism. For Expressionism had had a social aspect even before the war. Ludwig Meidner's *Revolution* (Plate 257) was only one instance of a discourse that grew up within Expressionism on the modern city and its social tensions. In Meidner's case this discourse was inflected towards a revolutionary Utopianism, which was to emerge again strongly after the war in the Novembergruppe of artists, in the wake of the German November Revolution of 1918. Perhaps more characteristic, however, of Expressionist meditations on urbanism was the quality of alienated melancholy to be read in Kirchner's 'City' series. With its elongated and angular forms, and its subject-matter of urban prostitution, his *Five Women on the Street* (Plate 258) seems to evoke what Simmel called 'bodily proximity and

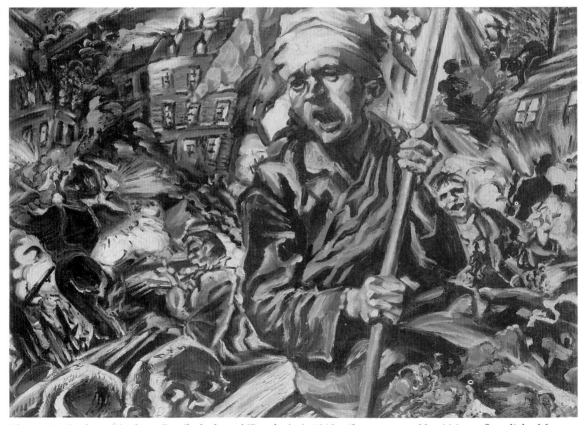

Plate 257 Ludwig Meidner, *Barrikadenkampf* (*Revolution*), 1913, oil on canvas, 80 x 116 cm. Staatliche Museen Preussischer Kulturbesitz, Nationalgalerie, Berlin. Photograph: Jörg P. Anders.

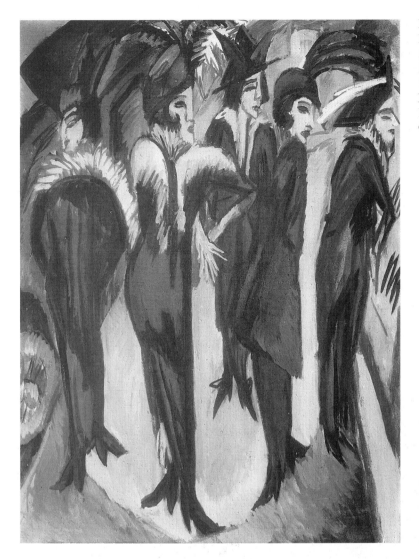

Plate 258 Ernst Ludwig Kirchner, *Fünf Frauen auf der Strasse* (*Five Women on the Street*), 1913, oil on canvas, 120 x 90 cm. Wallraf-Richartz-Museum, Cologne. Photograph: Rheinisches Bildarchiv, Cologne.

mental distance'. A third modification of the Expressionist discourse on the city, using Futurist technical devices such as overlapping planes and dynamic 'lines of force', is found in Grosz's *The City* of *c.*1917 (Plate 259). The effect is rather different from that of Kirchner's work. It is in fact quite hard to pin down, but there is more a sense of cynicism than of alienation. Distance is conveyed, but it is less the lugubrious, melancholic distance of the Kirchner than a relationship at once hedonistic and hostile. The contradictory grammars (massively receding perspective *and* overlapping planes; stylization *and* still legible figuration) produce a visual chaos clearly intended as an equivalent for the social and moral chaos of the modern city itself.

Such technically complex oil paintings by Grosz were constructed out of avant-garde references to Futurism and Expressionism as well as to more popular traditions of satire and caricature, rather than out of any visual 'faithfulness' to 'tangible reality'. Yet one of them, *Funeral Procession: Dedication to Oscar Panizza* (Plate 260), was included in Grosz's contribution to the 1925 Neue Sachlichkeit exhibition. Panizza had been a pioneering psychiatrist and author, driven to nervous breakdown after being persecuted by the state for blasphemy and treason. He did not in fact die until 1921, but for Grosz his fate seems to have been symptomatic of both the nihilism of urban society itself and the fate of the artist within it. The picture – painted throughout in lurid reds and featuring a large

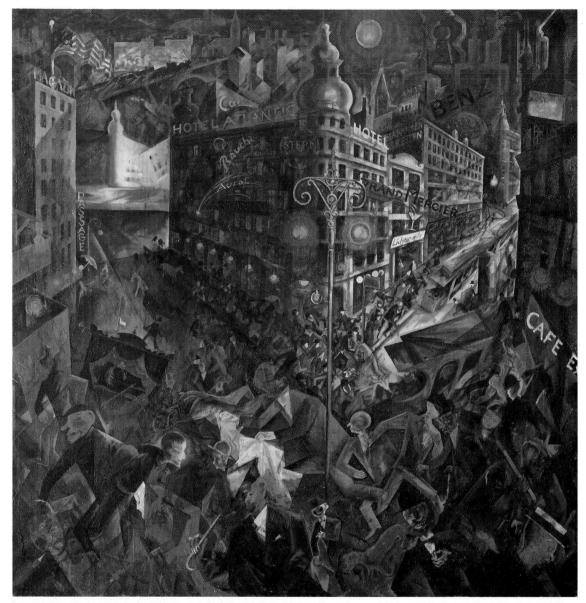

Plate 259 George Grosz, *Die Grosstadt* (*The City*), *c*.1917, oil on canvas, 100 x 102 cm. Thyssen-Bornemisza Collection, Lugano, Switzerland. © DACS, London, 1993.

skeleton emerging from its coffin into a chaos of architecture and half-animal half-human creatures – can be seen as a reworking of the medieval theme of the Triumph of Death. Grosz was interested in Bosch and Brueghel. This is an indication of his complexity: on the one hand, such an interest was shared by Brecht and is part of a wider realist interest in the popular; yet on the other, Grosz's work draws heavily on a Futurism that in its more typical manifestations forswore the past. For Marinetti, in Italy, Futurism was a rebellion *against* the art and culture of the past. Grosz synthesizes two ostensibly divergent interests here. The diarist Harry Kessler did not think it odd to describe Grosz as wanting to 'achieve by pictorial means something quite new … something that painting achieved in earlier periods'. Nor did he think it odd to single out Hogarth as a model for him while simultaneously asserting that 'Grosz is a Bolshevist in painting' (Kessler, quoted in M.K. Flavell, *George Grosz*, p.38).

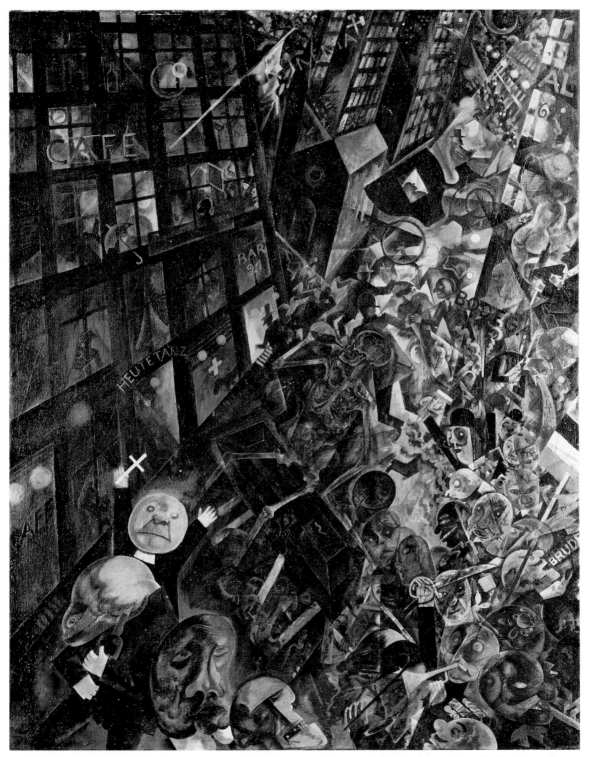

Plate 260 George Grosz, *Leichenbegängnis: Widmung an Oskar Panizza* (*Funeral Procession: Dedication to Oscar Panizza*), 1917–18, oil on canvas, 140 x 110 cm. Staatsgalerie, Stuttgart. © DACS, London, 1993.

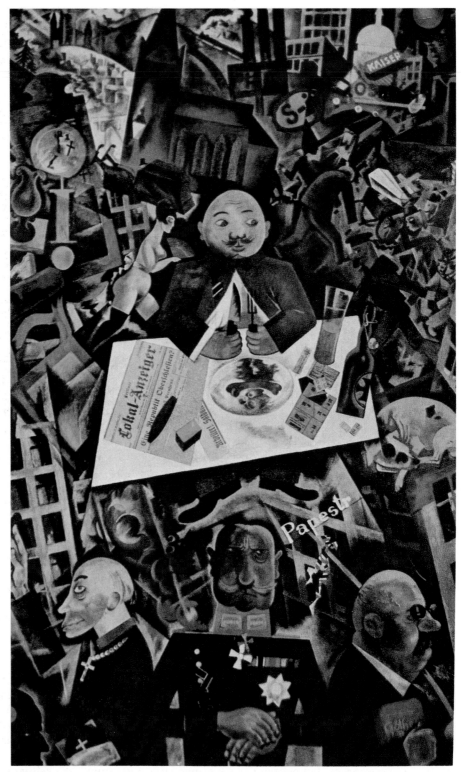

Plate 261 George Grosz, *Deutschland, ein Wintermärchen* (*Germany, A Winter's Tale*), 1917–19, oil on canvas, dimensions and present whereabouts unknown. Photograph by courtesy of Akademie der Künste, Berlin. © DACS, London, 1993.

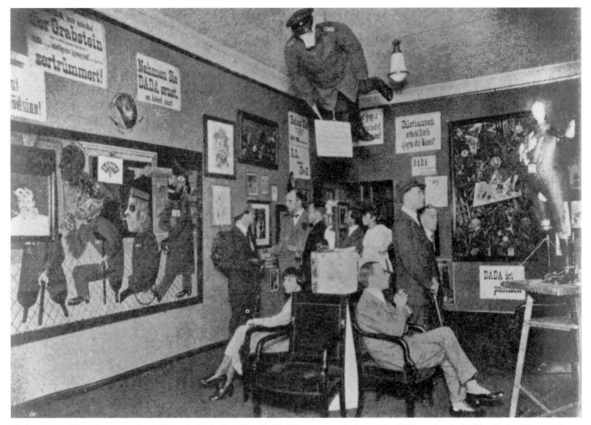

Plate 262 First International Dada Fair Berlin, 1920. Photograph from R. Hülsenbeck (ed.), *Dada Almanach*, 1920, Erich Reiss Verlag, reprinted by Something Else Press, Vermont, 1966. On the left wall: Otto Dix, *War Cripples*. On the rear wall, above the poster 'DADA is political': George Grosz, *Germany, A Winter's Tale*. On the ceiling: Rudolf Schlichter, *Prussian Archangel*, dummy, in German army uniform, with pig's head. Seated, left to right: Hannah Hoch; Otto Schmalhausen. Standing, left to right: Raoul Hausmann; Otto Burchard (gallery owner); Johannes Baader; Wieland and Margarete Herzfelde; George Grosz; John Heartfield.

Another of Grosz's pictures, *Germany, A Winter's Tale* (Plate 261), was exhibited at the Dada Fair in Berlin in June 1920 (Plate 262) alongside Otto Dix's *War Cripples*, several pictures by Rudolf Schlichter, and photomontages by John Heartfield and Raoul Hausmann, including the latter's *Tatlin At Home*. Berlin Dada was politically more militant than the original manifestation in Zurich. Its manifestos made the claim that 'Dada is German Bolshevism' (R. Hülsenbeck, 'En avant Dada', p.44). It wasn't, of course, but several of those who were involved – notably Grosz, Heartfield and his brother Wieland Herzfelde, the director of the left-wing publishing house Malik Verlag – joined the new German Communist Party (KPD) on its foundation in January 1919. *Germany, A Winter's Tale* is still more overtly allegorical of the nation's contemporary condition. The tilting planes, the sharp diagonals, the abrupt changes of scale and the hurrying figures are all still there. More explicitly, though, they include the city and the countryside, a church and a factory. And they are organized around, in fact function very much as a backdrop to, four main figures – a German burger (archetypal 'little man' eating his meal, reading his conservative newspaper and daydreaming of sex, positioned not illusionistically but flat on the picture surface) above three figures symbolizing the Church, the Military and the Education System – that is to say, the state apparatuses. In Grosz's works a small profile of the artist is sometimes incorporated, as a witness – in the *Winter's Tale* in the bottom left-hand corner, in *The City* at the base of the central lamppost.

These pictures are far from realism in any merely naturalistic sense. Quite the reverse, in fact: their meanings are allegorical, to be decoded by the viewer who can read them, and their technical organization is derived from the pre-war avant-garde. They are, however, obviously critical in intent, and embody an aspiration to the status of modern history painting characteristic of the critical avant-garde back into the nineteenth century.

Grosz was to make no more easel paintings until the mid-1920s, concentrating instead on reproducible prints, often for the publishing company Malik Verlag (Plates 263 and 264). These images underpin Grosz's reputation as a critical, realist artist. Yet the elements out of which they are constructed share much with his paintings – multiple imagery, which drew on avant-garde technical conventions, coexisting with stylized and carica-tured social types. He probably turned to making reproducible prints partly because of their more democratic credentials. And he was also influenced by the anti-individualist ethos of the Soviet avant-garde, which was making itself felt in Germany: the Dada fair had on display the slogan 'Art is dead. Long live the new machine art of Tatlin.'

A more specific event that might have prompted Grosz to give up painting occurred a few months before the Dada fair. It also marked the parting of the ways of Utopian Expressionism and a committed left-wing art, which was signalled at the Dada Fair by a poster saying 'Dada is against the Expressionist art swindle'. During and immediately after the German Revolution of November 1918, many artists of the predominantly Expressionist avant-garde had formed the Novembergruppe, an organization that declared its sympathy with the Revolution's aims. As the revolutionary wave ebbed, how-ever, so did the enthusiasm of many artists, resulting in a polarization between Left and Right within the Novembergruppe and in the avant-garde generally. March 1920 saw the Kapp Putsch – a rightist attempt by business interests, backed by the army and the

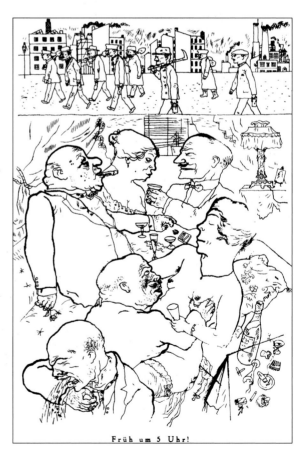

Plate 263 George Grosz, *Früh um 5 Uhr!* (*At 5 o'clock in the Morning!*), 1921, ink on paper, 50 x 38 cm. In 'The Face of the Ruling Class' portfolio, Akademie der Künste Archiv, Berlin. Photograph: Kranichphoto, Berlin. © DACS, London, 1993.

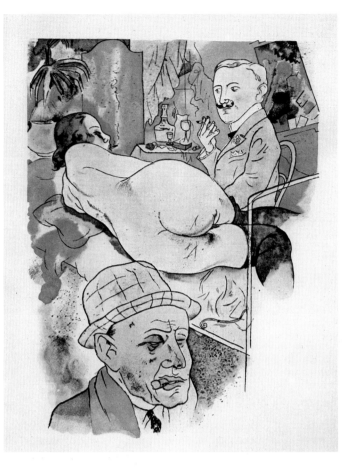

Plate 264 George Grosz, *Ecce Homo*, 1921, watercolour, 37 x 26 cm. In 'Ecce Homo' portfolio, Akademie der Künste Archiv, Berlin. Photograph: Kranichphoto, Berlin. © DACS, London, 1993.

Freikorps, to overthrow the government. The government actually fled to Stuttgart, but the coup was defeated after five days by a general strike, as well as armed working-class resistance in the Ruhr and elsewhere. One manifestation of this conflict occurred in Dresden. During a fight between workers and police, in which people were killed, a stray bullet entered the Zwinger Gallery, damaging an Old Master painting. The president of the Dresden Academy at this time was the Expressionist painter Oscar Kokoschka, who issued a statement addressed 'to all who propose in future to resort to firearms to argue for their political theories, whether of the Left or the Right or the radical centre', demanding they take their fight elsewhere, where 'sacred heirlooms' were not threatened, where 'human culture is not put at risk' (Kokoschka, quoted in E. Hoffmann, *Kokoschka*, p.143). Grosz and Heartfield replied with *Der Kunstlump* (sometimes translated as *The Artist as Scab*), arguing that such art works were not treasures elevated above the struggle but symptoms of the economic, political *and* cultural dominance of the middle classes over the workers. As Grosz amplified the point a few months later in his essay 'Instead of a biography':

> You pretend to be timeless and stand above party, you keepers of the ivory tower. You pretend to create for man – where is man? … Come out of your houses even if it is difficult for you, do away with your individual isolation, let yourselves be possessed by the ideas of the working masses and help them in their struggle against a rotten society.
>
> (G. Grosz, 'Instead of a biography')

Plate 265 Otto Dix, *Die Barrikade* (*The Barricade*), 1921, oil and collage on canvas (destroyed in 1954). Photograph by permission of the Otto Dix Stiftung, Vaduz.

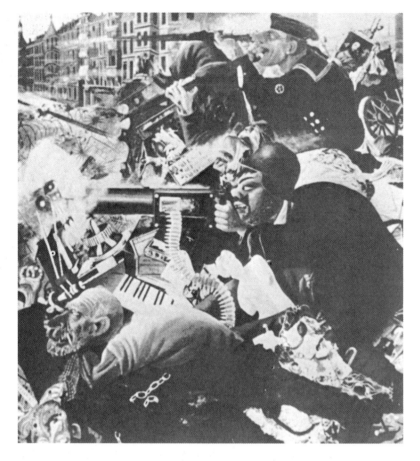

This event and its symbolic importance for art seem also to have been recognized by Otto Dix. In his *The Barricade* (Plate 265), three social types – a revolutionary sailor, a worker and an old man – are defending a barricade. The barricade, across which are sprawled the defenders, seems to be made up of bits of furniture, including a piano, as well as a small crucifix and a Classical figurine – the trappings of a bourgeois life. Further along it has been reinforced with a cart containing, as well as items of what seem to be women's underwear, a framed Titian painting, *The Tribute Money*, from the Zwinger Gallery. Again the 'realism' of the picture seems to operate at more than one level – partly as documentation of an actual event (though it is far from doing so naturalistically or 'photographically') and partly as a figure for the struggle against bourgeois society and its complicit cultural values (though Dix's somewhat caricatured depiction of his protagonists hardly suggests great sympathy for their struggle either). Dix had addressed the same theme in *Match-seller I* (Plate 266) of 1920. The specific incident is generalized to refer to social contradictions across post-war Germany, which Dix symbolized in pictures of crippled war veterans (Plates 41 and 262). Here the legless match-seller is, quite literally, pissed on by the bourgeoisie or, to be specific, by the middle-class woman's dachshund as she hurries by above (in every sense). Down in the gutter with the crippled veteran is a screwed-up piece of newspaper, collaged to the surface of the painting. It is Kokoschka's proclamation on sacred heirlooms and the sanctity of the cultural heritage. Dix nailed down the implications of Kokoschka's arguments with brutal directness, and put the claim of a transcendent art in its place through recourse to a very different sort of art.

The conception of art embodied in these pictures, which Grosz and Heartfield were developing in their writing, was known as *Tendenzkunst*, or 'tendentious art'. The demand

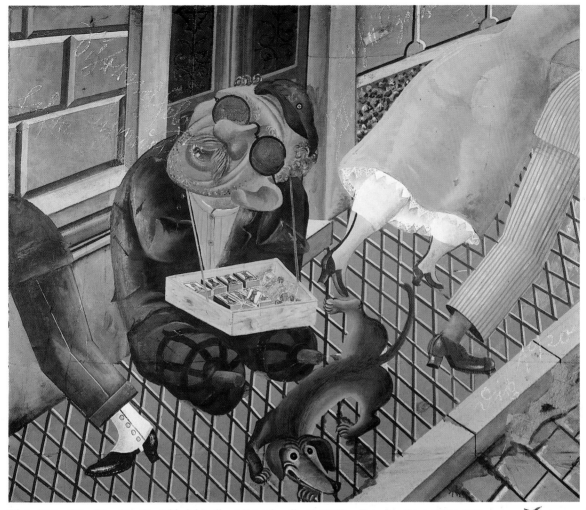

Plate 266 Otto Dix, *Der Streichholzhändler I* (*Match-seller I*), 1920, oil and collage, 142 x 166 cm. Württembergisches Staatsgalerie, Stuttgart. Reproduced by permission of the Otto Dix Stiftung, Vaduz.

was already beginning to be formulated, out of the decline of Expressionism and Dada, for an art practice that addressed the objective and collective demands of the social struggle, instead of the individualistic responses that had so far sufficed. The main point of Tendenzkunst was the claim that art was not neutral, disinterested or in any sense above society's material conflicts. The argument is not that art can be overtly committed to radicalism on the one hand, or to conservatism on the other, with a space remaining for non-engaged work (a still-life, perhaps?). It is rather that *all* work – whatever its explicit allegiance, subject-matter or style – is part of a wider 'tendency'. For example, art that is not overtly allied to change necessarily supports the status quo. It is an ultra-left theory, highly reductive in its implications, i.e. it reduces art to a branch of politics by refusing it any vestige of independence. It was not sustained for long, even by Grosz. None the less the conception of art as a weapon was a powerful one at various points during the period, notably in consort with a notion of proletarian culture. And of course, to say that the conception of Tendenzkunst is reductionist is not to endorse the view that the products of high art are socially neutral. It is, rather, that the relation between art and class interests is not simple and direct, not a matter of simple 'expression' or 'reflection', but an issue of considerable mediation, not to say obscurity.

The relationship between a notion of 'commitment' in art (enshrined in the concept of Tendenzkunst) and a notion of its 'objectivity' (as embodied in Neue Sachlichkeit) is clearly strained. Yet for left-wing artists in Germany the two ideas were *not* contradictory. Telling the truth was, so to speak, the Left's commitment. This commitment could be extended to include the idea of revealing the *underlying* truth rather than the superficiality of appearance. So in their pursuit of a realist representation of what it was that *made* 'reality' real, artists could legitimately go beyond an academic naturalism.

Neue Sachlichkeit

In the years immediately after the First World War, Grosz and Dix concentrated on themes of social marginalization and exploitation in the big cities. They depicted war veterans, workers, the bourgeoisie and prostitution, often using prostitution to stand for the corruption of society as a whole. Both used a mix of avant-garde techniques such as collage, Expressionist distortion, Futurist spatial dynamism, etc. But what made these cohere was a sense of purpose going beyond the techniques of the representation itself to the social effect that representation could have. In Dix's case it was a generalized scepticism whose sense of truth owed much to Nietzsche, in Grosz's case an explicit commitment to Communism.[2]

In this period from the establishment of the Weimar Republic up to the Neue Sachlichkeit exhibition in 1925, German society underwent a number of extreme changes that not surprisingly found their way into the work of artists committed to deploying their art towards a critique of that society.

On the Left, the main line runs through the Left opposition within the predominantly Expressionist-Utopian Novembergruppe, into the formation of the Red Group in 1924. This overall tendency is often referred to, in treatments of Neue Sachlichkeit, as Verism. The umbrella term, however, covers a range of political commitments and techniques. This generates difficulties and ambiguities for interpretation, the most contentious aspect of which is, precisely, the intersection and lack of congruence of formal and political values. In other words, technical radicalism does not necessarily indicate an artist's political radicalism; nor, indeed, is political conservatism guaranteed to accompany a technically conservative artistic practice. The situation created contradictory currents for artists of the Left. Grosz continued to produce albums of prints for Malik Verlag, including such aggressively oppositional collections as 'The Face of the Ruling Class' and 'Ecce Homo' (Plates 263 and 264). At the same time he signed a contract with the prestigious Berlin gallery of Alfred Flechtheim where he had a large exhibition of watercolours in 1923 and, on the strength of that, one in Paris in the autumn of 1924. Likewise in 1925 he published *Art is in Danger* with Herzfelde, expressing extreme scepticism that any kind of conventional art practice was viable, yet at the same time he returned to oil painting for the first time in five years, in particular producing portraits (Plate 267).

The tensions were less marked with Dix, yet the fact remains that at the same time as he was critically aligned with Verism (the socially 'cynical', tendentious wing of Neue Sachlichkeit) he was also moving away, not only from his technically radical representa-tions of the early 1920s but also from the very themes of war and social marginalization they had been intended to match. He developed a meticulous, even obsessive painting technique in which, after a traditional underdrawing, he applied successive layers of glazes and then erased all marks of manufacture. In doing this he was directly refusing the discredited subjectivity of Expressionism, manifest most characteristically in the 'gestural' brushstroke. By 1925 he, too, was undertaking more portraiture, and increasingly using his 'objective' technique on subjects that betrayed less of an overtly socially critical intent

[2] Dix's debt to Nietzsche is explored in I. Boyd White's 'Dix's Germany' and S. O'Brian Twohig's 'Dix and Nietzsche'.

Plate 267 George Grosz, *Selbstbildnis als Warner* (*Self-portrait as a Warner*), 1927, oil on canvas, 90 x 70 cm. Galerie Nierendorf, Berlin. © DACS, London, 1993.

(although, that said, these portrait figures do frequently connote a range of social attitudes – for example, an apparently jaundiced view of cosmopolitan emancipation in a portrait of the journalist Sylvia von Harden, Plate 268).

Despite this paradox whereby the more 'realistic' the art of its major practitioners became, the more it appeared to blunt its socially critical edge, Neue Sachlichkeit painting did remain bound up with a social discourse in Weimar culture and did maintain critical distance from the dominant values of that culture. 'Distance' is in fact the crucial term; for it was not so much that Neue Sachlichkeit unequivocally advocated an alternative social strategy, as that it represented an attitude of alienation from the actual lived reality. It was here that its critical charge lay. And it was here, in this sense of distance and in the despair that frequently followed, that Neue Sachlichkeit came to be criticized. It was too urban and dislocated for a National Socialist mythology of German *Heimat* (the sense of organic community required by Nazi blood-and-soil theory). Yet it was simultaneously too deficient in optimism for a Stalinist myth of the heroic working class.

Yet some circumspection is necessary. It was not a matter, for example for artists such as Grosz, Heartfield or Schlichter, of leaving the Communist Party. In 1928 Grosz was still writing: 'to awaken [the worker] for class struggle – this is the aim of art and I serve this

Plate 268 Otto Dix, *Porträt von Journalistin Sylvia von Harden* (*Portrait of the Journalist Sylvia von Harden*), 1926, oil on panel, 121 x 89 cm. Musée National d'Art Moderne, Centre Georges Pompidou, Paris. Reproduced by permission of the Otto Dix Stiftung, Vaduz.

aim' (quoted in B.I. Lewis, *George Grosz*, p.196). Certainly the revolutionary wave of the early post-war period had ebbed, but this does not mean that artists of the Left made a pact with the actuality of Weimar. Nor does it mean that they thought it was permanent despite themselves (which, in point of fact, it wasn't).

Difference and similarity

The distinction between Neue Sachlichkeit works and those of the Expressionist avant-garde is not qualitative: it's not that Neue Sachlichkeit pictures are 'worse' than those of the Expressionist avant-garde, however much Modernist art history neglected the former and gave prominence to the latter. Certainly it is not a matter of simple 'regression' from Expressionism to Neue Sachlichkeit. The relative technical radicalism of the one and the relative technical orthodoxy of the other do not equate easily with other sorts of radicalism and conservatism. In one sense, Neue Sachlichkeit's technical means are a critique of what were perceived as the ideologically implicated failures of Expressionist techniques. In another sense the distinctions that need to be made are three-cornered, involving not just Neue Sachlichkeit and Expressionism, but also the montage techniques that emerged with Dada. Rather than a wholesale shift – such as would be implied by notions of a 'return to significant subjects' – it is more likely that what took place was a lengthy process of re-address to, reappraisal of, and consequent re-working of some consistent themes within the tradition of representations of modernity.

Regarding Kirchner's city scenes, it has recently been shown by historians such as Rosalyn Deutsche ('Alienation in Berlin') that even if the *ideology* of Expressionism was essentialist – believing itself to be offering eternal statements about the human condition – what generated it was none the less the historically specific experience of alienation and sexuality in the capitalist city of Berlin. Expressionist technical devices of lurid colour, angularity and spatial distortion are present in both *Five Women on the Street* (Plate 258) and *The Street* (Plate 269) of 1913. So are the female figures – prostitutes apparently – in their nearly identical fashionable clothes; so, too, is the shop window. The connection between the prostitutes and the shop window, the commodification of sexuality in the capitalist city, is clear enough.

A decade later Schlichter painted *Passers-by and Reichswehr* (Plate 270). The similarities between the works are enough to make any differences signify – a pavement receding from the viewer, buildings in the background, a cluster of female figures, a male figure, a motor vehicle, and a shop window. One difference, as well as the fact that the Schlichter is a watercolour, concerns class. The 'game of looks' still seems to be sex, and moreover sex as something to be bought and sold. But the buyers and sellers seem different: there aren't any top-hats, canes or spats here; nor elegant furs and feathers – something that the one scraggy stole on view serves if anything to emphasize. The soldiers in their truck, and the stubbly man with his pipe, seem to be the parties competing for the attention of the three women, whose fashions, though undoubtedly fashions, are something less than *haute couture*. The result seems to be a Weimar reinterpretation of the Wilhelminian theme wherein the alienation, the commodification, the sexuality receive their economic – and military – anchorage. And the relative plainness, the 'factualness', of Schlichter's technique is inseparable from that re-presentation.

The Dadaist Hausmann had already argued that it was in its emotionalism and subjectivity that Expressionism's inadequacies lay: it 'failed because of its non-objectivity'. Artists such as Dix, Schlichter and Grosz were to take that quest for 'objectivity' further. This is a complex impulse, and one quite central to apparently diverse types of modern art. One result, as in the art of a Mondrian or a Malevich, was to focus on the 'objectivity' of the surface itself, leading ultimately to an 'abstract' art. But the other, found here in Verism, was to reconnect 'objectivity' with the normative and the social.

Plate 269 Ernst Ludwig
Kirchner, *Die Strasse* (*The Street*),
1913, oil on canvas, 121 x 91 cm.
Collection, the Museum of
Modern Art, New York.

Plate 270 Rudolf Schlichter,
Les Passants et Reichswehr
(*Passers-by and Reichswehr*),
1925–26, watercolour,
58 x 40 cm. Private collection.
Photograph by courtesy of the
Musée National d'Art Moderne,
Centre Georges Pompidou,
Paris. Reproduced by
permission of Galleria del
Levante/Schlichter Estate.

Reading 'objectivity'

As we saw when we considered the realisms that emerged in the Soviet Union, even the kind that most explicitly sought continuity with the past was neither transparently naturalistic nor simply academic. By dealing with new 'social types' and events, it raised technical questions about how these were to be represented. Likewise, when we look more closely at Neue Sachlichkeit painting, particularly the work of its left wing, we see that their representations of 'positive tangible reality' lead the viewer towards a preferred reading. It was not one of contentment with the urban world of stabilized German capitalism and its burgeoning range of consumer goods and commodified entertainments. This does not, however, mean that left-wing artists were floundering in despair. To say that would be to make the perennial mistake of seeing works of art as direct reflections of either objective reality or subjective states, rather than as constituted representations.

Ascribing meanings to pictures is of course problematic. None the less there does seem to be some substance to the claim that, firstly, there is a characteristic range of qualities in Neue Sachlichkeit pictures, *and* that these qualities produce the sense of a specific relationship to the depicted objects – a relationship, moreover, that is what the work 'represents' in a wider sense. The alienation, that is to say, is not a fortuitous feature of the pictures but something that is put into them in order that it may be read out.

It is possible to specify a range of typical features, of which at least some seem to be technical (i.e. observable and testable). There is: a fidelity to the outlines of objects; an acuteness of focus across the surface regardless of position in the illusioned depth; the isolation of objects from their context; a static compositional structure; the eradication of traces of facture; a tendency to make pictures out of the accumulation of details rather than a cohered, composed, 'organic' totality (Plate 271, for example).

Some of these features – such as the concealment of process or facture, and the fact that a coherent spatial illusion is produced – are arguably conservative relative to Modernism. (Having said that, though, there was obviously something troubling about this illusionism that chimed with the offence given to conservatives *by* Modernism.) Other features sit ambiguously. Making a picture out of an accumulation of items is a *bit* like making a collage. Paying as much attention to everything in a picture – someone's shoe as much as their face, the space between objects as much as the objects themselves – is frequently deemed to be characteristic of 'modern' art.

Something along these lines seems to have been noted by the earliest commentator on the new objectivity, Franz Roh, in 1925. In an elusive passage he tries to pin down the peculiar qualities of Verist painting (the term he used to denote the 'left wing' of Neue Sachlichkeit). He appears not to like these qualities very much: he speaks of the 'cruel world of Verism', the 'bitter sarcasm', and regards as 'inconsistent' the hope that the artists placed in the proletariat. Thus he notes Verism's 'unfragmented portrayal of nature' – which is a way of referring to its non-modern, non-Cubist pictorial space – yet recognizes that it does this 'without forfeiting exciting effects', i.e. it is not straight-forwardly Academic. His argument is that what is located in the world (i.e. in reality) is 'already … saturated with expression', and that somehow this expression can be got out of the world and into the 'world' of the picture without that quality being lost. The quality seems to be preserved, he is saying, by a kind of severance. He himself speaks of 'reality-excerpts', the claim being that the 'excerpt' keeps its pictorial effectiveness if it is 'peeled off from' the world 'and set within a frame in its entirety'. It is as though the depicted things are samples or specimens brought back whole from the surface of the world and deposited on the surface of the picture. The point is that these types of *effect* are produced by a specific, and deliberate, range of techniques.

These techniques are also applied to a relatively specific range of subjects, for the most part ordinary, overlooked things, from household utensils to the unnoticed or concealed blemish on a human body. This conjunction of a range of techniques with a

Plate 271 Dick Ket, *Stilleven met rode lap* (*Still-life with Red Cloth*), 1931, oil on canvas, 90 x 60 cm. Collection Gemeentemuseum, Arnhem.

range of subjects then starts to license a more metaphorical, or at least extended, range of attributes – 'emotionless', 'unsentimental', 'distanced', 'alienated' – and thereby to legitimate talk of a new, specifically modern mental relationship to the physical world. Once again, even an apparently mimetic realism turns out to be no mere trace or reflection of the object world, but a densely coded representation of it.

This paradoxical effect, that the hyper-naturalism of Verist painting generates an air of *unreality*, leads us to consider another area of Neue Sachlichkeit activity. For one of the prime sites of the new objectivity lay not in painting but in photography. Documentary photography always had a powerful claim to Truth: it aspired, literally, to be a print of reality, virtually unmediated. But both Brecht, and his friend the critic Walter Benjamin, disputed this type of claim to 'realism'. Brecht noted how an apparently objective photograph of the Krupp works would reveal little or nothing of its social relations. Benjamin observed in his essay 'The author as producer' how documentary photography ran the risk of turning even a rubbish heap or a decrepit tenement (let alone a factory) into an object of aesthetic contemplation. For both authors the solution lay in a shift – away from documentary's deceptive claim that it provided a single unmediated truth, and towards montage, towards the layering of one meaning over another, thus leading to the *construction* of a new meaning. They were saying, therefore, that to achieve a modern realism, it was essential to repudiate a more conventional realism. The kind of photography that perhaps does most to escape their strictures is that of the Russian Constructivist Aleksandr Rodchenko. By adopting startling viewpoints he forces the viewer to reconsider the normal significance of the world he depicts (Plate 272); these are the very qualities that led to his work being condemned as *un*realistic, as formalist, by the defenders of a more conventional Socialist Realism in the Soviet Union.

Plate 272 Aleksandr Rodchenko, *Cogs*, 1930, photograph by courtesy of the Museum of Modern Art, Oxford. Reproduced by permission of the A. Lavrentiev/Rodchenko Family Archive, Moscow.

Interchanges: the international dimension

In the 1920s, after the Russian Revolution, there was a considerable interchange of ideas in art between Germany and the Soviet Union. The earliest example was the First Russian Art Exhibition in Berlin in October 1922 which, as well as being the first showing in the West of the Soviet avant-garde, included figurative works from the pre-AKhRR period. After this the First German Art Exhibition was seen in Moscow and Leningrad from October 1924 through to early 1925. It was organized by the IAH (the International Workers' Aid, one of the cultural bridging organizations set up by the Third International), and it seems that a particularly strong impression was made by the Red Group. For Anatol Lunacharsky, the Soviet commissar for education and the arts, its members 'surpassed nearly all our artists in the degree of their mental assimilation of the Revolution and their creation of revolutionary art' (Lunacharsky, quoted in J. Willett, *The New Sobriety*, p.114). From the other side again, a large international art exhibition held in Dresden in 1925 contained a prominent representation of the newly formed Russian realist group, the OST (Society of Easel Artists). The OST's principal significance is that, while not going along with Constructivism's abandonment of painting, it equally sought a *modern* realist form distinct from what it perceived as the anachronism of the AKhRR's *peredvizhnichestvo* – their glaring debt to the Wanderers.

Some sense of the traffic in ideas and techniques can be got from the pictures themselves. On 24 March 1923, the fifth anniversary of the founding of the Red Army, the avant-garde dramatist Vsevolod Meyerhold mounted a production of *The Earth in Turmoil*, with an agitational staging devised by Sergei Tretyakov. Meyerhold and Tretyakov were to be the primary influences on Brecht's development of a new form of 'epic' theatre in the late 1920s and 1930s, around which he developed the theory of a modern realism which we briefly encountered above. The stage-set was a kind of gantry devised by the

Plate 273 Lyubov Popova, part of the stage-set design for *The Earth in Turmoil*, 1923, photomontage, gouache, newspaper and photographic paper collage on plywood, 49 x 83 cm. Costakis Collection.

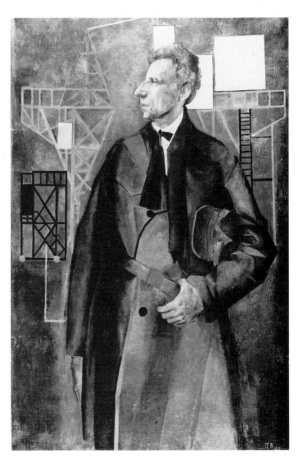

Plate 274 Piotr Vilyams, *Portrait of Meyerhold*, 1925, oil on canvas, 280 x 180 cm. State Tretyakov Gallery, Moscow. Photograph: Vneshtorgizdat, Moscow.

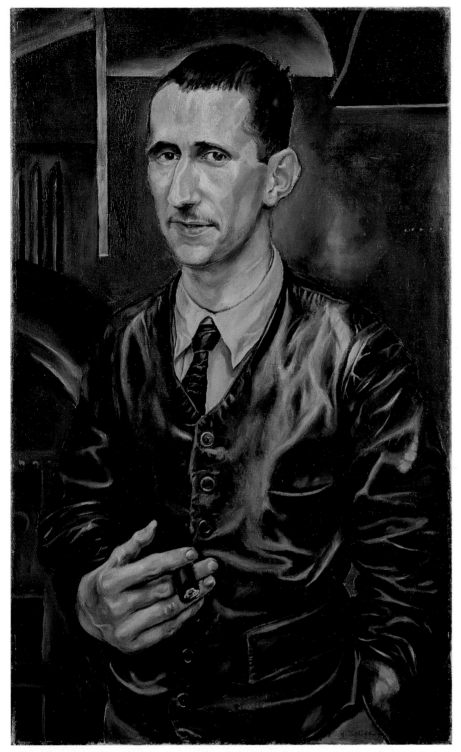

Plate 275 Rudolf Schlichter, *Porträt von Bertolt Brecht* (*Portrait of Bertolt Brecht*),
*c.*1926, oil on canvas, 76 x 46 cm. Städtische Galerie im Lenbachhaus, Munich.
Reproduced by permission of Galleria del Levante/Schlichter Estate.

Constructivist painter Lyubov Popova, featuring a crane, slogans, and screens for the projection of photographs (Plate 273). In *LEF* (the journal of the Left Front of the Arts) in 1924, Popova described the purpose of the set as agitational, and not aesthetic. In 1925 the OST painter Piotr Vilyams produced a portrait of Meyerhold – whose identity was signified by the presence, as a kind of attribute, of *The Earth in Turmoil* stage-set (Plate 274). A 'realist' painter makes a portrait of a radical theatre director whose identity is secured by an avant-garde Constructivist design.

In the mid-1920s Rudolf Schlichter – a member of the Red Group and, along with Grosz, on the left of Neue Sachlichkeit – painted a portrait of the young radical dramatist Bertolt Brecht (Plate 275). Brecht's class allegiance with the workers is suggested by his conspicuous leather jacket. Likewise his modernity is signified by the presence behind him of some kind of motor vehicle, although the distortions are such that it is quite likely that Brecht is standing in front of, not a 'real' car but a piece of painted theatrical scenery. It would make sense if it were from one of his own productions, given the apparent precedent of the Meyerhold portrait. It is quite plausible that Schlichter had seen

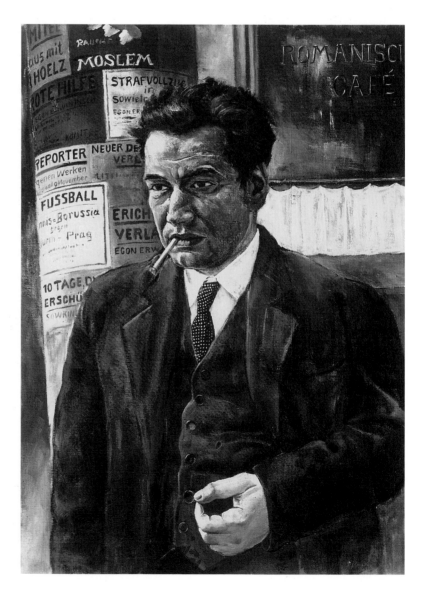

Plate 276 Rudolf Schlichter, *Porträt von Egon Erwin Kisch* (*Portrait of Egon Erwin Kisch*), 1928, oil on canvas, 88 x 62 cm. Städtische Kunsthalle, Mannheim. Reproduced by permission of Galleria del Levante/Schlichter Estate.

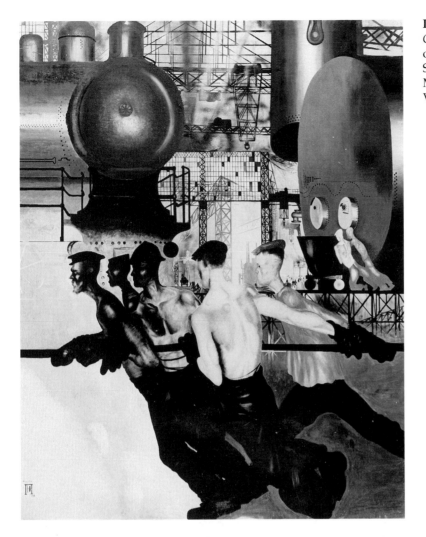

Plate 277 Yury Pimenov, *Create Heavy Industry!*, 1927, oil on canvas, 260 x 212 cm. State Tretyakov Gallery, Moscow. Photograph: Vneshtorgizdat, Moscow.

Vilyams's portrait of Meyerhold; and, more importantly, the aims of the two artists seem to be compatible.

In 1928 Schlichter exhibited the Brecht portrait in Berlin alongside a portrait of the Communist journalist Egon Erwin Kisch (Plate 276). Kisch was one of the main advocates in Germany of 'factography' – the reportage that was increasingly encouraged in the Soviet Union in the late 1920s in the drive to establish a 'proletarian culture'. Worker-correspondents were increasingly encouraged to write about their experiences in daily life and at work, thus downplaying traditional literary techniques in favour of documentary reporting of facts (hence, 'factography'). In his own practice Kisch, who had visited Russia in 1926, embodied such a hard-headed, campaigning type of writing and actually used the term *Sachlichkeit* to describe it.

The interests and influences between German and Soviet realism were mutual. It has for example been suggested that OST artists adapted some of what they saw in the work of Neue Sachlichkeit painters such as Grosz and Dix. An instance supporting this can be found in the distorted figures and not-quite-naturalistic spatial relations of a work such as Yury Pimenov's *Create Heavy Industry!* (Plate 277).

The OST focused on two themes. The first is found in pictures looking back to the period of heroic class struggle and civil war, as in Aleksandr Deineka's *Defence of Petrograd* (Plate 278), painted for the tenth anniversary of the Revolution in 1927. Such

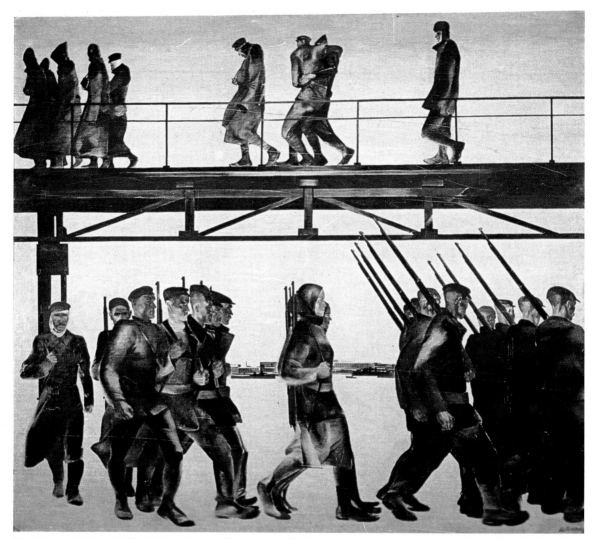

Plate 278 Aleksandr Deineka, *Defence of Petrograd*, 1927, oil on canvas, 210 x 238 cm. Central Museum of the Soviet Army, Moscow.

pictures do of course find an echo in Germany, notably in Otto Dix's work, but with the significant difference that when he took up such subjects retrospectively in the late twenties, he tended to mobilize explicitly religious connotations absent from the Russian work (Plate 279).

One of the problems with a rhetoric of Socialist Realism is that it can easily become the mirror of the rhetoric of Modernism: the idea that art should refer only to art is countered by a demand that art's sole business is to 'reflect' society. In practice, of course, both dimensions of reference are continually in play – in *both* discourses. In Socialist Realism, however, demands of typicality and popularity set the agenda for a naturalism in which the complexity of representation itself is suppressed in order that the audience may be more readily drawn to assent to the political message being conveyed.

A case in point is the highly composed image of absorption constructed by Vladimir Serov – also for the tenth anniversary of the Revolution – of a worker and a peasant united in victory amid the debris of the old order, inside the Winter Palace in October 1917 (Plate 280). For an OST artist such as Deineka, the situation is rather different. Committed to recording contemporary history, yet also to using avant-garde models to a certain extent

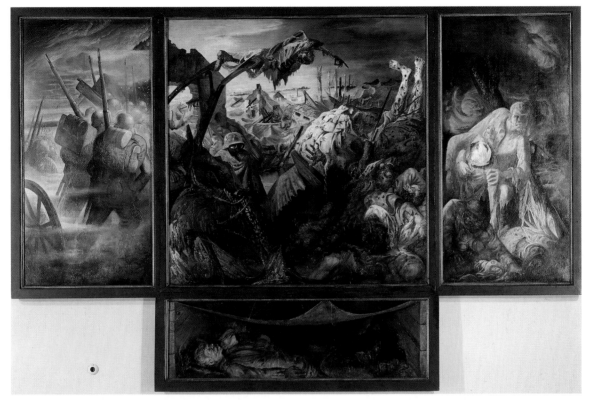

Plate 279 Otto Dix, *Der Krieg* (*War*), *c.*1928, triptych, mixed media on wood, central panel 204 x 204 cm, left and right wings 204 x 102 cm, predella 60 x 204 cm. Photograph: Sächsische Landesbibliothek Abt. Deutsche Fotothek, Dresden. Reproduced by permission of the Otto Dix Stiftung, Vaduz.

to counter the *peredvizhnichestvo* of the AKhRR, Deineka can, so to speak, leave the artistic reference closer to the surface. He is thereby enabled to make two points at the same time – one, the political point about the Revolution, the other a more reflective one about the conventional nature of representation. Thus, *Defence of Petrograd*, as well as being 'modernized' (stylized relative to naturalistic depiction), also owes a clear and considerable compositional debt to Ferdinand Hodler's *Departure of the Student Volunteers, 1813* (Plate 281) painted around 1908 to decorate the Friedrich Schiller university in Jena. For his part, Dix, in similar vein, also uses visual quotation – in his case from his *own* earlier work (Plate 282).

The second theme to emerge in OST work in the late 1920s was the heroization of the worker and of industrial scenes. This was linked to the policy of Socialism in One Country, which led to an increasing emphasis on heavy industry – firstly, as part of reconstruction, and then as part of the fulfilment of the Five-Year Plan. Images of this type became a staple of Russian realism. Deineka, in addition to the pictures already mentioned, produced numerous such images of workers and industry (for example, *On the Construction Site of the New Workshops*) as well as a series of studies of workers in the Donbas region in the form of watercolours, drawings, etc., many of which were used to illustrate magazine covers. Such subjects were of course not restricted to OST painters: the AKhRR's proletarianism ensured their commitment to the motif too, as in Ryazhsky's *Portrait of Stakhanov*, the shock-worker whose exploits came to dominate the production drive, or in Nikolai Dormidontov's *The Steelworks* (Plate 283). Such images are probably intended less to stand in their own right as depictions of this or that factory, than as metonyms for the Five-Year Plan in general.

Plate 280 Vladimir Serov, *The Winter Palace Captured*, 1928, oil on canvas, dimensions and present whereabouts unknown. Photograph by courtesy of the Society for Co-operation in Russian and Soviet Studies, London.

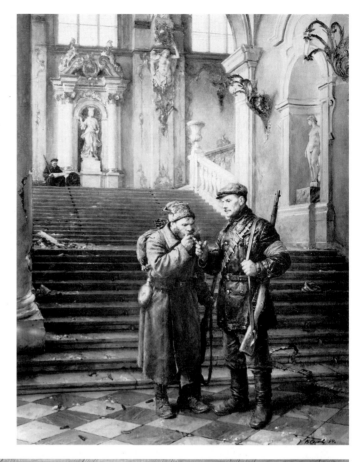

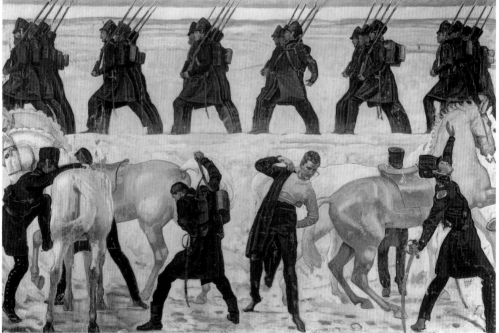

Plate 281 Ferdinand Hodler, *Auszug der deutscher Studenten in den Freiheitskrieg, 1813* (*Departure of the Student Volunteers, 1813*), 1907–8, oil on canvas, dimensions unknown. Friedrich Schiller Universität, Jena. Photograph: Bildarchiv Foto, Marburg.

Plate 282 Otto Dix, *Der Schützengraben* (*The Trench*), 1920–23, oil on canvas, 227 x 250 cm (now destroyed). Photograph: Sächsische Landesbibliothek Abt. Deutsche Fotothek, Dresden. Reproduced by permission of the Otto Dix Stiftung, Vaduz.

Plate 283 Nikolai Dormidontov, *The Steelworks*, 1932, oil on canvas, 63 x 98 cm. State Russian Museum, St Petersburg.

Plate 284 Karl Hubbuch, *Reklame* (*Publicity*), 1926–27, chalk and coloured crayons, 41 x 51 cm. Private collection. Photograph by courtesy of the Musée National d'Art Moderne, Centre Georges Pompidou, Paris. © DACS, London, 1993.

Having briefly reflected on a range of similarities and mutual influences, it is useful at this point to note a significant difference in typical subject-matter between German and Russian realism in the mid- and late 1920s. Neue Sachlichkeit subjects are overwhelmingly urban. They may be industrial, but much more common is the consumption dimension of urban life – either in the form of an urban landscape with its characteristic advertisement hoardings (Plate 284), or the human figure in modern interiors surrounded by consumer durables or technical equipment (medical equipment, radio spares, telephones, gramo-phones, even Bauhaus furniture). Just as there is a complex 'nesting' of reference in the apparently simple Meyerhold and Brecht portraits, so there is in some of Karl Hubbuch's naturalistic interiors (Plate 285). The Constructivist notions of 'non-objective' work, 'laboratory art' and 'art into production' had all tended to be set *against* a revived depic-tion in painting, with the latter coming up for the count as distinctly retrograde in comparison with the thrusting modernity of the former. Yet here we find Hubbuch representing Bauhaus furniture in a painting. His point seems to be to present it, not as the magnificent harbinger of a new society so much as a fashion accoutrement within the routines of daily life in a bourgeois-capitalist world – a feature of the life of a young secretary, perhaps, apparently lodging in a bed-sitter or a hostel, eating a plain meal and listening to a record-player.

These comparisons offer another glimpse of the complexities of realism. They also indicate how lessons from one art practice could be applied to another despite the enormous differences between the two societies in which the art was embedded. The

Plate 285 Karl Hubbuch, *Eingeschlafen* (*Young Girl Asleep*), 1925, crayon and watercolour on paper, 47 x 61 cm. Private collection. Photograph by courtesy of the Musée National d'Art Moderne, Centre Georges Pompidou, Paris.

Soviet Union in the late twenties and early thirties was a place where all was sacrificed to the production drive of the Five-Year Plans, the need to build up virtually from nothing the independent industrial state postulated by the notion of Socialism in One Country. By contrast Weimar Germany, at least until the Wall Street crash, embodied a level of consumer capitalism not to be seen again until after the Second World War. Weimar culture was a little like our own. Virtually all one knows of Stalinist Russia points to its being extremely remote from our experience.

Towards Socialist Realism

The Third Period

Subjects are of course one thing, techniques another, and intentions yet a third. The realism debate of the 1920s is so diverse on all these levels that it can't be summed up concisely. And yet, though there may be no 'essence' of the realism debate that can be applied across all countries, there are – to use Wittgenstein's term – 'family resemblances' (*Philosophical Investigations*). Artists in Germany and Russia, and indeed elsewhere from Mexico to France, reacted in varying ways to, on the one hand, the subordination of the Modern Movement into the luxury goods industry and, on the other, to the promise of the October Revolution. At one extreme, abstract art called itself 'concrete' and aspired to organize production; at the other, 'mirrors' held up to life produced representations as

complexly coded as any baroque allegory. None the less, despite the diversity of practices and arguments that can be treated in the debate over realism in art, a diversity that does much to sustain the interest of this question, the fact remains that historically debate was effectively closed down. As the twenties turned into the thirties, one conception of realism came to dominate. Before that, however, near the end of the twenties, there seems to have been a final flourish to the realism controversy in the Soviet Union.

The late 1920s saw a political change in the Soviet Union and a return to arguments for proletarian art. This affected some of the groups in Germany, as well as stimulating theoretical debate over realism and reviving activity by the avant-garde. Both the OST and AKhRR issued important declarations. Mayakovsky restarted the avant-garde LEF, and in 1928 the group October was formed. At the same time, on the 'proletarian' front, the Russian Association of Proletarian Writers (RAPP) was formed, and AKhRR took over the mantle of proletarianism in the visual arts. In Germany, in both literature and the visual arts, equivalent organizations were rapidly set up. In 1928 the German Revolutionary Artists' Association was formed. Whereas the old Red Front had always been a small organization, more like an avant-garde grouping (however much it claimed to stand for a wider constituency), the ASSO, as the Revolutionary Artists' Association was known, could claim a much wider membership. In Germany the Communist Party came to operate something like a proletarian culture within a culture – with newspapers, magazines, sports groups, and clubs for worker-writers and worker-photographers.

Of course this did not happen in a vacuum: cultural initiatives don't. In the Soviet Union the Stalinist-dominated Central Committee turned away from its Leninist policy of relative disengagement from art. In 1928 a new Central Committee resolution demanded social relevance from the arts. RAPP began to link its attacks on LEF to the mounting campaign against Trotskyism (Trotsky had been expelled from the party in December 1927, a year after being thrown off the Politburo). In Germany the Communist Party (KPD), which by this time caught a cold when Stalin sneezed, had passed its own resolution on cultural affairs and set up a cultural secretariat. Lying behind it all was Stalin's policy of Socialism in One Country, and in particular the decision to forge ahead with building an independent industrial base in the Soviet Union. The practical form of this was the first Five-Year Plan, the ideological component of which necessitated a heavy emphasis on working-class sacrifice and commitment in the name of building up the workers' state. A further implication was the need to counter oppositional class elements, whether internal in the shape of intellectuals and bourgeois experts on one side and the upper echelons of the peasantry on the other, or external in the shape of the foreign bourgeoisie. This was the 'Third Period' policy of 'class against class' (the first having been the revolutionary upsurge and its aftermath, the second the relative stabilization of the mid-1920s that was signalled domestically by the New Economic Policy; see E.H. Carr, *The Russian Revolution from Lenin to Stalin, 1917–1929*). It had its cultural repercussions in a renewed emphasis on the rhetoric of 'proletarianism'. This new proletarianism of the Five-Year Plan was, however, different from the old Proletcult. As John Willett has put it: 'their ambition was not to operate parallel to the party but to be in effect its executive arm in cultural matters' (Willett, *The New Sobriety*, p.181).

The October Group

The group 'October' issued a series of declarations and articles in the late 1920s, and held one exhibition, in 1930. It briefly united most of the main Constructivists and related vanguardists, and Deineka (though not apparently Malevich), as well as figures as eminent as Sergei Eisenstein in film, Hannes Meyer in architecture, and Diego Rivera during his visit to Russia in 1927–28. The group's 'Declaration' of 1928 is an important document in terms of the debate over contending definitions of 'realism' (see Bowlt, *Russian Art of the Avant-Garde*, pp.274–9). It marks both a restatement of earlier positions

and a significant development of them. At the same time it is also something of an epitaph. The AKhRR had already condemned its 'leftist' opponents for their abstraction, formalism and bourgeois ideology. Needless to say, this was rejected by October. And interestingly for the present discussion, this rejection was carried out, not in terms of a conception of 'realism' versus something else, but precisely as a conflict of realisms.

October set itself to 'build a proletarian realism that expresses the will of the active revolutionary class; a dynamic realism that reveals life in movement and in action, and that discloses systematically the potentials of life'. It is worth emphasizing what this realism is *not*: 'We reject the philistine realism of epigones; the realism of a stagnant, individualistic way of life; passively contemplative, static, naturalistic realism with its fruitless copying of reality'. That is to say, the matrix of heroic realism and illusionistic naturalism – basically, the realism of AKhRR – was being rejected for its passivity, its status as mere secondary copying, its implicit reliance on outmoded, pre-revolutionary precursors, and its archaic, artisanal individualism of production. By contrast October argued for 'a realism that makes things, that rebuilds rationally the old way of life, and that in the very thick of mass struggle and construction exerts its influence through all its artistic means'. And yet, despite similarities here with the Constructivist tradition, October also appear to be trying to avoid the excesses of the avant-garde: 'we simultaneously reject aesthetic, abstract industrialism, and unadulterated technicism that passes itself off as revolutionary art'. The course being steered by October is thus a challenging one – attempting to avoid both the passive realism of AKhRR and the kind of avant-gardism that had taken up the trappings of industrialization and technology only to transform them into a style. The new realism had the interventionist aspirations of the Constructivist avant-garde. Yet it retained a sense of the value of art that Constructivism had denied, while simultaneously seeking to avoid the academic aspects that clung to AKhRR's exhortations about artistic skill. For October, 'we emphasize that all means of expression and design must be utilized in order to organize the consciousness, will and emotions of the proletariat'.

These perspectives of the October Group, announced at the end of the 1920s, were a swan-song for the unstable union of avant-gardism and realism that had persisted in Russia since the Revolution. With hindsight, October's failure to make headway, and the effective capture of the idea of 'proletarian art' by AKhRR's 'heroic realism', can be seen to clear the way for Socialist Realism in art – an accessible, didactic art functioning in many respects as a publicity and propaganda arm of the political leadership. Prophetically, in October's 'Declaration' the notion that any one 'artificially created and privileged position' should have an 'ideological monopoly or exclusive representation of the artistic interests of the working and peasant masses' is seen as 'a radical contradiction of the party's and government's artistic policy'. In a few years, this was to *become* the party's artistic policy. And its chosen form was to be a development of precisely that 'realism' which to October was 'stagnant', 'passive' and 'static', and whose function was in the end the very opposite of collectively producing the new life – rather, 'embellishing and canonizing the old way of life' while 'sapping the energy and enervating the will of the culturally underdeveloped proletariat'.

It is idle to speculate about what a fully-fledged October-type practice might have looked like. The foreigners attracted to the cause of proletarian culture drifted away as the closure began to take effect. Rivera would have gone back to Mexico anyway, but for a while in the mid-1930s he was explicitly aligned with Trotsky – then in exile there – against Stalinism. Hannes Meyer also went to Mexico. Some of the prominent Russian Constructivists, such as Klutsis, Rodchenko and Lissitzky, were able to carry on careers as the graphic designers of Stalinism, for the Plans and such magazines as *USSR in Construction* (though Klutsis himself died in a camp). Some of this work is powerful and persuasive. It is not, however, as Constructivism originally set out to be, a transcendence of both wings of bourgeois practice, 'pure and applied' art. The avant-garde space, briefly

opened beyond its bourgeois boundaries, was closed. In the late 1920s and early 1930s, Stalinist proletarianism was hegemonic in the Soviet Union and in the KPD's sphere of influence in Germany.

German developments

In Germany in the late 1920s, economic and political crises resulted in increased social tension. Arguments grew as to how the arts should respond. In 1929 there was a decline in German industrial production and a halving of the crucial foreign, mainly US, investment. This economic downturn became a catastrophe after October 1929 – the Wall Street Crash. The world-wide recession of the 1930s was under way. As part of their strategy, conservative business interests and politicians enlisted the support of Adolf Hitler in their struggle against the Left. These developments, in tandem with rapidly rising unemployment, gave weight to demands for an art whose proletarian allegiances were not in doubt. The Left was not alone in this: on the other side, in February 1929, Alfred Rosenberg had formed the Kampfbund für Deutsche Kultur – the militant Nazi league for German culture, whose main target for attack was formulated as *Kulturbolschewismus* (cultural bolshevism).

The pressure was consequently on in art. The response by those artists working within the sphere of influence of the KPD was not of course to abandon the figurational aspects of the Verist wing of Neue Sachlichkeit so much as to drop those technical features of the figuration that could be seen as distancing and alienating. In short, there arose a demand for unambiguously 'proletarian-revolutionary' subjects, and moreover for a mood of 'optimism'. Grosz himself was criticized for lacking such optimism. What was 'needed' was a new image of the worker, which Grosz refused to provide:

> I see him [the proletarian] still oppressed, still at the bottom of the social ladder, poorly dressed, poorly paid … and often sustained by a bourgeois desire to go upwards.
>
> (Grosz, quoted in Lewis, *George Grosz*, p.196)

As a result he was pigeonholed as a rebel who had never matured into a full Bolshevik revolutionary, and accused of having failed to keep up with the times (i.e. of not having adapted to the demands of Stalinism). For his part, Grosz denied that he was a 'petty-bourgeois-anarchist', and instead rounded on what he contemptuously referred to as 'Hurrah-Bolshevism'.

M.K. Flavell has argued in her biography that, in these years, Grosz came to take up a position that he had earlier repudiated. The KPD's sectarianism led it virtually to welcome the prospect of a 'struggle' against both Fascism *and* social democracy. The all-enveloping counter-culture sponsored by the KPD paradoxically had the effect of concealing from the party its own relative weakness, not only in urban centres but more particularly in the countryside where the Nazis had their roots. Grosz seems to have been less sanguine. As the political tensions worsened, and the sectarianism of the KPD increased, he seems to have been confirmed in the belief to which he had been shifting since the mid-twenties. For Grosz, a role re-emerged for Art and for the Artist – as a witness of events rather than as a participant in them. Interventionist graphic works such as his Malik Verlag portfolios were relatively ephemeral, but a well-wrought painting could stand the test of time and re-emerge as an example – for those coming after, when the storm had passed – that resistance had persisted. Thus Grosz tended to become relatively *dis*engaged, as his 'realist' art took up the task of witnessing: in other words the purpose of his stance was to question the equation of 'realism' and 'engagement' with direct interventionism (Plate 267).

Others, of course, became more committed to the new cultural policy. The result was a hortatory painting, stripped of complexity and ambiguity, and often retreading the compositional devices of earlier art. Such a tendency is exemplified by Curt Querner's *The Demonstration* (Plate 286) of 1930, or Otto Griebel's *The International* (Plate 287) of 1929. The

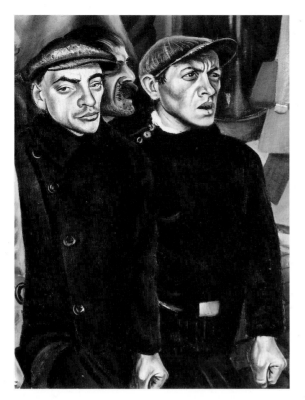

Plate 286 Curt Querner, *The Demonstration*, 1930, oil on canvas, 86 x 66 cm. Nationalgalerie, Staatliche Museen zu Berlin. © DACS, London, 1993.

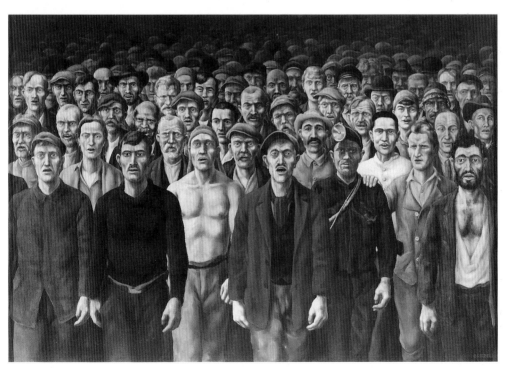

Plate 287 Otto Griebel, *Die Internationale* (*The International*), 1929, oil on canvas, 125 x 185 cm. Museum für Deutsche Geschichte, Berlin. Photograph: Sächsische Landesbibliothek Abt. Deutsche Fotothek, Dresden.

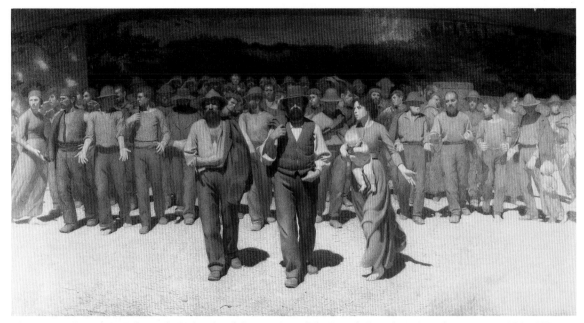

Plate 288 Giuseppe Pelizza da Volpedo, *Il Quarto Stato* (*The Fourth Estate*), 1901, oil on canvas, 283 x 550 cm. Civica Galleria d'Arte Moderna, Milan. Photograph: Saporetti.

device of a crowd walking towards the spectator was a common one in depictions of workers. Yet in the ASSO paintings it seems that, under pressure to be unequivocal about the message, the social types have become flattened into ciphers, cut-outs. This lack of robustness is, presumably, the very opposite of what the artists intended. The one-dimensionality is strange, as though even the power that a very similar composition could once deploy (for example, Plate 288) has been drained out, squeezed between frontality and a patronizing, tabloid-like clarity to produce a fake international of male proletarian intransigence. Instead of a believable unity there is a homogenizing literalness. 'Realism' was becoming implausible.

Proletarianism and alternatives

This lack of credibility was also being seen as a problem in the Soviet Union. Socialist Realism is most often viewed by Western commentators as the screwing down of a lid that had been inexorably closing on diversity in art for some time. Yet the situation may have been more complex. Katerina Clark has argued persuasively that the adoption of Socialist Realism was in some senses a reversal of the proletarian period that preceded it. It was done, she argues, by those who felt that there was a need to re-establish *quality* in art, which was being dangerously threatened by the aggressively proletarian dynamic. Clark has noted a distinct shift around 1930/31 in the slogans in the Soviet literary journal, *Liturnaya Gazeta*. Thus 'The book is an instrument of production', 'We shall include the writer in socialist construction', and 'For coal, for iron, for machines! Each literary group should work for these!' start to be replaced by 'For artistic quality' and 'Let us turn our attention to creative writing' (K. Clark, 'Little heroes and big deeds', p.203).

 It is likely that something similar took place in the visual arts. There is little doubt that Deineka was edged away from the interesting if unstable conjunction of 'correct' subject-matter and painterly techniques – derived from the avant-garde, and perhaps Neue Sachlichkeit – that mark his work of the 1920s and early 1930s (for example, Plates 278 and 289). His technique became increasingly orthodox in the later 1930s and 1940s, though

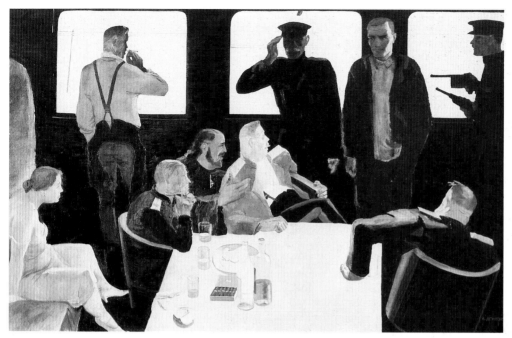

Plate 289 Aleksandr Deineka, *Headquarters of the Whites during an Interrogation*, 1933, oil on canvas, 130 x 200 cm. State Russian Museum, St Petersburg.

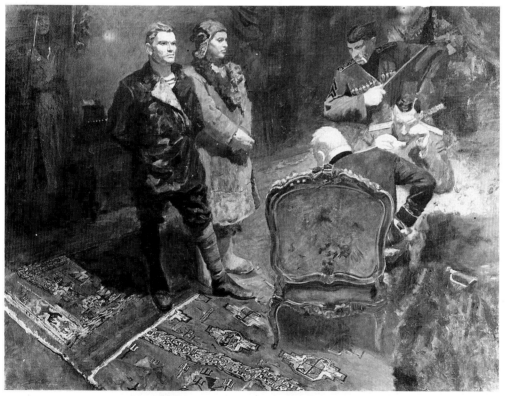

Plate 290 Boris Ioganson, *Interrogation of the Communists*, 1933, oil on canvas, 211 x 279 cm. State Russian Museum, St Petersburg. © DACS, London, 1993.

often retaining an element of expressionist distortion – which seems to have been more acceptable than Neue Sachlichkeit stylization. Why it should be more acceptable is not immediately obvious. Perhaps the evaluations that 'expressive' distortions encourage, such as 'vigour' or 'enthusiasm', are more in tune with Revolutionary Romanticism than are other departures from the literal or naturalistic that can give rise to claims of 'stasis' or 'distance'.

In any case, what this question points to – rather than the stability of any particular reading with respect to a notion of 'realism' – is precisely the fragility of the assumptions upon which whole edifices of official approval, or disapproval, could be raised. In this sense, an example much more consonant with the way things were going than Deineka's OST balancing act was Boris Ioganson's way of depicting an identical event in his *Interrogation of the Communists* (Plate 290). Here the solid vertical block formed by the Communist prisoners dominating the centre of the composition is contrasted with the relatively contorted, diagonal poses of their White captors placed off to one side, which are then echoed in the vertiginous carpet on which the Communists implacably stand. Thus psychological attributes are generated out of technically orchestrated clashes. Rather than the distance enforced by Deineka's flattening and stylization, the mixture of psychological drama produced by the physical typification of the White officers and the Communist prisoners, and the overall agitation of the surface, works to produce a kind of psychic invitation into the drama that is almost claustrophobic. In this sense it is the very essence of what a Brechtian notion of realism is *not*.

Stylization does not necessarily generate critical distance, however, as may be evident from Aleksandr Samokhvalov's extraordinary *Militarized Communist Youth* (Plate 291) of 1933. One suspects this may well have been an instance of the one-dimensional quality of militant proletarianism that humanists such as Lukács were concerned to redress in order to re-connect a socialist art with the believable dramas of bourgeois precedent, rather than these implausible ciphers who would not look out of place in Nuremberg. The dividing line between proletarian 'optimism', 'heroism' and caricature must have been hard to negotiate in practice yet it was crucial to the plausibility of the works.

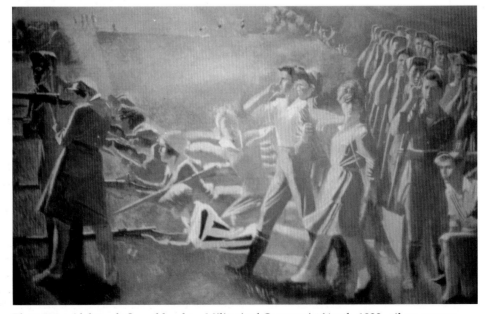

Plate 291 Aleksandr Samokhvalov, *Militarized Communist Youth*, 1933, oil on canvas, dimensions and present whereabouts unknown. Photograph: Vneshtorgizdat, Moscow. © DACS, London, 1993.

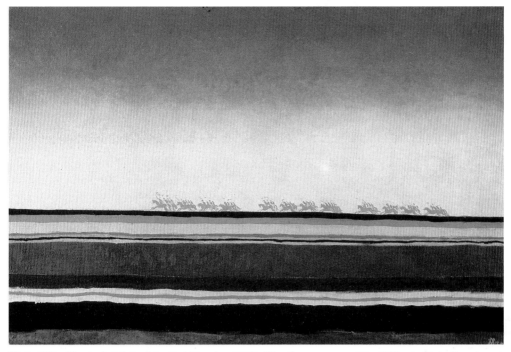

Plate 292 Kazimir Malevich, *Red Cavalry*, 1928–32, oil on canvas, 91 x 140 cm. State Russian Museum, St Petersburg.

In this connection, Malevich's late works such as his *Red Cavalry* (Plate 292) are often passed over in silence, or treated as a rather embarrassing appendage to his abstraction. Even the precise dating of these works is uncertain. Yet there remains something about his persistence, as well as about the quality of his work, that is not to be lightly dismissed in terms of the realism debate. It seems as though he intended his strange return to figuration specifically to pre-empt the victory of an increasingly academic Socialist Realism. The clue comes in a letter of 1932 to Meyerhold, where he warns that if the director proceeds with unadulterated Constructivism, 'then Stanislavsky will emerge as the winner in the theatre and the old forms will survive'. Likewise in architecture 'the Greco-Roman style will prevail'; and he adds: 'together with the Repin-style in painting'.

Malevich clearly perceived two things. He realized that the Revolution had changed things and non-objectivity simply was no longer possible, at least for the present: 'painting came across a new object that the proletarian revolution had brought to the fore, and that had to be given form.' But, just as important, he saw that the opening this gave for a return to conservative forms and forces had to be resisted by progressive artists, themselves adapting to the new situation: 'At the moment, in this phase of building socialism in which all the arts must participate, art must return to backward areas and become figurative' (letter to Meyerhold, April 1932). The point was *how* it did so. And Malevich's late figuration was arguably not so much a retreat as an extreme, unstable, yet ambitious attempt at synthesis, to meet the problem head-on.

No one has yet offered a persuasive account as to why Malevich repeatedly portrayed peasant subjects just at the time when the forced collectivization of agriculture was having fierce repercussions on life in the countryside. Whatever else he was doing, Malevich was not producing easily legible figures for the Five-Year Plan in his return to figuration. It seems that neither in terms of the subject-matter he chose to represent, nor in the manner of their representation, can Malevich's late work be seen as an unproblematic bow to Socialist Realism. Their unstable synthesis of avant-garde and figurative elements has no precise equivalent in the work of any other Russian artist. In terms of the spectrum of

realist art surveyed here, it could be argued that their closest relative abroad is Léger (though such a comparison is not usually made, and even when advanced tentatively – as here – still feels intuitively off-key in some respects even as it illuminates others).

Lukács

The shift from proletarianism to Socialist Realism is not solely a matter of artistic 'quality'. It is also to do with changed demands that are fundamentally political. Thus there is no doubt that Georg Lukács, the most profound thinker associated with Socialist Realism, was committed to a notion of continuity with the bourgeois tradition. Yet Lukács's aesthetic and philosophical stance was intimately linked to a political perspective. For Lukács the Revolution had produced a socialist state. The revolutionary reverberations of the early twenties had died down, and capitalism in the West had stabilized. It therefore became imperative not to become isolated from the socialist society as it existed, warts and all – because Lukács perceived that the major threat to civilization in his lifetime came not from bourgeois societies but from Fascism; and the fight against Fascism would be led by Communists. However – and this is the main point – Communism would require alliances in this struggle. This policy eventually materialized as the Popular Front against Fascism in 1935; but it had been emerging for several years, and Lukács himself seems to have arrived at this perspective as early as 1928. One of the central planks of this view was that what was needed, rather than an assault on bourgeois culture in the name of revolutionary proletarianism, was an alliance with the mature bourgeois-Classical heritage.

The first marker of this new orientation was the '*Linkskurve* Debate' of 1931–32 when Lukács led an attack on proletarian literature in the publications of the German Party.[3] The gist of his criticism was that while the working-class subject-matter was all well and good, the *forms* associated with it – the documentary and montage techniques of factography – were not. He criticized documentary for allegedly blurring the line between art and science by fetishizing facts; and montage, tellingly, on the grounds that abrupt shifts and leaps were to be avoided in favour of gradual passages and developments. This is an aesthetic hypothesis remarkably congruent, of course, with the relationship being advocated by Lukács between a 'progressive' Socialist Realism and the achievements of traditional bourgeois culture. Gradual transitions, it seems, are to be preferred not merely historically – socialist culture being built upon the basis provided by its bourgeois predecessor – but within the bounds of individual art works. The abrupt shifts of focus and broken surfaces associated with collage and montage were all too compatible with claims about the need for a revolutionary break with bourgeois culture.

It should perhaps be underlined here that Lukács's sense of realism referred to the bourgeois-Classical tradition, not to that aspect of the bourgeois tradition that had developed into the Modernist avant-garde. Quite the contrary. This latter, principally via its commitment on the one hand to post-Cubist forms of technical fragmentation, and on the other to Expressionist subjectivity, was held to have fatally weakened the bourgeois tradition. It had, the charge ran, failed to combat the strain of irrationalism that, particularly through the work of Friedrich Nietzsche and Henri Bergson, had emerged in bourgeois culture as that culture itself started to decline. In the socialist tradition, Fascism is seen as embodying irrationalist philosophy. Hence, for Lukács, the fight against Fascism involved bolstering the humanist values shared by the bourgeois and socialist traditions, and thus refusing all forms of Modernism – particularly where they encroached into socialist art, or even claimed to be an appropriately contemporary realism themselves. Given this analysis, it is possible to see how, for Lukács and indeed for social realists in general, Modernism came to be seen either as a kind of fellow traveller of Fascism, or a Trojan horse within the socialist camp – or both. As late as 1977 the Russian art theorist

3 See Georg Lukács, '"Tendency" or partisanship?', pp.33–44.

Avner Zis was still able to refer to 'the main direction of ideological struggle in the sphere of artistic culture' as being 'the conflict between realism and modernism' (A. Zis, *Foundations of Marxist Aesthetics*, p.31).

Socialist Realism: the 1934 Congress and after

Socialist Realism was enunciated at the First Congress of Soviet Writers held in Moscow in August 1934 (H.G. Scott, *Problems of Soviet Literature*). Over 600 delegates attended, including about 40 from abroad; and in 26 sessions no fewer than 300 contributions were made. And yet it would appear there was no significant disagreement. The implication is that the Congress rubber-stamped perspectives that had already been decided. Indeed they had. All the warring groups, proletarians and vanguardists alike, had been dissolved in 1932 and a single Artists' Union set up – which artists wishing to practise in the Soviet Union had to join. It is said that the policy itself was decided at secret meetings held in Maxim Gorky's flat in Moscow in October 1932 when an invited group of politicians and intellectuals argued over a name for the new kind of art. That this art would be 'realist' was not in dispute. Some, however, wanted it to be 'monumental'; some 'heroic'; and some, still, 'proletarian'. One figure in particular, however, kept insisting that it be 'socialist'. This figure was Stalin. 'Socialist Realism' it was.

One thing Socialist Realism did – as indeed Stalinism as a whole did – was to enlist Lenin. In 1905 Lenin had written a pamphlet called 'Party organization and party literature' in which he enunciated the principle of *partiinost* (C.V. James, *Soviet Socialist Realism*). This is an untranslatable Russian term embodying the proposition that 'Literature must become a component of organized, planned and integrated Social-Democratic [at that time, Communist] Party work' ('Party organization and party literature', p.26). Few claims have sparked such outrage among generations of liberal commentators; Lenin's argument is not, however, either as eccentric or as baseless as it is usually made out to be, being not far removed from, for example, Tendenzkunst (the claim that *all* art, irrespective of its intentions, embodies a political 'tendency'). Despite ambiguities in the text, it seems that Lenin was referring specifically to *party* literature – newspapers, pamphlets and so on, as well as presumably fiction published by party members, at least in the party press. As we have seen, during Lenin's time the party did basically keep its hands off the arts, intervening only when artistic questions strayed into areas of organization or ones that had a functional aspect such as education. Socialist Realism of the 1930s *did* however extend the principle of *partiinost* to 'the entire realm of culture', as Henri Arvon put it, thereby reducing artists and writers to the condition of 'docile bystanders explicating the political decisions of the Central Committee and party satraps' (H. Arvon, *Marxist Aesthetics*, p.92).

There is one picture that seems to condense this state of affairs, not to mention its contradictions, very nicely. It is by Aleksandr Gerasimov, who among other things happened to be Stalin's favourite artist. The technique is not wholly Academic – not as 'finished' or 'photographic' as, for example, Brodsky's *Lenin at the Smolny* (Plate 256); it is in effect a moderate, very moderate, academicized sort of modern surface, suggestive and a little brushy, 'expressive', and hence 'felt'. It depicts Stalin speaking at the Sixteenth Party Congress (Plate 293). To one side of him is the party, a mixture of obedient bureaucrats and Old Bolsheviks in their civil war medals (not many of them would be left, soon – after the purges). Behind him – as if overseeing the whole thing, giving his blessing one might say (as one is surely intended to) – is a white marble bust of Lenin. This juxtaposition is a hallmark of Stalinist entrenchment, and the way in which the picture sets it up is in itself interesting (and it is of course different from Brodsky's – the eagle-icon rather than the working man). But an added twist is given by the fact that it was the Sixteenth Congress that approved the first Five-Year Plan. As well as being a picture of Stalin's victory (it happened also to be his fiftieth birthday that year), and the smooth elision of Lenin in behind him, it is also in a sense a picture of its own triumph – of a

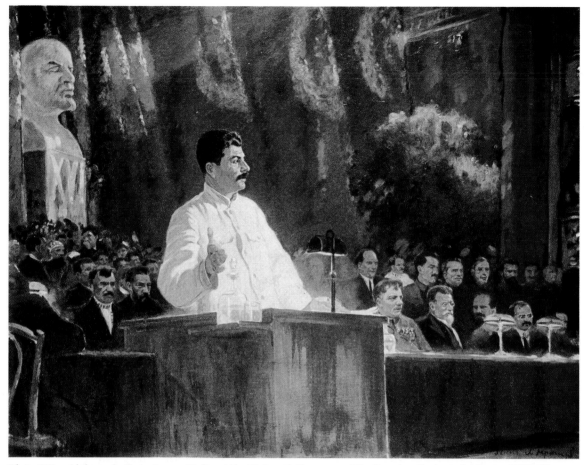

Plate 293 Aleksandr Gerasimov, *Stalin at the Sixteenth Congress of the Russian Communist Party*, 1929–30, oil on canvas, dimensions and present whereabouts unknown. Reproduced from *Art in the USSR*, special issue of *The Studio*, autumn, 1935.

semi-academicized, vestigially modern Socialist Realism triumphing over proletarianism as well as over the ruined avant-garde.

Given the impact that the notion of realism in art had between the wars, and given also the fact that debates in Russia constituted the epicentre for arguments internationally – for *and* against – it is important not to caricature Socialist Realism. It was not all manual workers with necks thicker than their heads, generals laden with medals and rosy-cheeked maidens gazing into the blue future. As with AKhRR's 'heroic realism' of the 1920s, one problem is that the doctrine does not constitute a set of prescriptions about style, but was able, along the lines already seen, to accommodate limited technical variation. In fact this feature is perhaps more pronounced than it was in the case of AKhRR. Thus Socialist Realist theory continuously harps on the notion of Truth. Just as Zis in 1977 spoke of the 'truthful depiction of reality', so Zhdanov in 1934 spoke of 'knowing life so as to be able to depict it truthfully' (A. Zhdanov, speech to the Writers' Congress, quoted in Scott, *The Soviet Writers' Congress, 1934*, p.21). Yet it is a perplexing fact that truthful depiction is *not* the same as what Zis calls 'precision in external description'. That is to say, Socialist Realism is actively distinguished from Naturalism.

It seems obvious to any outside observer that AKhRR's rehabilitation and transformation of the Wanderers tradition in the early twenties sets the tone for Socialist Realism. The rhetoric is more or less the same, and the pictures look very similar. And yet

in one of those bizarre reversals that characterize the whole question, Socialist Realism condemns the AKhRR tradition for its 'naturalism'. What Socialist Realism purports to be true *to*, that is to say, is not external appearances but 'the inner essence'. Furthermore, naturalism is interpreted as 'not an inferior variety of realism, but merely the reverse side of formalism' (Zis, *Foundations of Marxist Aesthetics*, p.245). Socialist Realism thus presents itself as the *synthesis*, the overcoming and transcendence of two equally discredited opposites that cancel each other out – the avant-garde on the one hand *and* naturalism on the other. Zis makes a distinction between the 'mechanical repetition' of reality and its 'creative reproduction' (p.39). In other words, what is to constitute an adequate Socialist Realism, on this model, is no simple matter, and consists more in the application of Marxist philosophy than in any direct match to observable features of the world as it is. Since definitive knowledge of Marxism is assumed to rest with the leadership of the Communist Party, the question of what is good and bad in art is – quite legitimately within the terms of the theory – to be decided by the politicians. This sounds hideous to Western ears, or indeed to anyone outside the orbit of the Stalinized Communist parties; but within them, all was seen to proceed from 'the people' transmitted via their historic representative, the party.

In practice this often led to a hagiographic depiction of leaders, and rampant idealizations of working people, as in Gerasimov's many portraits (Plate 294, for example) or Mukhina's monumental *The Worker and the Collective Farm Woman* (Plate 239). Yet Socialist Realism in the hands of an artist such as Deineka could produce telling images of ordinary people, or of the struggle against Fascism, that were simply not within the purview of the Western avant-garde. *The Outskirts of Moscow, November 1941* (Plate 295)

Plate 294 Aleksandr Gerasimov, *Stalin and Voroshilov at the Kremlin*, 1938, oil on canvas, dimensions and present whereabouts unknown. Photograph by courtesy of the Society for Co-operation in Russian and Soviet Studies, London.

Plate 295 Aleksandr Deineka, *The Outskirts of Moscow, November 1941*, 1942, oil on canvas, 92 x 136 cm. State Tretyakov Gallery, Moscow. Reproduced from *Alexander Deineka*, St Petersburg, Aurora Art Publishers, 1982.

forms a telling contrast with *Defence of Petrograd* (Plate 278) painted fifteen years earlier, though what that contrast is taken to mean will depend to a great extent on what one takes the concept of 'realism' itself to mean. Be that as it may, it is important for us to understand that Socialist Realism was not always a caricature. And to treat it as if it was is significantly to underestimate its power. It is perhaps also to underestimate the claims on art of those whose lives are marked less by a preoccupation with art than with the making and living of life itself. The a priori disqualification of such a constituency would surely deserve the disregard it encounters with Socialist Realism.

Brecht and Benjamin

The foregoing qualified appraisal is not, however, meant to endorse Socialist Realism. For Socialist Realism severs the very notion of a realism in art from the reflexivity characteristic of the avant-garde tradition. Yet it is this self-criticism that, arguably, is essential for a realist response to the modern condition. The self-criticism of the avant-garde, therefore, can be seen to exert a claim on the character of a modern realism in art, which neither the dismissiveness of this aspect by Socialist Realism, nor its attenuation into art-for-art's-sake in much of the Western 'Modern Movement', can ever wholly abrogate. Certainly Brecht felt this. The dispute he entered into with Lukács in the late 1930s constitutes the exchange that, perhaps more than any other, has come to symbolize and to summarize the contending aspects of the inter-war realism debate. In essence Lukács conceived realism as a given form, one that was at odds with *all* varieties of Modernism – from the most subjective Symbolist or Surrealist fantasy to the most detailed naturalism. For him, these were equal and opposite falsifications. Only a 'true' realism, based on the example of the great realists of the past, could penetrate the contradictions of modern capitalism. Brecht on the other hand, though agreeing that realism was the key issue for

modern art, and agreeing too that Marxism provided the basis of an adequate approach to the problem, argued that it was not so much an achieved form as something that had to be won and re-won in new conditions. To believe otherwise, he argued – that is, to vaunt nineteenth-century realists as models for modern practice – was itself to be paradoxically guilty of 'formalism' (see 'Popularity and Realism').

But, once again, the debate was not just about aesthetics. In a strong sense it was also about knowledge and power, and about where their limits are deemed to lie. Difficult as it is to determine such boundaries, it seems that an authoritarian element is not far away in Lukács's comments on the relationship of criticism to practice:

> Whoever attempts to replace Marxist criticism – which leads and guides, which analyses false paths of creative method, and struggles for the correct creative method – with mass work, is the literary-political equivalent of a party member who would claim that the work of the central ideological and strategic leadership could be 'replaced' by spontaneous discussion in the factories.
>
> (Lukács, *Die Linkskurve*, 1932, quoted in R. Berman, 'Lukács's critique of Bredel and Ottwalt', p.172)

Lukács of course has a point about the party: Marxism is not syndicalism. But how readily his argument transfers over to art is more contentious. This is clear from Brecht's comments, as reported by his friend Walter Benjamin, that there was no sense in which one could enter into a 'community' with Socialist Realists such as Lukács. Brecht went on:

> They are, to put it bluntly, enemies of production. Production makes them uncomfortable. You never know where you are with production; production is the unforeseeable. You never know what's going to come out. And they themselves don't want to produce. They want to play the *apparatchik* and exercise control over other people. Every one of their criticisms contains a threat.
>
> (Brecht, quoted in W. Benjamin, 'Conversations with Brecht', p.118)

Brecht was extremely sharp on this need to keep practice and all its diversity in the foreground, not to have it policed by a bureaucratically conceived criticism:

> It is wrong to develop a criticism that regards itself as a subject confronting an object, a legislative power for which art provides the executive power ... However independent art may be, the regulating mechanism (criticism) must be contained within it.
>
> (Brecht, quoted in Arvon, *Marxist Aesthetics*, p.109)

And he went on, specifically with the Zhdanovist apparatus of Socialist Realism in mind:

> Art is not capable of turning artistic ideas dreamed up in offices into works of art ... It is not the business of the Marxist-Leninist Party to organize poetic production the way it would set up a chicken farm. If it does, poems will be all as much alike as one egg is like another.
>
> (Brecht, quoted in Arvon, p.109)

Brecht's arguments were developed by Benjamin in his renowned 1934 paper, 'The author as producer'. This was delivered as a talk to a small organization known as the Institute for the Study of Fascism during Benjamin's exile in Paris. Groups of this type formed the basis for what was to become the widespread organization of the Popular Front against Fascism. In such a context, Benjamin's paper constituted an unexpected and presumably little comprehended rebuttal of the claims of Socialist Realism. Benjamin argued, first, that what was most important was not the 'attitude' of a work of art towards the existing mode of production, but how in fact it itself stood *in* those relations of production. The implication was that if it conformed to them unproblematically, it was in effect part of the capitalist system of production, whatever it might claim to the contrary in respect of its ostensible subject-matter. Many of Benjamin's arguments were elusive, but he was clear on this point: that it was 'highly censurable' to engage in a professedly realist practice (he refers to Neue Sachlichkeit, but we can take him to mean reborn figuration in general)

without also attempting to transform the institutional relations in which the 'realist' works would circulate and be consumed. And, he argued, this would be true however much the art works 'seemed to be of a revolutionary nature'.

It was, however, also the conclusion of Benjamin's paper that marked it out as running counter to Socialist Realism's stance. There are two sides to this. The first, one of the points where his argument is at its most elusive, follows from the foregoing. If it is not a work's depicted subject that guarantees its radicalism, its usefulness, but rather its form and the productive relations out of which it is made (for example, the way in which its technical and formal means transgress the ideological and institutional norms for the consumption of words and images), then where do the boundaries lie? Is an abstract painting more 'realist' in this sense than a recognizable painting of a strike or a blast furnace? Is a photomontage more 'progressive' than *any* painting? Benjamin certainly argues that 'an author who teaches writers nothing teaches no one'. This means that a work of art that does not break new ground as a work of art is, at bottom, going to be of no use to anyone because its quality as a conveyor belt for predigested conceptions will disqualify it from embodying the inquisitiveness and difficulty that are the hallmarks of all real learning. It will so to speak be a fake, posing at the frontier it in fact shelters behind.

That Benjamin did intend something along these lines seems to be demonstrated by the second point, also from his conclusion – that the purpose of the whole operation (i.e. of radical artistic or literary production) was to transform 'consumers' into 'collaborators'. At the very least this is an odd thing to be saying in the mid-1930s; and Benjamin was acute enough to know what he was doing. As we have seen, the Lukácsian aesthetic of Socialist Realism tended to the contemplative: you looked at realist art to receive a well-wrought message about the true condition of the world, granted by the knowledge of the artist and the skill that allowed him to transform his perception into the micro-world of the art work. Benjamin here, at a meeting of an organization subscribing to the ideals of a popular, socially conscious realism, was laying before them a highly sophisticated version of Proletcult – worker-correspondents revisited, if you like – just when that kind of leftism had been buried under a pile of optimistic managerial rhetoric that claimed to know everything better than you did.

Benjamin's argument need not be construed as a demand for everyone to take up pen, brush or camera, though no doubt he did hope that cultural practice would become more widespread. The nub is both simpler and more abstract: to take hold of the *meanings* that are laid before you; to reject conventional representations as misrepresentations, of yourself and the rest of the world; and to start offering your own representations, which you of course will have to construct rather than inherit. As such, it is a realist argument itself in the Brechtian sense – not to imitate the world but to act in and upon it, albeit through 'semantic' action as much as practical action. For Brecht, you do not enter the theatre in order to be 'taken out of yourself' into the imaginary world of the story, but rather to learn the meaning of your own – a story written in terms of capital and class.

Counter-conclusion

It may be useful to conclude this study of the realism debate between the two world wars by briefly considering a range of works with some claim to being 'realist'. Sergei Gerasimov's *A Collective Farm Festival* (Plate 296) is a paradigmatic Socialist Realist paean to the virtues of collectivization, a sort of Stalinist harvest festival. It represents an approach to realism that increasingly eclipsed both the more open-ended attempts to integrate Modernist technical innovation and social accessibility in Soviet art of the 1920s by painters such as Deineka (Plate 278), and previous avant-garde productions that had

Plate 296 Sergei Gerasimov, *A Collective Farm Festival (Kolkhoz Harvest)*, 1936–37, oil on canvas, 234 x 372 cm. State Tretyakov Gallery, Moscow. Photograph: Novosti (APN).

laid claim to entirely new forms of engagement with reality (Plates 241 and 243). The serious point about Socialist Realism is that it is a form of public painting: it addresses and articulates, however mendaciously, issues of shared moment. It is the feature of such art, such representations as Gerasimov's, that they assert their unifying meanings *over* actual social diversity. This does not mean that they are powerless or risible, much less simplistic. In the West nowadays it may not be possible to 'like' them. Being enmeshed in a different culture, however, is scant qualification for dismissing them.

In France, under its short-lived Popular Front government, Fernand Léger perceived Socialist Realism as an insult, and attempted to produce a new realism based on a combination of the object and the formal and technical legacy of Cubism. Stimulated by the Popular Front government's programme for increased sport and leisure facilities for working people, he embarked on a series of leisure scenes – of picnics, circuses and bicycle rides – that intermittently occupied him until his death in 1956. In the mid-1930s he also produced public, decorative images of (and for) sports halls, such as *La Salle de la culture physique* (Plate 297).

In Mexico and paradoxically in the capitalist United States, Diego Rivera painted large public murals as part of a self-conscious 'realist' project, conceived as distinct from Soviet Socialist Realism and in explicit reaction to what he saw as the élitism and inaccessibility of the avant-garde of which he had previously been a part in Paris (Plates 229 and 230). In the autumn of 1938 a manifesto, 'Towards a free revolutionary art', appeared in the New York magazine *Partisan Review*. Written up mostly by Trotsky from discussions in Mexico with Rivera and Breton, it referred to the Stalinist regime in the Soviet Union as a 'twilight of filth and blood' and condemned Socialist Realism as a 'shameful negation of the principles of art'.

Plate 297 Fernand Léger, *La Salle de la culture physique* (*The Sports Hall*), 1935, oil on canvas, 235 x 396 cm. Private collection, Japan. Photograph by courtesy of the Waddington Galleries, London. © DACS, London, 1993.

The main political event of the thirties in Europe, after the triumphs of Stalin on the one side and Hitler on the other, was the Spanish Civil War. Given the annulment in the Soviet Union (not to mention in Nazi Germany) of what one might with some licence refer to as the post-Cubist tradition of realism, arguably the main contender from that tradition – and certainly the subject of much debate at the time under the slogan of 'the realism controversy' – is Picasso's own *Guernica* (Plate 240).

Weimar Germany in the 1920s, before the triumph of Fascism, had been the site of yet another attempt to produce a 'new realism' – in this case one that owed less to Cubism than to a reaction against the Expressionist avant-garde (Plate 282). The aspiration to 'objectivity' found in Neue Sachlichkeit, however, had repercussions beyond the sphere of painting, enhancing the developing media of mechanical reproduction. Apparently fulfilling Walter Benjamin's argument that art should not merely supply but also transform a productive apparatus, John Heartfield, both in Weimar culture and later in exile from Nazi Germany in the 1930s, produced photomontages such as *Hurrah, the Butter is Finished!* (Plate 298). This criticism of Fascism is both generalized in impact yet anchored in specific events – in this case a speech by Hermann Goering to the effect that 'Iron always makes a country strong, butter and lard only make people fat'. As Benjamin wrote:

> the tiniest authentic fragment of everyday life tells more than painting does. Just like the bloody fingerprint of a murderer on a book page tells more than the text. A good deal of this revolutionary substance made its escape into photomontage. You need to consider only the works of John Heartfield, whose technique turned the book cover into a political instrument.
>
> (Benjamin, quoted in P. Pachnichke and K. Honnef, *John Heartfield*, p.99)

Plate 298 John Heartfield, *Hurrah, die Butter ist alle!* (*Hurrah, the Butter is Finished!*), AIZ,
19 December 1935. Akademie der Künste, Berlin. © DACS London, 1993.

Plate 299
Kazimir Malevich,
Self-portrait, 1933, oil
on canvas, 73 x 66 cm.
State Russian
Museum,
St Petersburg.

And what, finally, about sheer oddities such as Malevich's late practice in the 1930s? At one and the same time in 1933, he is producing pictures such as his own *Self-portrait* (Plate 299) and the *Portrait of the Sculptor V.A. Pavlov* (Plate 300). These works can be glossed over as a backsliding under pressure into a technically conservative footnote to Socialist Realism. For example, in a major article the critic Benjamin Buchloh presented an illustration of Malevich's 1933 *Self-portrait* next to an illustration of his Suprematist *Black Cross* of 1915, claiming that this juxtaposition indicated a retreat that was 'obviously' the result of a widespread and deleterious 'mechanism of authoritarian alienation' (B. Buchloh, 'Figures of authority, ciphers of regression'). But if we look more closely we see that, for one thing, the self-portrait is nothing like 'realistic' in the way that the *Pavlov* is. And in the bottom right-hand corner, instead of a signature, is a tiny black square. Then again, over Pavlov's shoulder, hanging on the far wall of the room, is ... a black square. What does it *mean* to use a logo of an abstract painting as the identifier for the subject of a semi-realistic portrait? What does it *mean* to paint a realistic representation, in illusionistic three-dimensional space, of the same abstract painting? These questions have not been satisfactorily answered. At the very least, the practice that sets them up seems to cut across ready or orthodox characterizations of Realism and its Others.

Misrepresentation of the complexity of art in this period under the convenient banners of cultural management does seem to matter, not least because rendering paintings

unproblematic is often only part of a wider strategy of making a contradictory reality seem normal. Brecht himself put the matter well:

> Realism is an issue not only for literature: it is a major political, philosophical and practical issue and must be handled and explained as such – as a matter of general human interest.
>
> (Brecht, 'On the formalistic character of the Theory of Realism', p.76)

Later he added the following note to his reflections on realism:

> It is not the idea of narrowness but that of breadth that goes with realism … When it comes to literary forms, one must question reality, not aesthetics, not even the aesthetics of realism. There are many ways in which truth can be concealed and many ways in which it can be told.
>
> (Brecht, quoted in G. Della Volpe, *Critique of Taste*, p.239)

For Brecht, then, the goal of realism required of the artist 'his whole imagination, his humour, all his powers of invention' (p.239). The notion of realism is not something secure and given, something conceptually and technically conservative, an avenue of retreat from the searching questions of the modern, but something radical and risky – to be won, precisely, from the conditions of a modernity that has so often been experienced as dissuasion from realism of any kind. The social relations of developed capitalism have given rise to a culture industry whose principal motifs have been distraction and fantasy. It is this condition that debates about a modern realism have striven to resist, and against which it finds its most appropriate measure.

Plate 300 Kazimir Malevich, *Portrait of the Sculptor V.A. Pavlov*, 1933, oil on canvas, 47 x 37 cm. State Tretyakov Gallery, Moscow. Costakis gift, 1977.

References

AKhRR, 'Declaration', 1922, in J. Bowlt (ed.), *Russian Art of the Avant-Garde: Theory and Criticism*, New York, The Viking Press, 1976; revised and enlarged 1988 (reprinted in Harrison and Wood, *Art in Theory, 1900–1990*, section IV.b.2).

AKhRR, *The Immediate Tasks of AKhRR: a circular to all branches of AKhRR – an appeal to all the Artists of the USSR*, 1924, in J. Bowlt (ed.), *Russian Art of the Avant-Garde* (reprinted in Harrison and Wood, *Art in Theory, 1900–1990*, section IV.b.3).

AKhR, 'Declaration', 1928, in J. Bowlt (ed.), *Russian Art of the Avant-Garde*.

ARAGON, L., *Pour un Réalisme Socialiste*, Paris, Éditions Denoel et Steele, 1935.

ARVON, H., *Marxist Aesthetics*, Ithaca, Cornell University Press, 1973.

BAXANDALL, L. and MORAWSKI, S., *Marx and Engels on Literature and Art*, New York, International General Editions, 1974.

BENJAMIN, W., 'The author as producer', 1934, in *Understanding Brecht*, London, New Left Books, 1973 (an edited version is reprinted in Harrison and Wood, *Art in Theory, 1900–1990*, section IV.c.16).

BENJAMIN, W., 'Conversations with Brecht', 1938, in *Understanding Brecht*, London, New Left Books, 1973.

BERMAN, R., 'Lukács's critique of Bredel and Ottwalt: a political account of an aesthetic debate of 1931–32', *New German Critique*, 10, winter, 1977, pp.155–78.

BOWLT, J. (ed.), *Russian Art of the Avant-Garde: Theory and Criticism*, New York, The Viking Press, 1976 (revised and enlarged 1988).

BOYD WHITE, I., 'Dix's Germany: from Wilhelmine Reich to East/West divide' in *Otto Dix*, exhibition catalogue, London, Tate Gallery, 1992.

BRECHT, B., 'On the formalistic character of the Theory of Realism', 1938, in E. Bloch, G. Lukács, B. Brecht, W. Benjamin and T. Adorno, *Aesthetics and Politics*, London, New Left Books, 1977.

BRECHT, B., 'Popularity and Realism', 1938, in E. Bloch, G. Lukács, B. Brecht, W. Benjamin and T. Adorno, *Aesthetics and Politics*, London, New Left Books, 1977 (reprinted in Harrison and Wood, *Art in Theory, 1900–1990*, section IV.c.17).

BUCHLOH, B., 'Figures of authority, ciphers of regression' in B. Buchloh, S. Guilbaut and D. Solkin (eds), *Modernism and Modernity*, Vancouver Conference Papers, Nova Scotia College of Art and Design, 1981 (an edited version is reprinted in F. Frascina and J. Harris (eds), *Art in Modern Culture: An Anthology of Critical Texts*, London, Phaidon, 1992).

CARR, E.H., *The Russian Revolution from Lenin to Stalin, 1917–1929*, London, Macmillan, 1979.

CLARK, K., 'Little heroes and big deeds: literature responds to the First Five-Year Plan' in S. Fitzpatrick (ed.), *Cultural Revolution in Russia, 1928–31*, Bloomington and London, Indiana University Press, 1978.

DELLA VOLPE, G., *Critique of Taste*, London, New Left Books, 1978.

DEUTSCHE, R., 'Alienation in Berlin', *Art in America*, January, 1983, pp.65–72.

FITZPATRICK, S., *The Commissariat of Enlightenment*, Cambridge University Press, 1970.

FLAVELL, M.K., *George Grosz: A Biography*, New Haven and London, Yale University Press, 1988.

GRAMSCI, A., 'Americanism and Fordism' in *Selections from Prison Notebooks*, London, Lawrence and Wishart, 1971.

GROSZ, G., 'Instead of a biography', translated by H. Hess in *George Grosz, 1893–1959*, exhibition catalogue, London, Arts Council of Great Britain, 1963.

HARRISON, C. and WOOD, P. (eds), *Art in Theory, 1900–1990*, Oxford, Blackwell, 1992.

HILTON, A., 'The revolutionary theme in Russian Realism' in H. Millon and L. Nochlin (eds), *Art and Architecture in the Service of Politics*, Cambridge Massachusetts, MIT Press, 1978.

HOFFMANN, E., *Kokoschka: Life and Work*, London, Faber, 1943.

HOLME, C.G. (ed.), *Art in the USSR*, special issue of *The Studio*, 1935.

HÜLSENBECK, R., 'En avant Dada' in R. Motherwell (ed.), *The Dada Painters and Poets*, New York, Wittenborn Schulz, 1951 (an edited version is reprinted in Harrison and Wood, *Art in Theory, 1900–1990*, section III.b.6).

JAMES, C.V., *Soviet Socialist Realism: Origins and Theory*, London, Macmillan, 1973.

LE CORBUSIER, 'The quarrel with realism' in N. Gabo, L. Martin and B. Nicholson (eds), *Circle: International Survey of Constructive Art*, London, Faber and Faber, 1937 (reprinted 1971).

LÉGER, F., 'The New Realism goes on' in *The Functions of Painting*, London, Thames and Hudson, 1973 (an edited version is reprinted in Harrison and Wood, *Art in Theory, 1900–1990*, section IV.c.18).

LENIN, V.I., 'Party organization and party literature' in *On Literature and Art*, Moscow, Progress Publications, 1967 (an edited version is reprinted in Harrison and Wood, *Art in Theory, 1900–1990*, section II.a.3).

LEWIS, B.I., *George Grosz: Art and Politics in the Weimar Republic*, University of Wisconsin, 1971.

LODDER, C., *Russian Constructivism*, New Haven and London, Yale University Press, 1983.

LUKÁCS, G., '"Tendency" or partisanship?', *Die Linkskurve*, 1932, translated by D. Fernbach in G. Lukács, *Essays on Realism*, Cambridge Mass., MIT Press, 1981 (an edited version is reprinted in Harrison and Wood, *Art in Theory, 1900–1990*, section IV.b.10).

MALEVICH, K., 'From Cubism and Futurism to Suprematism: the new painterly realism', 1915, in J. Bowlt (ed.), *Russian Art of the Avant-Garde: Theory and Criticism*, New York, The Viking Press, 1976 (an edited version, in an alternative translation, is reprinted in Harrison and Wood, *Art in Theory, 1900–1990*, section II.a.14).

MALEVICH, K., letter to Meyerhold, April 1932, reprinted in *Kunst und Museumjournaal*, no.6, 1990, pp.9–10 (reprinted in Harrison and Wood, *Art in Theory, 1900–1990*, section IV.d.1).

MALLY, L., *Culture of the Future: The Proletkult Movement in Revolutionary Russia*, Berkeley and Oxford, University of California Press, 1990.

MORRIS, L. and RADFORD, R., *The Story of the Artists' International Association, 1933–1953*, exhibition catalogue, Oxford, Museum of Modern Art, 1983.

Neue Sachlichkeit and German Realism of the Twenties, exhibition catalogue, London, Arts Council of Great Britain, 1979.

O'BRIAN TWOHIG, S., 'Dix and Nietzsche' in *Otto Dix*, exhibition catalogue, London, Tate Gallery, 1992.

OPEN UNIVERSITY, A315 *Modern Art and Modernism*, Block VIII *Russian Art and the Revolution*, Milton Keynes, The Open University, 1983.

PACHNICHKE, P. and HONNEF, K. (eds), *John Heartfield*, exhibition catalogue, New York, Harry Abrams, 1992.

PICASSO, P., written statement to Simone Téry in A.H. Barr jr, *Picasso: Fifty Years of his Art*, New York, Arno Press for the Museum of Modern Art, 1946, reprinted 1980 (reprinted in Harrison and Wood, *Art in Theory, 1900–1990*, section V.c.6).

RADFORD, R., *Art for a Purpose: The Artists' International Association*, Winchester College of Art Press, 1987.

REA, B. (ed.), *Five on Revolutionary Art*, London, Lawrence and Wishart, 1935.

RIVERA, D., 'The revolutionary spirit in modern art', 1932, in D. Shapiro (ed.), *Social Realism: Art as a Weapon*, New York, Frederick Ungar, 1973 (an edited version is reprinted in Harrison and Wood, *Art in Theory, 1900–1990*, section IV.b.13).

ROCHFORT, D., *The Murals of Diego Rivera*, South Bank Board, Journeyman Press, 1987.

ROH, F., *Post-Expressionism: Magical Realism, Problems of Recent European Painting*, Leipzig, 1925.

SCOTT, H.G. (ed.), *Problems of Soviet Literature*, 1935 (facsimile reprint retitled *The Soviet Writers' Congress, 1934: The Debate on Socialist Realism and Modernism in the Soviet Union*, London, Lawrence and Wishart, 1977).

SOPOTSINSKY, O., *Art in the Soviet Union: Painting, Sculpture and Graphic Arts, 1917–70s*, Aurora, Leningrad, 1977/8.

TRAUB, R., 'Lenin and Taylor: the fate of Scientific Management in the early Soviet Union', *Telos*, 37, fall, 1978, pp.82–92.

TROTSKY, L., 'Towards a free revolutionary art' in P.N. Siegel (ed.), *Leon Trotsky on Literature and Art*, New York, Pathfinder, 1970 (reprinted in Harrison and Wood, *Art in Theory, 1900–1990*, section IV.d.9).

WILLETT, J., *The New Sobriety*, London, Thames and Hudson, 1978.

WITTGENSTEIN, L., *Philosophical Investigations*, Oxford, Blackwell, 1953.

ZIS, A., *Foundations of Marxist Aesthetics*, Moscow, Progress Publications, 1977.

Index

Illustrations are indicated by italicized page numbers.